The Monstrous Races in Medieval Art and Thought

The Monstrous Race

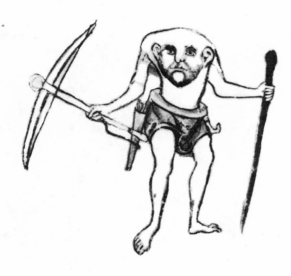

Cambridge, Massachusetts, and London, England

n Medieval Art and Thought

JOHN BLOCK FRIEDMAN

Harvard University Press 1981

Copyright © 1981 by the President and Fellows of Harvard College
Printed in the United States of America
Publication of this book has been aided by a grant from the Andrew W. Mellon
Foundation

Library of Congress Cataloging in Publication Data

Friedman, John Block, 1934–
 The monstrous races in medieval art and thought.
 Includes bibliographical references and index.
 1. Race. 2. Civilization, Medieval. I. Title.
GN269.F74 572 80-23181
ISBN 0-674-58652-2

In memory of Anne Lewis Miller

scholar and artist

April 4, 1925–March 26, 1967

Acknowledgments

I am very grateful to the officials of the many libraries in which I worked on this book, in particular those of the University of Illinois and the University of North Carolina, Chapel Hill, the Bibliothèque Nationale, Paris, the Bibliothèques Municipales of Valenciennes and Poitiers, the British Library, the Cambridge University Library, the National Library of Medicine, Bethesda, Maryland, the Duke University Library, the University of Toronto Library, and Sion College Library, London, for making their facilities available to me. The late George Healey of the Rare Book Room, Cornell University Library, Hubert LeRoux of the Centre d'Etudes Supérieures de Civilisation Médiévale, Poitiers, and J. B. Trapp of the Warburg Institute went out of their way to provide me with books and information. Material aid came from the Southeastern Medieval and Renaissance Institute, Chapel Hill, the Center for Advanced Study and the Graduate College Research Board, University of Illinois, and the Centre d'Etudes Supérieures de Civilisation Médiévale, Poitiers. At different stages of its composition my manuscript benefited from the aid of Edina Bozóky, Didier Coupaye, M.-T. d'Alverny, Karie Friedman, Bert Hansen, H. W. Janson, Robert Kaske, Ann Knock, Stephan Kuttner, Cora Lutz, Patricia G. Mayes, Mrs. Erwin Panofsky, Bruno Roy, David Sider, Nancy Siraisi, and Linda Voigts.

Contents

Illustrations

The Monstrous Races in Medieval Art and Thought

Introduction

The unusual races of men that make up the subject of this book represented alien yet real cultures existing beyond the boundaries of the European known world from antiquity through the Middle Ages. They occur with great frequency in medieval art and literature, lurking in *Mandeville's Travels,* populating the outermost edges of world maps, and resting uneasily in neat frames on the pages of the great illustrated encyclopedias.

I call them "monstrous" because that is their most common description in the Middle Ages. But many of these peoples were not monstrous at all. They simply differed in physical appearance and social practices from the person describing them. Some took their names from their manner of life, such as the Apple-Smellers, or the Troglodytes who dwelt in caves; some were physically unusual but not anomalous, such as the Pygmies and Giants; and some were truly fabulous, such as the Blemmyae or men with their faces on their chests. Even the most bizarre, however, were not supernatural or infernal creatures, but varieties of men, whose chief distinction from the men of Europe was one of geography.

The monstrous races were always far away, in India, Ethiopia, Albania, or Cathay, places whose outlines were vague to the medieval mind but whose names evoked mystery. As geographical knowledge grew, and the existence of many of these races began to appear unlikely, they were shifted to regions less well known—the Far North and ultimately the New World.

The medieval taste for the exotic was in some ways comparable to our *National Geographic* interest in primitive and colorful societies today. However, the very concept of a "primitive" society as one at an earlier stage of cultural evolution was not a part of the medieval

world view. On the contrary, exotic peoples were often seen as degenerate or fallen from an earlier state of grace in the Judeo-Christian tradition; even their humanity was questioned. Curious customs and appearance suggested to the medieval mind an equally curious spiritual condition. The peoples discussed in this book posed a number of knotty problems for Christians. Did the monstrous races, for example, have souls? Were they rational? Were they descended from the line of Adam as were all other members of the human family, or did they have another and separate lineage? How had they survived the Flood? Could they be converted to Christianity? Was their existence a portent of God's intentions toward mankind? If so—and this was the question toward which most medieval thinkers automatically gravitated—what was their significance in the Christian world scheme?

In the following pages I will consider these and related questions from the point of view of the intellectual historian, by bringing together the many medieval sources, visual and literary, of information and opinion concerning the monstrous races. Although pictorial representations of exotic peoples are extremely common, especially in popular works on medieval art, there has not been great interest in the history and significance of these pictures. Indeed, with very few exceptions, discussions of these peoples have been neither rigorous nor analytical. Moreover, because exotic men are considered by medieval authors of many different orientations and interests, a complete examination of their place in medieval thought requires that one look at the races from several perspectives.

For the natural historian of monstrous men, one of the two most useful studies to date is a long article written in 1942 by Rudolf Wittkower,[1] who surveys their traditions chiefly from the vantage point of an art historian. He separates—as many subsequent writers do not—the *races* of men, with inherited physical or cultural characteristics, from the various kinds of polymorphic creatures we commonly find on Romanesque capitals. Surprisingly, most recent writing about these beings does not make this distinction. Too often the fabulous races of men are lumped together with a great body of creatures plainly animal in conception, in books that concentrate on the influence of the bestiary upon medieval art.[2] But precisely because medieval men were so unsure about what constituted the human state, unusual yet clearly human figures meant something very different to them than did a two-headed lion or an ass playing the lyre.

Jean Céard's *La Nature et les prodiges,* a fascinating and carefully

developed book, is the best work on marvels since Wittkower's.[3] Un-
fortunately for our purposes, Céard considers the monstrous races of
Africa and India only incidentally to his main theme, the interest in
prodigies and portentous individual or "monstrous" births in six-
teenth-century France. He does, however, concisely summarize the
main points of the tradition of monstrous races in the first seventy
pages of his work.

He is, moreover, the only recent author to consider the word
"monster" in any depth. The word had three different senses in the
ancient world. Chiefly, it meant something outside the existing order
of nature. Aristotle considered anomalous births as monsters, *terata*,
which were defects of nature; he examined their physiological
causes and classified them by type. Works deriving from him, like
that of Taruffi, thus belong to the science of teratology.[4] Cicero dis-
cussed these births as portents of the will of the gods, including them
in a general critique of divination. Saint Augustine, following to
some degree the Roman encyclopedist Pliny the Elder, saw both the
individual prodigies of the womb and the legendary races of the East
as showing God's power and desire to revitalize man's sense of the
marvelous. Augustine's approach was well summed up by the great
thirteenth-century Dominican encyclopedist Vincent of Beauvais,
who observed that if God had chosen to set the nature of each crea-
ture at the first moment of its creation so that it would persist un-
changeably in its order, Nature would have come to direct herself
and the works and power of God would be forgotten by man. That
Nature often turns from her usual order, however, continually re-
minds men that God is the artisan of all natures and that He acted
not once only, but does so each day.[5]

Céard is concerned chiefly with individual anomalous births as
they relate to the very strong Renaissance interest in divination and
prodigies. Yet, as he points out, all monstrous forms fascinate and
terrify because they challenge our understanding, showing the fragil-
ity and uncertainty of traditional conceptions of man. It is precisely
these conceptions, perhaps more fragile in the Middle Ages than in
the Renaissance, that interest me here. Unlike Céard, I deal mainly
with medieval attitudes toward the fabulous races and the way in
which Western Christian thinkers came to terms with the questions
these beings posed about the nature of humanity. Occasional refer-
ences to Eastern Christian and Islamic interest in the races are not
meant to be representative of all that might be found; I wish only to
suggest analogues to what was taking place in Western thought. Un-
like Wittkower, I try to examine the reception of exotic peoples on

the basis of "texts," both verbal and visual, left to us from the period, and work primarily with a written literary tradition. I omit the more speculative areas of oral narrative and folktale.

Though this study begins with Hellenistic interest in the races, it moves quickly to the high Middle Ages, as this was the period that most preoccupied itself with my subject. A simple chronological treatment would impose an artificial order on such a sprawling and diffuse subject; attitudes toward the monstrous races varied widely according to place, medium of expression, and philosophical persuasion. My arrangement attempts to reconcile this diversity with my perception of certain broad patterns present in the tradition as a whole. I finish with the discoveries of new peoples in the Americas who replaced the races of the East in the European consciousness, assuming not only the name "Indians" but also the burden of many traditional attitudes toward "monstrous" men.

The Renaissance brought to my subject such different conceptions of man and cosmology that it seemed appropriate to take the beginning of the age of discovery as a natural stopping point, and to leave the Cynocephali, the Blemmyae, the Sciopods, and all their ilk resting comfortably at the edges of the Ptolemaic universe:

Retenues à la terre par nos chevelures, longues comme des lianes, nous végétons à l'abri de nos pieds, larges comme des parasols; et la lumière nous arrive à travers l'épaisseur de nos talons . . . La tête le plus bas possible, c'est le secret du bonheur.[6]

1 The Plinian Races

For the sake of convenience, I call the races I discuss here "Plinian," after the Roman author whose catalog of them was so widely diffused throughout the Latin Middle Ages. Yet the earliest accounts of these peoples are Greek, and it is with the Greek response to them that this study should rightly begin. Tales of unusual men to be found far to the east of the Mediterranean world must have intrigued listeners even in Greek prehistory; they are well developed in Homer, whose hero Odysseus has seen many cities and known the minds of many men.[1]

Though Odysseus never traveled to the extreme East, two later Greeks did so, and their accounts of an India populated by marvelous races of men conveyed to Hellenes, and later to Romans, something akin to the wonder of Homer's Cyclops and Lotus-Eaters. Ctesias, who lived in the early fifth century B.C., and Megasthenes, who lived in the fourth, are rather mysterious figures.[2] Indeed, some modern scholars question whether Ctesias ever traveled to India at all. A native of Cnidos, he was a physician at the Persian court. His impressions of the East he called *Indika;* the book itself has not come down to us, but Photius of Constantinople preserved much of it in his *Bibliotheka,* and there are some fragments in a few other writers. Most probably it was an armchair romance of travel, perhaps based on tall tales about India that Ctesias heard from merchants in Persia. Even the ancients were skeptical of his claims, if we can trust Lucian, who in the *True Histories* observed that "Ctesias . . . wrote a great deal about India . . . that he had never seen himself nor heard from anyone else with a reputation for truthfullness."[3] What matters to us here is the influence that Ctesias' book had on his contemporaries and on later generations of travel writers.

Megasthenes was less interested in Indian wonders and more curious about the actual customs of the people than was his predecessor.[4] Early in the fourth century B.C. he was sent as an emissary of Seleucus to the Indian court of Chandragupta, called by the Greeks Sandracottus, and traveled over much of the country. Although there are fabulous elements in his travels, he is nevertheless an important source of information about India's inhabitants and their religious and social practices.

The books of these two men, however limited and biased they may appear to us today, resulted for the first time since Herodotus in a considerable increase in Greek knowledge about India. Ctesias and Megasthenes belong less to the class of geographic writers than they do to that of Hellenistic paradoxographers, whose rhetorically heightened descriptions of peoples and marvels in other lands are a distinctive product of the Greek genius.[5] Whereas scientific descriptive geography was a rather limited discipline in the ancient world, involving the use of mathematics to determine the position of a country, Strabo's and even Ptolemy's works show us that describing a country and its peoples resulted in a genre of travel writing that was highly enjoyable as literature but factually a bit suspect.[6] Marcianus of Heraclea complains of the unreliability of many geographic itineraries in his prologue to the *Periplus* or coastal travels of Menippus: "Those who have truly dared to write periploi and wishing to persuade their readers, give names of places and numbers of stadia supposedly relating to regions and to barbarous peoples whose names indeed one cannot pronounce, seem to me to have surpassed in lying even Antiphanes of Braga."[7] Far from being perturbed by fabulous elements in such authors, Hellenistic readers seem to have enjoyed them, judging from the widespread popularity of Ctesias' and Megasthenes' works. Thus it was that the ancient world first heard of India as a marvelous region at the edge of the earth, where the sun rose and where the traveler encountered many strange peoples.

The most eminent Greek traveler to India was Alexander the Great. The vast body of legend that grew from his travels continued the paradoxographical tradition with respect to Indian peoples.[8] As a result of his supposed training by Aristotle, Alexander commissioned enormous numbers of men whose trades involved natural history, such as hunters, fishermen, and beekeepers to report to Aristotle on the wonders of his expedition. Aristotle supposedly used this information to compile his great work *De Animalibus*, as it was called in the Middle Ages. There is, moreover, an extensive liter-

ature purporting to be the correspondence of Alexander, such as the apocryphal "Letter of Alexander to Aristotle on the Wonders of India," telling of his campaign against Porus and listing some of the monstrous races he met with in his travels.[9]

This letter and several similar texts belonged to the genre of ficti-tious-letter writing used in late imperial rhetorical training. Closely related to the "Letter of Alexander" in rhetorical intention was the "Letter of Pharasmanes to the Emperor Hadrian," which, though its Greek original is lost, exists in several other languages.[10] The writer's name was sometimes corrupted to Fermes, and "Fermes" becomes the author of yet another letter, this time to "Trajan." These three letters, extant in Latin and in most of the European vernaculars, con-tributed several races to our catalog of unusual peoples living in the East. Many more accounts of marvels were transmitted directly to the Latin West by way of Latin Alexander legends and romances.

Knowledge of India's wonders in the books of Ctesias and Me-gasthenes became available to Latin readers through a vast encyclo-pedia of thirty-six books, the *Natural History* of Pliny the Elder, who died, appropriately enough for a natural scientist, by inhaling fumes from the erupting Vesuvius in A.D. 79.[11] His *Natural History*—"his-tory" here meaning an encyclopedia or compendium of informa-tion—must rank with Montaigne's *Essays* and Rabelais's *Gargantua* and *Pantagruel* as a work provoking wonder and pleasure anywhere it is read. It has been deservedly popular since its creation.[12] Though the *fortuna* of the *Natural History*, like that of many other large books in the Middle Ages, was that it would be much abbreviated and excerpted, the work served as a source for a great deal of infor-mation not only about plants, animals, and fish but also about an-cient art, architecture, eating customs, manufacturing, and the like for many hundreds of years. Indeed, some of its statements about the natural world were still being refuted by natural scientists like Sir Thomas Browne in the seventeenth century and later.

Pliny was an obsessive compiler and ransacker of other people's books for odd pieces of lore. He tells us in his preface to Book 1 that "by perusing about 2000 volumes, very few of which ... are ever handled by students, we have collected in 36 volumes 20,000 note-worthy facts obtained from one hundred authors." He was himself a keen observer and traveler, having been to France, Germany, and Spain. His knowledge of Africa, moreover, would have been fairly accurate because of his access to the *formulae provinciarum* or Sen-ate documents relating to various countries. The information he or-

ganizes concerning the animal world and the arts and monuments of men is rather simplified, intended for the ordinary reader who wishes to know generally about the world around him without going deeply into causes. Thus Pliny's method is often anecdotal. His Stoicism led him to believe that everything made by nature was intended to have a purpose, which the natural scientist tries to find in the most ordinary things as well as in wonders. "We marvel," he says in the preface to the eleventh book on insects, "at elephants' shoulders carrying castles . . . at the rapacity of tigers and the manes of lions, whereas really Nature is to be found in her entirety nowhere more than in her smallest creations. I consequently beg my readers not to let their contempt for many of these creatures lead them also to condemn to scorn what I relate about them, since in the contemplation of Nature nothing can possibly be deemed superfluous."

Contrasts among men fascinated him as well; he speaks of giants in his own day who attained a height of nine feet nine inches and then describes a dwarf only two feet high. These extremes do not disgust him as they might have done earlier Greek writers; he has a Roman tolerance for and joy in human diversity, and seems in Book 7 to take a special pleasure in describing the monstrous races of men.

To the races mentioned in his Greek sources Pliny adds from other authors or perhaps from fuller texts of Ctesias and Megasthenes a great many more races, and radically widens their geographic range. To some extent this is due to his conflation of Ethiopia with India. In this he was simply following a tradition as old as Homer (Odyssey 1.23–24), who had spoken of two races of "Aithiopes"—meaning "burnt faces," according to popular etymology. Ctesias had actually called Indians Ethiopians, a confusion that continued in both Greek and Latin writers through the Christian period.[13] Sidonius, for example, spoke of an Indian "like the Ethiopian in hue," and the author of the Greek Barlaam and Iosaphat claimed in the preface that his tale came "from the inner land of the Ethiopians, called the land of the Indians."[14] Because of this confusion, "Ethiopia" must be understood in the geographic portions of this study as a vague literary term rather than one denoting a specific place.

Let us look at the fabulous beings of India and Ethiopia as they were presented by Ctesias and Megasthenes, by the Alexander cycle, and by Pliny. I have listed them in alphabetical order and glossed their names where possible.[15] For convenience, those races who are characterized solely by their appearance or customs I have named arbitrarily, though of course my labels cannot compete with the long

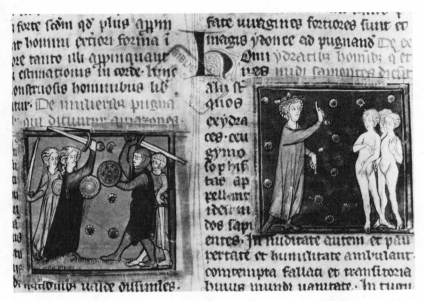

1. Amazons (left) and Gymnosophisti. Thomas of Cantimpré, *De Naturis Rerum*, Valenciennes, Bibliothèque Municipale MS 320, fol. 44r, thirteenth century.

and unusual names that so enhanced the appeal of these races for Western audiences.

Abarimon. Both Megasthenes and Pliny place the Abarimon in Scythia toward the unknown North. As their dominant characteristic is their backward-turned feet, in later discussions of the races they are often confused with other backward-footed men.

Albanians. The keen-sighted Albanian, according to Pliny, is owl-eyed and sees better by night than by day. He is, as well, gray-haired at birth.

Amazons (*"without breast"*). Alexander the Great's contacts with the Amazons, warlike women who live without men and sear off the right breast in order to draw the bow more powerfully, are often described in treatises on the races. I offer a picture of the Amazons from the *Liber de Naturis Rerum* of Thomas of Cantimpré (Figure 1). They will be discussed at greater length in Chapter 8 as examples of the "noble monster."

Amyctyrae (*"unsociable"*). This race has a lower lip—or sometimes an upper—that protrudes so far that it can serve as an umbrella against the sun. The Amyctyrae live on raw meat. A bestiary

2. Troglodyte catching game, Epiphagus, Blemmyae, and Amyctyrae. Bestiary, formerly in London, Sion College MS ARC L.40 2/L.28, fol. 117v, thirteenth century.

formerly in Sion College, London, shows the lip, though not the choice of diet (Figure 2).[16]

Androgini (*"man-woman"*). We learn from Pliny that these people, who live in Africa, have the genitals of both sexes. As Isidore of Seville said of them, "They both inseminate and bear."[17]

Anthropophagi (*"man-eater"*). These people are found sometimes in Scythia and sometimes in Africa. They drink from human skulls, Pliny writes, and wear human heads and scalps on their breasts. Later tradition has them eat their parents when they get old, or—as the Sion College bestiary shows us—anyone else they can find (Figure 3).

3. Cynomolgus, Anthropophagus, Himantopode, and Artibatirae. London, Sion College Bestiary, fol. 117.

Antipodes ("opposite-footed"). This race, which grew from a misconception of the Antipodes as a part of the world where men walked upside down, is very much like the Himantopodes in other respects. An Antipode is shown in a somewhat damaged bestiary in the Cambridge University Library (Figure 4).

Artibatirae. Pliny writes that these people walk on all fours, and they are so depicted, "prone as beasts," in the Sion College bestiary (Figure 3).

Astomi ("mouthless") or Apple-Smellers. In the most eastern parts of India, near the headwaters of the Ganges, according to Pliny and Megasthenes, live these mouthless men. They are hairy all over but wear garments of a soft cotton or down which they harvest from the leaves of trees. They live by smell, and neither eat nor drink, but smell roots, flowers, and fruits, especially apples, which they take with them on trips. They will die if they smell a bad odor. Two of these Apple-Smellers regard their food in a scene from Thomas of Cantimpré, *De Naturis Rerum* (Figure 5).

Bearded Ladies. These women are very common in different forms

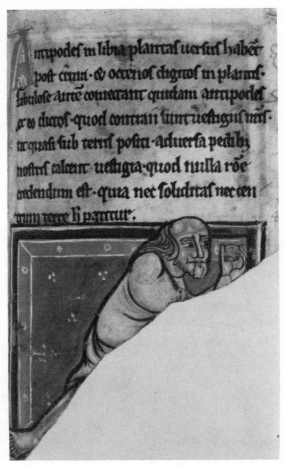

4. Antipode. Bestiary, Cambridge, University Library MS Kk.4.25, fol. 52r, thirteenth century.

in the legends of Alexander. One variety hunts with dogs in the mountains of India.

Blemmyae. In the deserts of Libya, according to Pliny, live men with their faces on their chests; they lack heads and necks and make up part of Shakespeare's "Anthropophagi, and men whose heads / Do grow beneath their shoulders." The Sion College bestiary depicts their most usual form (Figure 2).

Bragmanni. Among the marvels of India are the Bragmanni or naked wise men who spend their days in caves. Their name is an obvious corruption of Brahman. They are often conflated with the

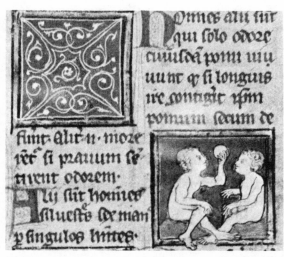

5. Astomi. Thomas of Cantimpré, *De Naturis Rerum*, Valenciennes, Bibliothèque Municipale MS 320, fol. 45r.

Gymnosophisti, who, Pliny says, spend their days standing in fire and staring at the sun. The Cambridge University Library bestiary shows the Bragmanni in their cave (Figure 6).

Conception at Age Five. Pliny speaks of a race whose women conceive at age five and die at eight. In later treatments they are usually shown by means of rather standard childbed iconography.

Cyclopes ("round-eye"). The one-eyed giants of Homer and Virgil

6. Bragmanni. Bestiary, Cambridge, University Library MS Kk.4.25, fol. 52v.

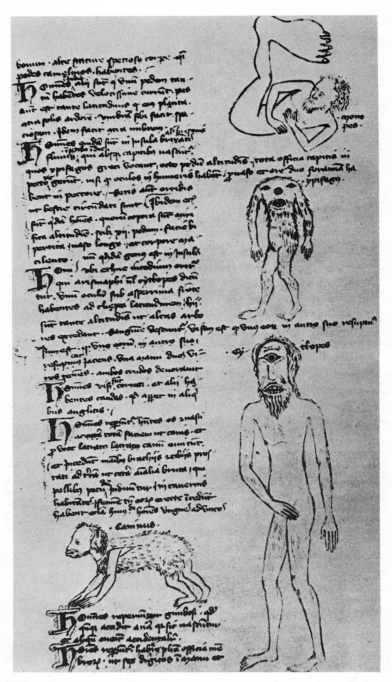

7. Cyclops (lower right) with Dog-Head, Sciopod, and Blemmyae. Thomas of Cantimpré, *De Naturis Rerum*, London, formerly in the A. Chester Beatty Collection, MS 80, fol. 9, 1425.

were supposed to have lived in Sicily, but a race of such people, bearing the same name, was also located in India. A particularly awesome example of a Cyclops can be seen in a southern French version of Thomas of Cantimpré (Figure 7).[18]

Cynocephali ("dog-head"). Among the most popular of the races are the Dog-Heads, who according to Ctesias, live in the mountains of India. They communicate by barking. Dressed only in animal skins, they live in caves and are fleetfooted hunters, using swords, bows, and javelins. In the Alexander cycle the Cynocephali—in addition to their other qualities—have huge teeth and breathe flames. A carnivorous dog-headed man is shown in the Sion College bestiary (Figure 3), where he bears the name of Cynomolgus or Dog-Milker from confusion with another race in Pliny.

Donestre. These men, whose name means "divine" in their own tongue, are described in the legends of Alexander. The Donestre pretend to speak the language of any traveler they meet and claim to know his relatives. They kill the traveler and then mourn over his head. One of a group of Anglo-Saxon texts concerning the wonders of the East illustrates the Donestre at work (Figure 8).

Epiphagi. These men are a Nilotic or Indian race and look like the Blemmyae described by Pliny except that they have their eyes on their shoulders. In some accounts they are bright gold in color.

Ethiopians. In the legends of Alexander, the Ethiopians are shown as black men living in the mountains. Popular etymology derived their name from the Greek words *aith* ("burn, blaze") and *ops* ("face"), suggesting that their color resulted from their close proximity to the sun. The geographic limits of Ethiopia were so vague that it was more of a literary than a cartographic entity, variously found in Africa, India, or both.

Garamantes. These people are an Ethiopian race described by Pliny. They do not practice marriage. In some texts they are located in India and called Gangida.

Giants. Giants belong more to the Alexander tradition than to the Plinian. Alexander meets and defeats them in India; they are sometimes hairy and sometimes smooth-skinned.

Gorgades. Pliny speaks of hairy women who live in the Gorgades Islands and who take that name. These may be the Gorillae, a race of hairy women mentioned by Homer.[19] In later authors they are called Gegetones or Gorgones and appear as horned and tailed men.

Hairy Men and Women. Many varieties of hairy people appear in Pliny and in the legends of Alexander, and I group them for convenience. The Alexander legends often locate these people at fords of

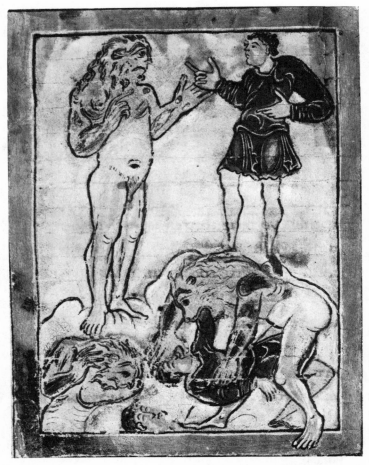

8. Donestre. Marvels of the East, London, British Library MS Cotton Tiberius
B.v, fol. 83b, eleventh century.

rivers where they serve as delaying figures to heighten the suspense
of Alexander's forward march. They are often river-dwelling. Some-
times they are six-fingered or six-handed; sometimes they are
women normal in all respects save their hairiness and boars' or dogs'
teeth.

 Himantopodes (*"strap-feet"*). An Eastern race with long, strap-like
feet, the Himantopodes appear only in later accounts.

 Hippopodes (*"horse-feet"*). Pliny says that these people, who have
horses' hooves instead of feet, live near the Baltic.

 Horned Men. These people are sometimes called Gegetones and

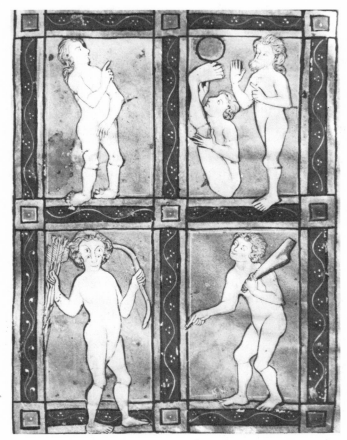

9. Antipode, Sciopod, Maritimi, and Troglodyte. London, Sion College Bestiary, fol. 118.

sometimes Cornuti. They frequently occur in an English setting in the later illustrated treatises on the monstrous races.

Icthiophagi ("fish-eater"). Fish-eating peoples are usually riverine and shown holding a fish.

Maritime Ethiopians. One especially charming race is the "Four-eyed Maritime Ethiopian" mentioned by Pliny in Book 6. He explains that they are so called "not because they are really like that but because they have a particularly keen sight in using arrows."[20] The illustrator of the Sion College bestiary (Figure 9), unable to represent this rather abstract concept, simply makes them a race with a second set of eyes above their normal ones, and shows them holding bows and arrows. Their name is sometimes given merely as Maritimi.

Monoculi ("one-eye"). These people are a variant form of the Cyclops; their name caused Latin readers some confusion from its similarity to the Monocoli, another name for the one-legged Sciopods.

Pandae. According to Ctesias, in the mountains of India live the Pandae—sometimes called Macrobii—who are unusual in that they bear children only once in their lives; at birth the children have white hair, which blackens as they age. The Pandae have eight fingers and toes, and ears so large that they cover the body to the elbow.

Panotii ("all-ears"). The remarkable ears of Ctesias' Pandae are, as it were, detached from their owners and made the attributes of a separate race called Panotii, whose ears reach to their feet and serve as blankets. The Panotii are very shy, and when they see travelers they unfurl their ears and fly away as if with wings. A fine specimen, with ears looped over his arms like sausages, appears in the Anglo-Saxon Wonders manuscript (Figure 10).

Pygmies. These people are among the oldest of the monstrous races. They are mentioned by Homer, and Herodotus speaks of a voyage to the interior of Africa in which some of the members of the party were carried off by dwarfish black men.[21] Ctesias and Megasthenes place them in the center of India. Pygmies speak the same language as other Indians but are only one and one-half to two cubits tall. Their cattle are proportionate in size. They practice no textile arts but braid their long hair into garments. They are constantly at war with cranes, who come to steal their crops. On occasion in the later Middle Ages they are conflated with dwarfs.[22]

Raw-Meat-Eaters. From the Alexander legends come these people, who are especially handsome and who live on a diet of meat and honey. They are usually shown holding a piece of flesh and a bowl.

Redfooted Men. These people, too, come from the fictitious-letter tradition and do not seem to have achieved very wide popularity in spite of their amazing appearance. They live near the river Brixon—a mythical tributary of the Nile—and have twelve-foot-long thighs. Their total height is twenty-four feet. Their arms are white to the shoulders and they have black ears, red feet, a round head, and a long nose.

Sciopods ("shadow-foot"). The Sciopods of India are one-legged but extremely swift; they spend their days lying on their backs protecting their heads from the sun with a single great foot. One is pictured with several other races in a bestiary at Oxford (Figure 11).

Sciritae. These are noseless flat-faced men, according to Megasthenes. They are small of stature and live in the North.

Shining-Eyed Men. There is nothing exceptional about these peo-

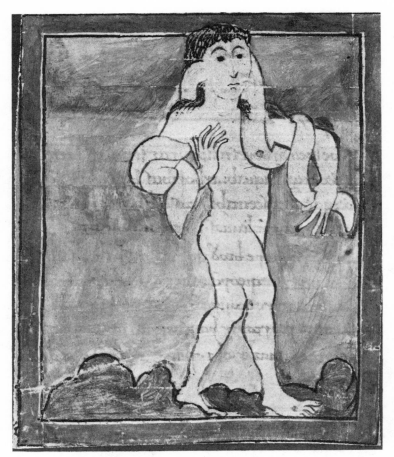

10. Panotii. London, British Library MS Cotton Tiberius B.v, fol. 83b.

ple, who belong to the Alexander tradition, except that their eyes gleam unusually.

Speechless Men. In Ethiopia, according to Pliny, live some speechless, gesturing men; they are shown communicating in this way by the Sion College bestiary illustrator (Figure 12).

Straw-drinkers. In Ethiopia, Pliny says, live a race similar to the Astomi. Noseless and mouthless, they breathe through a single orifice and eat and drink through a straw, as we see them doing in the Sion College bestiary (Figure 12).

Troglodytes ("hole-creepers"). In the deserts of Ethiopia live the Troglodytes who dwell in caves and lack speech. They may be related to a modern North African people whose underground homes

11. Sciopod and other monstrous men. Bestiary, Oxford, Bodleian Library MS Douce 88, Part 2, fols. 69v–70, thirteenth century.

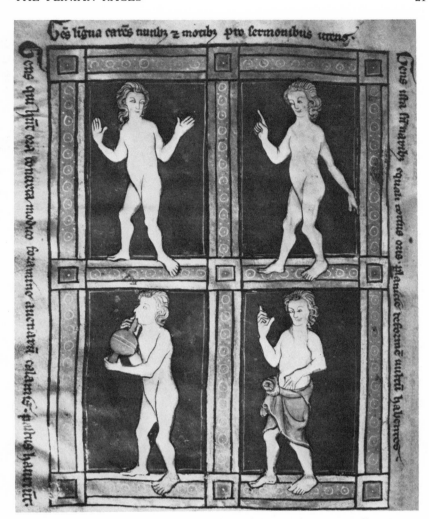

12. Speechless Men and Straw-Drinker (lower left). London, Sion College Bestiary, fol. 118v.

surround an open courtyard dug below ground level. Troglodytes are extremely fast and capture game afoot, as shown in the Sion College bestiary (Figure 2).

Wife-Givers. These men had a very limited popularity, appearing only in the Fermes and Wonders tradition. They are an amiable race who honor and give wives to any traveler who stops among them. A wife looks reluctant in a miniature from the Anglo-Saxon Wonders text (Figure 13).

13. Wife-Givers. London, British Library MS Cotton Tiberius B.v, fol. 86a.

These are the most commonly discussed and depicted of the mon-
strous races. As the fabulous peoples of the East became more acces-
sible to the West through Pliny's *Natural History* and other Latin
sources, their number increased from the nine or ten mentioned by
Ctesias and Megasthenes to several times that. The literary process
by which the races were augmented was rather like cellular division
and mutation.[23] In some cases one race was divided into several. In
others two or more were combined. Still other variants occurred

when an unfamiliar name was misunderstood and passed on in a new form.

New races with slight variations from an older form were often created by a compiler to augment his list. There seems to have been a need for amplitude and diversity among the early chroniclers of the monstrous races, and the tendency was to take a race with several unusual attributes and remove one to form an entirely new type. Such was the treatment given to the Pandae mentioned by Ctesias. They did not need their eight fingers and giant ears to be memorable, since they were already known for limited childbirth and white-haired children. Their ears were "borrowed" to become the dominant feature of the Panotii, whose entire existence is characterized by this single attribute, though some later authors make the Panotii exceptionally tall or as white as milk.

Races also multiplied through what we might call a creative mis-understanding of their names.[24] Pliny speaks of the Sciopods as Monocoli, transliterating the Greek word "one-legged," but this name was misread as Monoculus or "one-eyed" by Latin readers and was soon adapted to the descriptions of one-eyed beings like the classical Cyclops.[25] Those compilers of treatises on the monstrous races who translated from Latin into a vernacular seem to have been especially prone to misunderstand their originals, if we can judge from the practice of an Old French abbreviator of the Fermes material. For example, in the Latin "Letter to Hadrian" an unnamed race inimical to travelers—"we call them the enemy (hostes) because they capture us and eat us if they can"—becomes a race called the Hostes, though the Old French writer goes on to say that this means "enemy."[26]

The medieval fondness for abbreviations and simplifications is apparent in the way separate races who appear in sequence are combined into one. The "Letter to Hadrian" says of a certain kind of beast called Catini that these animals are beautiful. Then, in sequence: "There are men who eat raw flesh and honey. And leftward is the kingdom of the Cativi." After this the writer proceeds to the hospitable kings who give wives to their visitors. In the hands of the Old French abbreviator, this material becomes: "There are men called Catius, just and handsome, who live on raw flesh." And inhabitants of the region neighboring the Catius are now made into a kingly people, the "Reges."[27] Perhaps the most charitable thing one can say about this abbreviator is that he was confused by the minims in the words Catini and Cativi. As a result of this process of cellular

division and mutation, however, the medieval literary tradition had available to it about fifty different monstrous races of men, often shifting about geographically or combining with one another, concentrated mainly in Africa, India, and the unknown northern regions near the Caucasus.

The reader who has considered with some amazement the preceding catalog may wonder how the ancients—and later the merchants, crusaders, pilgrims, and missionaries—who traveled in these lands could have given credence to so many fabulous races of men. Hearsay and fictions about unfamiliar places die hard, of course. But curiously the direct personal observation of the East did not result in a corresponding reduction in the legends of the monstrous races said to live there. We must take into account at least two reasons why this should be so. First, there appears to have been a psychological need for the Plinian peoples. Their appeal to medieval men was based on such factors as fantasy, escapism, delight in the exercise of the imagination, and—very important—fear of the unknown. If the monstrous races had not existed, it is likely that people would have created them.

Second, many of the fabulous races did in fact exist. They continue to exist today, though we might find them difficult to recognize from the medieval accounts. A casual glance at our catalog will suggest several examples: the Pygmies can be identified as aboriginal people who are far from imaginary, reports of giants by European travelers in Africa may well describe the Watusi, Amazons reflect the customs of matriarchal societies, the Amyctyrae could have been based upon lip-stretching customs of the Ubangi, the Anthropophagi were cannibals, the Sciritae Tars, and so on.

Even the improbable-sounding Hippopodes may have had a basis in fact. A tribe exists today in the Zambesi valley on the border of Southern Rhodesia among whose members "lobster-claw syndrome" has become an established characteristic. This condition, which is hereditary, possibly via a single mutated gene, results in feet that are divided into two giant toes instead of five smaller ones—"ostrich feet," as they are described by neighboring tribes. The remoteness of the region and a considerable amount of inbreeding have encouraged the trait.[28] Similar conditions could have accounted for the strange feet or odd number of fingers attributed to several Plinian races.

Errors of perception on the part of early travelers could be responsible for other fabulous peoples. For example, baboons or anthropoid apes may be behind the tales of barking, dog-headed peoples. Interestingly this explanation was offered as early as Albert the Great,

who, when speaking of the great apes, noted that "they are those who are called dog-men in the mappamundi."[29] Similarly, the Blemmyae and Epiphagi, with their faces on their chests, were black, migratory Ethiopians whose actual existence is confirmed by historians. According to Evagrius Scholasticus, a tribe with the name Blemmyae several times attacked Christian settlements in North Africa between the middle of the third century and the fifth.[30] The absence of a neck and the presence of a face on the chest suggests that the Blemmyae made use of ornamented shields or chest armor. Such devices, seen from the defensive vantage point of an observer, might easily have made these warriors seem at a distance to be neckless.

The noseless and mouthless men who take their sustenance through straws may also have an anthropological explanation. The Greeks had regarded as especially reprehensible the barbarians' taste for beer. And the technique by which this beer was made and drunk—sending a straw down through a layer of cracked barley grains to reach the liquor below—may have created a type for the race who took nourishment with a straw. As for the Apple-Smellers, one scholar has suggested that the mouthless men who lived by smell alone were actually a Himalayan tribe who sniffed onions to ward off mountain sickness.[31]

Finally, there can be no doubt that the practice of Yoga in some sects of Hinduism, as well as other Indian religious customs, suggested the idea of physical and cultural monstrosity to Greek observers.[32] Probably the Sciopod who shields his head from the sun with his foot while lying on his back derives from observation of people in Yoga positions. Likewise, Parseeism and Zoroastrianism may be responsible for the Gymnosophisti, who worship the sun in one position all day, and the custom of suttee responsible for the idea of parent-eating races.

We can point to many likely sources for the legends of monstrous races. Yet, even knowing the sources, we have scarcely begun to unravel the intricate threads of their transmission from antiquity through the Middle Ages, or to account for Western interest in them. For their continued power to fascinate we must look to other characteristics of the late antique and medieval mind—characteristics that expressed themselves in errors of perception, but errors that were willful, poetic, and imaginative.

2 A Measure of Man

Greco-Roman accounts of the monstrous races exhibit a marked ethnocentrism which made the observer's culture, language, and physical appearance the norm by which to evaluate all other peoples. The Hellenes, like many other tightly knit cultures, tended to view outsiders as likely to be inferior and untrustworthy.[1] From them we have inherited words like "barbarian" and "xenophobia," which reflect their attitudes toward the world beyond Greek-speaking lands, attitudes that were often justified by experience. Yet at the same time the Greeks were an intensely curious, seafaring people whose great interest in the variety of human life often led them to venture into unknown territory. The works of Ctesias, Megasthenes, and other Hellenic travelers reveal both a fascination with the strangeness of other peoples and places and an implicit revulsion from the "other."

Although an alien was usually defined in antiquity with respect to his legal status as a non-national who did not have the protection of the law or the freedom of the city, his legal status was only one of the ways in which he was perceived to be different.[2] Other more intuitive indicators of foreignness were highly charged with emotional significance. Everyday cultural differences in such things as diet, speech, clothes, weapons, customs, and social organization were what truly set alien peoples apart from their observers in the classical world, and the power of these cultural traits to mark a race as monstrous persisted into the Middle Ages and beyond.

Even today these traits continue to signal whether a person is "one of us" or not. Most readers of fiction will have noticed that an instinctual indicator of social class or national difference is the food that a person eats. A character in a postwar British novel of social class is defined partly by the fact that she uses "sauce" on her food.

A writer evokes the cultural milieu of his boyhood by describing a typical family dinner. The epithets "frog" for a Frenchman or "kraut" for a German identify whole nations with a food known to be eaten there. Ants, sheep's eyes, wild game, wheat germ, pork—all place a distance between the people who eat them and the people who do not.

This was even truer in antiquity. As early as Homer's treatment of the Lotus-Eaters and Polyphemus (Odyssey 9) we see that for the Greeks a race's dietary practices were an important sign of its humanity or inhumanity.[3] It was common in the Greek periegesis or description of coastal voyages to name coastal or island peoples after their eating habits. Rather than trying to elicit the name that the people might use of themselves, the traveler characterized them by the dominant food in their diet.[4] Thus we find Agatharcides of Cnidos describing the peoples of Ethiopia as Fish-Eaters, Root-Eaters, Elephant-Eaters, and Dog-Milkers.[5] And Homer (Iliad 13) has Zeus surveying the distant Hippomolgi, or Horse-Milkers, with wonder. As late as the tenth century we see much the same habit of mind in the geography of Pseudo–Moses of Chorene.[6] In discussing Libya, the author simply lists the peoples there by diet, giving them long and resonant names: Rhizophagi, Struthophagi, Icthiophagi, Anthropophagi, and, in Scythia, Galactophagi. The point of view implicit in such labels is ethnocentric, for characterization by diet suggests the difference or remoteness of the other from the observer rather than the common bond of humanity. Although the Romans were considerably more cosmopolitan in these matters, it is suggestive that Pliny in his Natural History characterized many races according to their alien diets. Among them were the Astomi or Apple-Smellers, Straw-Drinkers, Raw-Meat-Eaters, snake-eating Troglodytes, dog-milking Cynomolgi, parent-eating Anthropophagi, and Panphagi, who devour anything.

The unusual diets of these races no doubt accounted for much of their immense popularity in medieval encyclopedias and Eastern travel narratives. In medieval representations of the Plinian peoples the artists take obvious pleasure in presenting unusual foods or eating habits, often going far beyond the verbal instructions in the texts. An example is the illustration cycle featuring the Cynomolgus from the bestiary formerly in Sion College (Figure 3). One of Pliny's races in Ethiopia, the Cynomolgi, or Dog-Milkers, is plainly a variant form of the Cynocephali of Ctesias and other Greek writers. In Pliny's catalog of the races, the Dog-Milkers appear right after the Anthropophagi (6.35.195, p. 482). The Sion College illustrator gives

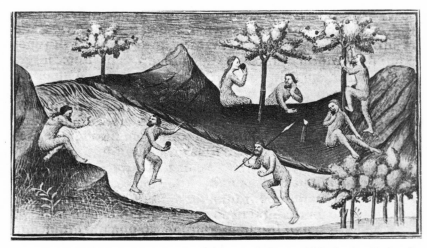

14. Riverine Apple-Smellers. *Mandeville's Travels,* Paris, Bibliothèque Nationale
MS Fr. 2810, fol. 219v, fifteenth century.

us an Anthropophagus in the upper right register, chewing on vari-
ous human parts; to his left is the Cynomolgus, whose rubric now
contains the new information that he too eats human flesh. Ap-
parently his dog-milking has been forgotten or the meaning of his
name was no longer understood when people ceased to read Greek.
The illustrator has handed him a limb similar to the one eaten by the
Anthropophagus and a new race of dog-headed cannibals develops
from the harmless Cynomolgus.

Another picture cycle, this time from *Mandeville's Travels,* shows
how diet contributed strongly to the races' capacity to evoke wonder
in a medieval audience (Figure 14).[7] The Middle English metrical
Mandeville presents somewhat more succinctly than the prose ver-
sion information about the people in the miniature.

> There is another island
> That men call Piktain
> And the people of that region
>
> Never eat or drink
> But everyone in that land
> Holds an apple in his hand
>
> By whose smell he lives
>
> And on the island of Dendros, I gather,
> That is next to it,
> Men live on flesh and fish.[8]

In the prose version we learn that the men of Dendros—whom we have met before in the Alexander literature—"have skins as coarsely haired as beasts, except for the face. These people go as well under water as they do on dry land."[9] The illustrator has seen fit, perhaps in the interests of economy, to conflate the people of Piktain with those of Dendros and make a single race of hairy, riverine Apple-Smellers. Perhaps, as well, he realized that people who could live on the smell of apples would seem more remarkable and alien to his audience than those who ate flesh and fish, even raw.

Nearly equal in importance to diet as a measure of man was the possession of speech. Homer had referred to a certain race as "barbarians," literally *barbaraphonoi* (*Iliad* 2.867) or those whose language sounds like "bar bar" to a Greek, and the term was not uncommon among later writers.[10] This suggests that to the Greek mind the concept of *audekseis,* the use of articulate speech distinguishing men from animals and non-men, was not enough to confer full humanity. The speech had to be Greek, for the sounds of the non-Greek-speaking "other" were not the true communications of rational men.[11]

Again, the Roman world was more cosmopolitan than the Greek in this regard, but characterization of the alien by language was shared to a lesser degree by Pliny. Interestingly, five of his races are monstrous wholly or partly because they lack human speech. In addition to their surprising countenances, the Cynocephali bark like dogs. Both the Astomi and the Straw-Drinkers by implication lack speech altogether, as do more explicitly the snake-eating Troglodytes and the speechless gesturing people.

Even the names foreign peoples used among themselves were held in low esteem by the ancients. Pliny observed that "the Greeks give to Africa the name of Libya . . . the names of its people and towns are absolutely unpronounceable except by the natives" (5.1, p. 219). And when Pseudo–Moses of Chorene names a few of the forty-three races in Scythia, he says of the rest, "The other people bear some barbarous names; it is superfluous to repeat them here."[12] As late as the fourteenth century we find the author of *Mandeville's Travels* including a variety of alphabets in his work to show that the alien had not only a different speech but even a different form of writing. One manuscript of the *Travels* adds to the six alphabets found in most versions two others, the alphabets of Cathay and of Pentexoire, the land of Prester John.[13] It should be noted that such curiosity about the speech of other races, while showing Western fascination with their strangeness, is often smug or moralizing and rarely depicts

these peoples to advantage. Mandeville is one notable exception to this statement.

Another mark of the alien was his existence outside the cultural setting of a city. Preeminently social and civil, the Hellenes had trouble viewing the members of primitive societies as men because they did not make use of the *polis*. For the Greeks, it was difficult to imagine a man independent of his city; slaves and aliens who had no city had no independent existence. The city conferred humanity, for it gave its citizens a shared setting in which to exercise their human faculties in the practice of law, social intercourse, worship, philosophy, and art. Partly because barbarians did not organize themselves into city-states as did the Greeks, we see Aristotle in *Politics* 1.2.18 thinking of barbarians as natural slaves and outcasts, agreeing with Homer that they were rightly ruled over by Greeks. As Aristotle pointed out in the *Nichomachean Ethics* 10.9.8–9, and *Politics* 1.1.5, "normality" was only possible to the inhabitant of the city-state on the Greek model. Men who lived outside cities, since their lives were guided by no law, were not really human, as for example Homer's Cyclopes, who lived apart in caves without *themites* or precedents to guide them.

The Romans, too, considered the ability to form cities as one of the distinguishing characteristics of humanity. Accordingly, the monstrous races who did not meet this criterion seemed to the ancients uncivilized and scarcely human. In a late antique itinerary, for example, we learn of "men large and half wild, Aegypanes, Blemmies, Iampasantes, Satyri, without houses or habitations."[14] Most accounts of the races, whether Greek or Latin, place just this sort of stress on the uncivilized nature of their habitat. Monstrous men ordinarily dwell in mountains, caves, deserts, rivers, or woods, and cannot truly be understood apart from their barren or savage landscapes.

When early Christianity inherited the concept of the city from antiquity and used it as a metaphor for a spiritual community of believers, the Plinian peoples, as non-Christians, were again excluded. Or, in one tradition, they were relegated to a metaphoric city of evildoers. Some Christian thinkers associated them with the line of Cain. Saint Ambrose, in his treatise *De Cain et Abel,* argued that the two brothers signified two inimical forms of human consciousness. One, symbolized by Cain, believed only in the primacy of man and in the creations of human genius, whereas the other, symbolized by Abel, rendered homage to God and to His works.[15]

In *The City of God,* Saint Augustine developed this view. He re-

called of Cain that after his malediction "he built a city" (Genesis 4:17). Just what sort of city this might have been was implied by the contrast between the two brothers. Developing his notion of the city, Augustine said:

I speak of . . . two cities, that is, two societies of human beings, of which one is predestined to reign eternally with God and the other to undergo eternal punishment with the devil . . . Cain . . . the first-born . . . belonged to the city of men; Abel was born later and belonged to the City of God . . . Cain founded a city, but Abel, being a sojourner, founded none. For the city of the saints is above.[16]

It was very common in early Christian commentaries to connect the monstrous races with Cain as their first parent, and to assume that the races partook of Cain's curse and promise of eternal torment in hell. In a number of illustrations for *The City of God* we see Cain building this "city of men" while the monstrous races are depicted in the background, as in a fifteenth-century example (Figure 15) where mosque-like architectural shapes suggest the artist's moral attitude toward the non-Christian world.[17] There is a certain irony in this attitude, insofar as early Christianity itself was nurtured and throve in urban centers of the ancient world, where specialization or division of labor allowed residents the luxury of a more sophisticated religion. The ills to which the flesh is heir were more common in city environments, as were all the vices, yet the Christian reaction against them was more often to create an ideal city than to retreat into a vision of a pastoral life. The stern Ambrosian association of the races with the city of man was only one of several Christian attitudes toward them, but whether they were relegated to their own sinful cities or to a wild landscape without cities, the monstrous races were early seen as exiled from the society of mankind because of innately evil dispositions.

In keeping with their uncivilized surroundings, the monstrous races in medieval art were often shown naked or wearing only animal skins, since they lacked textile arts. The Pygmies in some accounts were said to braid garments of their own hair. Undoubtedly the nakedness of many of these races was a necessary convention in that it enabled the artist to show their anatomical peculiarities. And obviously nakedness was the attribute of the Gymnosophisti or naked wise men—though on occasion they are decorously covered in leaves, as in a miniature from the Middle English Alexander cycle (Figure 16). However, in almost all other instances nakedness was a sign of wildness and bestiality—of the animal nature thought to characterize those who lived beyond the limits of the Christian

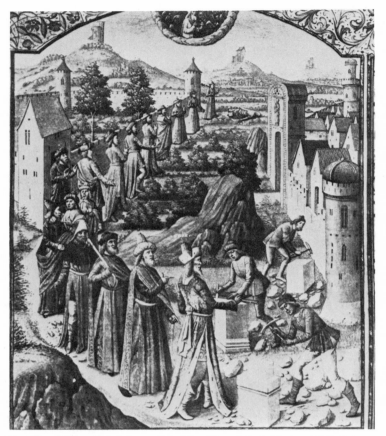

15. The City of Man. Saint Augustine, *The City of God,* Nantes, Bibliothèque Municipale MS Fr. 8, fol. 110, fifteenth century.

world. A hair or animal garment reflected only a slightly more charitable view of the being in question, giving him a status somewhere between animal and human. Huguccio of Pisa, the author of a very popular alphabetical dictionary, the *Magnae Derivationes,* explains the word *monstrum* by reference to *mastruca,* hairy garments of skins: "Who ever dresses himself in such garments is transformed into a monstrous being."[18] Even Heracles, who came by his lion skin honestly enough, was always shown wearing it and carrying a club, becoming a stock figure for the boor or bully in Satyr plays.

The ubiquitous club, a weapon made from a branch wrenched from a tree and so made without forethought or art, reveals yet another prejudice of the medieval world concerning alien peoples. Men

16. Alexander the Great and the Gymnosophisti. *Romance of Alexander,* Oxford, Bodleian Library MS Bodley 264, fol. 215, English, fifteenth century.

who carry clubs are ignorant of chivalric weapons and the military customs of civilized Westerners. Indeed, only the Amazons, who have a special status among the races, are regularly depicted with the armor and weapons of medieval men. More typical is a scene of the Blemmyae from an illustrated text of Mandeville (Figure 17). Here the Blemmyae carries a shield, but his offensive weapon is the long club or stave.

Alice Colby-Hall has pointed out that "in twelfth-century literature, peasants, giants, and non-Christian warriors often defend themselves with large sticks of some sort."[19] Undoubtedly one is meant to see a resemblance between the representative of a monstrous race and the rustic or churl whose uncivil nature is commonly shown by the club he wields. In portraits of the figure of Dangier in *Le Roman de la Rose,* the club is an emblem of his social and moral status. Sometimes the club is held by a churl or herdsman who is himself monstrous in physical appearance. The most familiar example of this is the set piece of description in Chrétien de Troyes's *Yvain* of the giant herdsman near the magic spring, dressed in untanned beef hides and holding a great club (l. 269f).[20] The club seems

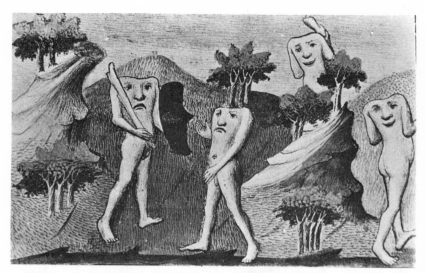

17. Blemmyae. *Mandeville's Travels*, Paris, Bibliothèque Nationale MS Fr. 2810, fol. 194v.

to symbolize this giant's monstrousness in a group of Arthurian murals from Schmalkalden, Thuringia, painted about 1250, where it is his distinguishing attribute.[21] Likewise, the giant in Aimon de Varennes's *Florimont* is described as so strong and savage that he uses only club and shield.[22] Saracens and devils in a great variety of Middle English romances wield clubs,[23] as does a monstrous figure labeled Violantia in a manuscript in the state library of Munich.[24] Finally we might note that although the weapon with which the first murderer, Cain, slew his brother was usually the jawbone of an ass,[25] in the Genesis scenes from the Paris Psalter he holds a club.[26]

In summary, the peoples introduced to the West by Ctesias, Megasthenes, and Pliny were perceived as monstrous because they did not look like western Europeans or share their cultural norms. Some of these races, like the Blemmyae and the Astomi, were physically anomalous; others differed in speech, diet, social customs, or modes of defense. Whatever the nature of the differences, however, the Plinian races diverged sufficiently from Western men to evoke very little feeling of brotherhood or empathy. The sense of the alien or "other" in the marvelous races of the East was so great as to disqualify them, in the Greco-Roman view, from the epithet "men." Both in themselves and in their geographic location, they were creatures of the extreme.

Greek attitudes toward the extreme in all things are too well

known to need extensive discussion here, and we may take Aristotle's remarks on this subject in the *Nicomachean Ethics* as representative, though in this work he is speaking about a virtuous mean. Defining the mean as "a point equally distant from either extreme," he argues that "excess and deficiency are a mark of vice, and observance of the mean a mark of virtue."[27] Extremes of all sorts could be imagined as "marks of vice," and geographic extremes could be "marks of vice" as well. The Greeks and Romans imagined themselves to be at the center of the civilized world and believed that their way of life constituted a standard by which all things far from that center were judged. The farther from the center, the more extreme a thing was, and therefore the more a "vice" it was. For the Greeks, the East or things Asian were extreme with respect to the mean, and we often find an aesthetic polarity between things Attic and Asian. Asia represented emotion, redundance, and formal disorder, whereas Athens and the Attic represented moderation, control, and formal balance.

Edgar de Bruyne, in his pioneering study of medieval aesthetics, has suggested that late antique and early medieval fascination with the monstrous races may be an outgrowth of this opposition between Atticism and Asianism. Presumably, the Attic sensibility, looking from the center out to the edges of the world, found the monstrous—with its corollaries, the enigmatic, the inflated, and the grandiose—attractive because its very Asianism gave a *frisson* of the beautiful.[28]

Extremes of form and of place were closely linked in antiquity and the Middle Ages. Being a seafaring people, the Greeks had fairly well-defined edges for the central community of nations that made up the human family, edges that constituted the borders of the known. But even as the known world expanded, the view from within it remained much the same. At the center of such a world was the perceiver. His race, language, and cultural characteristics were the mean, and everything moved toward the extreme as it moved further from him. The very greatest extreme was assumed to exist beyond the borders of the known, and held a great fascination for the observer at the center.

By the late antique period, the surface of the globe began to be distinguished into regions and the concept of environment developed, with the attendant idea that the *oikumene* could itself be divided into regions according to climate.[29] Men who lived in different climates would perforce be different from one another because of unequal climatic influence; indeed, there would be some areas in which conditions would be so extreme that men like those of the center could not

exist at all.[30] Such places received the label "uninhabitable," but were not necessarily considered empty of life. They contained no people like those of the center, but were considered to be likely and appropriate habitats for the monstrous races.

3 At the Round Earth's Imagined Corners

"Place," said Roger Bacon, "is the beginning of our existence, just as a father."[1] This axiom was especially true of the monstrous races, whose traditional placement at the world's edges was closely related to their monstrousness, both in character and in appearance. As men came to think about the earth's surface—either for practical reasons, to get from one place to another safely and quickly, or, more usually, to speculate on the relationship between their homeland and other places—they developed an elaborate theory of the relationship among character, appearance, and place, and it was in this context that the Plinian races acquired a traditional location in remote environments as part of the ordered fabric of medieval cosmography.

From the classical period through the Middle Ages, Western Europeans seemed to give an enormous ethnocentric shrug of distaste, which pushed the races outward and eastward from the Western centers of humanity. By the late antique period this outward movement had placed the races beyond even the barbaric peoples at the very perimeter of the Greek and Roman consciousness; in the Christian period, they were placed beyond Jews and Moslems. Moreover, the medieval world map gave a visual schematization to these ideas, confining the races to certain parts of the world. In those maps that give a theological turn to geography, monstrous men are symbolically the farthest from Christ of anything in the creation, and are represented in a narrow band at the edge of the world, as far as possible from Jerusalem, the center of Christianity. In those maps that rely on scientific thinking about climate and environment, the races

are shown in the Antipodes at the extreme south of the world, and their physical appearance and moral character are explained by the influences of the extremes of temperature to be found there.

Widespread use of the automobile has led us to think of maps and atlases as sources of practical and specialized geographic information. It would be a mistake, however, to regard medieval maps as we do modern road maps or political atlases, for in the Middle Ages the map was far more a visual work of art and an expression of contemporary cosmology and theology than it was an object of utility. Consequently, medieval maps are most often stylized sketches of the disposition of the earth's continents rather than aids to traversing these continents.[2] They are likely to be a hodgepodge of biblical, classical, and fabulous history mixed with the names of true places, cities, and peoples. Most of them, moreover, indicate in one way or another that God made the world and has a continuing interest in its fate.[3] Such maps, highly schematic, distorting the form of seas and continents to obtain visual symmetry at all costs, and often based as much on Roman authority as on the information of contemporary travelers, were works that had a strongly religious and cosmological function, and it can be no accident that of the three most elaborate ones surviving into the modern period, one is found in a psalter, one once hung in the schoolroom of a nunnery, and one hangs today in an English cathedral.[4]

About eleven hundred of these maps have come down to us in various forms, ranging in size from sketches three inches in diameter to fully developed pictures of the world ten and a half feet square.[5] The maps that contain the monstrous races of the Orient are of two types, the Noachid or tripartite maps and the Macrobian zone maps. The former, sometimes called the T-O maps, show the world as a flat, pie-like shape. This world disk is surrounded by a ring of ocean that forms the shape of the letter O. Within the O and dividing it into three parts is a shape resembling the letter T, whose stem is formed by the Mediterranean imagined as a narrow, vertical mass (North being generally to the left and East at the top) and whose crossbar was formed by the river Tanais (the Don) to the left and the Nile to the right. Were a cartographer to be placed like Keats's Cortez "when with eagle eyes / He stared . . . upon a peak in Darien" he would look down on a finite plane. According to Nicole Oresme, a popularizing translator of Aristotle and writer on cosmology (1332–1382), such an observer would see "Asia to the east, and Africa and Europe to the west and Africa to the south, and Europe to the north and between these two parts is the Mediterranean."[6]

As the Dominican, Leonardo Dati—or his brother, Gregorio—described this scheme in his cosmographic poem *La sfera* (1435), "A T within an O shows the design, how the world was divided into three parts."[7] The division of the world in the tripartite map is based on the story of how Noah repopulated the world after the Flood by giving one continent to each of his sons. Japheth received Europe, Shem received Asia, and Ham Africa. Usually in the more schematic maps these continents bear the names of Noah's sons, but this feature often disappears as man's knowledge of the world widens. In such maps the continent of Africa—with or without the name of Ham—is frequently located in the lower right of the world disk, containing at its outmost edge a band in which are to be found a number of monstrous races.

The Macrobian zone map is a far more theoretical type. It is designed to illustrate a passage in Macrobius' *Commentary on the Dream of Scipio,* in which the author points out that the earth,

a vast sphere to us . . . is divided into regions of excessive cold or heat, with two temperate zones between the hot and cold regions. The northern and southern extremities are frozen with perpetual cold, two belts, so to speak, that go around the earth but are small since they encircle the extremities. Neither zone affords habitation, for their icy torpor withholds life from animals and vegetation . . . The belt in the middle and consequently the greatest . . . is uninhabited because of the raging heat. Between the extremities and the middle zone lie two belts . . . tempered by the extremes of the adjoining belts; in these alone has nature permitted the human race to exist.[8]

A typical map illustrating Macrobius' zone thinking is found in the *De Philosophia Mundi* of William of Conches (1080–1145) in the Sion College bestiary. There are five zones in this map (Figure 18), beginning with the northern extremity at the top, in blue, with the rubric "Riphaean mountains." The known parts of the world are in white and mauve with a habitable zone, called "Temperata," divided by an ocean from an uninhabited zone, called "Perusta." Then comes a red central section and another habitable zone, "Temperata," white and mauve, sometimes called "Antipodum." Finally, we reach the uninhabitable "Frigida australis," again in blue.

Only a narrow part of the world as William understood it was inhabited, and the perspective from which the rest was seen was a very ethnocentric one, as the rubric "Nostra zona," common to these maps, makes clear. Often modified, this scheme was sometimes augmented by summary catalogs of rivers, islands, seas, mountains, and countries to bring it more in line with the Noachid maps; but it remains essentially theoretical, telling us, for example, that the frigid South is uninhabitable by reason of eternal frost.

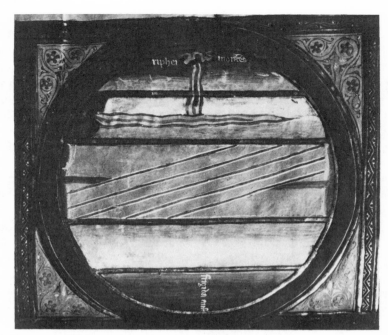

18. Zone map. William of Conches, *De Philosophia Mundi*, London, Sion College Bestiary, fol. 177v.

An interesting variant of the Noachid map combined with the Macrobian produced a third map or subtype which had an austral continent. These maps are incorporated into manuscripts of the commentary on the Apocalypse of the Spanish Benedictine, Beatus of Liebana (730–798),[9] the earliest surviving maps to depict the monstrous races. There are fourteen examples extant, and one of these, from Burgo d'Osma, made in 1086 (Figure 19), shows the Noachid structure covering about three-quarters of the earth's surface. The remainder is an austral continent in which a Sciopod reclines as if on a holiday while the southern sun blazes above his head.

So ubiquitous has been the popular view that the Middle Ages thought the earth was flat and that one would fall off if one sailed to the edge, that the obviously spherical earth in Macrobian maps may come as something of a surprise. Following Artistotle's *De Caelo* the earliest maps presented the earth as a globe, and there is no reason to think that this view was not widespread.[10] Only a very few medieval authors, holding fiercely literal interpretations of Genesis, denied the sphericity of the earth.[11]

The Noachid maps, most often nonhemispheric in configuration

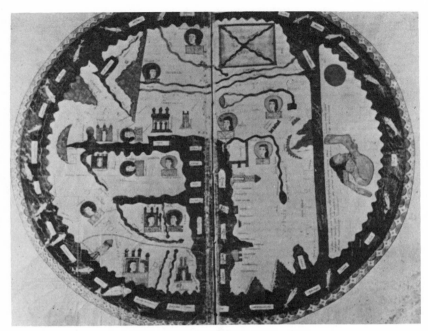

19. World map. Beatus of Liebana, Commentary on the Book of Revelations, Cathedral of Burgo d'Osma MS 1, fols. 35v–36, 1086.

and showing the world as a disk, probably do so more for aesthetic than for cosmological reasons. Indeed, contemporary with the maps of this type, we find such sophisticated proofs of sphericity as that of Aquinas, who argued that the earth must be round because changes in horizon and constellations occur as one moves over the earth's surface.[12] By the end of the Middle Ages, there were a number of popularizing treatises on the world machine and its parts, developing from the De Sphera of John Sacrobosco.[13] Sphericity, as we shall see, was a necessary concomitant of the idea of the Antipodes, which placed the monstrous races in a part of the globe opposite to and below the region of Western man.

Both the Noachid and the Macrobian zone maps had a wide and popular dispersion; they were common in medieval encyclopedias, where they often presented literally or symbolically the geographic and cosmological ideas in the texts they accompanied. For example, in the Liber Floridus of Lambert of St. Omer (1050–1125), which as the title suggests is a collection of some three hundred extracts or "flowers" from various authors, we find maps taken from Martianus Capella, Macrobius, Orosius, Isidore of Seville, and Bede.[14] Gautier

de Metz's *Image du monde* and the French and English translations of the *De Proprietatibus Rerum* of Bartholomaeus Anglicus are other popular vernacular works containing maps.[15] World maps, or schemata based on them, also appeared in the stained glass windows of churches, in floor mosaics and tympana, in bibles, psalters, and other works of religious instruction.

That such maps appealed strongly to a learned audience as well is shown by the example of Jacques de Vitry, the thirteenth-century bishop of Acre. Though he had been long in the Holy Land, he still turned to the mappaemundi when he came to write his *Historia Orientalis*. He devotes some twenty-five pages of this work to the Plinian races traditionally believed to live in these regions, obtaining his information about them not from personal observations, or those of other Western travelers, but "in part from the writings of the blessed Augustine and Isidore, and also from the books of Pliny and Solinus," and "in part from the mappaemundi"—a source of authority equal in weight to these writers.[16]

It must have been a combination of the descriptions of these races, their names, and their pictures in such maps that helped establish their reality for medieval people. Paulinus of Venice observes in the prologue to his *Satyrica Historia* that "without [maps] I say it would be not so much difficult as impossible to imagine or conceive in the mind the dispersal of the sons of Noah and the four great kingdoms. What is needed are maps with both pictures and words, for without the one, the other will not suffice. Pictures without words do not show provinces and kingdoms clearly, and words without the support of pictures do not enable the eye to comprehend the boundaries of provinces."[17]

Not only pictures of the races in their habitats, but also discussions of their relation to those habitats were of great importance. In the West, the notion that race depends on climate was well developed as early as Isidore of Seville: "In keeping with the differences in climate, the looks of men, their color, and their stature vary, and different dispositions appear. Consequently the Romans are stately, Greeks shifting, Africans sneaky, Gauls warlike by nature and plunge into things, all because the climates they live in differ."[18] As mapmakers and cosmological theorists became increasingly interested in the effects of climate and environment on man, the location of the Plinian races at the extremities of the world, either in the Antipodes or in the sub-Nilotic band at the edge of the world disk, became an important factor in explaining their unusual habits and appearance.

These maps differ as much in their accounts of the inhabitants of the extremities as in their presentations of the earth's surface. The Noachid map in its simplest form is man-centered and has what might be called an ethnological intent—to depict the monstrous races, among other peoples, in the regions of the earth they tradi- tionally inhabit in Pliny and in similar writers. Such maps name peoples, wonderful animals, cities, geographic configurations, and the like but provide no explicit reason why these features should be there or any explicit correlation of races and climate. Although much can be learned about the viewpoints of the makers, this requires an analysis of patterns within the maps themselves.

In contrast are those maps of the Macrobian type. In their purest form they are region-centered, saying little or nothing, however, about the peoples, cities, or other works of man in each region. They are primarily concerned with theoretical information about habit- ability or uninhabitability as determined by the position of a given land mass on the globe. The Noachid map, in other words, tells us the monstrous races are where they are because traditionally they have always been there; the Macrobian map tells us where they are likely to be because extreme peoples will be found in extreme places. As Ranulf Higden in his *Polychronicon* expressed it in speaking of Ire- land, "Note that at the farthest reaches of the world often occur new marvels and wonders, as though Nature plays with greater freedom secretly at the edges of the world than she does openly and nearer us in the middle of it."[19] Figure 20 shows one of the smallest maps of the Noachid type, coming from a psalter in the British Library. Though it is only three and one-half inches in diameter it contains a remark- able amount of ethnological information. There are, for example, one hundred forty-five names on this map, and fourteen Plinian races are depicted in a band to the south of Africa. There are, as well, scenes from the Alexander legends and a representation of Noah's Ark. It has been dated between 1200 and 1225.[20]

All of this varied information seems to revolve around a central point in the map: the city of Jerusalem. Jerusalem's placement on the world disk in the Noachid maps is a visual reflection of the belief that it was geographically the center of the world, an idea that developed from a reading of the phrase that salvation would come "en meso tes ges" from the Septuagint version of Psalm 73:12. This was rendered in the Vulgate as "operatus est salutem in medio terrae" where the theological concept was quickly interpreted as a geographical one, buttressed in part by Ezekiel 5:5, where God says that He will estab- lish Jerusalem in the midst of nations. Isidore of Seville spoke of the

20. World map. Psalter, London, British Library MS Add. 28681, fol. 9, thirteenth century.

city as the "navel of all the land" of Palestine,[21] and Rhabanus Maurus expanded this phrase to read "of the entire earth."[22] The significance of this city for Christians is clearly stated in a gloss on Psalm 73:12 by the Dominican exegete, Hugh of St. Cher. "In the middle of the earth," he explains, is "Jerusalem, where Christ by his

Incarnation, his preaching, and his passion, was the salvation of the human race."[23]

Below the Nile at the extreme south in the psalter map, fourteen of the monstrous races cluster in a narrow area whose circular shape repeats that of the world disk. They are strongly emphasized compared to other ethnological elements on the map, but very little physical space is allotted them; one feels that they are being pushed into the ring of ocean and the fabulous region of the winds. Opposite them to the north and similarly located at the edge of the world is the land of the unclean peoples associated with the names of Gog and Magog. They are surrounded by the Caucasus, in which is visible the great gate of brass placed there by Alexander the Great.[24] These mountains prevent the unclean peoples from approaching the center in the same way the Nile confines the Plinian races. To the East is a similar pattern, with a circle containing Paradise and the legendary trees of the sun and the moon; the four rivers of Paradise radiate outward from the enclosure.

The close visual association of the races with the winds, the oceans, and the great heat of the south connects them to three of the four elements, irreducible but chaotic building blocks of matter at the edge of creation. Their arrangement in this psalter map is reminiscent of a popular diagram of the microcosm and macrocosm often called Mundus Annus Homo, which showed, usually within a circle, an interlace of humors, seasons, and elements.[25] Often this pattern contained a portrait of Christ at the center. Furthering the resemblance, Christ's body dominates the psalter map.

The two largest maps to come down to us from the Middle Ages are likewise dominated by the figure of Christ (see Figures 30 and 31 in Chapter 4). The first is a map in Hereford Cathedral, measuring sixty-five by fifty-four inches and painted on a single skin. It was made in 1290 by Richard of Haldingham, a canon at the cathedral from 1305 to 1313.[26] The second, called the Ebstorf map, measuring ten and one-half feet square and using thirty-five skins, was made about 1240 in lower Saxony near Luneburg and named from its discovery in a closet in the former Benedictine nunnery of Ebstorf.[27] It was destroyed in the bombing of Hanover in 1943. The two maps are closely related iconographically.

On the Hereford map, Christ is placed in the *maiestas Domini* position at the eastern (upper) edge of the circle; below him is a circular Jerusalem with a crucifixion scene. A number of important spots in the Holy Land are named in the area surrounding Jerusalem, and

there are some Old Testament scenes and figures, such as the Ark, the tower of Babel, and Lot's wife.

One scholar has recently suggested that the Hereford map was "intended to attract attention to [the] timeless message . . . that Jerusalem and the cross are the focal point of a world dominated by death and the day of Judgment."[28] No doubt this could be said more strongly of the Ebstorf, which has integrated Christ into its very structure. His head emerges from the east, His wounded hands from the north and south, and His feet protrude from the edge of the world at the west.[29] He is shown, as well, rising from the tomb in a centrally placed Jerusalem. Cana with six water pots and Bethlehem with star, ox, and ass are shown from the New Testament, as are some Old Testament stories, Adam and Eve, the march of the Israelites, the tower of Babel, the story of Abraham, and the Ark on Mount Ararat. In addition, a large number of contemporary place names including monasteries and pilgrimage shrines are indicated, for unlike more schematic maps the Ebstorf and Hereford maps were based upon Roman geography and designed to be useful to travelers.[30]

The Ebstorf map contains the names and pictures of twenty-four monstrous races, and the Hereford map twenty. The latter places its alien peoples mostly to the south, but has located a few to the north as well. The former features a row of monstrous races confined in a narrow strip at the southern edge of the world, in the same manner as the small psalter map we looked at earlier. Here, however, the imagery is more explicit: the races are literally at the left hand of Christ. Viewed as a cosmological statement, the Ebstorf map would seem to be saying that Christ holds in his arms and spans with his body the microcosm and the macrocosm and includes the monstrous races within the world, yet keeps them at the greatest distance possible from the center. That center—Jerusalem and the Christian nations—constitutes the *oikumene*.[31] Beyond it are found the Jews and Moslems, and beyond them in regions like Scythia or the land of Gog and Magog are barbaric tribes. At the very edges of the world, at Christ's left hand, are the monstrous races.

If the relation of edge to center is not explicitly stated in the Noachid maps, it is made very clear in the Macrobian maps and the Beatus variant, for these types assign the name "Antipodes" to the region at the bottom of the world thought to be uninhabitable, or populated only by monstrous men.[32] According to the zone map in William of Conches' *De Philosophia Mundi,* between the zones of extreme heat and cold man can inhabit only two intermediate zones, where warm winds make climates suitable for living things. The

Latin world is in the North Temperate Zone with no communication possible between it and the southern part, for the two hemispheres are separated by immense oceans.

Martianus Capella in his *Marriage of Philology and Mercury* had elaborated on Macrobius' zone theory, giving Greek names to the people who were to be found in each zone.[33] The people in the southern habitable zone, whose night was our day, he called Antipodes or "opposite-footed people," a word bound to cause semantic confusion.

In time, the term "Antipodes" came to be used not only for the people living in the extreme South, but also for the region itself. It is perhaps surprising to people of our own time that of the two usages, the Antipodes as a race—even a monstrous race—may have received more credence in the Middle Ages than the existence of an inhabited continent "down under." A widespread etymological tradition claimed that such people lived in Ethiopia and that they were called Antipodes because their feet were turned backward.[34]

The Antipodes as a race are depicted in a miniature from the Cambridge University Library bestiary, though the artist takes a conservative view of "Antipodes" as a place. We see an illustration of a bearded man holding a ball; his leg has the foot turned backward (Figure 4). The accompanying rubric is skillfully interwoven with two quotations from Isidore's *Etymologiae*, one from Book 9 discussing the region of the Antipodes, and the other from Book 11 discussing the characteristics of a monstrous race with this name. Antipodes live in Libya, the rubric says, and have the foot turned backward on the shank. They have eight toes, or possibly eight fingers.[35]

The bestiary writer explains that "certain people fabulously conjecture, however, from their name, Antipodes, that [these men], whose footsteps are contrary to ours, are placed as it were under our earth and tread opposite to our feet." There were serious doctrinal reasons for this author's skepticism about the Antipodes as a place. Saint Augustine, in a celebrated pronouncement on the subject, had said in *The City of God* that there is no reason to believe the Antipodes inhabited, "for there is absolutely no falsehood in the Scripture ... And the idea is too absurd to mention that some men might have sailed from our part of the earth to the other and have arrived there by crossing the boundless tracts of ocean, so that the human race might be established there also by descent from the one first man."[36] His fear that there might be men in a part of the world isolated from the word of Christ was shared by Nicole Oresme, who likewise denied the habitability of the Antipodes on doctrinal grounds: "This

opinion ought not to be held, and does not agree with our faith, for the Gospel has been preached in all inhabited lands. And according to this opinion, such men would never have heard it nor could they be subject to the church of Rome."[37]

Though writers were cautious about the Antipodes, manuscript illustrators were greatly struck by the imaginative possibilities inherent in the idea. For example, a miniature from a French translation of *The City of God* (Figure 21) shows Saint Augustine preaching and depicts the earth with antipodal peoples opposite in all things to those of "our zone."[38] The peoples of the Antipodes shown in this miniature resemble those of northern climes.

In contrast, the maps in the Commentary on the Apocalypse of Beatus of Liebana often people this region with more remarkable beings. In the Escalada map in the Pierpont Morgan Library (A.D. 926), very early in the history of the Beatus form, there are two rubrics of interest. The first, drawn from Isidore of Seville, shows the moralizing view of the races that is characteristic of the Noachid maps; Ethiopia is labeled as a region "where there are men of diverse appearance and monstrous, terrifying, and perverse races as far as the borders of Egypt."[39] The emphasis on perversity and the borders of Egypt indicates what the races are like and where they are, but offers no explanation for them, merely stressing their remoteness. A twelfth-century Beatus map from Gascony even goes so far as to place a Sciopod *outside* the ring of ocean enclosing the world (Figure 22). In the Escalada map, unfortunately, no specimens of these monstrous men are depicted. The second rubric, for the fourth or Antipodal continent, also comes from a tag end of a passage from Isidore, and shows how Macrobian thinking on habitability was transferred from one type of map to another: "There is a desert land near the sun by reasons of heat unknown to us."[40] These two rubrics must have been the earliest form of this information on the Beatus maps.

Majus Pusillus, the maker of the Escalada map, had a student, Emetrius, who added new matter to these rubrics in his copies made at Tavara in 970 and 975. The second of these, in the Cathedral at Gerona, has a rubric identifying "the fourth part of the globe across the ocean whose interior is unknown to us because of the sun's heat and whose extremities Antipodes are fabulously said to inhabit."[41] The description is cautious, but the phrase "the sun's heat" serves very well to prepare for the picture of a being who might live there.

One figure appropriately shown in the Antipodes is the Sciopod, whose primary occupation ties him nicely to a hot, sunny environment, and whose foot, although not fastened on backward, does

21. Antipodes. Saint Augustine, *The City of God,* Nantes, Bibliothèque Munici-
pale MS Fr. 8, fol. 163v.

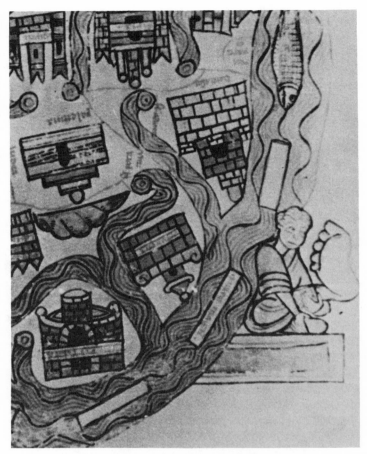

22. Sciopod on world map. Beatus of Liebana, Commentary on the Book of Reve-
lations, Paris, Bibliothèque Nationale Nouv. Acqu. MS 1366, fols. 24v–25r, twelfth
century.

point back when raised above his head. The Burgo d'Osma map
glossed its antipodean Sciopod with a tag from Isidore of Seville:
"Sciopods are reported, with a single leg and marvelous speed,
whence they are called 'shadowfeet' in Greek. In summer they lie
down on the earth and shade themselves under their great feet."[42]
 Environmental thinking in the Middle Ages could, however, be far
more sophisticated than that illustrated in the Beatus maps. Moral
disposition and physical appearance were firmly rooted in the medi-
eval concept of place, and this in turn was a natural outgrowth of
Macrobian zone thinking. The zone maps, with their well-developed

presentation of distinct climates separated from one another by bodies of water, were an important source for the idea of various nations or races of men whose distinctive features were a result of their native climates. Indeed, according to Polybius, climatic features are precisely the conditions "to which all men by their very nature must perforce assimilate themselves; there being no other cause than this why separate nations and peoples dwelling widely apart differ so much from each other in character, feature, and colour, as well as in the most of their pursuits."[43] Zone thought, then, early explained how the physical and cultural characteristics of peoples could be determined by their environment and their location on the world map.

Place influenced the inhabitants of a region in two ways. Through the power of the stars, which controlled people's destinies and changed their fortunes for better or worse, children born in a given region or climate would be influenced by the planet that was dominant there. For example, according to the Arab astronomer Albumazar (d. 885) certain parts of India and Ethiopia were dominated by Saturn, a malign planet that presumably had some effect on the unusual peoples to be found there.[44] Albert the Great presented such a view of astral influence in his De Natura Locorum, which states that "at every point of location of plants, and animals, and rocks, the circle of the horizon varies ... [and] the whole reflection of the sky varies in regard to the middle of habitation."[45] Astral influence, however, was difficult to reconcile with medieval Christianity's concept of free will, and it remained most popular among Moslem geographers.[46]

Place could also affect men through terrestrial forces. Galen's humoral physiology, based on the work of earlier physicians, gave rise to the theory that health or disease came about through the balance or imbalance of the four humors, which in turn could be affected by climate.[47] The Hippocratic treatise Airs, Waters, Places established just such a connection between humoral physiology and climate. The author wrote that he planned to compare Asia Minor and Europe "to show how they differ in every respect, and how the nations of the one differ entirely in physique from those of the other."[48] This work postulated three climates, one very cold, one very hot, and one a temperate region between the extremes. In the North lived such races as the Scythians and the Macrocephali, whose physical appearance was the result of climatic conditions. Unfortunately, his discussion of the southern regions, which included Egypt and Libya, or Africa, is lost. However, we may gain some idea of his attitudes from the Hippocratic Regimen: "The southern countries are hotter

and drier than the northern, because they are very near the sun. The races of men and plants in these countries must of necessity be drier, hotter and stronger than those which are in the opposite countries."[49]

The temperate, central zone is seen as the best environment for healthy, "normal" growth. Its influence on physical form is described in *Airs, Waters, Places*: "Growth and freedom from wildness are most fostered when nothing is forcibly predominant, but equality in every respect prevails ... For the seasons which modify a physical frame differ; if the differences be great, the more too are the differences in the shapes."[50] Indeed, "freedom from wildness" hints that not only physical but also moral and social excellence are favored by the climatic mean. This idea appears elsewhere more explicitly. Aristotle, in *Politics*, had spoken of the political and social advantages of the Greeks who inhabited the middle climate.[51] The pseudo-Aristotelian *Problemata*, a collection of questions and answers on such subjects as cosmology, music, medicine, ethics, and mathematics, probably the work of a Greek compiler of the sixth century A.D., stresses the psychological and moral influence of climate. The text asks why, at the extremes of climate, men are brutish in character and appearance. The answer is that excesses or extremes disturb the mind and soul.[52] A temperate clime, on the other hand, is most keyed to the balance of the humors in people and to the perfection of their moral and political faculties. Pliny, when discussing the ideal temperate climate, echoes these Greek sentiments. "In the middle of the earth," he says, "owing to a healthy blending of both elements [heat and cold] ... there are ... men ... of medium bodily stature, with a marked blending even in the matter of complexion; customs are gentle, senses clear ... and they also have governments, which the outer races never have possessed ... on account of the savagery of the nature that broods over those regions" (2.80, p. 321–323). Pliny, like his Aristotelian sources, saw a direct causal relationship between savagery in nature and savagery in men; the person over whom heat or cold holds sway will be crude, violent, and unaesthetic. Pliny is typical, moreover, of many writers on this subject in being more familiar with great heat than with great cold, and speaks at greater length of the sun's power to deform than of the effects of northern cold.

The threefold climatic division we associate with the Hippocratic corpus in antiquity did not suffice for the Middle Ages. As people came to see that more subtle distinctions in degrees of extremity were necessary to account for the variety of peoples in the world, the five zones of Macrobius, of which three were theoretically uninhabitable, were subdivided into seven habitable ones in the Northern

Hemisphere.[53] Even this system, however, retained the ethnocentrism present in the older form. In *De Natura Locorum* Albert the Great offers a discussion of the seven climates:

The place where men grow strongest seems to be most suitable for habitation. For where men are more generally handsome and brave and noble of stature, there man thrives more readily ... For this reason the fourth clime and the fifth one which is neighboring it are laudable, and are midway between these excellences, having the laudable middle properties of both regions; this can easily be understood by anyone who knows that the mean is determined by the extremes. Moreover, the life of those there is long ... and their customs good ... But the customs of the northern people are wolfish ... the people of the south are light-hearted. The middle people, however, between these easily cultivate justice ... embrace peace, and love the society of men.[54]

Not surprisingly, each European nation thought of itself as the "middle people," superior in climate, with the tacit assumption that other lands less temperate were less moral. On occasion, this view was openly stated. Gerald of Wales contrasts East and West in this manner: "The East has its abundance of poisons," he says, "yet we [in the West], possessing in golden moderation what is needed for decent use, are compensated for Oriental pomps by the fact of our temperate air."[55] An even more extreme chauvinism finds expression in the *Apologia* of the Frenchman, Guy de Bazoches, who impugns all other nations East or West by repeating Saint Jerome's observation that "France alone has no monsters, but abounds in wise, strong, and most eloquent men."[56]

Turning now from theory to practice, let us look at a typical popular writer who uses ideas about climate for dramatic effect.

The *Chronicles* of Benoît of Sainte-Maure (c. 1150) is a lengthy work of vernacular historiography in verse.[57] Although the author's nominal subject is the Norman dukes, he leads up to their reign with a type of universal history since the Flood (see Chapter 5). Presumably the work was written for an aristocratic—and not highly literate—audience which was interested in the genealogy of the region's notables. The values Benoît adopts in the work are precisely those of this audience, with aesthetic canons and codes of chivalric behavior such as one might find in an Old French romance. The author's rhetorical aim is to reassure his readers and confirm their sense of excellence and worth, as well as to titillate their imagination with the wonders to be found beyond their native region.

As was not uncommon in works of this type, Benoît instructs his readers in geography and cosmography, describing the world's latitudinal contrasts according to the climatic theorists fashionable in his

age. There is no sense that Benoît had thought deeply on these mat-
ters; his intention is to interest and please first and to instruct sec-
ond.[58] By now some of his ideas are commonplace to us. The extrem-
ities of the world are uninhabitable or nearly so because of the
temperature. As the North, by reason of its great cold, has no popula-
tion, Benoît says little about it. At the center of the world is the pleas-
ant, temperate region of Europe where there is neither too much
summer nor too much winter. It is the habitable region "which is
right and handsome and delightful and bounteous and abundant in
all that a man needs. The men there are of handsome form and of
wise manners, discreet, reasonable, and well dressed. They are nei-
ther too tall nor too short. There they use courteous manners and
have arts, laws, and justice; there they believe in one god, the crea-
tor."[59] His description of what is virtually a Utopian clime contrasts
strikingly with his portrayal of the extreme South. "In regions where
the days are hot and burning . . . [there are] people of different kinds
who have no law, religion, or reason, justice or discretion; not know-
ing the difference between right and wrong, they are more felonious
than dogs."[60] Just as the face reflects the heart, so the moral defor-
mity of the peoples in the torrid region is reflected in their physical
appearance. Benoît tells us that the men there are black, chinless,
large, and horned, and hairy right down to the ground. As if this
were not enough he gives them hanging ears, long noses, and large
feet.[61]

This portrait is designed to represent the Ethiopians, whose ap-
pearance had already been ascribed by Pliny to the extreme heat of
the region. Pliny had discussed this race at length in the *Natural His-
tory,* offering a climatic and environmental explanation for the phys-
ical differences between Negroid and Caucasian which was repeated
down through the fifteenth century. "It is beyond question that the
Ethiopians are burnt by the heat of the heavenly body near them,
and are born with a scorched appearance, with curly beard and hair
. . . and their [bandy] legs themselves prove that . . . the juice is called
away into the upper portions of the body by the nature of heat" (2.80,
p. 321). Moral overtones had been added to this portrait by Ptolemy
in his *Tetrabiblos,* known to the Middle Ages as the *Quadripartitum,*
a work describing the power of the stars over men. He had stated
that, in addition to being black, the Ethiopian was savage in habit
and shrunken in form and nature by the heat.[62] Even Albert the
Great had stressed the extreme effects of climate upon the Ethiopi-
ans: "Owing to the great heat of their clime, the earthly members
which are inside them, as bones, become very white as is apparent in

their teeth. Their flesh is suffused with blood as if they are glowing coals, as is apparent in their tongues and throats when their mouths are open. And they have prominent mouths, thick lips, reddened eyes, veins and eye lids on account of the heat."[63]

It was a short step from the quasi-science of such portraits of the Ethiopian to treatments in which he is morally inferior to Western men.[64] The scientific descriptions of the African available to Benoît were quickly adapted to the rhetorical traditions of his age, with its fascination for set pieces of description. Courtly romances gave readers and auditors elaborate physical descriptions of elegant nobles based on principles borrowed from the rhetorical manuals of Geoffrey of Vinsauf, Matthew of Vendôme, and others. Naturally the *ordo effictionis* or presentation of the beautiful person from top of head to soles of feet soon generated a corollary description—that of the extremely ugly man or woman, such as the passage depicting the hideous giant herdsman in Chrétien's *Yvain*.[65]

It is not surprising that a period that valued whiteness of skin and regularity of feature and physique should have reacted with aversion to the visual descriptions of the Ethiopian in Pliny and Ptolemy. Benoît must have been fully conscious that he was exploiting such canons of beauty when he added to his southern race horns and hanging ears. Several centuries later we find a similar dramatic exploitation of the latent fears and prejudices of the audience in a manuscript from the court of René d'Anjou (c. 1450). This is the beautiful Pierpont Morgan manuscript 461, a work on the wonders of the world arranged alphabetically. Everywhere in this work there is a tendency to heighten the Plinian descriptions of races and to make them more interesting and dramatic by calling them ugly or horrible. The Blemmyae, for example, an innocuous race in the accounts we have seen thus far, are in Morgan 461 called "full of great cruelty" and have "customs and conditions strange to the human race. They are not reasonable."[66] The manuscript presents much the same contrast between Europe and Africa that we saw in Benoît, assigning this information to "Erodotus" (fol. 31v). In short, Benoît and his followers, using the climatic observations of late antique and medieval science, develop a style of literary geography that will be found later in such works as *Mandeville's Travels,* in which scientific information is subordinated to the dramatic possibilities of the subject matter.

With the era of the great Portuguese explorers and their *portulani* or practical sailing charts, the older schematic cartography gives way to a more realistic kind, combining climatic or environmental

thinking with portrayal and location of contemporary cities, towns, castles, and ports, while still retaining the monstrous races at the edges of creation.

By the fifteenth century we see a number of radical changes —modern cartographers would say "advances"—in the older Noachid and Macrobian maps. Maps now begin to offer a great deal of miscellaneous information, the verbal as interesting as the visual. There had, of course, been a precedent for this in both the Ebstorf and the Hereford world maps, whose scale and verbal information went far beyond their cartographic functions. Indeed, the author of the Hereford map conceived of his work as a literary product. He provided his name and even a sketch of himself hunting on horseback, which corresponds to the author portraits found in medieval literary works.

The last mappamundi we shall consider is a rich blend of the old and the new styles. It is a recently discovered work of the fifteenth century, whose author tells us a great deal about his cosmological and cartographic beliefs, filling the margins of the map with rubrics so extended as to become little treatises in their own right (Figure 23). He gives his name as Andreas Walsperger, a Benedictine, and reveals that he made his map at Constance in 1448. Andreas is a surprising figure in many ways. His late date and his advanced conception of the world, which he owes to his ties with the geographical schools of Vienna and Klosterneuberg, contrast oddly with his fondness for certain of the schematic and theological features of the older maps.

Andreas declares in a rubric that he has constructed his map according to the most advanced scientific thinking: "This mappamundi or geometrical description of the globe is made from the cosmography of Ptolemy proportionally according to longitude, latitude, and the divisions of climate."[67] The map is oriented with South at the top—East at the top is the characteristic orientation of the earlier Noachid maps—and a rubric explains the qualities of the Antarctic and Arctic poles. The seven climates of Arab cosmography are indicated and explained with rubrics. A ring of ocean almost surrounds the *oikumene,* as in the earliest cartography, and there are other archaic theological details: an elaborate representation of the terrestrial Paradise and a central, if not exactly centered, Jerusalem.

The rubric for the austral region reads, "This is called the Antarctic pole . . . and here the land is uninhabitable. And around this pole are found the most marvelous monsters not only among animals but even among men." As illustration of this statement, based on cli-

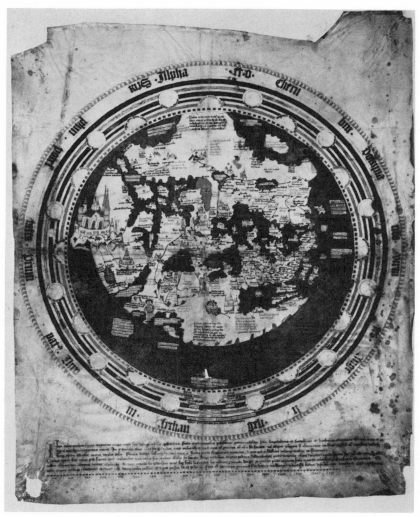

23. World map of Andreas Walsperger. Rome, Vatican Library MS Pal. Lat. 1362b, no folio, 1448.

matic and environmental premises, Andreas gives some concrete examples of the races to be found there. His catalog contains men with great lips, men with foxes' tails, Apple-Smellers, Cyclopes, Blemmyae, and Troglodytes, who, he explains, "have three faces." Sciopods too are found in the Antarctic, "one-footed men who run most swiftly; here men hide under their feet from the rain." In sum, Andreas presents a fairly large group of the Plinian races located not

in their usual lands of India or Africa, but at the South Pole. This may be due in part to his Ptolemaic conception of the world and in part to the fact that by 1448 people had a much clearer idea of what sort of men actually lived in Africa and India.

The Ptolemaic nature of Andreas' thought is also evident in the way he chooses to break up the conventional grouping of the races in the southeastern part of the world, apportioning some to the North. In this he was probably influenced by Arab cosmography of the sort found in the works of Pierre d'Ailly, as well as by German nationalistic historians, who had discussed from a Ptolemaic point of view the sorts of races that might dwell at the four extremities of the earth beyond the limits of the seven climates. These extremities are not very habitable,

particularly the two extremities of which one is toward the south and the other toward the north. Hence Ptolemy, Hali and other ancient authors aver that in these regions there are wild people who consume human flesh, and who have a vile and horrible appearance—this also according to Hali from the unfavorable temperature of heat and cold prevailing in those sections; whence their bodies are irregularly shaped and of evil and unsightly structure. For that reason their habits are base and their manners savage. Consequently the tribes there, whether beasts or monsters, are of such frightful shapes that one can scarcely discern whether they are human beings or animals.[66]

Though the Ebstorf and Hereford maps had placed Gog and Magog and the unclean peoples in the North, this was a placement decreed by legend rather than climatic thinking. Theory, however, allows Andreas to tell us that "in the Caspian regions are many and various monsters who, however, use human reason." Among them he places the Cynocephali and "Anthropophagi who eat the flesh of men." He has a fine picture of one of the latter, who is shown as a giant eating a man.

Andreas Walsperger, then, is an example of a cartographer who attempts to combine climate theory with anthropological material appealing not to science but to wonder and fantasy. Yet in adapting the older Noachid form of the map to the newer polar geography, Andreas still emphasizes the alien qualities of the races in order to exile them to the most distant parts of the globe.

4 Missionaries and Pilgrims among the Monstrous Races

The exile of the Plinian races to the edges of the world was countered by an opposing impulse that sought to draw them back, figuratively at least, to the center of the world in Jerusalem. This was the missionary impulse of Christianity. In time, the xenophobic strains in classical thought came to be softened by Christian universalism, with its doctrine of the potential redeemability of all men. John (10:15) had strongly hinted that God had other, un-Christian flocks. And as the concept of Augustine's City of God—whose total membership could be known only by God and not by man—became widely disseminated, an interest grew in including as many of these other flocks as possible in the community of the Catholic Church. By the sixth century even unusual races of men were coming under consideration as potential Christians. If they were descended from Adam, Augustine said, they must have souls, and if they had souls they could be saved by grace.[1] It might, therefore, not be going too far to apply to them Christ's command to the Apostles in Mark 16:15: "Go ye into all the world, and preach the gospel to every creature." This chapter will discuss some of the ways in which the monstrous races figured in the Church's program of salvation.

Missionary activities among the exotic races became a popular topic for Christian evangelists, who welcomed the occasion they provided for dramatizing the duties Christ had assigned to the Apostles before his ascension: "Go ye therefore and teach all nations, baptizing them in the name of the Father, and of the Son, and of the Holy Ghost" (Matthew 28:19). A particularly good example of this

type of writing occurs in a sermon, *Ad Fratrem in Eremo,* passing in
the later Middle Ages as the work of Saint Augustine, but actually by
a Belgian forger of the thirteenth century. The speaker recalls that

when I was Bishop of Hippo and with certain of the servants of Christ had
gone to Ethiopia in order to preach to them the holy gospel of Christ, we saw
many men and women having no heads but with great eyes fixed in the chest
and the other members similar to ours . . . Their priests practiced marriage but
were of such great continence that they consorted with their wives only once a
year and then did not perform their priestly duties on that day. We also saw
men with one eye in the forehead in the lower parts of Ethiopia. Their priests
shunned all human contact and all carnal desire.[2]

The writer goes on to contrast Christians with these races: "O miser-
able state of Christianity when pagans are the teachers of the faith-
ful!" One cannot conclude very much about evangelizing attitudes
during the apostolic period on the basis of such a text, but the juxta-
position of the missionary spirit with exotic races of men as late as
the thirteenth century shows that this theme still fascinated medie-
val men.

 The stranger the appearance of the creatures to be converted, the
greater the triumph for the missionary upon their conversion. This
can be seen, for example, in the fictitious *Letter of Prester John* ad-
dressed to Manuel of Constantinople and Frederick Barbarossa in
1163, and probably composed in one of the Latin crusader states.
John proclaimed himself ruler of a rich and powerful kingdom in
India, filled with gold, jewels, spices, and marvelous races of men. He
claimed to be a practicing Christian, and Pope Alexander III actually
replied to his letter in 1177, attempting to enlist him in the service of
the West in the war against Islam. The *Letter of Prester John* was
very popular and several times translated.[3] Its clerical author tried to
show that Christianity had taken root even as far to the east as India,
having been brought there by the Apostle Thomas. In "Greater
India," according to the author, was buried the body of this saint,
"for whom our Lord has wrought more miracles than for the other
saints who are in heaven."[4] Presumably Thomas had a strong evan-
gelical influence on the monstrous races of Prester John's kingdom,
for the writer notes that

we have in our country also other men who have hoofed legs like horses and at
the back of their heels they have four strong and sharp claws with which they
fight in such a way that no armor can withstand them; and yet they are good
Christians and willingly till their lands and ours and pay us annually a big trib-
ute . . . Men are here as small as seven-year-old children and their horses are as
small as sheep, and yet they are good Christians and willing workers. (pp.
70–71)

If men as unusual as these could be taught Christianity, implies the *Letter,* then the outlook is indeed favorable for the spread of the Gospel.

One race in particular stands out as a target for conversion in medieval treatments of missionary activity. These were the Cynocephali, who represent the Eastern races in many Pentecost scenes and were thought to have met and ultimately served the Apostles Andrew and Bartholomew, as well as Saints Matthaeus and Mercurius. In one legend a Dog-Head is not only converted, but becomes one of our most familiar saints.

There are a number of reasons for the conspicuousness of the Dog-Heads, both as infidels and as converts. Some have to do with the nature of the missionary impulse itself, which is, at least initially, propagandistic. It desires to show to the people at home the power of the Word over the most intractable of subjects during a formative and uncertain period in the history of the Church. For this reason, I think, we see a great interest in the conversion of the Cynocephali, either symbolically, by the Word as it descends upon the "nations" at Pentecost, or more literally, by the acts of the Apostles themselves among the Dog-Heads. Other reasons have an exegetical foundation. In Psalm 21:17 David cries out in despair that "dogs have compassed me: the assembly of the wicked have enclosed me: they pierced my hands and my feet." This passage was naturally connected with the passion of Christ, and Hugh of St. Cher, following Cassiodorus, explained that allegorically the dogs were the Jews, who were called dogs because just as a dog barks at what is strange to him, so the Jews rejected the new doctrines of Jesus and barked against them. Dogs also stood for heretics who knowingly rejected the truth.[5] To evangelize among the Cynocephali was to carry on Christ's missionary work among doubters and heretics in a special and direct way. Scenes of Jesus preaching to or surrounded by dog-headed men, as in an illustration in the eleventh-century "Theodore" Psalter in London (Figure 24), were not uncommon in medieval art.[6] Undoubtedly the miniature reflects a typological interpretation of Psalm 21:17.

Finally, the Cynocephali were attractive to the missionary spirit because of their established reputation. The early Greek travelers had described their appearance and customs at considerable length, stressing that they combined the natures of man and beast and, in some accounts, were cannibals. Thus they were not only more grotesque and unreasonable than certain other Plinian races, but also more familiar. Their conversion would be a special and dramatic triumph for Christian propagandists.

24. Christ with Cynocephali. "Theodore" Psalter, London, British Library MS Gr. Add. 19352, fol. 23r, eleventh century.

In the Acts of the Apostles, the Twelve were assembled in Jerusalem on the day of Pentecost and God's power descended upon each in the form of a tongue of fire. "They were all filled with the Holy Ghost, and began to speak with other tongues, as the Spirit gave them utterance. And there were dwelling at Jerusalem Jews, devout men, out of every nation under heaven" (2:4–5). These "nations," which included Parthians, Medes, Libyans, Arabians, and other exotic peoples, heard the Apostles speak, and the Twelve apparently used the speech of every nation assembled in Jerusalem. The account in Acts 2 tells us nothing especially unusual about the gathering of the nations, and the list of those present contains no monstrous men.[7] Artists illustrating the scene of the Pentecost, however, add a quite unexpected dimension to it.

An assembly of nations at Jerusalem is a common theme in East Christian art from the ninth century onward.[8] Though it takes sev-

25. Pentecost. Homilies of Gregory Nazianzen, Florence, Laurentian Library MS Plut. 7.32, fol. 18v, twelfth century.

eral visual forms, the one of special interest to us depicts the Twelve around an arcade or doorway containing persons who represent the nations. The importance of these scenes is not so much in the Apostles as it is in the audience who hears, by a miracle, their words. For aesthetic as well as doctrinal reasons, the cultural diversity of Acts is much simplified by the artists, and the nations are often reduced to two who are in dramatic contrast. Taking their cue from the reference to "Arabians" present at the Pentecost, painters of such scenes have divided the nations into two great families on the analogy of the two cities of mankind spoken of by Saint Augustine and others. One of the families in these pictures has three distinguishing characteristics: Islamic costume, black skin, and dogs' heads.

A miniature from a twelfth-century manuscript of Gregory Nazianzen (Figure 25) shows an arcade framing two figures whose religion and nationality are clearly contrasted by their costumes, color, and position.[9] The figure on the right wears the imperial dalmatic of Byzantium, while the one on the left is a black man dressed in pagan robes and an Arab headdress. These two, who embody the doctrinal

and political conflicts of Islam and the Eastern empire, are usually seen as the sons of Abraham. The pagan figure is Ishmael, the patriarch's son by his Egyptian handmaiden Hagar (Genesis 25:12), whereas the Christian figure represents Isaac, Abraham's lawful son (Genesis 21:12).

The salvation made known to the nations during Pentecost was often typologically paired with the Old Testament story of the Tower of Babel. Commentators on this story had understood Nimrod, the founder of the city of Babel, as a figure of human pride, whose actions in building the tower caused God to punish man by changing the perfection and unity of a single language into a confusion and disunity of tongues, and the single human family into distinct and hostile peoples. The ability of the Apostles to speak in the tongues of the nations at Pentecost restores unity to mankind and reverses the pattern instituted by the building of the tower. Hugh of St. Cher, for instance, notes that one event gathered people and the other dispersed them,[10] and the *Speculum Humanae Salvationis,* in its text and illustrations, actually places the tower beside the Pentecost to show the symmetry of the two stories.[11]

One provocative interpretation of the progeny of Nimrod connected his line with the line of Ishmael. As early as Rhabanus Maurus, for example, Ishmael's house was typologically associated with the Moors.[12] Jacques de Vitry begins his biography of Mahomet: "Mahomet was an Ishmaelite, born from Hagar the handmaid of Abraham ... Ishmael, a fierce man, whose hand was against everyone and everyone's hand was against him. For all of that, the Saracens mendaciously and foolishly ... take their name from Sara. More truely, however, they ought to be called Hagarini, from Hagar who was Abraham's concubine."[13] Eastern Christians felt that the line of Abraham's other son, Isaac, was the line of the "elect," whose culmination the Byzantines imagined themselves to be, in opposition to the house of Ishmael.

Historically attitudes toward Ethiopia had been ambivalent, and undoubtedly these conflicts were present in the black figure of Ishmael within the arcade. Climatologists and moralists believed Ethiopia to be the home of all that was primitive and ugly, and many poets felt the same way. The *Chanson de Roland* speaks of "Ethiopia, a cursed land," where "the black men ... had great noses and winnowing ears." As these "Sarrazins" charge him, Roland watches them come, a "cursed people, blacker than ink; their only whiteness is their teeth."[14]

Color polarities were easily interchanged with moral polarities,

and the blackness of immorality contrasted with the whiteness of salvation. The black Ethiopian was associated with sin and with the diabolical by homiletic writers such as Paulinus of Nola, who explained that they were burned black not by the sun but by vices and sin.[15] In a commentary on the tenth-century *Ecloga* of Theodulus, a very popular school text in the Middle Ages, the innocuous word "Ethyopum" is interpreted allegorically: "Ethiopians, that is sinners. Indeed, sinners can rightly be compared to Ethiopians, who are black men presenting a terrifying appearance to those beholding them."[16] Fulgentius of Ruspe spoke of baptizing an Ethiopian whom he saw as "one not yet whitened by the grace of Christ shining on him."[17] And the theme appears in romances telling the story of the King of Tars, where a Saracen sultan marries a Christian princess who eventually converts him. Upon baptism he changes color from black to white. Another episode concerns a Tatar king who produces a child by his Christian concubine which is black on the left side of its body and white on the right. Once the child is baptized the blackness disappears.[18]

Yet according to Salvian, barbarian peoples like the Ethiopians were to be pitied as much as reviled, because they lived without God, and their evil nature was in a way pardonable since they had not yet received the Word.[19] Psalm 71:9 was read as a prophecy that they would, indeed, receive the Word of God, for Christ's power was there understood to extend to the ends of the earth and would make even the Ethiopians bow down before Him. Saint Augustine saw in these verses an example of metonymy: "By the Ethiopian, to take the part for the whole, all the nations are signified. God chose to mention that people above all the others, as at the ends of the earth."[20] Hugh of St. Cher found in Psalm 71 a conversion theme, connecting it with the mission of the Apostles and observing that the Ethiopians were converted by Saint Matthaeus.[21]

The black figure of the Pentecost miniatures thus contains elements of both the unredeemed savage and the heretical Arab, whose conversion to Christianity fulfills Scripture. Christian longing for such a conversion took many forms. In its more intellectual phase we find it embodied in the *Apology of Al-Kindi,* a dialogue between a Christian and a Moslem which defends Christianity and exposes the doctrinal flaws of Islam. This apologetic treatise was supposedly written by a ninth-century Nestorian. When Peter the Venerable had the Koran translated into Latin in the twelfth century, he ordered the *Apology* translated by Peter of Toledo and published with it.[22] In imaginative literature there are dramatic conversions of famous

26. Pentecost. Armenian Gospel Book of T'oros Roslin, Baltimore, Walters Art
Gallery MS 539, fol. 379r, 1262.

Moslem knights like Fierabras and Otuel in late medieval reworkings
of the *Chanson de Roland*.[23] Though formally diverse, the examples
cited here share much the same missionary impulse seen in the Pen-
tecost miniatures, and each helps to explain the others.

The desired conversion of the alien and unbeliever, which is sug-
gested by the contrasted figures in the arcade, takes a startling turn
in a fairly large group of Armenian and Syrian miniatures a century
or so later than the Gregory of Nazianzen miniature. These paintings
of the Pentecost introduce to the pair of human figures representing

the lines of Ishmael and Isaac a third, far more monstrous figure, who has the head of a dog. In some miniatures the Ishmaelite himself is given a dog's head. An Armenian gospel book illustrated by the eminent painter T'oros Roslin in 1262 (Figure 26) shows over the arcade an inscription that reads "Medes, Parthians, and Elamites," although the figure next to the nimbed king is most likely a Jewish elder intended to represent the Old Law.[24] Prominently placed in the middle is a dog-headed figure who I believe represents Islam and the line of Ishmael; apparently the painter wished to show the power of the Word over a people who have become monstrous through heresy. Obviously influenced by the T'oros Roslin miniature is an Armenian manuscript (Figure 27) of the fifteenth century, which places in the arcade a single figure with three heads, one of which is that of a dog.[25]

There was a fairly widespread connection of Saracens and Cynocephali in the Middle Ages, in both East and West, as the Moslems were often described by Christians as a race of dogs, an epithet ultimately deriving from Western biographies of Mahomet, which pictured him as a Christian heretic, a Roman cardinal disgruntled because he was not elected pope. In a Spanish biography of the early ninth century, for example, we learn that he denied Christ's divinity, died a drunkard, and was eaten by dogs or pigs on a dung heap.[26] This fantasy, though lurid Christian propaganda, was accepted as true even by Christians who had had fairly considerable contact with Islam.[27]

The epithet "dog" was used of the Moslems literally as well as figuratively in the early thirteenth-century chanson de geste Les Enfances Vivien: "Cursed be the dogs who engendered them."[28] In the Middle English romance Kyng Alisaunder, the conqueror fights Darius, who has many "heathen" in his armies including "Duke Mauryn . . . whose men could neither speak nor shout / But only bark and rage like hounds."[29] "Mauryn" sounds rather like "Moor" in this context. The dog-headed Saracen by the end of the Middle Ages was sufficiently popular as an image to appear in a niello world map dating from 1430. This map offers a rubric for a people called Beni Chelib which reads, "Ebinichebel is a Saracen Ethiopian king with his dog-headed people."[30] Here the Latin words transliterating the Arabic "banu kalb" ("sons of a dog") are made into the name for the king of the dog-headed people. The conjunction of Saracen, Ethiopia, and Dog-Head on this map is an interesting one, for it stresses remoteness, monstrosity, and religious heresy in much the same way as did the Pentecost pictures.

27. Pentecost. Paris, Bibliothèque Nationale MS Syr. 344, fol. 7, 1497.

For a full understanding of the dog-headed Moslem in the arcade, however, we must return to interpretations of Psalm 21:17, where the Jews who "barked" at strange doctrines preached by Jesus were the dogs who circled the speaker. Just as the Jew who refused salvation was seen as a savage animal, so is the Saracen who here does the same thing. To refuse the Word is to deny logic and so to lose humanity. The Dog-Head in these scenes, then, represents at once the Moslem heretic who will, in the propagandist painter's view of things, yield to the Word through Western military might, and the savage races of men at the edges of the world, whom the Word will convert by softening their hearts.

Once Christianized, a Cynocephalus was extremely useful to the missionaries. His conversion through divine intervention showed the surpassing power of the Word in a propagandistic context. In addition, the Dog-Head became the willing helper or servant of the missionary figure, aiding him to make further conversions among the pagans, or serving his master in military forays.

Just such a conversion of a Cynocephalus appears in the apocryphal Acts of the Apostles, a form of Christian literature very popular in the early centuries of the Church, especially in the eastern part of the Empire.[31] These accounts of the Apostles' deeds are closely related in inspiration to the Pentecost illustrations and borrow much from the Greek travel romances, seasoning their stories with an abundance of marvels and rhetorical elaboration. Since the adventures and martyrdoms of most of the Twelve are not even mentioned in the canonical Acts, these apocryphal accounts were understandably attractive. They not only satisfied a thirst for more information about the Apostles, but also excited their readers' imaginations with the novel and exotic, and provided illustrators with much new imagery. In their emphasis on martyrdom, moreover, the apocryphal Acts were closely related to the "saint's life" genre, which borrowed heavily from them.

As concerns novelty, the Apostles mentioned in the Book of Acts do not travel to especially exotic places, a shortcoming remedied by the apocryphal Acts. Luke describes the activities of Peter, John, and Phillip in Judea and Samaria, and the deeds of Paul primarily in Rome, alluding to certain adventures of other Apostles, notably Barnabas, in Cyprus. The apocryphal Acts, however, add many new adventures to Luke's account and provide elaborate stories about the acts and deaths of others unmentioned in the Scriptures. Moreover, tradition deriving from these new acts considerably widens the Apostles' geographic range. In some accounts, Thomas goes to

Parthia, Matthaeus to Ethiopia, Andrew to Syria, and Bartholomew to India.[32] This is seen in the Beatus map from Osma, which shows busts of these men in the various lands in which they performed their work of conversion.

With this background in mind let us turn to the Acts of Andrew and Bartholomew among the Parthians in the Ethiopic *Contendings of the Apostles,* an apocryphon translated from Coptic and Arabic originals and heavily dependent upon the more widely known Acts of Andrew and Bartholomew, which exist in Greek, Syriac, Latin, and Old English. The story of the *Contendings* is simple and dramatic. Christ sends the two Apostles on a special mission to the cannibals in Parthia which, though having representatives at the Pentecost, was a land sufficiently remote to figure as monstrous in the geographic thought of the early Christian period. As Andrew and Bartholomew prepare to approach the chief city of Parthia, one of the cannibals appears, looking for a meal. At this point we leave the frightened Apostles in the fashion of a cliff-hanger melodrama and meet the cannibal. An angel of God says to the cannibal (named, appropriately enough, Abominable), "O thou man, whose face is like unto that of a dog . . . Behold, thou shalt find two men sitting under a rock, . . . let no evil thing befall them through thee . . . lest their God be wroth with thee."[33] The cannibal is understandably perplexed by this speech and asks the angel for clarification. "Who art thou? I know neither thee nor thy God; but tell me who is the God concerning Whom thou speakest unto me." Hereupon the angel gives him an account of the Creation and sends him as a sign of God's power a miraculous circle of fire which frightens him and makes him call upon God for compassion, promising to become a true believer. The angel then asks, "If God saveth thee from the affliction of this fire, wilt thou follow the Apostles . . . and wilt thou harken unto everything which they shall command thee?" Abominable demurs, hesitant because of his lack of human speech, dog head, and bestial nature. The angel, however, promises to give him a human nature and to restrain his bestiality, making the sign of the cross over him and blessing him in the name of the Father, the Son, and the Holy Ghost, exactly as Jesus had bid the Apostles do to the nations in Matthew 28:19.

"Rejoicing and . . . glad because he had learned to know the right faith," the cannibal seeks out the Apostles. It is only after this conversion that the author tells us what Abominable looks like and records his dramatic impact upon Andrew and Bartholomew.

Now his appearance was exceedingly terrible. He was four cubits in height, and his face was like unto the face of a great dog, and his eyes were like unto

lamps of fire which burnt brightly, and his teeth were like unto the tusks of a wild boar, or the teeth of a lion, and the nails of his hands were like unto curved reaping hooks, and the nails of his toes were like unto the claws of a lion, and the hair of his head came down over his arms like unto the mane of a lion, and his whole appearance was awful and terrifying. (pp. 173-174)

Introducing himself to the Apostles by his pagan name of Abominable, he becomes their guide and Andrew renames him Christianus.

The missionary and propagandistic overtones of the encounter between the cannibal and the Apostles are reminiscent of much in the canonical Acts and of the illustrations of the Pentecost. A divine instrument—a circle of fire used to amaze and frighten the cannibal—is analogous to the descent of the Holy Spirit in fire at Pentecost, which makes the barbarous nations able to understand the Apostles. Just as the nations have willingly assembled to hear and see a miracle, so the cannibal has a "natural" desire to know about the new God. So, too, the angel's establishment of the right faith in contrast to Abominable's implicit polytheism suggests the array of religions represented by the nations. Once Abominable yields to the power of the Word he loses the brute nature that characterized him before knowledge. Conversion, then, not only bestows grace and salvation upon the unbeliever, but to some degree it removes monstrosity as well. If the Moslems of the Pentecost miniatures became dogs through their rejection of the Word, Abominable loses much of his doglike nature through his acceptance of it.

Andrew and Bartholomew gain fame and honor in making a Christian of a creature like this, and the whole vignette is a vivid illustration of Psalm 18:4-5: "There are no tongues or languages where their words are not heard; their sound goes throughout the world and their words go to the ends of the earth." These verses had been taken by Hugh of St. Cher to refer to the fame of the Apostles and the way in which their words had reached the most inaccessible parts and peoples of the world.[34]

The story of Abominable's conversion and his new life as a guide and soldier of the Apostles strongly influenced the *acta* of Saints Mercurius and Christopher, who were both associated with Cynocephali. The former was little known in the West but the latter had an immense popularity there and became the patron saint of travelers.

Mercurius' legend derives more directly from the narrative of the apocryphal Acts of Andrew and Bartholomew than from specific details, for he himself is not a Cynocephalus but merely employs them as helpers. Mercurius, a military saint, enjoyed a great vogue in Egypt, and appears as well in Greek *menologia*—collections of short

illustrated accounts of the saints—though he is rarely represented in the West. The narrative of his birth bears a strong resemblance in outline to the *Contendings,* for his father and grandfather were hunting near Rome when they encountered cannibal Cynocephali who ate the grandfather but were prevented from eating Mercurius' father by an angel of God, who prophesied the birth of a wonderful son. The father converted the Cynocephali and they became gentle, eventually serving Mercurius in his battles against the pagans, where, on command, they regained their savage natures and cannibal tastes.[35]

Though his legend is widespread in Eastern hagiographica, owing to Mercurius' having killed Julian the Apostate in Chrysostom's version of his life, he appears with his dog-headed helpers only in the Jacobite Arabic and Alexandrian synaxaria (brief accounts of a saint and his feasts), as well as in a fifteenth-century Ethiopic recension.[36] In art, he is depicted in a wall painting in the Coptic monastery of Saint Antony in Egypt, dating from 1232–1233, where Mercurius triumphs over a bearded pagan attacked by his two dog-headed assistants.[37]

A variant form of Mercurius' dog-headed helpers was reported in the West in a story told by Paul the Deacon in his *History of the Lombards.* The Lombards "pretend that they have in their camps Cynocephali . . . They spread the rumor among the enemy that these men wage war obstinately, drink human blood . . . The enemy being made credulous . . . dare not now attempt the war they threatened."[38]

More familiar to us is Saint Christopher, whom Western art usually portrays as a giant bearing an infant Jesus on his shoulder.[39] A very popular Eastern version of the story, known to some extent in the West as well, makes Christopher into a Cynocephalus. This version of his life is a slavish reworking of the cannibal episode in the *Contendings of the Apostles.* Born a pagan and called Reprobus, reminding us of Abominable in his unredeemed state, he changes his name to Christopher when converted to Christianity. Whether his convert name ("Christ carrier") suggested the visual motif of his bearing the Christ child or whether that story preceded the name is not clear. In some accounts the form of this saint changes upon his conversion in an interesting analogy with the baptismal changes from black to white related in the King of Tars material.

Well before the tenth century this legend seems to have made its way west to Ireland, where its presence can most probably be explained by the activities of monks who could still read Greek. The earliest Western form of the dog-headed Saint Christopher story

known to me is in the *Libar Breac,* which glosses an eighth-century Irish kalendar and offers a *passio* of Christopher: "Now this Christopher was one of the Dog-heads, a race that had the heads of dogs and ate human flesh. He meditated much on God, but at that time he could speak only the language of the Dog-heads."[40] A certain Baceus sees him and reports back to the King, "I have seen a man with a dog's head on him, and long hair, and eyes glittering like the morning star in his head, and his teeth were like the tusks of a wild boar." The nearly contemporary *Old English Martyrology* gives a virtually identical account.[41]

Latin versions of this story are less dramatic and a bit more cautious about accepting literally the saint's dog-headedness. A factual tone and a lack of visual imagery characterize an early, anonymous *passio* from the *Acta Sanctorum,* which speaks of "a man who comes from the islands, of canine race." He has a "man's body, but a dog's head."[42] From the tenth century come two versions of Christopher's life by Walter of Speyer, one in prose and another in verse. In the former the saint is described concretely but guardedly: "He was tall . . . and had the sharp face of a Cynocephalus, as they say," while in the latter "he took his origins from the race of Cynocephali, a people in speech and countenance dissimilar to others." After baptism, in Walter's prose account, Christopher's dog head "shone whiter than milk"; in this image there may also be a recollection of the black Cynocephali of the Eastern Pentecosts, and the color changes through baptism in the Tars legend. The verse life concludes with the arrival of an angel, who tells Christopher that his name and nature are changed— "called by his parents Reprobus, but by God Christopher"—and that he is now destined to preach the word of Christ.[43]

Although these literary examples of a dog-headed Christopher are numerous, only two unequivocal representations of this aspect of his story survive in Western art, both from the western part of the British Isles and undoubtedly influenced by the popularity of the legend in Ireland.[44] In the *Libar Breac* a gloss reads "Christopher, that is conchend" or dog-headed. The parish Conchan on the Isle of Man may take its name from an early interest in a dog-headed Christopher, if we can judge from the number of cross slabs to be found in the parish bearing his image. One, which is possibly a lintel for an old church (Figure 28) shows a pair of Dog-Heads on the sides of the cross shaft.[45] The church of St. Keverne in Cornwall, not very far from the Conchan monuments, depicts in a now practically destroyed wall painting a number of scenes from Christopher's life,

28. Cross slab with Cynocephali. Conchan, Isle of Man, tenth century.

surrounding the larger representation of the saint himself. In one register is an animal-headed figure with the extended snout characteristic of the dog-headed figures in Byzantine painting.[46]

The similarities between the story of Saint Christopher's conversion and that of Abominable in the apocryphal Acts of the Apostles are too numerous to be coincidental.[47] Most of the details of Abominable's appearance before his conversion are to be found in the Greek and Latin versions of the Christopher story. Both are cannibals of giant stature, both have dogs' heads, both change their names from pejorative pagan ones to favorable Christian ones. The poetic simile, probably based on Revelations, of Abominable's eyes like lamps of fire becomes in the Christopher story eyes that glitter like the morning star, and in both descriptions the teeth are compared to

boars' tusks. A more subtle parallel is the attempt at psychological portraiture in each story. We recall that Abominable was instantly curious about the God of the Apostles, suggesting that the author wished to endow him with a natural sense of religion. Christopher, as well, has a natural love of God. In both stories the missionary activity is performed by an angel.

With their emphasis on wonders, exotic lands, and divine intervention in human affairs, both the saints' lives and the apocryphal Acts of the Apostles show their kinship with the genre of travel romance.[48] Their heroes are saints and missionaries, whereas the central figures in earlier romances usually had socioeconomic or political reasons for their travels, but all these accounts reveal a recurrent Western interest in exotic peoples. As a result of the geographic expansion eastward by Alexander the Great, Eastern lands became a source both of tribute and of a variety of products rare in the West. With the rise of Christianity a missionary impulse fused with these more practical concerns and for several centuries overshadowed them. But when Islamic control of the Mediterranean made travel extremely hazardous, the missionary impulse had to be absorbed more in literary fantasy than in practical action.

By the end of the Middle Ages, with the greater ease and safety of travel, the missionary spirit resumed the more political cast that had been its inheritance from the Hellenistic age. The declining fortunes of the Latin crusader states, the disunity of the crusaders themselves, and the increasing power of Islam combined to make missionary undertakings concerned less with converting remote peoples and more with enlisting them against the Moslems.

The letter sent by Alexander III in 1177 to Prester John by the hand of Phillip the Physician—who, incidentally, never returned—was only the first of these "missions." In the thirteenth century there were several missionary voyages to the Tatars made by friars who saw themselves following in the footsteps of the Apostles, and who believed, on the strength of Prester John's words, that Genghis Khan was his descendant and potential ally against Islam. So many Christians lived in Tatar lands, they reasoned, that the Khan must only be waiting for the stategic moment to convert to Christianity.[49] The first friar to make one of these journeys was John of Plano Carpini.[50] His trip was followed by a number of others with political, fact-finding, and mercantile purposes, of which one of the most famous was the voyage of Marco Polo.

The final phases of the missionary impulse—at least before the

discoveries of Columbus—were the Crusades and the pilgrimages to the Holy Land. As travel became more attractive owing to better roads, more facilities for shelter, more settled political conditions, and greater available wealth convertible to letters of credit for the lower nobility and bourgeoisie, the average man, if he had the funds, could follow in the footsteps of the Apostles.

No amount of money or improvements in roads could diminish the vast and frightening distance between the pilgrim or crusader and Jerusalem, in an age of travel by horse, foot, and wagon. But works of art and architecture designed to offer the traveler an overview of the world could relate him to the central Jerusalem and provide him spiritual comfort and practical information while he was yet far from his goal. They gave him a sense of where he had been and what he was likely to see farther along the way, itemizing cities, mountains, and monasteries to afford him a sense of scale. Thus, maps and cosmographic works of art encountered along the pilgrimage roads, whatever their main aesthetic or doctrinal purposes, frequently had a teaching and guiding function and shared common visual patterns.

Perhaps the chief reason for travel outside one's parish in the Middle Ages was to see wonders along the way. The pagan belief that every god has a special place where worship is efficacious became the Christian doctrine that the birth and burial places of saints and martyrs were especially recognized by God and should be visited by the traveler. Such shrines appear prominently in the aforementioned travel guides. And as the line between sacred and profane wonders was not always distinct, it should not surprise us if the monstrous races make their appearance in these medieval *guides Michelin*. The narrow zeal of the missionary became more secular and more tolerant in the medieval pilgrim and crusader, and the desire to convert was linked with the desire to behold. Indeed, however pious and fanatic the motives of the early crusaders, the narratives that some of them produced were the first major sources of direct personal observation and accurate information about foreign cultures which the West had had since the great Roman historians. Men like William of Tyre, Robert of Clari, Villehardouin, Joinville, and Jacques de Vitry, among the miracles and other signs of God's special favor they recorded, said quite a lot about the social, military, and religious practices of their antagonists, and about the unusual rites of many Eastern Christian sects as well. Yet such was the reverence for the authority of Pliny, Solinus, Saint Augustine, and others who spoke of the fabulous races, that even though the authors of the Crusade narratives had not seen any monstrous peoples they still in-

29a. Mission of the Apostles. Tympanum, Vézelay, 1122.

cluded them in their works. Jacques de Vitry, for example, devotes twenty-five pages to the Plinian races, among other wonders of the Holy Land he discusses in the *Historia Orientalis*. In addition to what they knew from these narratives and could see in the travel guides along the way, travelers during and after the First Crusade came increasingly in contact with Byzantium and had many opportunities for hearing Greek and Eastern tales of wonder and for seeing the illustrated scientific manuscripts, psalters, and gospel books so common in the Eastern empire. All of this could not but whet the voyager's appetite for marvels of all kinds and make him eager to know what lay ahead on his journey.

One of the great sacred places on the pilgrimage roads of France, where travelers passing through to Jerusalem would be likely to stop, was the Church of the Madeleine at Vézelay.[51] Originally built as a pilgrimage shrine for the relics of Mary Magdalene in the eleventh century, at the crossroads of the routes to Jerusalem and the shrine of Saint James of Compostela, it was the place where Saint Bernard had preached the Second Crusade in 1145. As the pilgrim entered the church he saw above the central portal a vast tympanum depicting the Mission of the Apostles (Figure 29a).[52] Above the main scene of the tongues descending upon the Apostles, and separated from it by a wavy border borrowed from mappaemundi and intended to represent the ring of ocean marking off the known world from the chaos

29b. Detail of Mission of the Apostles: Sciritae.

beyond, is a frieze of unusual peoples who receive the Word, among them four identifiable Plinian races: the Sciritae or noseless men, Pygmies, Panotii, and Cynocephali (Figures 29b–29e).

The tympanum was begun in 1124 and carved by the same artisan who did the capitals in the ambulatory at Cluny in 1115.[53] Though nothing is definitely known about the person who planned its iconography, the director of studies under Abbot Renaud de Sémur at the time was Peter the Venerable, whose interest in matters Eastern and Islamic we have already noted. Peter left Vézelay in 1120. It is likely, however, that he contributed to the imagery of the tympanum.[54] Certainly the capitals within the church of the Madeleine show that the carver had seen Greek manuscripts of Cosmas Indicopleustes, and there is some evidence that he used illustrated psalter manuscripts of Eastern origin as well.[55] I suspect that the sword-wielding Dog-Heads prominently placed near Christ are borrowed from manuscripts like the "Theodore" psalter, the Chudlov psalter, and the psalter in the Vatican Barbarini collection, Greek 372.[56]

29c. Detail of Mission of the Apostles: Pygmies.

Though in inspiration and imagery the Vézelay tympanum is quite close to the Eastern Christian Pentecosts we have examined, it is profoundly different in intention and attitude, reversing in some ways the patterns established there. For one thing, the monstrous races are outside, enclosing the Apostles rather than enclosed by them, and for another, the single Dog-Head of the Pentecosts is now but one of several unusual beings who receive the Word, presenting a far more embracing view of the cosmos for the edification of the pilgrim. In fact, with its wavy ring of ocean separating the unusual races from the Apostles, the tympanum is as much a geographical as a theological statement. Instead of being brought metaphorically to Jerusalem, the races exist in their own habitats at the edges of the world, even shown with their children, swords, and horses, awaiting the Word which is about to come to them across the water.

More literal guides for the pilgrim and crusader are the Hereford and Ebstorf world maps (Figures 30 and 31). The Ebstorf artist shows us the burial places of Mark, Bartholomew, Phillip, and Thomas. He

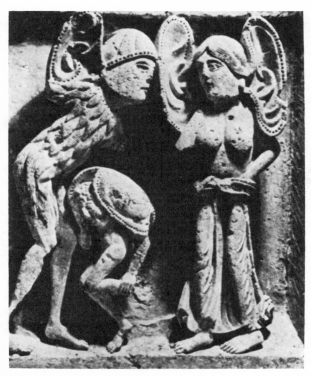

29d. Detail of Mission of the Apostles: Panotii.

commemorates, as well, a number of holy places of special interest
to pilgrims: Hippo and Vadamer, where Saints Augustine and Mat-
thaeus preached, the chapels of Ratdolt and Saint George, the mon-
asteries of Saint Mary in Germany, of Saints Giles, Maurice, and
Dionysius, and the shrine of Saint James of Compostela. Palestine
contains as many names as all of Asia, and in the rubric for Jerusa-
lem the compiler remarks of the Church of the Holy Sepulcher that it
is sought avidly by the pious of all nations.[57]

The most eminent student of the Hereford Cathedral map, G. R.
Crone, has suggested a practical function for the map, which I think
is shared by the map of Ebstorf. Crone believes that Hereford was
based on a tenth- or eleventh-century archetype that had as its pur-
pose the indication of pilgrim routes through Europe to the central
Jerusalem of the Holy Land.[58] In a more recent study he has devel-
oped this idea at much greater length. He sees the map as closely re-
lated to the intellectual and geographical milieu that produced the
tympanum at Vézelay in the twelfth century. The Mediterranean

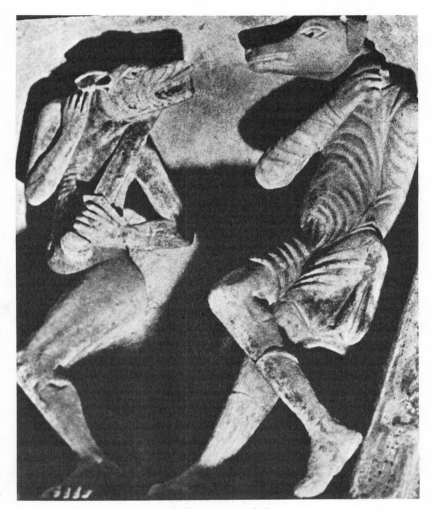

29e. Detail of Mission of the Apostles: Cynocephali.

portion of the map suggests to Crone "that the compiler was using material from itineraries. There is clear indication of a route across the Alps through northern Italy."[59] He points out that "towns in Asia Minor, Macedonia, and a few in Italy, are intended to illustrate the journeys of Saint Paul—particularly his second journey in Asia Minor and the stage from Philippi to Thessalonica."[60] The map gives the word "Recordanorum" at the spot in southern France where passed one of the major pilgrimage and trade routes, the "Voie Regordane."[61] And there are, as well, along the way to the shrine of

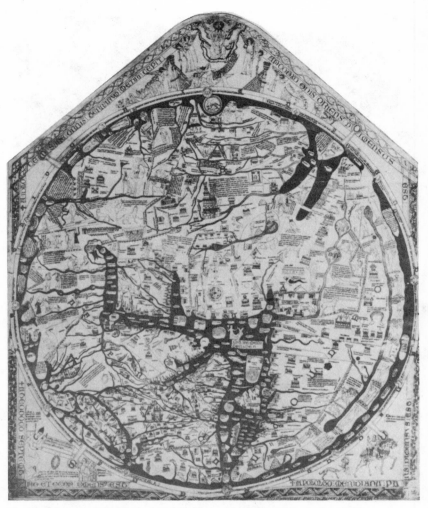

30. World map of Richard of Haldingham. Hereford Cathedral, c. 1290.

Saint James of Compostela names of places that Crone thinks may
have come from pilgrim itineraries.[62]

George Zarnecki, in his study of some of the churches in the region
of Hereford Cathedral, has shown how English pilgrims in the
twelfth century brought back drawings of motifs that they saw along
the pilgrimage route from Paris to Compostela to use in the con-
struction of buildings.[63] It is quite possible that Richard of Hal-
dingham got some of his geographic information in exactly this way.

In addition to the extensive Christian notation on the Ebstorf map,

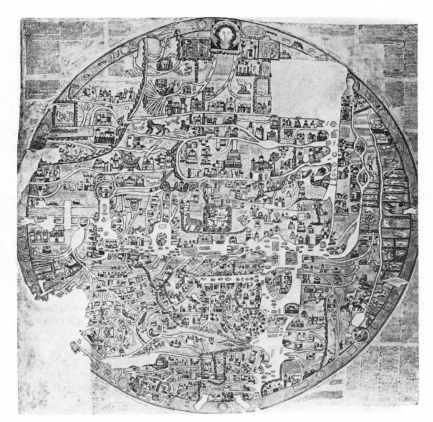

31. World map from Ebstorf. Destroyed 1943, c. 1240.

evidence for its function as a practical guide for pilgrims and travelers is to be found in an explanatory rubric identifying its "Roman" origins with those of the Hereford map: "A map is called a figure, whence a mappa mundi is a figure of the world. Julius Caesar first made one, collecting all the provinces, islands, cities, mountains, and rivers for the beholder on one page." The mapmaker goes on, presumably talking now about his own work: "It can be seen that [this work] is of no small utility to its readers, giving directions for travelers, and the things on the road that most freely delight the eye."[64]

Anyone spending much time studying these maps will be struck by one point that they have in common with the Mission of the Apostles material: the importance of the Cynocephali. The map-

makers show themselves abreast of the most current geographic
theories about the Dog-Heads, and offer two distinct placements, one
old-fashioned and the other contemporary. As more came to be
known about the remote lands of the East, the monstrous races were,
by some geographers, shifted from their customary haunts in India to
the still unknown North, around Norway and Finland in particular.
Each of the great maps contains two different representations of this
race. The Ebstorf map locates them in western Africa and in eastern
India near Paradise. The Hereford artist places one pair in the North
and the other, depicted as dog-headed giants, slightly below Paradise
next to a scene of the expulsion of Adam and Eve and near a Baby-
lon whose rubric claims that "the giant Nimrod founded it"—that is,
the Nimrod described as a giant by Pseudo-Methodius.[65] The Ebstorf
rubric is similar.

Giants placed near Paradise, dog-headed or otherwise, suggest the
story of the fallen angels copulating with the "daughters of men" and
producing a race of giants, which is mentioned in the Book of Enoch
and in the midrash.[66] These giants were supposed to have been killed
by the Flood, which God sent in anger upon the world, but according
to some legends they survived it. In the Ebstorf map, not far from the
Dog-Heads below Paradise, is a scene of the Ark on mount Ararat,
with the raven flying across the base of the mountain. Such an asso-
ciation may be what the author of the *Romance of Sidrak and King
Bokkus* had in mind when he made the following reference in his
prologue:

> Far in the land of India is a hill
> Called the green raven's hill
> And it has this name because
> Noah sent the raven to see
> If land might anywhere be found.
>
> There dwell people of wondrous appearance.
> Their bodies are like ours are here
> But their faces are like
> Those of hounds.[67]

The northern location of the Cynocephali in the Hereford map fol-
lows a tradition based on the *Cosmographia* (768–784) of the
Pseudo–Aethicus Ister, now generally believed to be the Irish bishop
Virgil of Salzburg,[68] and on Adam of Bremen's *History of the Arch-
bishops of Hamburg*.[69] The Carolingian author of the *Cosmographia*
had said of the Cynocephali that they are "near the Germans in the
northern part of the world. The remainder of their members are of
the human race, their hands and feet just as the race of men, of tall

stature, altogether a truculent race."[70] This passage seems to have stimulated Adam of Bremen's imagination and supported his already strongly nationalistic inclination to locate interesting peoples in the northern and eastern European region he called "Scythia."[71] The Amazons had been moved to the North by Arab historians by the end of the tenth century, and Adam locates them there as well, telling us that their male children are Cynocephali.[72]

So ubiquitous was the belief that strange and uncivilized men inhabited the North that we have frequent references to the idea in vernacular poetry. In *The Owl and the Nightingale,* written in the second half of the thirteenth century, northern lands are made the home of savages. The poet combines the Gog and Magog tradition with exegesis of Isaiah 14:13, which placed Satan in the "sides of the north," and with the prejudices concerning the diet of aliens when he says:

> That land is horrible and wretched,
> its inhabitants wild and miserable.
> They have neither peace nor calm
> and do not care how they live.
> They eat fish and raw flesh
> and tear at it like wolves.
> They drink milk and whey—
> they know no better.
> They have neither wine nor beer
> but live as do wild animals
> and go about clad in rough skins
> just as if they came up out of hell.[73]

Though travel guides like the Vézelay tympanum and the mappae-mundi catered to the pilgrims' desire for geographic information, novelty, and wonder, they served other functions as well. As a result of their appearance in these guides, the Plinian races in one way or another were placed in Christian contexts, and their existence was made to seem part of a divine plan. The Ebstorf map was probably used for teaching purposes much like the roller-mounted world maps above the blackboards of thousands of modern classrooms. Moir thinks, moreover, that the Hereford map may have been a reredos or altarpiece, which could help explain many features of its design.[74] These works, then, teach and affirm the existence of the fabulous races, carefully arranging and identifying them by name and habits as part of the symmetry and order of the cosmos. (The figures in the Vézelay tympanum were also labeled by painted legends, now unfortunately effaced.) They offer a familiar perspective, for even

though the maps and the tympanum were raised above eye level, the viewer would have looked at the earth as though sitting on it, and seen the monstrous men in their river retreats and mountain fastnesses as though walking up to them. The poses, rubrics, and drawings are intimate and charming. At Vézelay the Panotii are shown with their children, and a Pygmy mounts a horse with the aid of a ladder. The Hereford map gives a pleasant sketch of Richard the mapmaker out hunting, while several of the Ebstorf rubrics speak familiarly to the viewer: "You will find, if you take care to examine it, the most important names on the map," or "If you will look, you can find enough elephants near the mountains called Seven Brothers."[75]

The presence of the monstrous races in works of art that very likely served a guidebook-like function along the way to the Holy Land is intriguing evidence of their growing acceptance by the medieval world. Even in such contexts, however, we find signs of ambivalence, or at least uncertainty about their status. They are still separated from other men by water (as in the Ebstorf map and the Vézelay tympanum) and sometimes more openly associated with diluvian images (as in the Hereford map). This water not only keeps them at a geographic distance from European Christians, but also, in recalling the Flood, raises important questions concerning their place in Christian history.

5 Cain's Kin

The ancients' disinterest in the lineage of the Plinian races was due in part to the fact that exotic peoples were the objects of curiosity rather than of serious study. If they were not citizens—indeed, if their customs and appearance cast doubts as to their humanity—their origins could not greatly concern the Greeks and Romans.

For the writers of the Old Testament, history began with the creation of a single family in Genesis, and comprised a series of events involving men whose ancestry was of great significance, for that single starting point made the chronological relation of one event to another, and especially of progenitor to progeny, very important. Genealogies in this kind of history became a key to God's plan for mankind. Hebrew stress on one God and one chosen people constituted a historical focus too narrow to accommodate alien races of men. The only unusual races mentioned in the Scriptures are Pilosi and Pygmies (Isaiah 13:21 and Ezekiel 27:11), and these are more the creation of Jerome's translation than of the Hebrews.

Thus the Plinian races are denied an ancestry in both classical and Hebrew thought. They have no place in the one because their cultural differences set them apart as too alien to be of historical significance, and no place in the other because they belong neither to the house of Israel nor to its immediate enemies.

Christianity, however, early began to reexamine history in the light of the events of the New Testament, looking at the Greco-Roman world as well as at traditional Jewish sources, in an effort to show a divinely planned succession of events in a Christian cosmos. One of the first efforts in this direction was the idea of the Six Ages of Man, a form of periodization found in a great number of the early

chronicles.[1] The Six Ages were poetically described by Peter of Riga in an allegory that made them an analogue to the six days of creation:

> The first age begins when God created
> Adam and runs to Noah. The following
> goes to Abraham. To David extends the third age.
> The fourth to those who passed into Babylonia.
> The fifth begins with Christ's coming and the
> sixth from there to the end of the world.[2]

Chronicles using this form of periodization often joined to it another structure: Old Testament history synchronized in parallel columns with Greek and Roman history and fable, in a sweeping narrative of all events since the six days. First shaped by Sulpicius Severus and Eusebius, such universal histories were enormously popular; there were some sixty works of this type compiled by 1100.[3] The Six Ages and parallel histories format made it quite easy to incorporate material that would not, strictly speaking, have had a place in sacred history, and some attempts were made to fit the Plinian races into these works.

Medieval examinations of the races with respect to the first two ages of man—from Adam to Noah and from Noah to Abraham—are of particular interest to us, for it was here that moral and historical speculation about the monstrous races flourished. The chief problem of the Christian thinkers who took the geographic lore of Pliny seriously was how to fit the monstrous races into the narrative of events recorded in these two ages. Any Christian who had read Pliny's chapter on the races, or who had seen them depicted in the travelers' guides of the pilgrimage roads, was bound to wonder, since these races were not mentioned in the Scriptures, if they had descended from Adam, and, if so, how they survived the Flood and what should be the attitude of the Christian toward them. These questions in the Middle Ages were equivalent to asking whether the Plinian races were, in fact, men, for only a descendant of Noah could qualify as human. In an age when the child was still considered an extension of the parent, genealogy offered the most direct approach to any problem of identity, and the monstrous races were no exception in this regard.

To the question of the origin of the monstrous races and of their place in sacred history, medieval writers offered two kinds of responses, one of which replaced the other during the Carolingian period. Broadly speaking, the first of these was the proselytizing missionary view. Although generally an expression of curiosity about, and sometimes even sympathetic interest in, the races, this attitude

in its more serious manifestation was rooted in Christian apologetic. The monstrous races were neither an accident in the Creation nor indicative of a failure in God's plan. They were a part of His creation whose meaning and purposes were, if unclear, still regarded in a positive light. The second point of view was negative; it was associated more with the rise of rhetoric than of theology and replaced curiosity about the races and evangelical interest with suspicion, fear, and hostility.[4] Rather than merely manifesting the variety of the Creation, the monstrous races were seen as cursed and degenerate, a warning to other men against pride and disobedience.

The nature of their curse was never fully agreed upon. Some writers argued that the races were distorted in form because they were descendants of the children of Adam who disregarded his warning not to eat certain herbs. Others took them to be the descendants either of Cain or of Noah's son Ham, who had been guilty of crimes that earned them exile. And others simply enjoyed the *frisson* that a heightened rhetorical treatment of such alien beings could produce.

All pejorative views of the Plinian races, however, assumed their decline from the perfection of prelapsarian man. Late classical writers, taking their knowledge of early man from such sophisticated accounts as Ovid's myth of the first age, assumed that in appearance and basic social patterns men were pretty much as they had always been, though they had undoubtedly declined from a golden to an iron age in morality. In marked contrast, the Judeo-Christian view, infused by Hellenistic Platonism, was based on the belief in the creation of a single perfect man from whom all others were descended. It allowed, accordingly, of very little physical or social diversity. In short, men who did not wear clothes, who ate snakes or each other, and who did not cultivate the soil or form cities were quite likely to be explained by a corruption of the human species through some crime or sin.

The concept of the decay of the species was natural to Judeo-Christian culture for, as Hayden White has pointed out, implicit in biblical treatments of the differences among men after the Flood was the idea of "better" and "worse" races; tribal and racial differences become evidence of "species corruption."[5] Since God created Adam to embody his idea of the perfect man, all of Adam's descendants should be images of him; that they were not—and that some were less like him than others—was often seen as the consequence not only of the Fall, but also of alien strains entering a tribal line of descent, so that the resulting people were less than fully human. Divine punishment, of course, could also change or "corrupt" a species.

Thus, unusual peoples were viewed as marginal in more than one sense. A neo-Platonic doctrine of emanation from the Idea in a series of increasingly inferior steps led to the belief, especially in rabbinic Judaism, that a minority was *per se* inferior to the majority because the majority was closer to God's image. To thinkers of this persuasion, mixtures of animal and man, or physically anomalous men, could only be regarded with extreme distaste.[6]

As for alien forms of social organization, Western feudal society could not view these as representing earlier stages of development; in Christian history all men had their start at the same time, from the same parents. Cultural evolution from primitive to complex was simply not part of the conceptual vocabulary of the period. To the medieval mind it was more natural to explain social differences as the result of degeneration or decadence.

Inevitably, too, the geographic distance of the monstrous races from Western Europeans came to be regarded as reflective of their spiritual state. Some texts proposed that God had exiled the races because He saw that they were dangerous to humanity. Consequently their physical and social abnormalities were not at all evidence of the plenitude of the Creation and the "playfulness" of the Creator, but rather of God's protective care of His children, and of His power to pass on His curse from generation to generation. Writers who held such views regarded the races with awe and horror as theological warnings.

But this conception was some time in coming. Among those who viewed the monstrous races as potential Christians who needed only to be brought to the truth was Saint Augustine, who combined missionary zeal with the Roman cosmopolitan tolerance of ethnic diversity. In *The City of God* the treatment of monstrous races is relatively positive, and the discussion of the lineage of the races and their human status (Book 16) was repeatedly quoted or summarized through the Renaissance. Actually, Augustine's remarks gained their importance and popularity more from the veneration with which he was regarded than from cogency and boldness of reasoning. Reading the eighth chapter in the larger context of the work itself, we can see that it forms part of Augustine's argument that all men throughout the world who worship the same God are encompassed in His universal city, which includes rather than excludes. The heavenly city on earth whose existence he wishes to demonstrate draws its inhabitants from all nations no matter what their languages, laws, and customs. Such a city will certainly have a place for unusual races of men.

Since everyone has heard of such people, Augustine is concerned to address the question of their lineage and their place in the vast structure he has been developing. Accordingly he asks whether the monstrous races one reads about in the Gentile writers "were descended from the sons of Noah, or rather from that one man from whom they themselves sprang" (16.8, pp. 41–43). In speaking of the Gentile writers he undoubtedly means Pliny, since he offers a catalog of the races that echoes Pliny's seventh book.

But Augustine does not attempt to answer this question as a natural scientist would. Since the phenomenal world was so often to him a figure for a spiritual one of greater importance, he shows little interest in scientific or anthropological questions. In speaking, for example, of the repopulation of the earth after the Flood, where another writer might have seen an opportunity for an hexameral or scientific digression, Augustine lets the zoological shade into the metaphysical, observing that the animals who went with Noah on the Ark may have been there less for their postdiluvian usefulness than to figure forth the mystery of the Church (16.7).

Augustine believed that there could be no human being who was not part of the divine plan for man. The question was whether the Plinian races were in fact human. In addressing this problem he considers two aspects of humanity—the possession of reason and the descent from Adam:

Whoever is born anywhere as a human being, that is, as a rational mortal creature, however strange he may appear to our senses in bodily form or colour or motion or utterance, or in any faculty, part or quality of his nature whatsoever, let no true believer have any doubt that such an individual is descended from the one man who was first created. (16.8, pp. 43–45)

If the races possess reason, they must be distinguished from ordinary animals, who have only a brute soul and so no religious feelings. In this belief Augustine is merely following the pagan philosophers, as he indicates in *De Trinitate* where he speaks of man " as the ancients defined him, a rational, mortal animal."[7] His denial that the outward man marks the Christian was an important contribution to thinking about the races. The idea was singled out for special consideration by an important commentator on *The City of God,* Francis de Meyronnes (d. 1328), who as a scholastic naturally fastened on the Aristotelian elements in the older author's discussion. In a series of *veritates* culled from the work, the commentator glosses Augustine's remark, stressing the inner reason over the outward appearance: "Accordingly when he speaks of different kinds of monstrous men in

different lands, we should understand that if they reason they are men, and their bodily form is not important."[8]

Augustine, however, does not commit himself to the humanity of the races quite so fully as later writers give him credit for doing. He ends his discussion with a statement of three alternative possibilities: "Let me then tentatively and guardedly state my conclusion. Either the written accounts of certain races are completely unfounded or, if such races do exist, they are not human; or, if they are human, they are descended from Adam" (16.8, p. 49). It is the last possibility with which Augustine is traditionally associated, and certainly the tenor of *The City of God* would support an inclusive rather than exclusive attitude toward the Plinian races. But if Augustine grants tentatively their descent from Adam, he does not go into the details of that descent or discuss how the races might have come to be so different from other men.

This was not a question to be ignored by students of the first two ages of the world, obsessed as they were by genealogies. No amount of emphasis on the races' reason and on their place in the heavenly city would keep ethnocentric Westerners from wondering about their unusual form and why they differed so much from other descendants of Adam. Although Augustine had not dealt with these questions, there were others who pursued them and offered a variety of possible explanations and lineages for the monstrous races.

Curiously, the ancestors most frequently suggested—though human—proved to be villains of Christian history who transmitted their evil natures to the fabulous peoples of the East. Thus, the same genealogical approach that led, in Augustine, to an open and accepting view of the races could also be used to encourage hostility and mistrust.

Treating the bad seed in order of seniority, we begin with Adam's children. One body of thought in the Middle Ages glorified the physical and mental nature of Adam as being of all living creatures closest to God. Existing in its most developed form in rabbinic commentary on Genesis, this idea passed into the Latin West through Irish authors and Peter Comestor, who seem to have been especially interested in Jewish legends, or midrashim.[9] Extolling Adam's astounding knowledge, goodness, and physical beauty, the midrash derived from Philo philosophic explanations for why postlapsarian man no longer resembled Adam.[10] Since God had made the first man, it followed that man-made copies must necessarily be inferior to the original, receiving dimmer forms and powers. According to the midrash on Genesis,

the generality of men inherited as little of the beauty as of the portentous size of their first father. The fairest women compared with Sarah are as apes compared with a human being. Sarah's relation to Eve is the same, and, again, Eve was but as an ape compared with Adam. His person was so handsome that the very sole of his foot obscured the splendor of the sun.[11]

These differences between Adam and his children were attributed by some writers to more than a mere decline of the species. Three anonymous Middle High German poems written between 1060 and 1170, called collectively the Vienna Genesis, introduced an apocryphal tale in which Adam's children corrupt the species by their disobedience. These poems were intended to present the Book of Genesis to a lay audience and may have been written by a member of the secular clergy.

In the Vienna Genesis we learn that Adam commanded his children to avoid certain plants so that their own offspring might not have deformed bodies. Ignoring his command, they ruined their posterity. As the account develops, it contains a good deal of rhetorically inspired fear of and hostility toward the Plinian races, as well as marked prejudice against Ethiopians. But most important, the author alludes to Saint Augustine's belief that the form of the body is not necessarily a clue to the quality of the soul, and he goes out of his way to reject this point of view. The passage enumerates, in the manner of a Plinian catalog, the offspring of Adam's children:

Some had heads like those of dogs; some had their mouths on their breasts, their eyes on their shoulders; they had to make do without a head. Some had such large ears that they covered themselves with them. One had a single foot, very large; with it he ran quickly as the animals in the forest. Some bore children which went on all fours like cattle. Some completely lost their beautiful coloring: they became black and disgusting, and unlike any people. Their eyes shone, their teeth glittered. Whenever they revealed them, they made even the devil terrified. The descendants displayed on their bodies what the forebears had earned by their misdeeds. As the fathers had been inwardly, so the children were outwardly.[12]

The poet, after telling the story of the herb-eating children, observes that Adam had another son named Seth, a model child, from whose seed humans came. Very little is said of him in the Scriptures, but he figures prominently in apocryphal tradition as a replacement son to Adam, helping to offset the physical loss of Abel and the spiritual loss of Cain.[13] Through Seth's line, mankind gains Christ as a second Adam. As Honorius of Regensburg explains in the Lucidarius, "Christ did not wish to be born from the cursed seed of Cain . . . and on behalf of Abel came Seth, of whose line Christ is born."[14] The poet of the Vienna Genesis has God call Seth's line His children

to distinguish them from the monstrous children. Even they, however, were fallible. The rest of the story tells how the children of Seth took wives of the children of Cain; giants were born and God angrily flooded the earth.

Similar lines pertaining to the species corruption of Adam's children appear in the *Reinfrid von Braunschweig* (c. 1300), which seems indebted to the midrashic texts on the perfection of Adam. According to the *Reinfrid*, Adam had a wondrous pharmacological power given him by God and knew the properties of all herbs. Whenever a pregnant woman tasted one particular variety, her offspring were perfectly formed. Another herb, however, brought down a curse. A third turned the unborn child into an animal. Naturally Adam, out of his great knowledge, told this to his children and warned them to avoid those plants by which their progeny would be corrupted.[15] The outcome of this warning is never stated, but since God later destroys the world and kills off humankind because of "sinful guilt," we presume the children did not heed their father's words.[16]

The learned Latin tradition offers a version of this legendary explanation, most probably drawing upon the same source as did the vernacular texts. An interpolation in the Rothschild Canticles, in a hand different from that of the rest of the work, describes how Adam at Damascus warned his daughters about the special natures of various herbs.[17] In the choice of this city, the author was probably influenced by Peter of Riga's *Aurora*, which explained that Adam after his expulsion from Eden "to a field in Damascus" became a farmer.[18] Interestingly, the Rothschild Canticles not only describe the monstrous progeny of the daughters, but also show pictures of them in several accompanying miniatures. Each is introduced by the same formula—"If you eat ... you will conceive"[19]—followed by a description of the race in question: men with the heads and necks of cranes; Cynocephali; giant-footed men; men with horses' hooves for feet; a man with an enormous foot, obviously a Sciopod but called monoculus and "Ciclops"; Panotii; men half ape; and Pygmies. We then learn that "Adam forbade all his daughters to eat these herbs, but they ate them nonetheless, and it came about that they bore half-men who were conceived from these herbs and therefore had souls like those of beasts."[20]

The matter of the forbidden herbs was not the only transgression of which Adam's children were guilty, of course. Even more important was Cain's murder of his brother Abel: "All who descended from Cain, Christ hated ever after," says the A text of *Piers Plowman,* echoing a view of Cain and his descendants that was wide-

spread during the Middle Ages.²¹ Indeed, much more was known and
thought about this figure than would be possible to learn from read-
ing his story in the Scriptures. In the course of time, apocryphal
accounts of his legend added many features that made him an ideal
ancestor for the monstrous races in hostile Christian treatments.²²
They stressed Cain's violent nature, his association with the devil,
and his degradation from human status, often figured by his ugliness
or physical deformity.

Rabbinic tradition, coming to the West by the avenues mentioned
earlier, developed a suitably evil lineage for Cain. Whereas Genesis
tells us simply that Cain was the firstborn of Adam and Eve, the
Zohar, a thirteenth-century collection of midrashim, explains the
difference between the two sons of Adam as follows: "When the ser-
pent injected his impurity into Eve, she absorbed it, and so when
Adam had intercourse with her she bore two sons—one from the
impure side and one from the side of Adam ... Hence it was that
their ways in life were different ... From [Cain] originate all the evil
habitations and demons and goblins and evil spirits in the world."²³
The Pirkê de-Rabbi Eliezer, a midrash of haggadic material dating
from the early part of the eighth century, gives a slightly amplified
form of this story, in which Satan, "riding on the serpent, came to
[Eve,] and she conceived [Cain]; afterwards Adam came to her, and
she conceived Abel ... Hence thou mayest learn that Cain was not of
Adam's seed, nor after his likeness, nor after his image."²⁴ Effec-
tively dissociating Adam from responsibility for the children of Cain,
this rabbinic explanation prepares the way for the idea, in later
Christian thought, that just as the children of Adam partake of his
punishment for violating God's commandment, so the children of
Cain partake of their father's curse for rebellion and fratricide.

The Zohar observes that when Satan copulated with Eve, she bore
Cain "and his aspect was not like that of other human beings."²⁵ Ap-
parently the fact that there were no other human beings besides his
parents did not perturb this author. Even before there were other
men, Cain was set apart. Presumably his own parents had some in-
kling of his character, for most of the Adam apocrypha describe a
dream that Eve had before Abel's murder. For example, the Middle
English Life of Adam and Eve has Eve say "I saw in my dream Cain
gather Abel's blood in his hands and devour it with his mouth."²⁶
Cain's descendants, who retain his cannibal tendency, are shown on
the Hereford world map, where the author places the Anthropophagi
in northeast Asia. Their legend reads, "Here are exceedingly trucu-
lent men, eating human flesh, drinking blood, cursed sons of Cain."

The story of Cain's punishment, exile, and death influenced later views of his progeny, punished by deformity for their ancestor's crime, and, like him, exiled from mankind. Although the Book of Genesis tells us little about his life after he killed Abel, writers of midrashim and apocrypha were quick to supply details, and gave medieval readers a very clear sense of where Cain lived during his exile and exactly how he died. Whereas Adam, Seth, and Seth's children dwelt on top of Mount Eden, according to the Syriac *Book of the Cave of Treasures,* Cain and his children lived on the plain below. Adam in his testament warns Seth, "Keep ye your offspring separate from the offspring of Cain, the murderer." After the children of Seth had buried Adam, they lived apart from those of Cain. The author continues the topos of the testament and has Seth, gathering up his own children, tell them, "I will make you to take an oath, and to swear by the holy blood of Abel, that none of you will go down from this holy mountain to the children of Cain, the murderer. For ye know well the enmity which hath existed between us and Cain from the day whereon he slew Abel."[27]

Most accounts of Cain's life during the period of exile on the plain stress changes in his physical appearance as a result of God's curse. After the murder of his brother, he received as a punishment horns, or lumps on his body, as a sign of his degraded human nature. An Armenian Adam book, following Jewish tradition, says that Cain was afflicted with seven punishments, of which the first was "that upon his head sprung up two horns."[28] That this idea was known in the West is evident from a comment by Rupert of Deutz, who observes, "God set a sign on Cain . . . that he bore a horn on his forehead, or something like, which is not from the authority of Scripture, but from Jewish fable."[29] One of the capitals of Autun (Figure 32) shows Cain with what appear to be these very horns growing from his head.[30] For the story of the lumps, we must go to the Middle Irish *Lebor Gabála,* a *prosimetrum* of biblical and Irish history dating from the middle of the twelfth century. "God set Cain in a sign," the author said, "a lump upon his forehead [and a lump (on) each of his cheeks, and a lump on each foot and on each hand] . . . Then Cain . . . dwelt, a wild fugitive, in the eastern border of the land called Eden."[31]

During his period of exile Cain, physically deformed by lumps and horns, dwelt far from man and as a creature alien to him. Understandably, most apocryphal accounts prefer to ignore the story of how Cain built a city and fathered Enoch, instead enjoying his appropriate end as a savage beast.[32] In his last days Cain sometimes

32. Death of horned Cain. Capital, Autun Cathedral, c. 1150.

wears a garment of leaves, looking rather like a *wodewose*. The Armenian Adam book relates that after Cain had lived in miserable exile for eight hundred and fifty years and wanted to die, "God brought from above a skin and covered him."[33] Such a garment was a sign of Cain's monstrosity; it also helped to bring about his death at the hands of Lamech, who mistook him for an animal.[34]

Cain's death was a popular theme in the Middle Ages; again Jewish sources amplified his rather enigmatic disappearance from biblical history. Saint Jerome, in a letter to Pope Damasus, had mentioned one of Cain's biblical descendants, Lamech, as the man who killed Cain and referred to "a certain Hebrew book" as his authority.[35] Undoubtedly he meant the apocryphal Book of Lamech, of which we find many traces in later literature and art.[36] Rashi, for example, in his glosses on Genesis, explains that "Lemech [sic] was blind and his son Tubal was leading him [while hunting] . . . when Tubal saw Cain

33. Lamech kills Cain. Picture Bible, London, British Library MS Egerton 1894, fol. 3a, thirteenth century.

coming . . . who appeared to him as a wild animal."[37] The *Book of the Cave of Treasures* makes Cain's home, the land of Nod, into the forest of Nod in which Cain, dressed in skins, thrashing about in the trees like a beast, is shot by the blind Lamech.[38] A lovely picture Bible in the British Library depicts the whole story (Figure 33).[39]

The illustration for the killing of Cain here and in a related manuscript in the John Rylands Library shows Cain in the bushes looking like a wild beast, but instead of the horns found in the midrashic account, he has flamelike hair, quite different from the hair of Lamech and his young guide Tubal Cain.[40] His matted, flamelike hair signifies his wild, uncivilized state; it was adapted by the painter from the flamelike locks of the vices in Carolingian illustrated manuscripts of Prudentius' *Psychomachia,* where it indicates sinful violence, as well as from the story of Esau in Genesis 25:25: "Red all over, like a hairy garment." Esau was, moreover, bloody and cruel like his ancestor Cain, and was a type of the malicious man.[41] The illustrator of the Rylands Library manuscript clearly made these connections because he shows Lamech, whose hairstyle is quite different from that of Cain in the killing scene, with flamelike hair himself when, in a rage, he kills the young guide who directed the arrow toward Cain.

One of the most interesting attempts to connect Cain genealogically with the monstrous races occurs in a Middle Irish historical

treatise on the Six Ages of the world. This work, Bodleian Library
Rawlinson MS 502b, divides its treatment into two parts, the first
tracing a line of monsters from Cain's offspring down to the Flood,
and the second explaining how monsters were disseminated after.
the Flood. From the former we learn that God commanded the pos-
terity of Seth not to mix with the posterity of Cain, but that they
transgressed this teaching and begot children, "so that thence sprung
the monstrous creatures of the world, giants and leprechauns and
every monstrous illshapen form that people have had."[42] The author
tells us that Cain's descendants did not survive the Flood. Yet the
line of monsters is perpetuated by a new figure, who is the spiritual if
not physical heir of Cain. In the section on the Second Age of the
world, where we find an account of Noah and his sons, the author
says:

His famous father cursed the son called Ham so that he—he excelled in per-
versity—is the Cain of the people after the Flood. From him with valour
sprung horse-heads and giants, the line of maritime leprechauns, and every
unshapely person; those of the two heads—it was a crime—and the two bodies
in union, the dun-coloured one-footed folk, and the merry blue-beaked people.
Every person in the east without a head, going from glen to glen, and his white
mouth protruding from his breast, he is of the posterity of Ham.[43]

In sum, this writer has brought the monstrous races through the
Flood and provided a catalog of them which shows the impact of
Pliny's *Natural History* in Ireland. We recognize the giants, one-
footed folk, and men with faces in their chests whom the author has
placed geographically "in the east"; the maritime leprechauns, how-
ever, and the intriguing merry blue-beaked people seem to be purely
Irish contributions.

Though the authorship and development of this Irish Six Ages text
is little understood, it appears that in a prose historical work, the
Lebor Na Huidre, there was a passage telling how Ham received a
curse from Noah and became the heir of Cain.[44] From Ham sprang
the monstrous races after the Flood. This account was eventually in-
corporated into the Rawlinson manuscript; there a poetic summary
by Dubliter, a lector of Glenn Uissen who was active in the last years
of the eleventh century, follows the prose text on the Six Ages. Styl-
istic reasons suggest that Dubliter was not the author of the prose
version but was working with an independent older text, itself an in-
terpolation into the *Lebor Na Huidre.* The material I have cited from
Rawlinson is not peculiar to it by any means, but appears in later
versions of the Irish Six Ages incorporated in works such as the
Ban-Shenchus (1147) of Gilla Mo Dutu,[45] the *Book of Lecan,*[46] and the

34. Ham, Nimrod, and Cain (left of center). Reformatio Languentis Animae: Arbor bis Mortua, Oxford, Bodleian Library MS Douce 373, fol. 5, Flemish, before 1538.

Lebor Gabála.[47] These texts illustrated what Charles Donahue has aptly termed a "conflict between older, more imaginative Celtic Christian speculation and a school which insisted on rigid historical consistency."[48] In this regard, the races' parentage from Ham is, as he notes, "a late and not wholly successful intruder."[49]

Ham's name (spelled "Cham" in the Middle Ages) was easy to confuse with Cain in medieval orthography, since the three minims of the m could be read as an *i* and an *n*. This confusion occurred widely in English, French, and Latin spellings. Ranulf Higden in the *Polychronicon* was alluding to this familiar identification when he spoke of "Cain, who is commonly called Cham."[50]

A sixteen-century manuscript miniature of a tree of vices in the Bodleian Library (Figure 34) shows Cain perched in an upper-middle vine tendril, wearing a coat of leaves or hair. His vine is suggestively linked to that of his postdiluvian analogue, Ham. The artist here has—through his interlace pattern—made visual the typological identity of Cain and Ham which was suggested by the author of Rawlinson 502b. He has gone one step further, in fact, by also depicting Ham's son, Nimrod, the father of the African peoples.

When the flood waters had receded and Noah and his children had come forth from the Ark, the earth was divided among the sons for repopulation.[51] Shem, Japheth, and Ham each received a portion of the world; the first son got Europe, the second Asia, and the third

Africa. Ham was assigned Africa, according to Jerome, because his
name was derived from *calidus* or "hot."[52] The ninth-century exe-
gete, Angelomus, elaborated on this etymology, connecting Ham and
his progeny specifically with Africa because of the climate of that
land.[53]

In Genesis 9:21 Noah, overcome by wine, lay down to sleep, and
Ham, seeing his father's nakedness, called his brothers to look and
mock Noah. They piously refused and covered him up. Noah, upon
waking, cursed his son, saying rather ambiguously, "Cursed be Ca-
naan; a servant of servants shall he be to his brothers" (9:25). The
many patristic explanations of this curse need not detain us here.[54]
We can see, however, that just as Ham and Cain were linked by the
orthography of their names, they were also identified by both receiv-
ing a father's curse.[55]

Ham's curse connected him particularly with the Ethiopians,
called the "dun-coloured one-footed people" in the Rawlinson trea-
tise. Perhaps the most sweeping account of the curse, and the one
that reveals most strikingly the deeply rooted and early hostility to-
ward black men on the part of Arab geographers, occurs in the work
of the eleventh-century traveler Ibrihim ben Wasif Sah. Entitled the
Abrégé des merveilles by its modern editor, this work reports that
Noah cursed Ham by asking God that all his reprobate son's descen-
dants be black and that they be the servants of Shem's children in
the future. Giving a vivid portrait of Ham's son Nimrod as having
black skin, red eyes, a deformed body, and horns on his forehead, he
concludes that Nimrod the hunter was the first black man after the
Flood.[56]

Interest in Ham's curse was to have long-range implications in the
history of the Plinian races, for it provided biblical underpinnings for
the enslavement of African peoples and the idea that they were more
animals than men.[57] Though Genesis says simply that Ham's son
Canaan was to serve Shem and Japheth and their descendants, the
curse was applied to Ham and all his posterity, making him the first
of a line of servants—and eventually slaves—after the Flood. Am-
brose, for example, says that "slaves came from sin, just as Cham the
son of Noah, who first merited the name of slave."[58]

The *Lebor Gabála* augments this. Noah "cursed Ham, and thus he
spake: 'Cursed and corrupt is Ham, and he shall be as it were a slave
of slaves for his brethren.' "[59] Similarly, in the Adrian and Epictetus
dialogue the question is raised, "From whence or in what manner are
slaves made?" The reply is "from Ham."[60] In the translation of and
commentary on *The City of God* made by Raoul de Presles, the au-

thor observes in Book 16, citing Peter Comestor, "Thus it can be seen how the line of Ham was evil, for from it descended servants."[61]

These accounts not only came to serve as moral justification for slavery and race prejudice down to our own day,[62] but they also contributed to the increasing separation between high and low social stations in the Middle Ages and to the stereotypes of the villein as comic, ugly, crude, and even monstrous. In the early treatises on heraldry, which echo the changing relation of retainer and lord at the end of the Middle Ages, we can see certain assumptions about the nature of "gentlemen" and, by implication, contrary assumptions about those who are not gentlemen. Thus in the fifteenth-century *Liber Armorum* we learn "how gentlemen originated and how they may be distinguished from churls." Cain, by killing Abel, became a "churl and all his offspring after him by God's curse and that of his father Adam." Seth, on the other hand, was made a gentleman. Noah descending from Seth was a "gentleman by nature" and the ungentle remainder of the world was then destroyed by the Flood, but afterward ungentleness was reborn in Ham.[63] This sort of social thinking was particularly popular in England where, in the Middle English *Ywain and Gawain*, the churl of the woods with club by the magic fountain is called "a churl of Cain's kindred."[64]

Among the progeny of Ham we find a variety of "ungentle" peoples. Pseudo-Aethicus in the *Cosmographia* says that "the Moors are from the line of Ham,"[65] and in the twelfth-century *Itinerary* of Rabbi Benjamin of Tudela we learn that at "Seba on the river Pishon (Nile) . . . is a people . . . who, like animals, eat of the herbs that grow on the banks of the Nile and in the fields. They go about naked and have not the intelligence of ordinary men. They cohabit with their sisters and anyone they find. [The Egyptians] bring many of them back prisoners, and sell them . . . And these are the black slaves, the sons of Ham."[66] Other progeny were cannibals. A curious dialogue between Saint Andrew, Saint Matthaeus, and some cannibals occurs in a variant form of the apocryphal Acts of the Apostles, where the Apostles trace for the cannibals an insulting genealogy which concludes, "Ham cursed by his father was reprobate in his progeny, proscribed through the ages, from whom the filthy people take their source, whence they are shunned by God, and you, O cannibals, are the filthiest."[67]

A mixture of Ham and Cain legends, seasoned by an interest in the Tatar empire, seems to have been responsible for a peculiar interpolation in one group of the manuscripts of *Mandeville's Travels*. Some French versions of the work assign Asia, rather than Africa, to

Ham. One of these, in the Fitzwilliam Museum, Cambridge, explains that the great Khan and Ham are of the same family.

I will tell you why he is called the great Khan. You ought to know that the whole world was destroyed by Noah's flood except Noah, his wife, and children. He had three sons, Shem, Ham, and Japheth, and they seized the whole earth. Ham for his cruelty took the best part, which is called Asia, and Shem took Africa. And because Ham was the greatest and most powerful of them, from him descended more generations than from the others. And the enemies from Hell came often to sleep with the women of Nimrod's line, and engendered divers monstrous and very disfigured men, some horse-footed giants, some with great ears, some with one eye and some with other disfigured members, and from Ham's lineage came the Saracens and the various men who dwell on the islands around India.[68]

Apparently the French *Mandeville* redactor based this fantasy on the similarity between the names "Khan" and "Cham." But he has done more than merely conflate the two figures; he has also altered the geography of the legend—in a perfectly reasonable way—to make the Khan, who is emblematic of the ferocious Eastern ruler, the possessor of Asia after the Flood. This bit of geography is then fused with the Nimrod story, making his children copulate with fiends to produce the monstrous races. Something of this view may lie behind a remark in Felix's *Life of Saint Guthlac,* where demons are spoken of as the "seed of Cain."[69] Linked, moreover, with the monstrous races of the line of Khan-Ham are the pagans or Saracens, though this is a common connection in other texts. For example, in a Provençal manuscript of the Adrian and Epictetus dialogue we find the question "Whence come Saracens?" and the reply "From Caym."[70] Though the textual history of *Mandeville's Travels* is very complicated, this version may show Irish influence because it is a member of the "insular" family of manuscripts made from the original French *Mandeville* in England sometime before 1390.[71]

Our focus thus far has been primarily on historical accounts of the monstrous races that associated them with sin, evil, and heresy. The descendants of Cain and Ham seem, indeed, to have become ubiquitous by the thirteenth century, and almost any person or people viewed with distaste or hostility by a Christian writer was likely to receive honorary membership in their family, as genealogy was used to justify an unfriendly or suspicious attitude toward the peoples who dwelt on the fringes of the medieval Latin world. An examination of an imaginative work from the early medieval period shows how the idea of the cursed line is carried out in a literary treatment of one of Cain's progeny.

The author of the Old English *Beowulf,* in depicting the monster

Grendel, has drawn on just the kind of material we have been discussing. But he has gone further, creating a character who is baleful and dangerous as a result of his ancestral curse—who is inimical to men, though related to them by common descent from Adam.

The passages concerning the origins of the monsters in *Beowulf* were discussed by O. F. Emerson as long ago as 1906 and have excited new interest in recent years.[72] The first of these occurs as part of the description of Grendel (ll. 100–114) and seems generally in keeping with the poet's genealogical interests. Hrothgar's thanes lived happy in the newly built Hall of the Hart,

> until the time when a fiend in hell plotted malice. It was the angry spirit called Grendel, the famous stepper at the edges of the land, who held moor and fen and the high places there. The wretched one had dwelt with a giant sea race a while since the Creator had condemned him. Almighty God had requited the act of him who slew Abel on Cain's kindred. Nor did Cain rejoice in that battle. God for that crime banished him far from mankind. From him were born all monsters, giants and elves, and hell demons, as well as the giants who strove with God a long while; He paid them their reward for that.[73]

Having established Grendel's lineage, the speaker shifts from static genealogy to narrative action, bringing the monster to Hart Hall on the first of his nighttime attacks.

The second passage (ll. 1259 to 1268) also comes at a point that marks a change in the movement of the story. After a feast in honor of Beowulf's triumph over Grendel, the Danes fall asleep and awaken to find a monster once more in their midst.

> Grendel's mother, a devil woman, remembered her misery. A water monster, condemned to dwell in cold streams, since Camp was become a sword killer of his only brother, his father's son. Then as an outlaw, marked by murder, he fled from human pleasures, dwelt in the wilderness. To him were born many doomed spirits, of whom Grendel was one, the hostile one, bloodthirsty as a wolf.

The rather formulaic qualities of these two genealogies and their placement at transitional points of the narrative suggest that they might have been brought over entire by the author from other works and that they embody traditional material rather than being the products of the poet's imagination.

Interestingly, if one looks at the manuscript or at the Zupitza facsimile, it is clear that at line 107 "in Caines cynne" had originally read "in Cames cynne" and had been altered.[74] On the other hand, at line 1261 in Klaeber's and Wrenn's editions, the word "Cain" actually read in the manuscript "Camp." Did the monstrous races cited by the poet originally derive from the line of Ham and were they reassigned to Cain at line 107 with the scribe forgetting to make the

necessary change at line 1261, or the reverse? The facts of the passage themselves, of course, fit Cain rather than Ham, if we stick to a literal interpretation of Cain's legend. Yet the two figures seem to have been conflated, consciously or unconsciously, in the mind of the poet or scribe.

The most obvious explanation, and one offered by James Carney, Charles Donahue, and others, is that the poet was aware of an Irish source that substituted Ham for Cain as the progenitor of the races. The idea is given support by the fact that the four beings mentioned as the spawn of Cain in *Beowulf* correspond to the four monstrous races mentioned in the Rawlinson Six Ages text.

Yet Margaret Goldsmith, in her *The Mode and Meaning of Beowulf*, has found the arguments for an Irish legend involving Ham unconvincing, and it will be necessary to take her objections into account. She feels that the supporters of an Irish source "prove no more than that there were two traditions . . . As to the substitution of Ham for Cain, it is quite obviously wrong for *Beowulf*, since the killing of Abel is part of the story, and the spellings of the name therefore only indicate that at some time in its transmission the manuscript was copied by a man who believed the Ham version of the origin of monsters."[75]

It seems to me that these objections slight the metaphoric implications of an identification of Ham and Cain in the Irish legends. The presence of Abel in both passages of genealogy in *Beowulf* does not rule out the association of Cain and Ham typologically. Each was a bad brother and son; each lived at a time when the earth was not yet populated; each produced a cursed line. In the *Book of Jubilees* Ham even leaves his father after the curse and builds a city just as Cain does.[76]

It may not be overingenious to argue that in the inability of the scribe to decide who is the symbolic father of monsters, Cain or Ham, we see an analogy to a somewhat similar desire to have things both ways in the Irish *Lebor Gabála*, where the author first gives the Cain account and afterward observes, "Others say however that it was not of them that they were found: it is of the seed of Ham."[77] It seems reasonable to conjecture that the *Beowulf* poet knew and used an Irish form of the history of the first two ages and that, wishing to provide historical continuity, he offered the monstrous races a joint lineage.

Traditional genealogies, however, serve only as background for the poet, who goes well beyond such material in his treatment of Grendel and his mother. They are by no means merely local water

trolls whose depredations at the court of Hrothgar come from hunger or evil temper and who have been given an aura of antiquity and universality by their association with Cain. Rather their elaborate genealogy ensures their membership in Adam's family, though distantly, and means that they belong to the same species as their victims. Margaret Goldsmith has made this point well. She observes that "though bestial in habit, they are understood to be human beings who hate their own kind ... The Grendel kin are ... misshapen and denatured human beings, such as existed, according to the scriptural story, before the Flood."[78]

Grendel and his mother feel a hostility toward mankind more complex than the purely instinctual view of men as potential dinners which we found in the treatment of the dog-headed cannibals in the apocryphal Acts of the Apostles. The motive for Grendel's anthropophagy is not only simple animal hunger. He feels a human emotion—the envy of the exile at the joyous singing and communal feeling of the men in the meadhall, an emotion similar to that of Satan in Avitus' second book on the Pentateuch.[79]

Grendel, of course, is not one of the Plinian peoples. Though there are at least two of the Grendel folk, we are not told of a whole race of them, and the family has none of the Indian or African associations of the Plinian races. The materials with which the *Beowulf* manuscript was bound together—the *Letter of Alexander to Aristotle* and the *Wonders of the East,* to name the most important texts—depict beings who, like Grendel, are cannibals, are of giant stature, and possess bestial attributes similar to Grendel's clawed hands. But they seem flat by comparison, for they lack the emotional range and individuality that the *Beowulf* author has given to his monster. Goldsmith sees the greater impact of Grendel as owing, at least in part, to the sense of mystery that surrounds him:

The monsters in *Beowulf* are not in the least like the monsters in *The Marvels of the East* or any other of the Mediterranean sources ... The more one reads literature of the *Mirabilia* type, the more one is aware that these works have the fascination of the grotesque, like the two-headed calf at the fair; they depend upon their fantastic physical details for their appeal. In complete contrast, the adversaries in *Beowulf* are never fully visualized. (p. 99)

True as this may be, I think we should not underrate another source of Grendel's dramatic impact, namely his heritage from Cain and Ham. The poet has been able to draw upon a rich legacy of evil and hostility for the portrait of Grendel, which allows him to transcend a purely local role. Through his connection with the universally condemned figures of Christian history he gains a moral dimension not

available even to his adversaries, except in their victory over him.

This lineage, coupled with the poet's narrative skill, has produced both the most interesting monster of the Middle Ages and the most extreme statement of hostility toward monsters generally. In *Beowulf* we are far from the tolerant and curious attitude that we saw in Pliny's *Natural History,* or the inclusive missionary spirit of Saint Augustine. Gone is the familiar and harmlessly distant teratology of the classical world; we now have monsters who live near civilized men and are actively hostile and harmful. As the poet brings them from the remote reaches of the world into close proximity to mankind, hinting that their incursions are God's test of the proud beauty of Heorot, he makes them portents of divine attitudes toward man.

6 Signs of God's Will

The ancient world believed that many natural phenomena were signs revealing the gods' attitudes and intentions toward men. Although the Babylonians, Greeks, and Romans were all practiced in interpreting such signs, divination was most popular among the Romans, who saw in flights of birds and in spots on the livers of sacrificial animals predictions of the future. They also interpreted unusual weather and the anomalous young of animals and men as omens concerning the success of public undertakings.[1] Livy, for example, cataloged many portentous events, from red rain to animals speaking in the voices of men, which warned the Roman state that the gods were unhappy with the citizens' neglect.[2] Such events and births were called *portenta* or *monstra*.

Roman interest in *monstra* was largely based on Greek accounts of similar incidents, such as the story in Herodotus of a mare giving birth to a hare. This portent—the Greek word was *teras*—was a sign, to those skilled in the interpretation of such events, of the failure of Xerxes' campaign against the Greeks.[3] Though initially the noun *monstrum* was a translation of the Greek *teras* and described random unusual births of a highly individual nature, eventually the word came by transference to be used adjectivally of unusual races of men. The process was a long and complex one, and like most instances of lexical change cannot easily be detailed.

The present discussion outlines two approaches to the development of the word from late Roman times down through the Middle Ages. On the one hand there is the lexical-etymological approach, the "dictionary" sense of *monstrum*, where the word is seen in isolation in *differentiae* and glossaries. By the seventh century *monstrum* had been used by Isidore of Seville to refer to races of men, but the

word still retained the older sense of "portent" because the lexica copied definitions from one another rather than reflecting the living language. On the other hand there was a contextual development by way of writers rather than grammarians—Pliny, Solinus, Saint Augustine, and the Pseudo-Aethicus Ister's *Cosmographia*—where the word was adapted not only to the Indian and African races described by early Greek travelers, but to any people who deviated from Western cultural norms. Chronologically speaking the two approaches existed simultaneously, but the second affected the first very little because the lexical sense of *monstrum* was found in works that looked back to Republican authors. The lexica were part of an effort to freeze the development of Latin and save it from the pollution of barbarian and unclassical words by making available to the reader Silver Age forms and definitions. Naturally, better-educated writers like Saint Augustine were aware of both senses of the word and used them both freely.

The original sense of the word did, however, color and inform its second use to describe races of men. *Monstra* involved for all Latin readers the showing forth of divine will. In the classical period they were usually seen as a disruption of the natural order, boding ill; in the Christian period they were a sign of God's power over nature and His use of it for didactic ends. In popular and pious literature monsters were, therefore, closely connected with Christian miracles and the marvelous. It was in this light that Saint Augustine regarded them when he spoke of how, at the Resurrection, God would violate the course of nature by restoring monstrous men to perfect form. The monstrous races, like the individual wonders of Ireland cataloged by Bishop Patrick, were seen as messages from God to man. "Many wondrous signs," said Patrick, "that are signs of future ill / Or of good, has God given us in His mercy, Lord of the World: / That He might frighten those whom He willed to see them."[4]

If the races were signs from God, the question then arose: What were they meant to signify? This problem lent itself particularly well to the exegetical techniques so familiar to us in bestiaries, spiritual encyclopedias, and other homiletic works of the later Middle Ages. It produced a number of moral interpretations of the races that made them figures for various virtues and vices. The end result was a heightened treatment of alien peoples in didactic literature, exaggerating their unusual qualities so as to bring out their "monstrousness" in both the older and the newer sense.

Antique and medieval writers sought the meanings of objects in the etymologies of their names, for they believed that the name of a

thing, far from being arbitrary, was the key to its nature. As Isidore
says in a capsule description of the method of his *Etymologiae*,
"When we know the origins of a word we understand its power all
the more quickly."[5] He bases his thought here upon the very old be-
lief that Adam spoke "true" words in Paradise when he named the
members of the Creation, and that just as these members were re-
lated to each other and to their Creator through a vast orderly sys-
tem, so their names were related in the same mysterious way. Clas-
sical and medieval thinkers believed that when two words were
similar, the things they signified were linked also. Etymology, there-
fore, could reveal hidden meanings that might elude someone who
merely looked at the object named. It was this belief in the impor-
tance of names that underlay medieval interest in Latin roots and the
widespread use of etymological books.

Among the literary activities of the declining Empire, the writing
of *differentiae* or synonym collections drawn from earlier Roman au-
thors and the compiling of glossaries of their by then archaic voca-
bularies occupy an important place. Showing how words of like
meaning but unlike form could be used by the student desiring ele-
gance of Latin style, the *differentiae* explain subtle distinctions in
usage; they also give us a clear idea of what *monstrum* and its syn-
onyms must have meant to cultivated men during the late Empire.[6]
By contrast, the glossaries, with definitions rather than distinctions,
were primarily monastic productions designed to aid teacher and
student in the reading of Roman texts. Called *glossae collectae*, such
compendia incorporated many of the earlier *differentiae*, breaking
them into separate entries and then listing these alphabetically.[7] Mo-
nastic manuscripts of the poets and dramatists acquired the glosses
of several generations, which were eventually excerpted to form
large collections like the great ninth-century *Liber Glossarum*. Since
these *differentiae* and definitions supplied the lexical background of
educated men until well into the Renaissance, they are a very impor-
tant source for our understanding of the changing meaning of *mon-
strum* within broad periods of history.

The word *monstrum* and its adjectival form in the Middle Ages
were generally used to refer to things *contra naturam*, as when Ni-
cole Oresme said in the *De Moneta*, "It is monstrous and unnatural
that an unfruitful thing should bear."[8] Oresme's definition repeats
what we would find in the earlier Latin word lists, which often in-
cluded *monstrum* and its synonyms, since the word was a very com-
mon one in the works of Roman poets, historians, and annalists.[9]

Latin-Greek lexica of the early Middle Ages indicate that the word

teras, which in late Greek was distinguished from words like semeia
and phasma by referring to earthly rather than heavenly prodigies,
was the source for Latin monstrum, portentum, prodigium, and os-
tentum.[10] As most of the authorities who have written on prodigies
in the Roman world have pointed out, these four Latin words were
used more or less interchangeably in the early prose writers.[11] Three
collections of differentiae—by Marcus Cornelius Fronto in the first
half of the second century, by Sextus Pompeius Festus in the second
half, and by Nonius Marcellus in the fourth century—will show us,
however, that the words did differ subtly from each other, in ways
that affected the later compilers who pillaged the differentiae in
making up their glossaries.

Fronto's De Differentiis Vocabulorum offered the student the fol-
lowing distinctions among the four words: "Ostentum is called so
because it deviates from the customary, as for example if the earth or
sea or heaven were seen to burn. Portentum is something further off,
and signifies something in the near future. Monstrum is something
against nature, as for example the Minotaur. Prodigium is something
from which a detriment is expected."[12] The Differentiae of Festus
approaches the words etymologically, explaining that monstrum
comes from monendo or monere and that it shows the future and
warns of the will of the gods. Examples he gives of monstra are
things contra naturam, like footed serpents and two-headed men.[13]
Nonius Marcellus distinguishes the words on the basis of the gods'
intentions: "Monstra and ostenta are warnings (monita) of the gods,
prodigia show threats and anger of the gods, portenta are signs that
signify something imminent."[14]

It is difficult to generalize from these examples, but monstrum
does seem to have been early identified with unnatural births or
composite creatures and to have been seen as a warning. Its closest
synonym "prodigy," is likewise a thing rather than an event, and
may be alive, but it may also be something inanimate (a comet, for
example) to which we attach a prophetic significance.[15]

By the Carolingian period the word monstrum in the glossaries
seems definitely to have been distinguished from other forms of
prodigy as a zoological phenomenon. Thus, the eighth-century al-
phabetical Affatim collection—so named from its first word—ex-
plains that monstrum means "deformity of members."[16] Somewhat
later, the Elementarium of Papias the Lombard (c. 1060) defines it as
something "born outside of nature."[17] The glossaries of Papias and
his successors usually provide illustrative information and examples
for each word listed.[18] Interestingly, although Papias does not in-

clude races of men under the rubric *monstrum*, he shows himself
well aware of this usage in his entry for the Panotii: "They say there
exist monsters with enormous spread-out ears."[19]

The most important and extensive of the lexical-etymological
treatments of *monstrum*, and indeed the first real attempt at a defini-
tion that goes beyond the Roman "*contra naturam*," is that of Isidore
of Seville. This writer made the bold inductive transfer from individ-
ual monstrous births to the idea of monstrous races. In the section
entitled *De Portentis*, which makes up part of Book 11 of his *Libri
Etymologiarum*, he devotes several pages to individual portents and
to fabulous races. Book 11 treats man, his anatomy and various ages
and states, as well as portents and transformations of bodies from
one shape to another. Isidore is interested here not only in words de-
scribing the human condition, but in the very nature of man.

He begins his section on portents with the standard definition.
Quoting the Roman encyclopedist Varro, on whom he relies very
heavily, he says portents are things that seem to have been born
contra naturam. After a paragraph of etymology—"monstrosities,
monstra, are named from an admonition, *monitus*, because they
point out something by signalling ... what may immediately ap-
pear"—he observes that there are varying usages of the word in his
time: "This is the word's proper meaning, although it has been cor-
rupted by the misuse of many writers."[20] A portent or monster is di-
vinely caused, "since God now and then wishes to tell of coming
events through some fault or other in newborn creatures" (3.4, pp.
51–52). Isidore classifies portents—*monstra* is not at this point the
main word he uses to describe them—according to Aristotelian cri-
teria: "Prodigies or portents therefore exist either by virtue of some
bodily size beyond the measure common among men, such as was
Tityon ... or else by a smallness of bodily stature, as the dwarfs or
those whom the Greeks call Pygmies ... others from a hugeness of
parts, such as misshapen heads, or superfluous members" (3.7, p. 52).
Although he does not use the word *monstrum* here, there is little
question that he is using the other terms interchangeably with it, for
elsewhere, in the *Liber Differentiarum* (c. 612), Isidore says that
"*monstrum*" is something born beyond nature either exceedingly
large or exceedingly small."[21] His choice of the Pygmies to illustrate
a defect from the common stature among men is one of the first in-
stances—if not *the* first—in which a race is cited as a collective prod-
igy. A little later, in his discussion of superfluity, he mentions the
Cynodontes, a race of men having two rows of teeth.

Isidore's remarks on what constitutes monstrosity and his use of

35a. Monstrous races. Bestiary, Westminster Abbey Library MS 22, fol. lv, thirteenth century.

Plinian peoples to illustrate deviation from the mean inspired later writers and at least one artist.[22] The illustrator of a bestiary in the Westminster Abbey Library fills two pages with monstrous races (Figures 35a–35b), contrasting the Pygmies and the Giants in their defect and excess of normal stature.

Though it is unlikely that Isidore had any direct knowledge of

35b. Monstrous races. Bestiary, Westminster Abbey Library MS 22, fol. 3r, thir-
teenth century.

Aristotle's work, he must have had access to many of his ideas
through the lost encyclopedia of Varro; indeed, the notion that indi-
vidual monstrosities result from an excess or defect of the materials
of "fetation" rather than from a true violation of the laws of nature is
one of the Greek philosopher's basic beliefs. Throughout Aristotle's

works there are passages analyzing the nature and causation of human and animal young that do not resemble their parents. He is skeptical of the view that such births have any supernatural importance.[23] In the *Generation of Animals* Aristotle describes some examples of *terata*:

Others do not take after a human being at all in their appearance, but have gone so far that they resemble a monstrosity, and, for the matter of that, anyone who does not take after his parents is really in a way a monstrosity, since in these cases Nature has ... strayed from the generic type ... This, then, is one sort of 'monstrosity' we hear spoken of. There are others which qualify for the name in virtue of having additional parts to their body, being formed with extra feet or extra heads.[24]

The causes of these deviations are purely scientific. The Aristotelian *Problems* says that "monsters occur when the semen is mixed together and confused either on its exit from the male or in a later mixing in the female."[25] Extra feet or other members, however, come about "in the fetations, whenever more material gets 'set' than the nature of the part requires: the result then is that the embryo has some part larger than the others."[26] Aristotle went to considerable lengths to rebut what was evidently a customary view, pointing out that since "Nature is the universal determinant of order" monstrosities are "contrary not to Nature in her entirety but only to Nature *in the generality of cases*. So far as concerns the Nature which is *always* and is *by necessity*, nothing occurs contrary to that."[27] Aristotle seems to deny elsewhere the existence of races who mix human and animal forms or of individual anomalies like the Centaur of classical myth: "It is however impossible for a monstrosity of this type to be formed (i.e., one animal within another), as is shown by the gestation periods ... which are widely different, and none of these animals can possibly be formed except in its own proper period."[28]

Such then is the Aristotelian background for Isidore's view of monstrosities. Isidore in the *Etymologiae* shares Aristotle's belief that things *contra naturam* do not truly violate the natural laws of the universe; he has transmuted the idea into a distinctly Christian view of nature controlled by the divine will.

Varro says that portents are things which seem to have been born contrary to nature, but in truth, they are not contrary to nature, because they exist by the divine will, since the Creator's will is the nature of everything created. For this reason, the very pagans called God 'Nature' sometimes, 'God' at other times ... A portent, therefore, does not arise contrary to nature, but contrary to what nature is understood to be. (3.1–2, p. 51)

This view appears in other Christian writers, most notably in Saint Augustine.[29] Whether Isidore arrived at it independently is hard to say, but considering his extensive use of Varro it would seem more likely that he developed it from Aristotelian remarks he had read in that author.

What does seem to be peculiarly Isidore's is the intellectual leap from individual prodigies to races of unusual men. It is not clear how well he understood the implications of this leap, because of the rather offhand way he introduces it: "Just as among individual races there are certain members who are monsters, so also among mankind as a whole, certain races are monsters, like the giants, the Cynocephali, the Cyclops, and others" (3.12, p. 52). Isidore does not develop his analogy further, but uses it as the grounds for introducing several races to his list of monstra. In advancing the idea that an entire race can be monstrous, he has brought to the conservative lexical tradition a reading of monstrum that had not previously received the sanction of dictionary inclusion.

The old Roman sense of monstrum persisted, however, in the majority of medieval glossaries and lexica. For example, the twelfth-century commentator Arnulf of Orleans treated the word frequently in his glosses on Lucan, and was well aware that it could mean a warning by the gods concerning the present time.[30] Even as late as the fourteenth century, Pierre Bersuire explained in his *Repertorium Morale* that "monsters are creatures born outside, beyond, or contrary to nature, just as if a man were to be born with a cow's head, or with two heads, or the feet of a lion. . . . Such things therefore are called monstra, from monstrando either because they show or signify some future event or because they show some rare or marvelous thing."[31] In the main, then, a person looking in a lexicon would be apt to find the word used to mean an individual anomaly, and would need to look to developed literary contexts to see it applied to races of men.

In the account of marvels given in the seventh book of Pliny's *Natural History*, the word monstrum is used in both its traditional and its generic sense. At the beginning of the Social Wars Pliny speaks of multiform births as belonging among monstra; and, discussing cannibal tribes, he says races of this monstrous character (huius monstri) have even lived in Italy (7.2, p. 512).

Whereas Pliny applies the word tentatively to races of men, his abbreviator, Solinus (c. A.D. 200), excerpting in his *Collectanea* human and animal marvels from the *Natural History*, uses mon-

strum and its derivatives often and intentionally to heighten the drama of his own writing. William Stahl has noted that Solinus consciously edited the material he presented.[32] A survey of the many wonders recorded in the *Collectanea* yields nine instances of *monstrum;* in seven of these, Solinus either substitutes it where Pliny had used *prodigium* or *portentum* or adds the word to descriptions directly paraphrased from the *Natural History.*

In only one instance does Solinus use the word as we saw it among the lexicographers, and here it is as an adjective rather than as a noun. Solinus paraphrases Pliny in a section on the marvels of women, referring to a certain Fausta who had borne quadruplets as a portent from the gods. Solinus, however, as is his wont, elaborates and dramatizes his source, speaking of "this monstrous fecundity" which portends a future disaster. That Solinus is aware of the use of *portentum* for religious purposes is clear from his example, but his instinct for the marvelous leads him to embellish Pliny's *portendit* with *monstruosa fecunditate.*[33] Collecting portents interests him little; indeed, he seldom indulges in the cataloging of prodigies we find in Pliny, a literary practice that seems to have been on the wane, at least in its traditional forms, under the Empire.[34]

A more characteristic use of *monstrum* for Solinus is to describe hybrid, unusual, or frightening animals. Here he uses the word not to describe a particular animal, seen on a particular day with particular implications for the Romans, but rather for species of animals that have existed since the Creation and that are remarkable in themselves. For instance, paraphrasing Pliny, he remarks that at Rome Pompey exhibited Ethiopian "Cephos" with men's rear feet and forepaws like hands. He calls these hybrids *monstra* (20, p. 133); they are clearly *contra naturam* but there is no religious significance to that fact. In another place he describes how the crocodile is hunted by a race of exceedingly small but brave men, who allow their prey—called *monstra*—to chase them and who then turn and catch the saurians (27., p. 144).

For our purposes, however, Solinus' two most significant applications of the word are to men. Beyond Ethiopia, he writes, are some frightful solitudes, harsh deserts stretching to the Gulf of Arabia. At the extremity of the eastern part, people have a monstrous appearance: some are noseless, some drink through a straw because of their small mouths, and so on. His usage indicates that he imagines these people as both human and a species or race (*gens*) who look monstrous because they deviate from normative humanity—*monstrosae*

gentium facies (30, p. 132). An even more striking adjectival use occurs in the rewording of a passage from Pliny concerning the islands called Gorgades, once the home of the Gorgons. These islands were also the homes of hairy women and swift-footed men, several of whom were captured by Hanno on his periplus. Solinus says that "in these islands dwell Gorgons, monsters, and doubtless monstrous men dwell as far as this too" (56, p. 210).

Solinus had an important influence on the geography of the *Cosmographia* of Pseudo-Aethicus, and may have affected the author's vocabulary as well, for the word *monstrum* is used of a race several times in this work. The Cynocephali, for example, are described as "a truculent race, unheard of monsters."[35] Another passage tells how, in the eternally frosty northern regions, "monsters have been seen . . . who seem to be incredible, nor is it a wasted labor to tell about them, because they ought to strike great terror in the reader and an insupportable fear in those hearing about them. Nor is there any goodness or beauty in them" (3.38, p. 27). These passages give *"monstra"* a new aspect; the word is not only applied to races of men but acquires an element of exoticism connecting it with secular marvels.

Two theoretical statements from works of wonders show us that by the thirteenth century *monstra* had become part of the stock exoticism of the literature of entertainment. The *Otia Imperialia* of Gervase of Tilbury, composed for Otto IV between 1209 and 1218, is a compendium of knowledge and anecdote to "keep a drowsy emperor awake." The prologue to the third *decisio*, containing an elaborate account of the monstrous races of India and Africa, speaks of the relation of marvels to the desire of man for entertainment. Gervase discusses the difference between miracles and marvels, explaining that

because the desire of the human mind to hear and consume novelties is always kindled, it is necessary that the old be changed into the new, the natural into the marvelous, and with respect to many familiar things, into the strange. We think that a novelty can be judged by four considerations: creation, outcome, rarity and strangeness . . . We customarily call miracles those things outside nature which we ascribe to a divine power, as when a virgin bears, and those things marvels which do not yield to our understanding, even when they be natural.[36]

Among the "natural" wonders Gervase cites are the monstrous races, their rarity and strangeness appealing to man's imagination, arousing his curiosity, and bringing him happiness. As the author of the Middle English *Kyng Alisaunder* said in his own account of the monstrous races of India,

> There is no man, fool or sage,
> King or duke, or knight of renown
> who does not wish the happiness
> which comes of hearing of wonderful adventures.[37]

One notable quality of the "wonderful adventure" or secular marvel was that it was morally neutral and boded man neither good nor ill. In this respect it differed from the essentially theological *terata* and *monstra* of antiquity, for when a thing happened *"para physis"* or *"contra naturam"* in the classical world this was usually a bad or foreboding event. The antique *monstrum* suggested a weakness or disarrangement in the familiar order of existence. A theophany to the ancients, in other words, was usually bad for mankind, even in the limited form of an anomalous birth. A. O. Lovejoy has noted that nature "early took on a eulogistic coloring . . . and became the source of value-judgments . . . it was tacitly assumed that 'nature,' *i.e.*, the actual cosmos and its laws, must be wholly excellent, and that 'harmony with' and 'conformity to' it . . . must be a moral imperative."[38] Violations of nature's laws, then, would seem to be violations of divine order. Christian thought held that God violated the order of nature often and at will to show man something, and since God is benign His theophanies are always good. He is more powerful than nature and uses nature cooperatively in order to show forth His will in miracles. As Bonaventure had said of *monstra,* God "frequently acts against the customary course of nature either for vengeance or for pity."[39] The medieval *monstra ex monstrando* fit well into this scheme; they begin to take on some of the connotations of Christian miracle and to be, in certain respects, fused with *miracula* and *mirabilia.*[40]

Saint Augustine coupled the idea of *monstra* with *miracula* to argue that, far from violating nature's laws, *monstra* showed God's will to men, as the etymology of the word would suggest. Indeed, from the earliest theophanies of the Old Testament, all sacred history is a history of the suspensions of the physical laws of the universe, from Moses' holding back the waters of the Red Sea to Christ's resurrection. We find in Augustine a strong interest in miracles, fostered by a certain hostility toward the validity of sense impressions, and a concomitant belief that supernatural experience is the greatest conveyer of truth to man. He enjoyed explaining or justifying miracles by reference to examples in pagan literature, much as he did with his Plinian catalog of monstrous men in Book 16 of *The City of God*. For example, in the fourth chapter of Book 21 where he talks about the fate of bodies in eternal hell fire, he adduces from the

books of the pagans the story of the salamander who lives in fire and the legend of Mount Aetna. The last two books of *The City of God* are filled with examples like these and serve as one of the great sources for discussions of miracles in the later Middle Ages.

Two subjects that seem to have interested Augustine particularly were the relationship of *monstra* to *miracula* and to the Resurrection. Was monstrosity a question of substance or accident? Would monstrous men be resurrected in their monstrous form or in a new one? In developing his thought on these subjects, Augustine first treats God's will and power over nature: "Since God is the author of all natural substances ... this [miraculous activity] is the will of almighty God ... He is assuredly called almighty for no other reason except that he can do whatever he wishes."[41] Augustine proposes that the writings of the pagans themselves contain evidence that God can make changes in the physical universe at will. "Hence we must produce from the writings of the most learned men among them an example to show that a thing can come to be different from what had formerly been known about its fixed nature" (21.8, p. 49). One such example might be certain changes in a star, according to Varro. Augustine comments that "as great a writer as Varro would surely not call this a portent unless it seemed contrary to nature" (21.8, p. 51). Here he seems to be using *portentum* in the sense in which it is used in the early *differentiae*—as a prediction of an imminent event. He goes on to observe, "We commonly say, of course, that all portents are contrary to nature, but in fact they are not ... For how can anything done by the will of God be contrary to nature, when the will of so great a creator constitutes the nature of each created thing?"He concludes, "A portent therefore happens not contrary to nature, but contrary to what is known of nature ... Therefore, just as it was possible for God to make such natural kinds as He wished, so it is possible for him to change those natural kinds into whatever he wishes. From this power comes the wild profusion of those marvels" (21.8, pp. 51, 57). For Augustine, then, *miracula* are the Christian equivalent of the Roman *prodigia, ostenta, portenta,* and *monstra.* "These marvels are apparently contrary to nature ... To us these marvels, these *monstra* ... should demonstrate ... that God will do what he has declared he will do with the bodies of men, and that no difficulty will detain him, no law of nature circumscribe him" (21.8, pp. 57–59).[42] The thrust of Augustine's argument is that God is above nature and, as the existence of *monstra* proves this thesis, they should be a subject of fascination to Christians.

Augustine's identification of *monstra* and *miracula* was influen-

tial. When Cesarius of Heisterbach in 1180 came to offer his defini-
tion of a *miraculum* he might have been talking about a Christian
monstrum. "We call a miracle whatever is done outside the accus-
tomed course of nature, whence we marvel . . . Miracles are authored
by God . . . Sometimes God performs them in the elements, and
sometimes he shows his power to mortals."[43] Cesarius observes that
miracula can occur in all aspects of the creation—the four elements,
birds, fish, reptiles, and animals, as well as men.

Although Augustine does not single out the word *"monstra"* from
among its synonyms when he talks about such creatures or events as
part of God's plan, he does concern himself specifically with this
word in a striking passage from *The City of God*, where he answers
pagan objections to Christian belief in resurrection in the body.
"With mingled horror and ridicule they mention monstrous births,
and ask what will be the state of each deformed creature in the res-
urrection" (22.12, p. 271). The problem is not resolved until the nine-
teenth chapter, and then only tentatively by way of a rhetorical
question: "Will He [God] not be able to remove and destroy all the
deformities of human bodies, not only the common ones, but also the
rare and monstrous?" (22.19, p. 291). In the *Enchiridion* Augustine
says that He can: "We are not justified in affirming even of monstro-
sities . . . that they shall rise again in their deformity, and not rather
with an amended and perfected body . . . And so other births, which,
because they have either a superfluity or a defect, or because they
are much deformed, are called *monstrosities,* shall at the resurrec-
tion be restored to the normal shape of man."[44]

Though Augustine here uses *monstra* in the sense of anomalous
births rather than races of men, he was apparently understood by
Otto of Freising in his continuation of *The City of God* to mean races
as well. Appropriating many of Augustine's special themes in his
own *Two Cities,* Otto treats the question of the resurrection of *mon-
stra* less leniently, granting some races a more perfect form and de-
nying others any part in the Resurrection. "We must not suppose
that giants are brought back in such great stature, dwarfs in such ex-
treme littleness . . . the Ethiopians in an affliction of color so dis-
agreeable . . . All the others, creatures that lack reason, however
nearly they approach to human form . . . have, as is well known, no
part in this resurrection."[45]

Many medieval thinkers took an active and favorable interest in
monstra only because they served as an illustration of God's desire to
instruct people or set them in a place of honor in the hierarchy of
creation. *Monstra* were, after all, something associated with pagan

antiquity and took second place to the wonders of the two Testa-
ments. Thus, the author of the *De Mirabilibus Mundi,* before he gets
to a catalog of Plinian races, offers the warning that Christian won-
ders are more remarkable and improving than any to be found in the
Natural History: "O truly a wonder above all wonders that Christ
was born of a virgin, broke the gates of Hell and redeemed mankind.
Pliny once wrote concerning natural history. If I write what he him-
self set out, he spoke of wonders, I speak of morality."[46] It is only
with this disclaimer that the author can feel comfortable treating
monstrous men, and we can say generally that *monstra* appealed to
the medieval imagination as much for the possibilities they offered
for moral instruction as for their amusement value and their curios-
ity.

The medieval propensity for moralizing or drawing spiritual in-
struction from all aspects of the natural world is especially marked
in homiletic treatments of the monstrous races. Certain medieval
bestiaries interpolated among their animals a section on the Plinian
races, and moralized them much as they moralized the pelican or the
unicorn. Collections of exempla drew *moralitates* from the races,
making them into figures for unattractive human qualities and vices.
And at least one vernacular homilist translated and moralized a sec-
tion concerning them in a medieval encyclopedia, showing them si-
multaneously as evidence of God's power over nature, as evidence of
His fecundity of imagination, and as examples of conduct for con-
temporary men.

Saint Paul's dictum that all that is written is written to our profit
could be applied in the Middle Ages not only to real books but to
metaphoric ones as well. Indeed, so familiar a part of medieval
thought is the concept of the book of nature in which God speaks to
man that we need to refer to it here only in passing.[47] The book as a
metaphor of the creation had been well presented by Alan of Lille,
who said that "the world is like a book and the creation is like a pic-
ture in it for us."[48] Of course, this book of nature in which God
speaks to man indirectly must be read together with the *liber scrip-
turae* in which He speaks directly. Only by a knowledge of both
books can humans attain a proper relation to God, for the things of
sense, to use Nicholas of Cusa's phrase, are the books through which
God our teacher declares truths to us, and the things of the world are
written on the page with God's own finger.[49]

To the medieval *physicus*—what we would today call the natural-
ist—every creature is a shadow of truth and life, and the natural
world holds in its depths the reflections of Christ's sacrifice, the

image of the Church Militant and the various virtues and vices. As Saint Bonaventure observed, the ignorant man sees only forms—the mysterious letters on the page of the book of nature—without being able to read them, whereas the wise man passes from the visible to the invisible, and, reading this book, reads the thoughts of God.[50] If the material world points to the spiritual, the monstrous races do so even more than other natural objects because God expressly violated the order of nature to make them in order to show His will.

The study of spiritual truths by means of the natural world was the stated aim of Thomas of Cantimpré, whose encyclopedia, *De Naturis Rerum,* combines *moralitates* with scientific information based on Pliny's *Natural History.* He wishes, Thomas says in the prologue, "to compile in one volume, and that a small one, those facts concerning the natures and properties of created things which are both noteworthy and accordant with morality."[51] Citing Aristotle's *De Partibus Animalium,* he exhorts the reader to "consider the forms of creatures and delight in the artificer who made them"(pp. 120–121), for there is something miraculous in all natural things, and all were created for a purpose. He believes that the natural world can be a valuable tool for the homilist "to allure the ears of the sluggish in a new manner." "Hence," he continues, "we have briefly set forth the moral meanings and significances of things" (p. 120).

To see the medieval moralist at work with the things that make up the book of nature, let us consider an example of a *moralitas* drawn from *De Naturis Rerum.* In the portion of the encyclopedia dealing with species of birds, Thomas uses the sparrow as an illustration of a vice: lack of steadfastness or loss of belief in times of temptation. "The dung of sparrows," he explains, "is very hot when dropped but cools quickly. And this signifies those who in safety believe and in time of temptation doubt."[52] We may be disturbed by the seeming arbitrariness of this lesson, for, after all, one could as easily say that sparrow dung signifies the anger of the righteous, hot at first, but quickly cooled by charity. The widespread practice, however, of interpreting a thing from contrasting points of view, *in bono* and *in malo,* suggests that medieval men were not disturbed by arbitrary moralization. Thomas of Cantimpré does not, in fact, use the monstrous races as material for homily. Although he devotes Book 3 of his encyclopedia to them and includes a fairly original discussion of their nature, he follows Pliny closely.

The methods of homiletic exegesis were applied to the Plinian races in a group of bestiaries of thirteenth-century English provenance.[53] These differ from the usual medieval bestiary in that they

contain extensive sections on monstrous races of men, opening with a paraphrase of Isidore's remarks on portents from the *Etymologiae*. The bestiary, or book of animal lore, developed from the Greek *physiologus* by an elaborate process of accretion and allegorization.[54] As the name suggests, the genre consists of works treating animals, though some bestiaries contain chapters on stones and trees. It was quite exceptional for such works to include races of men.[55] The compiler of the original English bestiary that served as the archetype for the several copies in this group, however, was especially interested in miraculous and marvelous violations of nature's order.[56] He incorporated other material extraneous to the bestiary form, such as information on the seven wonders of the world and on divination. His Plinian races, though subject to the same moralizing methods as the other entries, are included not as animals, but as men.

The Douce bestiary in the Bodleian Library is a fair representative of the group as a whole. The incipit for the teratological section comes from Isidore's *Etymologiae* but the text does not follow the Spanish author's order of presentation and greatly simplifies his elaborate Aristotelian treatment of the races. When the bestiary compiler moves into his moralization of the Giants, who had received a fairly Euhemeristic treatment in Isidore—"giants, that is, exceedingly large and strong men"[57]—he follows Isidore in defining them: "There are giants beyond the common mean of men in size." He independently draws his *moralitas* much as Thomas does: "Giants signify proud men who wish to seem greater than they are, who when you praise them feign virtue."[58] The author finds an Old Testament parallel in the figure of Saul, who was both proud and tall, and observes, "Concerning the pride of Saul, it is said that from his shoulders upward he was taller than all of the people."[59] The pride symbolized by giants, of course, suggests its opposite. "Humility, truly, is commended in David, where it is said that he was the smallest of his brothers."[60] David, in his contest with Goliath, seems to take the place of the Pygmy, although this is not explicitly mentioned.

Several other races are arbitrarily assigned a moral significance. The Cynocephali represent "detractors and fomentors of discord" and the capacious ears of the Panotii fit them well for the hearing of evil. Members of an unnamed race (the Amyctyrae) who cover themselves with the lower lip "figure those of whom it is said 'the mischief of their lips will cover them'" (Psalm 139:10).[61] The Douce bestiary shows fifteen different races in the accompanying page of il-

lustrations, but the compiler deigns to treat only those mentioned here. He apparently felt that he had given his readers a sufficient sample of his method to allow them to continue to draw forth moral implications from *monstra*. "The remaining races the attentive reader can describe more fully if he wishes, either in black letters or in golden ones."[62]

The Douce moralist interprets *in malo* all of the races; wishing to rebuke backbiters, malicious talkers, liars, and the like, he chooses races from Isidore to use as exempla without inquiring too deeply into why they should represent only sins and vices.[63] It seems likely that he had no theories about them, favorable or unfavorable. As a man interested in marvels and the way they "speak" to mankind, he merely adapted potentially dramatic material to his homiletic designs.

Similar but much more elaborate moralizations of *monstra* occur in the *Gesta Romanorum,* an extremely popular collection of pseudo-antique tales, each accompanied by a well-developed Christian *moralitas.* Created in an English Franciscan milieu before 1342, the *Gesta* drew much of its material from the *moralitates* of Robert Holkot.[64] Chapter 175 of the work is entitled "Concerning the Diversity and Marvels of the World with an Exposition Included."[65] As with the Douce bestiary, the material on monstrous races is not really appropriate to the *Gesta,* since it is the races themselves and not what they do that makes them marvelous. The chapter's rubric, however, with its emphasis on wonder and diversity, focuses on the "showing forth" by the races of God's plenitude and creative imagination; apparently this was sufficient to anchor this non-narrative material in the work. Consisting not of a tale from antiquity but rather of a catalog of sixteen of Pliny's races, the chapter begins, "Pliny recounts," with no attempt to conceal or alter its source. Each race is accompanied by a moral interpretation.

A few of the many *moralitates* offered will give the flavor of the work. Cynocephali represent preachers who ought to be clad in animal skins, that is, in bitter penance, as an example to the laity. Large-eared Scythian Panotii freely hear the word of God by which they keep their bodies and souls from sin. Short-nosed, horned, goat-footed men are the proud, who raise the horn of pride everywhere and have little nose for their own salvation; their goat feet hurry them to lust. Pygmies, two cubits tall, riding on goats and fighting with cranes, designate those who are short with regard to the length of a good life; they begin but do not persevere and do not fight

long enough against the cranes, that is, the filthy vices. In Ethiopia, Pliny's four-eyed maritime Ethiopians signify those fearing God, the world, the flesh, and the devil. They turn one eye to God to live rightly, another to the world, which they ought to flee, a third to the devil against whom they ought to stand firm, and a fourth to the flesh, which they ought to punish. Finally, in Europe, there are beautiful men with the head, back, and neck of a crane; they represent judges who ought to have long necks in the manner of cranes in order to think wisely in the heart first, before they offer the sentence of the mouth. "If all judges were like this," the author concludes, "there would be fewer bad judgments offered" (p. 576).

As was the case with the Douce bestiary compiler, the author of the *Gesta Romanorum* is concerned more with the vice to be castigated or the virtue to be praised than with the race he uses in illustration. He has a very subtle mind and uses many striking and imaginative Augustinian personal metaphors—nose of discretion, eye of reason, and the like. His short-nosed men with little nose for their own salvation signal his reading in other moralizing works; short- and twisted-nosed men occur in a similar context illustrating a passage from Leviticus in the *Bible Moralisée*.[66] Occasionally personal fervor bursts out: "Apply this example to the proud," he commands the reader at one point. One wonders, too, if the crane-headed men of Europe are not his own invention, for the personality of the author comes through more in his comments about judges than anywhere else in this portion of the *Gesta*, giving the impression that he speaks from personal experience. These stylistic virtues notwithstanding, the homiletic method here and the attitudes toward the monstrous races behind it are very similar to those in the Douce bestiary. There is one striking difference: two-thirds of the races mentioned are moralized to signify virtuous conduct. It is clear from the author's treatment of them that he has no theoretical presuppositions that would lead him to choose some for virtue and others for vices; they hold little interest for him beyond the homiletic.[67]

The most elaborate moralization of the Plinian races occurs in an Old French verse translation of Thomas of Cantimpré's third book of the *De Naturis Rerum*, "De Monstruosis Hominibus." The poem survives in a single beautifully illustrated manuscript in the Bibliothèque Nationale, Paris.[68] We know from internal evidence that the poem was composed by the Clerk of Enghien about 1290, and the first miniature shows a man in clerical garb reading aloud; this is possibly the author, though such portraits were conventional. Of this Clerk we know nothing except that he was a well-traveled man with

a taste for secular literature and a keen eye for contemporary aristo-
cratic life. He names six French and German wines, makes reference
to the Papal Curia, to regions in France and Belgium, and to chivalric
customs such as the crying of "merci" by a vanquished knight in sin-
gle combat. Among the books he alludes to are the *Roman de Carité*,
written in the previous century by Renclus de Moiliens, the *Roman
de Renart*, and the *Ysopet*, perhaps of Lyons, whose social and topi-
cal allegory and custom of applying a contemporary *moralitas* to sec-
ular stories of animals strongly influenced the Clerk in his own liter-
ary practice. He was, moreover, skilled in the rhetorical practice of
his age and a storyteller of above-average ability.

That he wrote for a secular and probably aristocratic audience is
suggested both by the manuscript and by the nature of the work it-
self. Luxuriously done, the volume must have appealed to the collec-
tor or bibliophile for there are forty-nine miniatures, with illumin-
ated capitals in colored frames and gilded paragraph markings.[69]
More telling, however, is the author's idea of excerpting the mon-
strous races from an encyclopedia to make a separate book of won-
ders in verse, which would appeal to an after-dinner audience. His
frequent use of the word "marvel" and his many appeals to the audi-
ence, of the "listen to me, lords and ladies" variety, show him to be
familiar with vernacular romances containing monstrous races, such
as the *Roman de toute chivalrie* of Thomas of Kent—the source of
Kyng Alisaunder—and with the techniques of minstrel recitation.[70]

His version follows the order of the original, but is greatly embel-
lished. He adds new details and even races, such as men whose
lower bodies are those of dogs, and heightens or dramatizes his ma-
terial, making the races uglier and more monstrous than Pliny ever
did.[71] At many points in the text where the original is bland or neu-
tral, the Clerk of Enghien's version is designed to inspire fear and
loathing in the audience. Thomas had said of the Antipodes that
"there are men who have the soles of their feet transposed."[72] In the
hands of the French translator this innocuous race takes on a new
character:

> There are yet other men here
>
> Who have the soles of the feet transposed,
> Who are terrifyingly ugly to see
> As you can imagine.
> Thus I wish to describe them to you.
> A vile, low people they are
> And vile and evil their law and customs,
> For there is no accord between them,

And there are battles between them every day
And thus one kills the other
Without one crying to the other 'merci'!
(ll. 453, 455–468)

Though the Clerk does not pursue the etymological method of his predecessors, he shows himself quite aware of the meaning of *monstra* and perhaps more than any of the other homilists we have examined keeps the derivation *monstra ex monstrando* in mind, as he continually shows us that the races reveal some aspect of God's plan. "God has made nothing in vain," he exclaims, "nor without reason" (l. 13). The one-eyed Arimaspians are this way because "nature lets nothing go in vain" (l. 727), and their single eye is useful to them. Of wild men, tall and hairy as pigs, he asks, "Why are they so ugly and horrible? As one finds in the Bible [he alludes to Isaiah 45:18] God makes nothing in vain, and we ought to be very pleased to know that he made us handsome beyond all other creatures, according to his image" (ll. 1031–1038). The monstrous races have what the Clerk calls "high significance" (l. 27), and one of his aims is to extract this significance for the reader.[73] Thus he presents his races with remarks like "It would be best for us to do as well, / I think, as do these Ydriien" (ll. 151–152), or "For such men signify to you" (l. 557). He sees himself in this role as following in the footsteps of Aesop, who also added morals to little tales, and indeed at the conclusion of the poem he sums up what he has done: "I have made this book in a tale after the fashion of the fables of the *Ysopet*" (ll. 1754–1755).

Many of his moralizations, like those of Aesop, are directed at contemporary vices and secular figures. The Epiphagi, a form of the Blemmyae, are first established as very ugly—"You don't see any gentle or beautiful forms there!" says the French translator—and then compared in their physical ugliness to the moral ugliness of grasping and venal lawyers: "Are there any people like this in our own land? Yes, and you need not search further for them. What are they? Why they are lawyers . . . who have their mouths in their bellies" (ll. 828, 831–833, 842). Similarly, Giants are described and compared to contemporary men: "For the nature of this race, I wish to lead you now to the present; these are some great earthly lords" (ll. 265–267).

Two themes that especially interest the Clerk of Enghien are sexual morality and the position of women in the medieval hierarchy. Bearded ladies with clothes made of animal hides are related to women of the author's age. "I don't want to forget," he says, "certain women of whom I have spoken before in my treatise. But I don't

know if by sin they were first thus conceived. They have great and extended beards, long and large right down to the waist. An ugly thing it is, so God me save" (ll. 929–936). This deformity is made a figure for the inversion of the accepted relationship between the sexes, for the Clerk points out that one does not have a beard without boldness, and women ought to be meek. "Boldly keep your wives, that their beards do not descend to their waists. Women ought not to be bold. They have no beards and don't you doubt it a bit. A bold woman is against nature, for a woman ought not to have a beard either by law or by natural reason" (ll. 947–956).

Thomas of Cantimpré in his prologue to Book 3 tells the story of St. Antony's meeting with a strange creature in the desert, called an Onocentaur—the issue of an "adulterous mingling" of man and animal.[74] The Clerk is fascinated by the moral implications of Thomas' word "adulterous" and constructs not only a suitable habitat and qualities for the Onocentaur but an additional race living near it and proceeding from the same mixture of man and animal. "True it is . . . what others witness and say, that in the eastern parts are men horrible, vile, villainous, and bad, who do not dwell in towns but in deserts and mountains. They have very strange faces and are men above the waist but animals in many strange ways below. Cruel, bad, stinking, and fierce, they come from adultery" (ll. 32–43). Apparently the author sees in the bestial half of these creatures a form of species corruption brought upon them as punishment for their sins. The verbal similarity between adultery and adulteration may have led him to believe that the one was an appropriate reward for the other. Bearing this out are the neighbors of the above tribes, "inverted" Cynocephali, whose nature develops from the imaginative implications of their sexual crime. "Similarly," he says, "there are men in this land, according to what I have heard, who keep no faith or measure toward their wives; they leave their filth like mute beasts. They are men toward the head and mad dogs below the loins, they are so corrupted by sin" (ll. 47–54).

The Clerk's fascination with adultery continues for another hundred lines or so into his treatment of the Amazons. This traditionally admirable race is still able to provide him with a *moralitas* based upon sexual evils:

> Others ought to act as do the Amazons:
> fine ladies, maidens
> who are often married to bad and notorious men.
> When such women suffer their villainous,
> malign, and crazed words,
> they ought to interdict them here

> like the Amazons, who by their noble natures
> Show you they have never practiced adultery;
> thus they engender nobly
> if the philosopher does not lie.
> For a woman has no more precious thing
> to guard then her body, which
> she ought to make a gem.
> (ll. 89–102)

Fine ladies morganatically joined to evil men are the stuff that medieval romances are made of. It should not, therefore, surprise us if the Clerk of Enghien picks out this sort of *moralitas* to "allure the ears" of his aristocratic audience.

The contemporary and secular flavor of this poem should by now be evident. While offering to its readers all the moral warnings associated with the original sense of *monstrum,* it is also filled with lively descriptions of peoples who are "monstrous" in a newer sense—monstrous because they are strange and marvelous, objects of wonder regardless of what they may portend. And though they are often seen as figures for Christian virtues, their use as exempla for vices is beginning to add yet another overtone to the adjective "monstrous."

This poem, one of the most interesting treatments of Pliny's races, sums up the uses of the word *monstrum* that we have traced from antiquity to the Middle Ages. Partly because of the skill of its author, it has infused traditional prodigy material with the vigor of romance and marvels literature to produce a uniquely medieval approach to *monstra*—pious, eager to uncover God's meaning in the book of nature, and frankly curious about the alien races who make up part of it. The attitude is well expressed by the Clerk of Enghien in his prologue:

> Because of the most noble matter
> which ever was or will be
> it is my pleasure to limn and uncover
> a subject that serves as an example
> after the nature of men living today.
>
> In foreign nations they are not a bit
> like they are here. You know
> truly that the Oriental is quite otherwise than we are.
> (ll. 1–11)

7 Exotic Peoples in Manuscript Illustration

Treatments of the Plinian races in art mirror the decline of the moralizing impulse found in late medieval culture. Their presentation in book illustration, for example, develops from crude and rigid treatments in the early encyclopedias and in the bestiaries, where they were subordinated to moral ends; it becomes more naturalistic and fanciful in the ornately illustrated works on travel and wonders of the East so popular in the fifteenth century, when the fabulous races serve as a pastime for wealthy bibliophiles and armchair travelers. This change reflects not only the broadening effect upon the European consciousness of exotic travel—the Crusades, the merchant voyages, the papal embassies and pilgrimages that become so important a part of the imaginative life of the period—but also an increasing interest in naturalistic observation for its own sake, freed from moral judgment and showing a fascination with human diversity.

Obviously these developments in the artistic presentation of the Plinian races do not occur in isolation from the mainstream of medieval art. In the later views of the exotic races, in landscapes graced by perspective, and in costumes touched by aristocratic fashion, there are certain familiar changes which have been noted by historians of medieval art. And of course the narrative development that marks picture cycles of a religious nature applies to our subject as well. Yet the peculiar fascination that these races of men had for the medieval mind also affected their visual depiction, and shifting attitudes toward them are reflected in their iconography.

Early artistic treatments of the races show their essentially Plinian

origins in the West, for the *Natural History*—though it located monstrous men in specific countries and habitats—did not so much make them objects of exotic travel as objects of moral reflection and members of scientific categories. The point of view that develops from Pliny's way of treating the Astomi or Panotii or Pygmies isolates these races from one another; they exist in the abstraction of the list rather than in a definite geographic space. Moreover, Pliny's abridger, Solinus, concentrated on the marvelous or awe-inspiring quality of each race at the expense of its geographic context, and by the eleventh century, when illustrated encyclopedias such as the Monte Cassino Rhabanus Maurus codex make their appearance, the separation of the monstrous races from true geographic and naturalistic space is complete.[1]

Typically, in what might be termed "scientific" and "moralizing" treatments of the races in medieval art, we find them enclosed in a series of frames, or registers, each race independent of the others and isolated by the borders of the frame within which it rests, in a pose that is usually frontal and static. In short, although these portions of the encyclopedias often bear the rubric "Concerning Monstrous Men of India or Africa," we seldom see the races conceived in a landscape, African or otherwise, or engaging in social acts or contacts. They are presented by the artist neutrally, as an illustration of the text, and there is little sense that the artist thought of them as residents of a land to which the viewer might possibly travel.

The illustrations of the Sion College and Westminster bestiaries are instructive (Figures 2 and 35).[2] In the former, four races are held rigidly on each page, separated from each other and from the rest of the page by strongly drawn registers of an artificial and stylized type. The rubrics outside the framed areas identify and characterize the races in an impersonal and objective way as they float in a free space, not greatly separated from each other, yet not touching. In the latter, the races are arranged in rows without borders. Possibly the illustrator who first developed the pattern for these bestiary illustrations had seen the pictures of the monstrous races in the Rhabanus Maurus codex at Monte Cassino, where the races are arranged in ladderlike registers, four or five in a row (Figure 36).[3]

The English bestiaries do not show great freedom or imagination on the part of the artist, and the pictures suggest that the illustrators were performing a routine function. In this they are typical of bestiary illustrators generally. The mentality that produced this genre was essentially that of the cataloger and moralist, to whom no one animal was of greater significance than another.[4] Though there is, ad-

36. Monstrous races. Rhabanus Maurus, *De Universo*, Monte Cassino MS 132, fol. 166, eleventh century.

mittedly, a good deal of variation in the way the figures are placed or clothed, the correspondence between text and picture is fairly rigid. Striving primarily to illustrate the text, the artist does not act as a creator himself and does not interpret his text to any great degree. Perhaps the exception here might be the contrast in size between the Pygmy and the Giant—suggested by the text of Isidore—in the Westminster page, where the artist has whimsically created a striking opposition between the two main figures. Overall, perhaps the greatest degree of artistic freedom evident in the treatment of the monstrous races in the bestiaries is the borrowing of a detail used successfully to portray one race, and its adaptation to the rendering of another. Thus, in the Sion College page, we see that the limb in the mouth of the Anthropophagus is borrowed to illustrate a like quality of the race in the adjoining register.

When we contrast these illustrations, however, with those in the nearly contemporary but far less moralizing illustrated encyclopedias of the late thirteenth century, we see some interesting responses to the text by imaginative illustrators. To some degree the differing milieux from which the two sorts of manuscripts come make comparisons inexact. It is likely that the later encyclopedias, because of their secular audience, were the products of scribes and artists commissioned by wealthy men, and that the bestiaries had a more specifically clerical or monastic origin. In the illustrated encyclopedias, the painter often is more responsible for the presentation of the race than is the compiler of the text. An example of the encyclopedic form of presentation is the De Naturis Rerum of Thomas of Cantimpré in the Valenciennes Municipal Library, MS 320, from the last quarter of the thirteenth century.[5] The opening miniatures of the cycle of illustrations for Book 3, "De Monstruosis Hominibus" (Figure 1), show two races, the Gymnosophisti or naked wise men and the Amazons, who differ more in social customs than in physical appearance from Western Europeans. Although the text tells us a good deal about the nakedness of the Gymnosophisti and the reasons for this particular feature of their ascetic way of life, they are, remarkably, shown clothed. On the other hand, the text says nothing at all about the clothing of the Amazons. Yet the illustrator, while showing some of the other monstrous men in Book 3 naked, chooses to dignify with rich apparel the Gymnosophisti and the Amazons. Fine clothing, which was associated with social status and wealth, apparently fulfilled this artist's idea of what warlike women and ascetic sages should possess, even though by presenting the latter clothed he was contradicting his text.

In this manuscript, moreover, which was a product of a commercial scriptorium and obviously intended for an owner of wealth and taste, the artist has given a certain emotive cast to the races, rendering his responses to them—or what he took to be the responses of his age. The miniatures for Book 3 are graceful and elegant; certainly there is no sense that the artist wished to inspire fear or disgust in the beholder. Though no other race receives the preferential treatment of the Gymnosophisti or the Amazons, all are depicted as essentially human and acceptable to a western European consciousness.

The draughtsmanship is anatomical, measured, and impersonal, with little attempt to make the races physically contorted or bizarre, and most of their poses are melancholy or thoughtful. Costume and weapons are frequently anachronistic. The beautiful women with silver swords wear contemporary chain mail, as does the figure of Colossus, who ends the sequence of pictures for Book 3. The club, which often symbolizes the savage or uncivilized nature of the races, is used by this illustrator only once, as the weapon with which the Pygmies fight their traditional foe, the cranes. Even the hairstyles, such as the fashionably waved locks of the hairy wild men, show the artist's fondness for aristocratic decor and his general concern to make his subjects acceptable to his audience. He uses nakedness only when an anatomical anomaly cannot be shown on a clothed figure. In spite of the artist's original touches, however, the general impression of the page is relatively static, and since the pictures are interspersed with Thomas' serial rubrication—"in another place are found"—they cannot be said to exist for themselves.

The later illustrated encyclopedias, if we can generalize from the fairly typical manuscript of Valenciennes,[6] seem to have developed the independence of the artists and allowed them considerable latitude in interpreting traditional material. Most artists nonetheless were still bound to the texts they were illustrating, with the exception, however, of the creators of marginalia, whose imaginative renditions of monstrous men showed a different kind of artistic freedom.

Lilian Randall has so well described the genesis and the development of marginal illustration in the Gothic period that there is no need to review familiar material.[7] What we can learn from surviving representations of the races in marginalia is that, in a setting where fancy and imagination were given free reign, the exotic races still appear in recognizable and traditional form. Of all the Plinian races, the Sciopod and Blemmyae were the ones most commonly drawn.

37. Sciopod. Church of Anzy-le-Duc, Burgundy, 1150.

Sciopods, because they are so striking to the eye and the mind, seem to have been a popular subject for representation; they appear not only in manuscript marginalia, but in important sculptural programs at Sens, Lixy, and St. Parize-le-Châtel.[8] One especially acrobatic specimen is associated with a flame-haired demon at Anzy-le-Duc (Figure 37). A good example occurs in an initial in a charming work on natural history by Heinrich von Schüttenhofen, dating from 1299,

EXOTIC PEOPLES IN MANUSCRIPT ILLUSTRATION

38. Initial *U* with monstrous men. Heinrich von Schüttenhofen, *De Naturis Animalium*, Vienna, National Library MS 1599, fol. 2v, 1299.

in which a Sciopod and a Blemmyae lurk in the shaft of the letter *U* and have not been fully released into the margin (Figure 38).[9] Another occurs in a psalter by Leonardo d'Fieschi (northern French), dating from the same period and now in the Walters Art Gallery (Figure 39).[10] Here the Sciopod is somewhat more detached from the initial and remains anchored at the border of the text. The illustrator's conception of the Sciopod as female was undoubtedly influenced by the fish-tailed female Sirens so common in marginalia.[11] Certainly the traditional resting pose of the Sciopod makes it fit well within the shape of an initial, because its very nature militates against its being free-standing in the manner of other races.

Otto Pächt has pointed out with reference to Anglo-Norman illus-

39. Sciopod. Psalter of Leonardo d'Fieschi, Baltimore. Walters Art Gallery MS 45, fol. 92, northern France, thirteenth century.

tration that "the human figure, single or in scenes, had hardly ever been granted its own living-space . . . it had taken refuge in the . . . ornamental growth of initials."[12] Pächt's observation also holds true for these early representations of the races in marginalia. Tightly controlled by their interlace with the initial and, in the case of the Sciopod, requiring the foliage of the initial as a perch, the races in

40a. Blemmyae. Psalter, Duke of Rutland Collection, Belvoir Castle, fol. 57, English, 1250.

this sort of art are visually tied to the illuminated letter. But more than this, their very presence on the page is dependent upon the presence of other decoration. Exotic creatures in decorative schemes do not need to have a separate "outside" existence or to be mentioned in the text, but owe their places to artistic convention. Even when removed to some distance from the other decorative elements, as in a *bas de page*, such figures are basically extensions of the ornamentation.

The Rutland psalter, an English manuscript from the Duke of Rutland's collection in Belvoir Castle, offers a series of these *bas de pages* in which the drawing is not structurally related to the margin, though it appears at the same point in relation to the left-hand initial

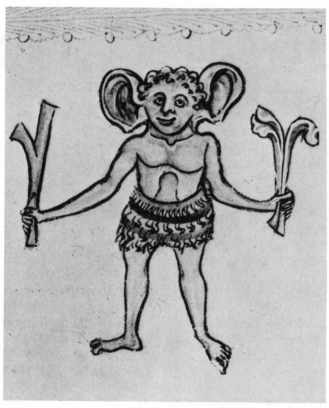

40b. Panotii. Psalter, Duke of Rutland Collection, Belvoir Castle, fol. 88v (b), English, 1250.

border.[13] In one, a Blemmyae and a Panotii (Figures 40a and 40b) carrying crossbow and club appeal to a realistic taste. They may have been borrowed from a manuscript containing an entire cycle of the races similar to those of the English bestiaries.

Because the figures in marginalia are independent of the text, they give the artist considerable scope to express his fancy. This may explain the sex change of the Sciopod, the exaggeration of a single feature to the point of caricature, and the general heightening of dramatic impact upon the beholder. Indeed, the Rutland figures convey a personal blend of the artist's unconscious aggression, fear of the villein, and fascination with polymorphism. It was perhaps of just such artists that the author of the early thirteenth-century treatise *Pictor in Carmine* spoke when he wished for properly typological

subjects to adorn the walls of churches instead of "headless men grinning."[14]

A concomitant of the increased interest in the creatures that inhabit the Romanesque artistic imagination is a new sense of discovery of landscape and scenery.[15] Besides illustrated travel books, two of the main sources of representations of the natural world for medieval men were herbals and manuscripts describing the labors of the months. Early herbal painters had shown only the parts of the plant useful to the pharmacologist, the leaves and the stem, just as early painters of the races had ventured little beyond the anatomical peculiarities of their subjects.[16] By the end of the Romanesque period, however, we begin to find plants conceived of in settings, often of a narrative type, as in a scene of a mandrake collector from the *Tacuinum Sanitatis* or table of health (c. 1390) in Vienna (Figure 41).[17] Here the mandrake appears in a landscape filled by plants, animals, and men; one need only compare it to a similar scene in the Monte Cassino codex (fol. 473) to see the differences in the awareness of landscape. Similarly, illustrations of the labors of the months move from simple stylized representations of the labor to portrayals in a context of landscape and scenery.[18] The *Très Riches Heures,* with its magnificent scenes involving the minutely observed agricultural countryside of France, is a late example.[19]

In works of travel whose illustrations draw on this developing awareness of landscape and scenery, we can chart the emergence of the monstrous races into a geographic setting of their own, which replaces the blank frames allotted them in moralizing works.[20] Crusade and pilgrimage narratives had helped create the *persona* of the traveler, so well represented in English by the narrator of *Mandeville's Travels.* So, too, the missionary and merchant voyager had acquired an iconography in the works of Oderic and Marco Polo. Several cultural developments helped encourage this new breed of traveler, who was a curious observer. One such was the nominalism of the later Middle Ages which stressed that seeing and touching the world were ways to know it.[21] Another was the nascent scientific curiosity of the age, drawing voyagers toward the men, animals, and plants of remote lands.[22] Deeply rooted in Christian thought, the metaphor of man as *homo viator*[23] became part of the medieval consciousness.[24] And John Mandeville observed of his own countrymen that they were destined by their stars to travel. In contrast to people who live under Saturn and accordingly have no desire to leave home, Englishmen in the seventh climate, that of the moon, are natural voyagers, since this astronomical body "is swiftly and easily moving and

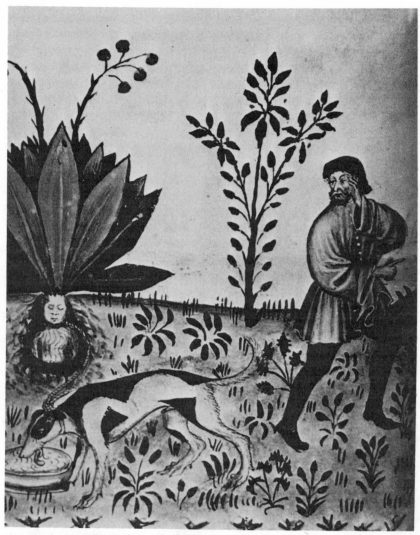

41. Mandrake gathering. Tacuinum Sanitatis, Vienna, National Library MS 2644, fol. 40, fourteenth century.

the planet of freedom and passage. And for that reason it gives us a natural desire to move swiftly and to go on various roads and to seek exotic things and other diversities in the world."[25]

Visits to the exotic shores and distant shrines that Chaucer's Wife of Bath loved so well are also, I believe, responsible for some of the changes in the way the monstrous races were represented in medie-

val art. Visitors to the Holy Land and to the shrines and famous churches along the way satisfied a secular restlessness and love of movement as well as a spiritual longing for wonders and marvels.[26] Burchard of Mount Sion (c. 1280) justifies this wanderlust by patristic authority: "Saint Jerome tells us that we read in ancient histories about men who visited countries and crossed seas to the end that they might behold with their eyes the things whereof they had read in books." He then mentions Apollonius, who supposedly sought the Gymnosophisti in India, and concludes, "What wonder, then, if Christians long to behold and visit the land whereof all Christ's Churches tell us?" He promises that, from his own experience and from information obtained from Saracens and Syrians, he will satisfy his countrymen's "desire to picture to their minds those things which they are not able to behold with their eyes."[27]

Though pilgrim narratives tend to be practical, offering the names of suitable hostels and inns and of Venetian sea captains with whom to strike a good bargain, on occasion they show a certain ethnological interest.[28] Indeed, later itineraries often show a marked ethnocentrism. An anonymous French author writing in 1480 observed of the various kinds of Christians who shared the right of visitation at the Holy Sepulcher, "The fifth are called Indians and are very black and deformed men."[29] To my knowledge, other than the travels of John Mandeville the most striking blend of the pilgrim itinerary with the wonders of the East is found in the *Itinerary* of John Witte of Hese, a priest of Utrecht who, setting out for Jerusalem in 1389, went as far as Purgatory and the walls of Paradise. In Witte, the Plinian races become part of the sights around the Holy Land. For example, after leaving the desert of Sinai and the holy places in Egypt, John goes to Ethiopia: "Sailing further we came to the Pygmies who are small men . . . and they are deformed and do not build houses but live in mountain caverns and caves . . . nor do they eat bread but rather herbs of various kinds and milkfoods, as do beasts."[30] He continues his travels beyond Ethiopia and goes to the land of the Cyclopes or "Monoculi," an aquatic people who, he says, swim under water to attack ships and gather fish. "The aforesaid Monoculi are short, fat, and strong, and they eat other men and have one eye in the forehead shining in the manner of a carbuncle and they work always at night" (p. 183). Finally, John reaches the land of Gog and Magog in the Caucasus, where "there are marvelously constructed men who have two faces on one head, one at the rear and the other at the front" (p. 193). He then sails back to his starting point. Presumably this kind of material was of an interest equal to the more sober accounts giving the dimensions of the Church of the Holy Sepulcher.

Pilgrims and other travelers reacted personally to the cultural oddities they encountered, and were often repulsed by a people's physical appearance, dietary habits, or religious practices. Just as they colored their narratives upon their return to express these strong feelings, so we find that the illustrators added many a hostile and dramatic thrust to their pictures of the races in the travel books. Undoubtedly, some of this drama was the result of the considerable amount of action in the miniatures, which frequently show the races doing things to each other or to travelers. The approach of travel literature to the exotic races is thus different from that of other works in that it takes as its subject not the races themselves, but their relationship to people of the West.

Such relationships are, not surprisingly, antagonistic in the illustrated Alexander manuscripts, where the Macedonian conqueror meets and fights with some of the more horrible and aggressive of the Indian races—who soon become part of the standard Plinian catalog. Their unusual physical appearance is heightened by the artist's stress on teeth, bristles, claws, flaming breath, and the like.[31]

In a group of Anglo-Saxon illustrated manuscripts depicting the wonders of the East, we find that this Alexander material, with its stress on the horrific, overshadows the more innocuous traditional Plinian races. Only half of the eighteen distinct races illustrated are Plinian, while the other half are of a type far more dramatic. We are concerned here with an illustrated Anglo-Saxon translation of a Latin *Mirabilia* text and a similar translation of the *Epistola Alexandri* bound with *Beowulf* and other items in Cotton Vitellius A.xv. The same material exists in two other English manuscripts, Tiberius B.v and Bodleian 614, the former a vernacular copy of Vitellius, and the latter a Latin text with pictures. The Cotton manuscript dates from the year 1000; its miniatures come from an earlier cycle of superior quality. Tiberius (from 1050) and Bodleian 614 (from the early twelfth century) are in their illustration programs much more closely related to each other than to Vitellius.[32]

One of the most important characteristics of the Anglo-Saxon Wonders texts and their illustrations is that the races are seen in some sort of relationship to the viewer, rather than in the isolation of an empty frame. In the *Mirabilia* manuscript, we find a tricolored race, lion-headed and twenty feet long; when one pursues these people they quickly flee, sweating blood as they go. Both the text and the accompanying miniature perceive this race only in its relation to Western man, since its identifying behavior—running away and sweating blood—posits a foreign beholder. The *Mirabilia* text also

speaks of a race of man-eaters twelve feet high and seven feet wide, who live in the river Brixon. They are all black "and we call them the enemy." Other monsters called Homo Dubii flee quickly when they see foreigners. Another race is described as bad, bearded, and barbaric. Still other people called Donestre are deformed from head to belly, but the rest of the body is like that of a man. Speaking the tongues of all nations, the Donestre flatter, snare, and eat travelers. Finally, members of a variant form of the Gymnosophisti are benign and will give their wives to travelers.

The fictive genesis of the *Mirabilia* literature is that of a letter sent from a traveler in lands of Eastern wonders back to a powerful figure in the West who commissioned the trip or requested ethnographic information. Thus, the texts associated with the name of Hadrian play on the idea of the writer as an emissary sent to collect specimens of unusual animals and men to satisfy the curiosity of the emperor and the Roman populace.

A variant of this genre offering lengthy narrative development is the "Letter of Alexander to Aristotle," in which an observer reports on the races, rarely sympathetically. The text gains a certain narrative immediacy from the fact that Alexander says he is taking time out from battles to write the letter, and from phrases like "Then *we saw* women and men hairy in the manner of beasts ... who, when *we wished* to approach nearer, threw themselves in the water of the river."[33] Not only does the narrator react to the hairy men and women, but they react to him as well by taking flight or hiding—and well they might. A rubric for a miniature in a French Alexander romance describes the event presented in the miniature: "How Alexander found a wild man and had him burned because he lacked reason and was thus like a beast."[34] A naked hairy bearded giant is shown tied to a stake and held in the fire by a man with a forked stick while Alexander and his retinue watch. In some cases, the races in the *Epistola Alexandri* are hostile, giving a certain logic to the military contacts of romances like that in Harley 4979. "Then we found a wood full of enormous Cynocephali, who, trying to provoke us, fled, shooting arrows" (p. 33).

The naturalist's voice joins that of the colonialist, when of a certain race Alexander says, "We took two of them, of the color of snow, similar to nymphs" (p. 57). This attitude has its analogue in Harley 4979, which describes Alexander fording a river with his army and coming to an island to find a golden people, six feet tall, headless, with eyes and mouth on their chests, and beards reaching from the groin to the knee (though the miniature on the leaf facing

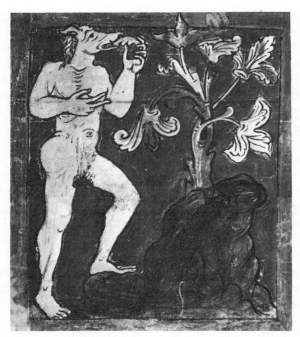

42. Cynocephalus. London, British Library MS Cotton Tiberius B.v, fol. 80a.

shows these beards stopping well short of their genitals). Alexander took thirty of these Blemmyae with him to present these wonders to other Westerners (fol. 73).

The Latin "Letter of Fermes to the Emperor Adrian" has equally elaborate descriptions of the races seen by the traveler *persona*. Here the literary device of compiling wonders for the delectation and instruction of the emperor is most noticeable at the end of the work, where the author is purposely dramatic in his attempts to convey to the reader the fear and awe inspired by the races. Thus, the Cynocephali "have the manes of horses, most powerful and immense teeth, and breathe flames."[35] As in the Alexander letter, the speaker easily assumes the *persona* of the collector; speaking of boar-toothed, hairy women he says, "I had a desire to seize them and bring them alive to Rome" (p. 513). But in this case the monstrous people are not passive; they kill several armed knights and fight for a long time (p. 513). And the Panotii flee from the author and his men in a way designed to establish a relationship. "When they saw our men they spread their ear flaps, so that you might imagine them to fly with them" (p. 514). Such a remark suggests that the Panotii found Westerners as peculiar in appearance as the All-Ears were found to be by the narrator.

43. Lion-headed man. London, British Library MS Cotton Tiberius B.v, fol. 81b.

The key texts developing the traveler's mentality dramatize the monstrous races, making them as grotesque and horrible as possible. The Cynocephali have horses' manes and fearsome tusks; they breathe fire and flame. The Icthiophagi are six feet tall and grow beards to the knees and hair to the heels. A race living in the Brixon is fifteen feet tall and has red knees and black hair. Given this raw material, it is understandable that the artists who illustrated the *Mirabilia* texts should feel inclined to heighten the dramatic qualities of their subject as much as possible.

Accordingly, there are certain characteristics that the miniatures in the travel books share, though as a group the works are very diverse and range in time over some four hundred years. Typically, the painters present a group of races crowded into a landscape; in the earliest examples, a mountain or hill stands for the landscape. In the later works, the painters revel in the newly acquired knowledge of perspective and tend to glorify plenitude; the sheer quantity of the wonders is as important as their marvelous nature.

For example, in the Anglo-Saxon Tiberius manuscript, a Cynocephalus is shown walking, or mounted upon, a wild crag (Figure 42). In the same manuscript, the lion-headed man twenty feet tall has rocks in the background of his picture (Figure 43), and the Blemmyae

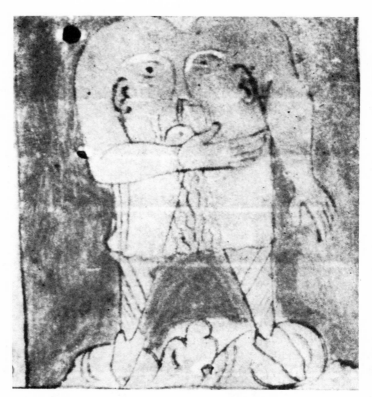

44. Blemmyae. Marvels of the East, London, British Library MS Cotton Vitellius
A.xv, fol. 102b, 1000.

in the *Beowulf* codex is mounted upon small rocks (Figure 44). The
Tiberius illustrator also placed his Donestre upon a mountain (Figure
8), as he did his Panotii, honey-eaters, bearded huntresses, Ethiopi-
ans, and camel-footed and hairy women. Such features of the land-
scape are too common, especially in the Tiberius miniatures, to be
merely accidental or of a purely ornamental significance.

The races, in acquiring a landscape of their own, have acquired a
more distinct relationship to the travelers who view them, for the
landscape with which they are typically associated—one of moun-
tains and hills—had moral connotations for medieval Westerners.
Generally speaking, monstrous men were placed on mountains be-
cause these features of the landscape, as Marjorie Hope Nicolson has
well shown, were considered hostile and frightening.[36] In Hayden
White's words, "desert, forest, jungle, and mountains" serve as "the
physical stages" on which the western European consciousness

could act out fantasies of wildness and savagery.[37] Thus these places, and especially mountains, inspired great fear and distaste in medieval men. John of Salisbury referred to the Great Saint Bernard as a "place of torment"[38] and when Adam of Usk crossed the Saint Gotthard Pass in 1402, he had himself carried on a litter and was blindfolded to allay his terror.[39]

There are numerous classical and biblical precedents for this attitude toward mountains. Greek, and later Roman, fondness for the mean and for landscape that showed the influence of art over nature tended to make mountains unattractive for aesthetic reasons, whereas the New Testament followed Isaiah 13 in the belief that topographical height was associated with pride and Satan. The midrash went so far as to suggest that mountains came into existence from human depravity. And it was a rabbinical commonplace that mountains were the earth's punishment for the sin of Adam: "Thenceforth she was to be divided into valleys and mountains."[40]

The above examples are chiefly mythic and metaphoric in nature, but there is in the accounts of actual and literary travelers a close and constant connection between incivility and mountainous and rocky sites. In the *Periplus* of Hanno we learn that

on the high ground ... were Ethiopians who were inhospitable, whose pasture land was infested with wild beasts and shut in by high mountains ... which mountains were occupied by Troglodytes ... Leaving the islands we ... came to ... the lake, above which towered lofty mountains, thronged with savages, clad in skins of beasts; they pelted us with stones, and drove us away.[41]

Later medieval examples of these attitudes include *Beowulf,* in which the Grendel family live in rocky and remote regions, and the ending of *Gawain and the Green Knight,* in which the Green Man, loudly sharpening his ax, waits for Gawain on high crags.

Another work that establishes an important connection between monstrous beings and wild landscapes is the *Liber Monstrorum,* which, because of its eighth-century date and its reflection of "Celtic Irish learning, notions, and attitudes" as well as its use of Alexander material, sheds considerable light upon this aspect of the Anglo-Saxon *Mirabilia* texts.[42] Perhaps the earliest work to give us a markedly and consistently hostile treatment of the monstrous races, the *Liber Monstrorum* springs from the new interest in rhetoric that we associate with the Carolingian revival of learning. The treatise, in three parts, catalogs human monsters, monstrous animals, and serpents. Though some of the creatures are of the traditional Plinian kind, others such as Cacus, Geryon, and the Eumenides are drawn from Greek and Roman fable, mostly through the agency of Virgil.

It may be that the author of the *Liber Monstrorum* had no strong feelings of a theological nature about monstrous races of men, yet his highly rhetorical prose seems to have given later writers and illustrators the impression of a more definite point of view about his subject than he actually possessed. As a consequence, the impact of the *Liber* as a sourcebook for writers and painters wishing to depict the Plinian races may be in large measure a result of their response to the author's involved and ornate style, which conveyed to later users an air of authoritative difficulty and antiquity.[43]

The *Liber* catalogs thirteen different creatures from the late antique Alexander legends, mostly by way of the "Letter of Alexander to Aristotle" and the *Mirabilia* texts. The author also uses certain polymorphic and dangerous monsters of classical fable, such as the Chimera and Gorgon. Naturally the Oriental and classical wonders, since they are in most cases inimical to man in the original sources, are easily adapted to figure in hostile or frightening contexts in the *Liber Monstrorum*, and they come bringing with them a topographical context that heightens their ability to induce fear.

The author's topographical interest shows that to him a monstrous being is inseparable from a certain kind of landscape. The fiction with which he begins the work—that his treatise is written to answer certain questions posed by an unnamed patron—allows him to catalog such landscapes.

You have asked about the hidden parts of the earth and if truly there were as many species of monstrous beings as had been reported in the hidden corners of the earth, beyond the deserts, and islands of Ocean and in the remote hiding places of the furthest mountains. You have desired me specifically to speak of the three earthly genera that strike mankind with the maximum awe and terror. That is, the monstrous progeny of men, the numerous hideous beasts and the hideous species of dragons, snakes and vipers.[44]

In an elaborate metaphor he notes that the patron's questions have cast him like a sailor from the fantail of a ship down to the beasts of the sea, and he compares the subject of his treatise to a dark and stormy sea. Thus landscape and violent seascape are important in his conception both of monstrosity and of the emotions it engenders.

The author believes that since the repopulation of the earth by the sons of Noah there are far fewer monsters; fortunately for mankind, in most parts of the earth they have altogether disappeared. Not surprisingly, the verbs he uses in the prologue to indicate this disappearance and to create the rhetorical mood—*eradicata, subversa, revulsa* (p. 38)—suggest the same violence and disorder that his topographical images had produced.

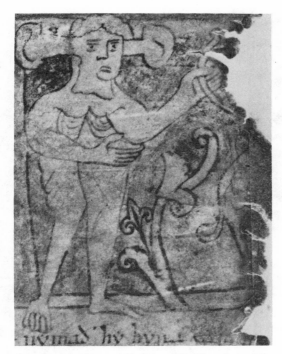

45. Panotii. London, British Library MS Cotton Vitellius A.xv, fol. 104a.

Leslie Whitbread has claimed that the work makes "no attempt [at] ... theological interpretation," but there is a strong implication from these verbs that a just God wished to eliminate monsters from the world.[45] Even the simplest descriptions of the races in the *Liber Monstrorum* bear out this idea. Traditionally an innocuous people, the author's Pygmies are called *invisum* or hostile, and the six-fingered men of the Alexander legend are called *bellicosissimos* (pp. 40, 54). The Cyclopes are offered in their most grisly guise, feeding on human blood, one holding two men in his giant hand as he eats them raw (p. 46). The Cynocephali are our familiar Dog-Heads, but the author plays down their human characteristics to stress the way they imitate beasts and eat raw meat (p. 50). A monstrous being living near "Oceanus" terrifies sailors by his appearance (p. 58), and a race of Giants living in the Brixon love raw flesh (pp. 58–60). An island in the Red Sea is the habitat of the race appearing in the Fermes texts as Donestre, who pretend to know the languages of travelers only to ensnare them (p. 62).

It is clear that, for the author, where the monstrous beings live has

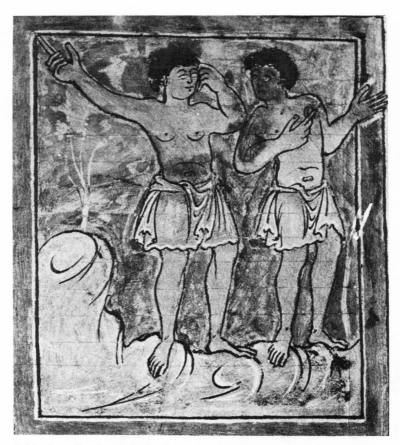

46. Ethiopians. London, British Library MS Cotton Tiberius B.v, fol. 86a.

a definite relationship to their nature, though not a climatic and caus-
ative one. The races in the *Liber Monstrorum* are placed where they
are because of God's providential concern about their danger to
mankind. In addition to their remote mountain habitats, monstrous
races live in swamps, at the bottom of deep pools, in the vast wilder-
nesses of deserts, and in other hiding places at the edges of the world
and in its hidden regions, such as the islands of Ocean. To be sure,
some allowance must be made for the author's dependence on the
distant dwelling places mentioned in his Oriental sources, but still it
seems clear that for rhetorical purposes, or from genuine conviction,
he has gone out of his way to make these beings enemies of mankind
who are deservedly banished from the centers of civilization, and to
make their deviation from the physical norms and customs of medie-

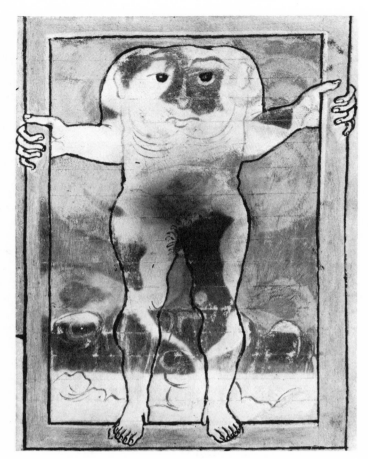

47. Blemmyae. London, British Library MS Cotton Tiberius B.v, fol. 82a.

val people responsible for their exile and their hostility and danger to humans.

The demonic energy that the author of the *Liber* sensed about the monstrous races, making them ever ready to burst into the world of western Europeans, is translated from word to picture in the illustrations for the Anglo-Saxon *Mirabilia* texts. Pächt has spoken of the way in which figures, in the developing native English manuscript art, begin to step slightly out of the registers which contain them, as though they "begin to be ejected from the picture."[46]

By the eleventh century, English illustrators were increasingly using pictures to create feelings of energy and movement. The artists of the Cotton Vitellius and Tiberius manuscripts, influenced by the

dynamism of the races, allow their monstrous men to fill or dominate their frames, either from top to bottom or side to side. In the older manuscript the Panotii has stepped out of his frame (Figure 45). The artist of the Tiberius manuscript has at one point shown an Ethiopian's hand emerging from the picture as though to suggest an energy too great to be contained within the frame (Figure 46); at another point a Blemmyae grasps the frame with both hands as though stretching confining bars (Figure 47). This uneasy relationship of creature to frame suggests that the monstrous men are leaving the borders confining them to the static page and beginning to occupy landscapes; they cannot be contained in isolation, as they were in the miniatures presenting the moralists' point of view.

The last stage in the development we are tracing occurs in miniatures of a complex type that are found in works of exotic travel surveying the regions in which the races dwell. The use of dramatic *personae* such as Marco Polo and John Mandeville are combined with potpourri miniatures that might be called "menu" pictures. The manuscripts that compose this group are for the most part aristocratic and luxurious. Manuscript Fr. 2810 in the Bibliothèque Nationale in Paris, a gift of John the Fearless to the Duke of Berry, contains miniatures depicting the travels of Marco Polo and Mandeville through exotic landscapes. A similar manuscript of Marco Polo, Bodley 264, contains two menu pictures of monstrous races, as do Morgan 461 and its close copy in a private collection at Coulommiers.

In works like Fr. 2810 the character of the traveler is constantly in evidence in the miniatures, much as John appears in the margins of scenes in the illustrated Apocalypse manuscripts. The Boucicaut Master of Fr. 2810 must have been very sensitive to the traveler *persona* and quite familiar with his text and with others like it, if we can judge from the evidence of the miniatures. Though Marco Polo travels through a part of the world not usually associated with the Plinian races, the illustrator inserts them into his miniatures whenever he can. On folio 15v, we see two travelers conversing while a hairy wild man looks at them from a mountain (Figure 48). The rubric reads, "Here Marco Polo explains the nature of this country and tells of its marvels," but the hairy wild man and the mountainous landscape are the artist's own contribution, as are the indicating hands of the traveler.[47] On folio 29v we find a menu picture showing the traditional monsters of Africa and India now inhabiting Siberia, since that is where Marco Polo is going. He, however, had only said of the inhabitants that they were "wild." The artist on the strength of this word fills the wild and mountainous landscape with a Cyclops, a Blemmyae, and a Sciopod (Figure 49).

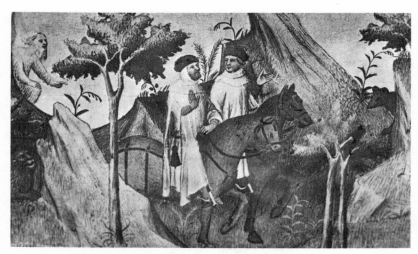

48. Marco Polo depicts wonders. Paris, Bibliothèque Nationale MS Fr. 2810, fol. 15v.

The illustrated Marco Polo bound together with a romance of Alexander in Bodley 264 gives us two examples of the menu picture, folios 260 and 262, where the artist tries to incorporate the main types of monstrous races (Figures 50 and 51).[48] Here the landscape is

49. Men of Siberia. Marco Polo, Paris, Bibliothèque Nationale MS Fr. 2810, fol. 29v.

50. Monstrous races. Marco Polo, Oxford, Bodleian Library MS Bodley 264, fol. 260.

51. Monstrous races. Marco Polo, Oxford, Bodleian Library MS Bodley 264, fol. 262.

52. Adoration of an idol. Marco Polo, Oxford, Bodleian Library MS Bodley 264, fol. 262v.

not mountainous but riverine and the races are in most cases engaged in their characteristic actions. A Blemmyae raises his club against a dragon-like creature while in the foreground a Cyclops regards a club-wielding Sciopod. Their weapons draw the viewer's attention to the Cynocephalus with shield and spear in the upper right. All these creatures are seen with the bodies of hairy wild men; only the faces or the Sciopod's foot indicate differences in identity. The next picture shows races that have come up to the very edges of civilization: a group of knights survey from a castle window a hairy Giant, an Anthropophagus with a limb, and a horned man, perhaps a Troglodyte, who is catching a stag. Undoubtedly the characteristic shield with face that some of these races brandish—it can be seen in the somewhat later Fr. 2810—is designed to identify them with the

53. Mandeville and companion observe wonders. *Mandeville's Travels*, Paris,
Bibliothèque Nationale MS Fr. 2810, fol. 182.

horned idol worshipped in a niche on folio 262v, who carries a shield
and spear similar to those borne by the Dog-Head and the Giant (Fig-
ure 52).

Wittkower has pointed out that the presence of this book in the
same manuscript as a romance of Alexander suggests some direct in-
teraction between the genres of travel book and romance.[49] Ap-
parently the illustrators of a work of travel preferred the fantastic lit-
erary tradition of monstrous races of the Orient to the more sober
rendition of Marco Polo. Thus, the illustrator of Bodley 264 produced
menu pictures containing Pliny's races, with which he was obviously
familiar or for which he had graphic examples. Wittkower has con-
cluded from these borrowings "that illustrations of the romance
could, without any scruples, be transferred into the context of a tra-
veler's report" (p. 169). He observes that there is no reason to think
that a medieval audience regarded the pictures in the Alexander ro-
mance as having a different or lesser degree of veracity than the pic-
tures for the travel text; they were all history (p. 170).

Much of the material in the portion of Fr. 2810 containing *Mande-
ville's Travels* shows that the Boucicaut Master's helpers adapted
ideas that he had already worked out in the early folios. They had,
however, a more developed *persona* to introduce into the pictures.
Mandeville had adopted the role of a pilgrim in his first voyage to the

54. Monstrous races of India. Harent of Antioch, *Livre des merveilles du monde*, New York, Pierpont Morgan Library MS 461, fol. 41v, fifteenth century.

Holy Land and then changed in the second part of the narrative into a curious traveler impelled by primarily secular motives.[50] This is shown by the illustrators, who in the early miniatures give Mandeville and his companions the regalia of pilgrims and a generally pious and humble demeanor. By the time Mandeville is pointing out to his companion the wonders of Ethiopia, a wild and mountainous region (fol. 182), he is wearing worldly dress and has a confident and lordly stance (Figure 53). This picture is simply a reworking of the similar composition in Marco Polo. Similarly, the artists adapt the menu picture from Marco Polo, and, using nearly the same scene in Mandeville (fol. 194v), fill it with four Blemmyae (Figure 17).

The final form of the tradition we have been tracing is the *descriptio mundi* or illustrated travel book. Morgan 461 is one of the most beautifully illustrated of these works and offers some elegant menu pictures containing the monstrous races. Though the tone of the work is rather like that of *Mandeville's Travels*, the book is alphabetically arranged to consider the whole world, including those parts of

55. Monstrous races of India. *Livre des merveilles du monde*, Château d'Aulnoy, Coulommiers (Seine et Marne), Collection Durrieu, fol. 36, c. 1440.

it familiar to western Europeans. In each region, wonders are detailed. The compiler, believed to be Harent of Antioch (who had translated Gervase of Tilbury's *Otia Imperialia,* a work much cited in Morgan 461), offers information useful to the pilgrim traveler, such as names of churches especially hospitable or worth visiting, on folios 79–126. A large proportion of the work consists of categorized *mirabilia* and monstrosities, marvels of water, fish, and plants, and the like, following the order of Bersuire's *Descriptio Mundi.*

Since the miniatures appear at the heads of individual chapters they summarize what is to come and include as many salient details of the chapter as possible. Both illustrator and compiler exhibit a deeply rooted ethnocentrism which makes the perceiving eye in the pictures that of the biased and civilized Westerner. In a discussion of Europe we find the old chestnut about Europeans being handsomer, stronger, taller, and bolder than the men of the south and north (fol. 31). The author assigns this view to Herodotus. That the artist held it as well is shown by the fact that the less unusual a race is in its appearance or description, the more conventionally it is dressed; in India, for instance, both types of Apple-Smellers have normal clothes (Figure 54). The Giants, who are simply ordinary men on a large scale, are aristocratically dressed and form a little group unto themselves. The copy of Morgan 461 at Coulommiers (Figure 55) is

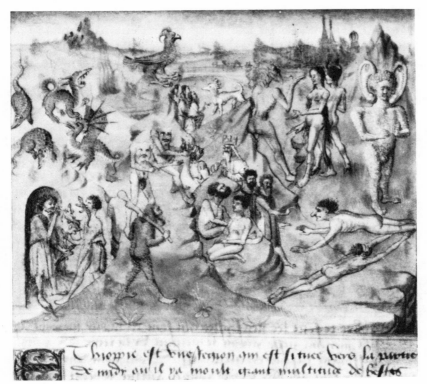

56. Monstrous men of Ethiopia. New York, Pierpont Morgan Library MS 461, fol. 26v.

virtually identical but shows the Giants as somewhat smaller and slightly more outlandish in costume. The miniature depicting Ethiopia, on the other hand, shows mostly hairy men (Figure 56).

Although in this type of collection the *persona* of the traveler is not as well developed as that in Marco Polo and Mandeville, the artist uses similar figures for contrast. In the lower right foreground we see a group of fashionably dressed Westerners who regard the women in suttee and the riverine Icthiophagi. They make gestures that link them with the traveler figures in Fr. 2810. The same group appears with much the same gestures in the Coulommiers copy.

Many changes in fifteenth-century cosmographic thinking have found their way into Morgan 461. There is, for example, a general increase in non-Plinian matter and the compiler makes up new names and more extravagant qualities for some of his races. The familiar Apple-Smellers now have relatives: a group of lovely maidens smell-

ing flowers in a meadow. If they are kept from their favorite smell, they die. The compiler has made considerable use of Oderic of Pordenone's travel narrative and shows us the greater interest in objective geography and anthropology characteristic of the century, paying some attention to the religious practices, customs, and pastimes of real men. He also shows us something of the Renaissance interest in the lives of eminent Romans.

Such pictures of India and Ethiopia are very far indeed from the scenes of the same races depicted in the Westminster and Sion College bestiaries. The artist has come to identify himself with the curious Westerners; together they regard wonders in a landscape that is based on Renaissance laws of perspective and that shows in the background the towers of Heliopolis characteristic of many fifteenth-century miniatures.[51] There is no particularly moral point of view present here, but merely a kind of ethnocentric nationalism. The races do not *signify* anything beyond the pleasure they give to the beholder. These beautiful aristocratic picture books are the high point of the tradition we are tracing; from the 1450s onward the races become increasingly hairy and undifferentiated, lumped together in the person of the hairy wild man of the woods.

8 Monstrous Men as Noble Savages

The literature of Alexander's travels made the peoples of India dramatic and frightening to Westerners; it even tinged with menace some innocuous races in Ethiopia whom medieval readers had already met in Pliny's *Natural History*. The impression, however, that these races engendered only fear and hostility in the Middle Ages would be incomplete and inaccurate. Our subject is so broad that it generated many inconsistencies, as do most long-lived issues in cultural history.

The very Alexander literature that titillated its readers with fire-breathing Cynocephali and hairy Giants presents another and quite contradictory view: certain Eastern peoples were idealized in the role of noble savages and sages whose example might be studied with profit by Western Christians. Other texts contemporary with the Alexander material widen the range of alien races that could be seen as "noble" monsters. Such idealizing treatments of the monstrous races in late medieval writing prefigure in many ways the romantic primitivism of the eighteenth and nineteenth centuries.[1]

As to the causes of this changing attitude toward the Plinian races, it seems likely that more extensive mercantile travel, especially to the East; the Crusades, which put Westerners in contact with a formerly abstract enemy; and the exportation of Christianity to the East by Friar missionaries who saw all nations as potential Christians under one god were contributing factors. Many historical developments come together in the sort of cultural relativism so strikingly expressed in Jacques de Vitry's prologue to his list of Eastern races.

Citing Paul's command in Romans 14 that we avoid judging the od-
dities of other men, Jacques says that

the Cyclopes, who are all one-eyed, should be no less admired than those who
have two or three. And just as we consider Pygmies to be dwarfs, so they con-
sider us giants . . . And in the land of the Giants, who are larger than we are,
we would be considered dwarfs by them. We consider the black Ethiopians of
bad character; among them, however, the one who is blackest is judged most
beautiful.[2]

These changes in attitude were very gradual, of course, and it is dif-
ficult to find many statements similar to this in the thirteenth cen-
tury. Likewise, the conception of the "noble" monster is hardly in the
mainstream of the tradition we have been examining. It is, however,
an interesting development in itself and it adds an important dimen-
sion to our subject, showing the remarkable range of attitudes it was
capable of creating in the medieval consciousness. I do not wish to
overemphasize the role played by romantic primitivism in the grad-
ual inclusion of the monstrous races within the Christian cosmos.
They were not, for the most part, idealized at all, for the European
sense of humanity was too fixed, ethnocentric, and based on biblical
definitions of mankind to allow this. No medieval author I have read
wanted to live as a wild man or an Indian sage, however much these
forms of life might have appealed to men of the Renaissance and
later centuries. Rather, noble savages among the monstrous races
were regarded with salutary reflection and perhaps a certain amount
of awe, but they were kept always at the margins of the European
imagination.

We shall examine four medieval versions of the "noble" monster,
two of which owe their importance to the Alexander literature and
two of which are drawn from other sources. These are, respectively,
the Brahmans, the Amazons, the Ethiopian king Caspar, who devel-
ops from the legend of the Three Magi, and the benevolent Saracen
emir of the Old French poem *Floire et Blanchefleur*. A fifth figure, the
Plinian wild man of the woods, came to be regarded at the end of the
Middle Ages as a kind of noble savage. He appears in Spenser and in
Spanish Golden Age literature as the "Salvage Man" who haunts the
woods, speechless, but driven by good impulses. His development,
however, belongs to later phases of our subject that lie beyond the
scope of this book.[3]

Medieval moralists found the above-named representatives of the
Eastern races exemplary figures whose entire lives lent themselves
to moral comment. Individuals such as the Ethiopian Caspar and the

Saracen emir displayed by their conduct the best qualities of their respective races, which had traditionally been seen as monstrous. Collectively, the Amazons and the Brahmans were significant for their ways of life, which though alien had much to recommend them—discipline and bravery in the first instance, wisdom and asceticism in the second. Treatments of them consistently placed a greater emphasis on their similarities to European Christians than on their dissimilarities, and often concluded that God teaches men by showing us virtuous lives lived in contexts different from our own.

From antiquity onward the West's interest in primitive and alien societies revealed not only a fascination with their eating habits, appearances, and languages (or lack of them), but also a philosophical curiosity about these peoples. Struck by the simplicity of their lives and the apparent absence of most of the cares borne by Western men, observers of the monstrous races often commented favorably upon their directness, their justice toward one another, their unselfishness, and other qualities difficult to attain in a complex society. These virtues of the simple life were the very ones that appealed to the Greco-Roman sensibility in the idea of a Golden Age. Ovid's *Metamorphoses*, for example, had celebrated a distant, pastoral time, when men were innocent of modern vices. The Plinian peoples were distant geographically rather than temporally, but otherwise shared many of the features attributed to men of the Golden Age. They included societies without money or materialism, herdsmen like the Cynocephali, people who lived off the land or were fed from above, people noted for their longevity and good health, and many praised for their justice. It is therefore not surprising to find quite early an idealizing strain in the literature concerning these peoples.

Greek and Roman satirists, adopting the *personae* of simple and virtuous yet barbaric men from remote lands, such as the Scythians and Ethiopians, had often criticized the morals of their age. And travelers from Odysseus to Gulliver have compared their own national characteristics to those of distant peoples. For Agatharcides of Cnidos, who listed races of men according to their diets, the Icthiophagi of Ethiopia were a people of model character, heedless of power, living without external war or internal conflicts and eschewing luxuries of all types.[4] They epitomized the Golden Age. Ctesias' treatment of alien races is similar. The Indians and Pygmies, he notes, have a highly developed sense of law and justice, and the "Cynocephali have a great sense of justice."[5] In his *Indika* can be found the seeds of a romanticized communism: "The richest of the

Cynocephali wear linen clothes, but they are few. They sleep on beds of leaves rather than of cloth and down. The one held for the richest among them has the most sheep; otherwise they have goods in common."[6]

Dionysius' *Periegesis* (c. A.D. 300), in the Latin version by Priscian, passed on to the Latin Middle Ages some of these examples of romantic primitivism derived from the lives of the fabulous races.[7] And Lactantius Placidus, the sixth-century grammarian, looks back to Greek sources in his commentary on the fifth book of Statius' *Thebiad* when he says of the Ethiopians: "Certainly they are revered by the gods because of justice. Even Homer indicates this when he says that Jupiter frequently leaves heaven and feasts with them because of their justice and equity."[8]

The Christian analogue of the Golden Age was the age of prelapsarian innocence. Being more narrowly bounded by the definitions of biblical history it was even less accessible, but it did have a geographic locus, vague though it was, in the East. Toward this Paradise many a travel book and pilgrim narrative carried its readers.[9] No doubt Mandeville's interest in Paradise is reflected in John Witte of Hese, who wrote in his *Itinerary* of coming to the walls of Paradise somewhere beyond Ethiopia. Wherever the terrestrial Paradise might be, it drew its seekers through the traditional haunts of the Plinian races. Small wonder, then, that some of the lost virtues as well should be found among these races.

By the fourth century idealizations of exotic peoples are a standard feature of geographic writing. In the anonymous *Expositio Totius Mundi et Gentium* (c. A.D. 359) the merchant author surveys the economic importance of the Roman Empire, describing among other peoples a Golden Age race clearly modeled on the Bragmanni. These are the Camarines who lived in "the part of the West called Eden by Moses." They are pious and good and have no defect of body or spirit. They eat wild honey, pepper, and manna which rains from heaven, have no fleas or lice, do not sow or reap, and have wonderful stones in their land. They live their lives in great happiness, suffering no illnesses, and know the day they are fated to die. In their social relations they are equally exemplary, knowing no anger, covetousness, or deceit and of course having no law cases.[10] Though the writer cannot place the Camarines before the Fall, he has placed them in Eden and given them a full set of prelapsarian virtues. A variant form of this account occurs in a tenth-century Georgian letter which was attributed to Saint Basil in the Middle Ages; the connections between it and the fictitious correspondence of Alexander to

Aristotle are obvious. Indeed, the letter of Basil to his teacher Evevlos speaks particularly of the Gymnosophists and describes Eden in the northwest where they have their home near Paradise. They, too, live on honey and manna.[11] Such peoples have been aptly described by Leonardo Olschki as figures from the "Far East Utopia," ideal peoples needing only baptism to become Christians.[12]

As another illustration of this point of view we may consider a description of the Chinese—often labeled "Seres" in medieval catalogs of fabulous races—offered by John of Plano Carpini, a Franciscan sent on an embassy to the Tatars in 1246 by Pope Innocent IV in the hope of converting them to Christianity, or at least enlisting their aid in the Christian struggle against Islam. "The men of Kytai [that is, Cathay or China] are pagans," said John.

> They have their own form of writing, and, it is said, both the Old and the New Testaments. They have Lives of the Fathers and hermits, and buildings made like churches in which they pray and they say that they have saints. They worship a single God and honor Jesus and our Scriptures, but they are not baptized. They are a benign almsgiving race and they revere Christians No better workers in the arts of men than these people can be found in the world.[13]

It is difficult to avoid the Utopian thrust of this passage, which appeals to the materialism of the West while at the same time offering the near perfect Christianity of the Chinese as a model for Westerners to follow.

A confrontation between virtuous Eastern peoples and an ambassador of Western values was an immensely attractive idea to the homilist. Indeed, such an exchange had been one of the oldest components of the Alexander legend. Both Greco-Roman and Jewish stories exist of a dialogue between the conqueror—who was *par excellence* the Westerner going east—and the Gymnosophisti or Bragmanni of India, the most widely known of the Golden Age races. To these men, usually depicted as naked sages, Alexander posed a series of philosophic questions in the tradition of the *Deipnosophists*. After they had shown their wisdom, he rewarded them with marvelous gifts, as we learn from Plutarch's *Life of Alexander*.[14]

Descriptions of the Indian holy men were among the earliest written accounts of Eastern peoples to reach the West, appearing in Megasthenes' *Indika* in the fourth century B.C. Indeed, Megasthenes provides a good deal of information about the different forms of Brahmanism, the physical contortions of Yoga practitioners, and the life of the Sadhus, whom he calls Hylobii (Gymnosophists who live in caves and clothe themselves in leaves).[15] He describes the wise

men of India as having no need for Western luxuries, practicing no metalwork, commerce, or warfare. Their avoidance of negative emotions such as envy or anger—two of the perturbations of the soul shunned by the Stoics—and their diet of acorns and wild fruit allowed them to live to an advanced age, free from the cares of agriculture, livestock management, and conquest or empire.

The appeal of so austere a way of life was considerable, both to the Greco-Roman sensibility and to the Judeo-Christian. Its confrontation with Western "worldliness" in the person of Alexander was widely reported and elaborated upon. The exchange took two basic forms. In some cases, Alexander spoke directly to the chief of the Bragmanni and the substance of the conversations forms the fictitious *Colloquy* first associated with the names of Palladius of Heliopolis and Saint Ambrose.[16] In other cases, they exchanged a series of letters more elaborately outlining Western and Eastern points of view. Both forms of these fictional exchanges had a long and fascinating *fortuna*. In each are lauded the Bragmanni's simplicity, their rejection of agriculture and boviculture, their vegetarianism, and their days spent in prayer:

As for us, Brahmans, since we emerge victorious from the wars that we wage within ourselves, we live for the rest in perfect peace, safe and sound, untroubled; we enjoy the sight of our woods, look up to the sky and hear the cries of eagles and the delightful singing of various other birds. In the open air we cover our bodies with leaves, eat the fruit of the trees, drink water, sing hymns to God.[17]

A charming depiction of the leaf-clothed Bragmanni—who may also be wearing slightly self-satisfied expressions—appears in the Alexander romance at Oxford (Figure 16).

The letter version of this debate is most widely known as the correspondence of Alexander and Dindymus, the king or chief sage of the Brahmans, in which Dindymus replies to certain inquiries put forth by the conqueror about the life of the Bragmanni. This correspondence is a classic vindication of primitivism and the ascetic mentality, stressing the simplicity of Brahman life, nudism, vegetarianism, communal property, and avoidance of conflict. There were, as might be expected, many abridgments and expansions of the exchange; the longer series of letters contains a reply by Alexander—who does not fare too well in the argument—praising riches and power as well as attacking the technological backwardness of the Indian people.[18] These letters were very widely known and often appeared by themselves or in compilations with other Alexander literature.

Typical collections contain a Latin Julius Valerius abridgment of the deeds of Alexander, a text of Alexander's letter to Aristotle, and the correspondence of Alexander and Dindymus, in this order. This combination appears, for example, in British Library manuscript Royal 13.A.i of the eleventh century, in Royal 15.C.vi of the twelfth century, and in Cotton Cleopatra D.v of the fourteenth century. Some manuscripts, such as Harley 5054 give the Valerius abridgment followed by the Bragmanni matter alone. In other versions we find abstracts of the letters followed by the *Colloquy;* such are the contents, for example, of Royal 7.A.i from the fifteenth century.[19] Forms of the correspondence and of the *Colloquy* also occurred in the great encyclopedic compilations of the Middle Ages by Jacques de Vitry, Thomas of Cantimpré, Vincent of Beauvais, and Roger Bacon, as well as in popular vernacular works such as *Mandeville's Travels.* It is not difficult to see, therefore, how this particular source of romantic primitivism was disseminated in the West.

That the Bragmanni and the Gymnosophisti were of special interest to medieval moralists is not surprising. When we consider that the debate between East and West was rich in moral lessons, and that in form it was very like a school disputation, we can see some of the appeal it must have had for learned and pious audiences. Jacques de Vitry sees much that is monitory in the account of the Indian sages and Alexander. The Gymnosophisti, he says, "go naked, poor, and humble, holding in contempt the fallacious and transitory values of the world" (p. 199). After an account of their social organization and peaceful conduct, he tells of their meeting with Alexander. "When Alexander came upon them he marveled exceedingly at them and said, 'Ask me what you wish and I will give it to you' " (p. 200). The sages suggest that he give them immortality, and when he says that he cannot, they ask him why, if he knows himself to be mortal, "does he hasten through the world, doing great harm?" (p. 200). Here the moral is not imposed by the commentator, but put into the mouths of the Gymnosophisti in a form that would be appropriate to pagans as well as Christians.

Jacques de Vitry introduces the next race, the Bragmanni, as "exceedingly marvelous men who live beyond the Ganges." Their "religion, morals, and rites, moreover, the diligent reader can fully learn from the following letters which Alexander sent to them" (p. 200). These letters are, of course, the famous correspondence between Alexander and Dindymus, to which Jacques devoted a very large portion of his chapter, thirteen pages in the printed text, though he still abbreviates his original considerably. Much of the material he

retains is an extended attack on paganism, polytheism, and an over-valuing of temporalia in the form of gold.

It is interesting to note that of all the fabulous races mentioned in the *Historia Orientalis,* only three are given extended treatment, while the rest receive one-sentence descriptions drawn mostly from Pliny and Solinus. The three favored nations are the Gymnosophisti, the Bragmanni, and the Amazons. The Amazons, who also enjoyed special status among the Plinian races, were warriors rather than pacifists, worldly rather than reclusive; they can hardly be said to have much in common with Dindymus. Yet they did share one thing—they, too, were thought to have taught Alexander the Great a moral lesson. There was a Talmudic tradition in which the conqueror, in Libya, meets some Amazons whom he asks for bread. To show him the vanity of wealth they give him golden bread, which, of course, he cannot eat, and he leaves their land, saying that he was a fool until instructed by women.[20]

This story seems not to have had the wide currency of the Dindymus legend, yet the Amazons were spoken of respectfully from antiquity onward. Having a large empire in Asia Minor, they spent their days in war and military exercise. They produced many legendary queens, of whom Penthesilea, who fought at Troy and was killed by Achilles, was perhaps the best known.[21] One interesting story concerning the Amazons appears in Quintus Curtius' *Life of Alexander,* which describes how Queen Thalestris, hearing of the conqueror's military prowess, desired to have a child by him.

She, fired with a desire to visit the king, came forth from the boundaries of her kingdom, and when she was not far away sent messengers to give notice that a queen had come who was eager to meet him and to become acquainted with him ... She was at once given permission ... She came forward attended by three hundred women, and as soon as the king was in sight she herself leapt down from her horse, carrying two lances ... With fearless expression Thalestris gazed at the king ... she did not hesitate to confess that she had come to share children with the king ... The passion of the woman, being, as she was, more keen for love than the king, compelled him to remain there ... Thirteen days were spent in satisfying her desire.[22]

Her pomp and ritual, her large retinue, and her boldness are all stressed, and these qualities are not undercut by the typical antique preoccupation with the allegedly lustful nature of women.

In fact, lustfulness was not a quality generally associated with this race. On the contrary, by most accounts they owed their strength in battle to long abstinence from intercourse. Jacques de Vitry, writing of these "women eminent in arms and battle" (p. 198) found no fault with their sexual behavior, but rather said, "Since so much bodily

energy is consumed in frequent copulation, so all the more rarely do they conjoin with their mates; in such a way are these female warriors stronger and greatly suited for fighting" (p. 199).

Though Jacques says nothing about the Amazons' contact with Alexander, their placement in the *Historia Orientalis* next to the Bragmanni suggests that the author knew the Jewish tradition concerning their gift of golden bread. In any event, Jacques strove to make them dignified and instructive figures. They appear again with the Bragmanni in the fourteenth-century manuscript, Cotton Galba E.xi, which contains two letters of Dindymus to Alexander preceded by accounts of the Amazons.

In certain ways, the treatment of the Amazons and of the Alexander and Dindymus correspondence found in Thomas of Cantimpré's abbreviation of Jacques more effectively serves the cause of romantic primitivism.[23] Thomas follows Jacques in the order of presentation, discussing first Amazons, then Gymnosophisti, then Bragmanni. He diverges from his source, however, in presenting these races as ur-Christians. Thomas stresses the prophetic Christianity of the Bragmanni, who "wrote openly concerning Christ's coeternity with the Father before the Son came in the flesh."[24] He gleans passages from Jacques that deal specifically with the pious rather than the ethical side of the Brahmans, and sees the Amazons as military allies against the enemies of Christendom. In this he claims to be following Jacques, saying that the earlier writer called the Amazons by the name of Christians and praised them for fighting fiercely against the Saracens.[25] Actually, Jacques merely compares Georgian Christian women to Amazons. The miniature of aristocratic Amazons in armor (Figure 1) came from a manuscript of *De Naturis Rerum*.

Well before late medieval moralists assigned a significance to each of the races in works like the *Gesta Romanorum*, the Amazons, the Gymnosophisti, and the Bragmanni had been established as instructive and sympathetic figures. Undoubtedly, interest in these particular peoples was part of a larger search for a harmonious and simple way of life like that believed to have existed during the Golden Age or in prelapsarian Eden. Although only one of a number of different approaches to Eastern cultures, this primitivism did color many medieval treatments of the monstrous races.

Two other examples of "noble" monsters were men who through color or religion were "monstrous," yet who had redeeming features, not least of which was their recognition of Christianity. The Ethiopian Caspar and the Saracen emir may seem to some readers less satisfying examples of medieval primitivism than the Indian sages and

the Amazons. First, they are individuals representing the exception rather than the rule for their respective races. Second, their "wisdom," though independently arrived at, is essentially a confirmation of Christian dogma. Whereas the Brahmans were recognized to have evolved their own cultural outlook in which Christians found much that was sympathetic, the Ethiopians and Saracens were seen differently. Being closer to Europe, they tended to be viewed in terms of their historical interactions with the Judeo-Christian world. A "good" Saracen was less the product of an exotic civilization than a pair of alien eyes in which Europeans could see their own values mirrored. Yet to see these men freshly, in literary or artistic context, allowed the Westerner to call his own values into question and so, at least momentarily, to redefine his traditional conception of humanity and of monstrosity. Moreover, the very history that prejudiced medieval men against Africans and Islam gave to the figures in these stories a certain richness and complexity they would not otherwise have had.

In the second chapter of Matthew certain wise men or magi came from the East to Jerusalem to revere the infant Jesus. Though these men were not named in the Bible, their existence and actions so aroused the interest of medieval commentators on the Scriptures that by the mid-thirteenth century a representative exegete, Hugh of St. Cher, could say (following Pseudo-Sedatus and Pseudo-Jerome) that the magi were named in Latin Balthazar, Melchior, and Caspar, that they were actually kings as well as magi, and that they were the descendants and geographic representatives of the three sons of Noah. "By these three men, who are born out of the line of the three sons of Noah, the coming of the nations to the faith is prefigured," says Hugh.[26] Caspar, the youngest of the three and an Ethiopian king, is a good descendant of the patriarch's evil son Ham; in him are centered the myths and images of the black man converted to Christianity and thus whitened by grace.[27]

For the later Middle Ages, the most elaborate account of Balthazar, Melchior, and Caspar appears in the *Historia Trium Regum* of John of Hildesheim, a Carmelite and teacher of biblical studies in Paris, who wrote his treatise between 1364 and 1375. John's version of the three kings' early history contains a number of motifs from the apocryphal Acts of the Apostles. The three start for Jerusalem from different places and naturally have "exceedingly different modes of speech."[28] But the power of the Word changes this and before long "each spoke the other's tongue" (ch. 15, p. 232). In describing the kings, John makes Caspar the largest of the three, "and a black Ethio-

57. Caspar as a black magus. Adoration of the Magi, limewood retable, Swabian, Royal Scottish Museum, Edinburgh, c. 1520.

pian" (ch. 21, p. 237), and he is so depicted in a late Gothic wood sculpture in the Royal Scottish Museum, Edinburgh (Figure 57). John qualifies his statement, however, with the climatic information that the kings and their retinue were "very small," for the nearer the rising sun the smaller and more delicate men are. The kings build a city called Sewa which eventually has Prester John for a temporal ruler and Saint Thomas of India for a spiritual ruler; the latter is martyred there. "And all the men who were born in this land had the faces of dogs" (ch. 32, p. 256), though it is not clear if this race—borrowed from the apocryphal Acts of the Apostles—played a part in the martyrdom.

In time Caspar was seen as the immediate ancestor of Prester John and took on much of his descendant's mythic power, while at the same time he was connected with other figures from Scripture—the Ethiopian eunuch of Acts 8:27 who is a figure for virtue, and the nation spoken of in Psalm 67:32: "Ethiopia shall stretch out its hand to God." Saint Augustine understood by this that Ethiopia believed in God,[29] and the commentary of Hilary of Poitiers took this to mean that Ethiopia received the Christian faith, presumably from its connections with Caspar and Prester John.[30] Thus, either directly or indirectly, the youngest magus was seen as instrumental in the conversion of his country. The belief that Caspar was a noble African king helped connect him with the legend of Prester John, as well as to make him a more sympathetic figure in popular culture, where the climate of opinion was prevailingly hostile toward black Africans.[31]

As we have seen, the black man was frequently identified with Islam and with the Cynocephali in certain Eastern Pentecost scenes, and there were numerous representations of the Saracen as a Moor in the romances and chivalric poems deriving from the *Chanson de Roland.* Yet contemporaneous with such portraits of the ignoble black Saracen was a more positive view in the Old French poem *Floire et Blanchefleur,* composed about 1170.

The hero and heroine of this story, Floire and Blanchefleur, have loved each other since early childhood. Separated from Floire by the boy's pagan father, the girl is sold to merchants in an effort to alienate the noble Floire's affections from her. After a search, the young man finds out that his love has been placed in the harem of the emir of Babylon, who because of her beauty wishes to make her one of his many wives. Eventually, Floire makes his way into the emir's household concealed in a basket of flowers. The lovers are reunited and lie chastely together in bed when the emir discovers them. Enraged, he threatens them with death. Each offers to die for the other and their innocent love so softens the emir's heart that he forgives them and, dubbing Floire a knight, makes him the foremost man in his retinue. The lovers, of course, live happily ever after. From the rather Herodlike ranting of the emir when he first discovers the pair, we might expect some display of Saracenic despotism and savagery, but in fact the poet praises the emir for his benevolence and wisdom.

In the early lines of the work the poet establishes Saracens as violent, vindictive, and anti-Christian. A pagan king named Fenix, we learn, "into the Christian country came / To burn the towns to ashes, plunder, / Rob, and despoil, and rip asunder."[32] The emir, too, displays stereotypic Saracenic cruelty in his practice of keeping a wife

only one year: "She's then beheaded" (l. 1734) or "he has her blinded" (l. 1847). We therefore expect him to behave the same way toward Floire and Blanchefleur, for "into such rage the emir flew / He knew not what to say or do" (ll. 2446–47), and his rage is connected with the polytheism popularly practiced by the Saracens of romances: "By all the gods to whom I pray, / You'll die, and shamefully, today! / I'll kill you and the whore" (ll. 2464–66). But the Saracen emir is quickly responsive to innocence and tenderness: "He was powerless to keep / His heart hard when he saw them weep" (ll. 2758–59), and his obvious softening of attitude pleases his retainers greatly.

Once the emir has heard the children's story he becomes increasingly benign, and the poet begins to praise him in a way uncharacteristic of the traditional treatment of the Saracen. The emir responds most unautocratically to the advice of the counselors, and indeed, the parliamentary side of the poem is one of its many surprises, for we learn that "The emir was serenely wise; / He asked the nobles for advice" (ll. 2862–63). Eventually he is reconciled with the two, and, kissing and embracing Floire, showing him "friendship and compassion," he even unbends towards Blanchefleur in a most unchauvinistic way, for the poet, surprised, remarks, "Indeed, with supreme courtesy, /He took Blanchefleur's hand tenderly" (ll. 2866, 2868–69). The poem ends with feasting and reconciliation of all parties, and the emir marries one of Blanchefleur's friends, Claris. Floire returns to his home, is made king, and converts to Christianity. Though we hear no more of the emir we may assume he continues along the virtuous path on which he has set out, and that he and Claris live happily in the flower-filled paradisal splendor of Babylon.

This poem contains elements of several different attitudes toward alien peoples and so is an interesting one with which to conclude this part of our discussion. There is, first, a degree of political realism; the fact that Christian and Islamic countries had been in contact with each other for a long time allowed the author to write with some assurance about the military raids of the Saracens, the emir's harem, and possibly his practice of consulting the nobility on matters of state. At the same time, many details of the poem are not realistic but reflect the wishful thinking of a primitivist approach—the imagery of Babylon, for example, has overtones of the Eastern Paradise so often sought in medieval travel literature. That the emir should be described as "serenely wise" (despite violent treatment of his wives) is reminiscent of passages describing the sages of India. Finally, the poem's emphasis on childlike and asexual love is strongly in the tra-

dition of the prelapsarian Eastern Paradise, while missionary interest in alien peoples shows up in the conversion of Floire to Christianity, as well as in the emir's allusion to polytheism, though such allusions are characteristic of most medieval treatments of Islam. More subtly, the essential goodheartedness of the emir, his capacity to be moved by the situation of Floire and Blanchefleur, points to his redeemability.

In examining the various attitudes of the Middle Ages toward alien peoples, a natural tendency would be to classify these attitudes either as friendly or hostile, in varying degrees. Henri Baudet has chosen to look at the problem in another way, however, using *Floire et Blanchefleur* as one of his examples. He distinguishes two kinds of relationships between Europeans and non-Europeans. The first entails "concrete relations with concrete non-European countries, peoples, and worlds. This is the relationship that freely employs political, military, socioeconomic, and sometimes missionary terminology." The second is quite a different relationship whose "domain is that of the imagination, of all sorts of images of non-western people and worlds . . . images derived not from observation, experience, and perceptible reality but from a psychological urge."[33] *Floire et Blanchefleur* contains elements from each of these domains. Yet what is perhaps most remarkable about it is that the imaginative side, the side derived from "a psychological urge," should be a romanticizing positive view of the emir, when the realistic side shows him as a violent Saracen despot. Here indeed is a triumph of romantic primitivism, not only over prevailing mistrust and fear of alien peoples (by far the stronger psychological urge for the Middle Ages), but also over the political facts of Christian-Islamic hostility.

However attractive the romantic primitivist point of view to the medieval mind, it did not make many converts. Alexander, for instance, though drawn to the peaceful life that Dindymus described, found himself so trapped by the circumstances of his career that he could not accept it.

I know that what you say is true. You are a man of godlike nature, who has been set down in these places and allowed to live, without any worries, the life of full contentment and serenity and to enjoy the peace, safety and riches provided by nature. But I live in a world of violent commotions and terror, in constant fear of many of those who serve as my guards . . . Even if I choose to live in these deserted places, I shall most certainly not be allowed to do so . . . But, despite these complaints which I have here set before you, you have revived me and freed my mind for a while from struggle and conflicting thoughts.[34]

In Baudet's words, if Alexander's "primitivism mourned the past, Utopianism looked toward the future" (p. 34). He notes that the sort

of nostalgia we see in the romanticizing of certain of the monstrous races "is inexorably tied to the degenerative view of history which holds that time has brought us further and further from our real destiny: happiness" (p. 35). Utopianism, however, is more closely tied to evolutionary theories of history in which men move closer to ideal happiness through the improvement of their society and conditions of labor.

Though the societies of monstrous men never fully developed their Utopian possibilities, this element is present in many descriptions of them. The question to be asked was whether the simple primitive way of life should be aspired to as a model or looked upon with nostalgia as something that Europe had lost. Some writers, like Jacques de Vitry, advised Christians to study the races and try to profit from their observations. Others remained silent, leaving readers to draw their own conclusions.

Utopianism, like romantic primitivism, is less connected with a concrete place than with an ideal or fantasy; it is adaptable to as many forms as there are alien cultures. A description similar to that of the Bragmanni could be applied to the Indians of the New World. And it was. A woodcut of these Indians, done in 1505, contains the following rubric:

They go naked, both men and women; they have well-shaped bodies, and in colour nearly red; they bore holes in their cheeks, lips, noses and ears, and stuff these holes with blue stones, crystals, marble and alabaster, very fine and beautiful ... They have no personal property, but all things are in common. They all live together without a king and without a government, and every one is his own master. They take for wives whom they first meet, and in all this they have no rule. They also war with each other, and without art or rule. And they eat one another, and those they slay are eaten, for human flesh is a common food ... They live to be one hundred and fifty years old, and are seldom sick.[35]

If this rubric seems to recapitulate much of what we have learned about the monstrous races of Africa and India, it also shows us the great continuity of European thought about such peoples. The complex of ideas concerning the noble savage persisted, and was eventually exported to the New World.

9 The Human Status of the Monstrous Races

It was not, of course, the chief concern of those who wrote about "noble monsters" to establish their humanity or to consider their place in the Great Chain of Being. But as information came back about surprising men heard of or met with by the missionary travelers to the Orient, and about genuinely unusual men in Africa such as the Pygmies, new links had to be forged in this chain to accommodate Pliny's races. It was fitting, then, that the monstrous races—like so much else in the natural world—should be subjected to the rigorous analysis of the Schools in the thirteenth century. Both senses of the word *monstrum*—as a portentous individual birth and as an unusual race of men—came to occupy the attention of many thinkers of the late Middle Ages.

The legal and religious status of anomalous births was of considerable interest to the new breed of jurists commenting upon Roman law and to their near contemporaries, the canonists, who wondered how to apply the sacrament of baptism to such beings. The former, as might be expected, considered *monstra* with respect to human form, law, and their place in society, whereas the latter were concerned with their salvation as rational creatures having a soul. And even though members of the more extreme races had not been seen in the West, some scholastic theologians and philosophers had begun to argue that the existence of such creatures fulfilled an aesthetic need. Monstrosity, in this view, provided a desirable contrast with the more harmonious form of Western men, contributing to the *concordia discors* of the universe. Three races in particular—the Blem-

178

myae, the Cynocephali, and the Pygmies—were the subject of scholastic debate because their physical shape and social customs raised serious questions concerning their human status. These races did not fare well in the schoolroom, where it was concluded, by and large, that monstrous beings had not full human reason but rather its "shadow," by which they could perform many human actions without at the same time being men.

In the ancient world, *monstra* were considered to be omens of political or civil misfortune, and the sober Roman historians Livy and Tacitus—to say nothing of the more sensational Julius Obsequens— were full of accounts of defective human and animal births which filled the beholder with horror and revulsion because they suggested a frightening breakdown in cosmic order and an imminent danger to the state. As Suetonius said of Augustus, "he abhorred dwarfs, cripples, and everything of that sort, as freaks of nature and of ill omen."[1] It is a familiar human failing to confuse the messenger of bad tidings with the message itself, and under Roman law monstrous infants were immediately put to death. For example, Livy tells of how hermaphroditic children when born were not allowed to touch Roman soil, but were instantly carried to the sea and thrown in.[2] The same fate lay in store for other forms of anomalous birth. The Laws of the Twelve Tables, the customary law of Rome dating from as early as 450 B.C., codified this popular practice and extended it to all anomalous children: "A father shall immediately put to death a son recently born, who is a monster, or has a form different from that of members of the human race."[3] In this law, human form was a prerequisite for human social or legal status; whoever failed to meet this requirement did so because of God's anger toward men and should be destroyed. Not only did the *monstrum* reveal God's anger and thus serve as a focal point of danger to all men, it lacked a place in Roman society because of its inability to perform within it.

This harsh attitude toward *monstra* was somewhat softened in the portion of the Roman law compiled at the orders of the Emperor Justinian, and known to the Middle Ages as the Old Digest. The Old Digest in its medieval form contained a great deal of postclassical interpolation, of which one passage, associated with the name of Julius Paulus (fl. c. 200), deals with *monstra:* "Those beings are not children who are born formed in some way which is contrary to the likeness of the human race; as, for instance, where a woman brings forth something monstrous or unnatural. A child, however, which has more than the ordinary number of human limbs seems to be, to some extent, completely formed, and therefore may be included among

children."[4] In defining those beings who "are not children" the inter-
polation is making a civil distinction as well as one between human
and monstrous. A child with extra members, as long as those mem-
bers are human, is granted social status according to this reading.

The Old Digest was intensively studied in the great legal center of
Bologna from the late twelfth century on, and acquired a vast body
of commentary. Not unexpectedly, by the fourteenth century the
passage concerning *monstra* had attracted the attention of two of the
most celebrated jurists, Baldo Ubaldi (1319–1400) and his teacher
Bartolus of Saxoferrato (1314–1357). The former had said of the pas-
sage in question, "That which does not have the body of a man is
presumed not to have the soul of a man, because it is presumed . . .
that nature does not bestow a soul where there is not a body . . . since
form gives essence to a thing, that which does not have the form of a
man is not a man."[5] Baldo continues, "That which lacks the form of a
man lacks civil liberty in name, but he who has something of human
form, despite defect of form, holds in effect civil liberty." Bartolus
goes somewhat beyond his pupil in his comment on the passage: "A
monstrous birth, that is, against nature or human form is said to be
legitimate."[6] In fastening on the legal status of *monstra* from the
point of view of form, legal accountability, inheritance, legitimacy as
heirs, and the like, the civil lawyers gave the Middle Ages intellectual
support for the notion of formal humanity as a starting point for any
discussion of man's place or worth in the universe.

While these commentators tried to define the human by the visi-
ble, another group, the canonists, were concerned with the invisi-
ble—man's soul. There is much more discussion about *monstra*
among the canonists, for several reasons. *Monstra* posed a practical
problem for the parish priest who had to decide whether or not a
child was human in order to baptize it, and who also needed guid-
ance in the form of the baptism itself. This led theologians who dealt
with the sacraments to speculate about the humanity of *monstra*
from a somewhat different point of view than that which we have
seen before; their conclusions eventually were incorporated in paro-
chial manuals.

Though *monstra* are not discussed in the *Decretals* or the *Decre-
tum* themselves, the article "De Baptismo" in the former provided a
locus for speculative commentary on *monstra*. If there is any doubt
as to whether the infant is baptized, the article observes, the priest
ought to use the formula: "If you are baptized, I do not baptize you,
but, if you are not yet baptized, I baptize you."[7] One of the great
fourteenth-century canonists, Guido da Baysio, Archbishop of Bolo-

gna (d. 1313), considering the formula "ego baptizo" in a comment upon the *Decretum,* employs the *Decretals* as an illustrative cross reference. He wonders what to do when the creature to be baptized is a monster born with two heads: "Ought it to be baptized as one creature or two?" He calls upon Aquinas for help with this question:

> When a monster of this type is born, according to Thomas, either it is certain that there are two rational souls or it is not. It is indeed certain if there be two heads and two necks and two chests, because by consequence there will be two hearts; in such a case they are baptized as two beings ... for example if there are not two distinct heads, but two necks wellfounded in the same nape, then first one is baptized and then the other. One can, in case of doubt, say, "If you are not baptized, I baptize you."[8]

Guido's stress on the head as an index of humanity, as we shall see in our discussion of Alexander of Hales, is a standard part of medieval thinking about human form. In perhaps the most advanced scientific work of the century, Peter of Abano's exposition of the pseudo-Aristotelian *Problemata* (1310), the author observes of *monstra:* "You know that it is to be seen especially by the form of the head if an animal ought to belong to our race. Indeed, if it has a fully formed head, even if in many other parts it be monstrous, it can be said to be one of us. Our doctors of law, considering this, grant baptism to such beings just as if they were of our species."[9]

That such questions about the sacramental and spiritual nature of anomalous births were more than mere problems for abstract scientific discussion or dry casuistry in the Middle Ages is evident from the fact that we find the matter treated both in chronicles dealing with the lives of real people and in the Roman rituals or handbooks of the administration of the sacraments for priests. The Franciscan traveler John de Marignolli (1290–1359) refers to a child born in his time near Florence that had among other oddities two perfectly formed heads "and was baptized just as if it were two persons." So, too, in the *Chronicle* of Baldwin, of the east Flanders town of Ninove, we learn of an event which excited the interest of the townspeople. In the year 1299 a pauper girl bore a monstrous child that had two heads and "was baptized by the midwife and straightaway died."[10] The chronicler tells us nothing more about the baptism, but presumably it was a double one of the type mentioned by Guido da Baysio. This would have fulfilled the requirement recorded by Pseudo–Albert the Great in the *Secrets of Women:* "Those that have separate heads ... and separate souls ought to be baptized as two persons."[11]

In manuals for priests we find detailed instructions for the baptism of monstrous children. Probably the earliest of such works, the

Manipulus Curatorum of Guido of Mont Rocher, was extremely popular; there were more than one hundred editions prior to the end of the sixteenth century. Guido (b. 1333) was possibly Spanish and dedicated his work to the Bishop of Valencia. Other than this, nothing is known of him. Well versed in canon law and scholastic theology, the author provides guidelines for the priest in virtually every contingency.

But what if there is a single monster which has two bodies joined together: ought it to be baptized as one person or as two? I say that since baptism is made according to the soul and not according to the body, howsoever there be two bodies, if there is only one soul, then it ought to be baptized as one person. But if there be two souls, it ought to be baptized as two persons. But how is it to be known if there be one soul or two? I say that if there be two bodies, there are two souls. But if there is one body, there is one soul. And for this reason it may be supposed that if there be two chests and two heads there are two souls. If however, there be one chest and one head, however much the other members be doubled, there is only the one soul.[12]

Guido was aware of the best thinking of the canonists; in his manual he simplifies the problem for the priest, stressing the importance— unlike the civil jurists—of soul over form, and noting that two bodies suggest the existence of two souls. He does not, however, offer support from the *Decretals* for his beliefs.

The successor to the *Manipulus*, the *Liber Sacerdotale* of Alberto da Castello, a Venetian Dominican (d. 1521), was the most widely used collection of this type until the establishment of the *Rituale Romanum* ordered by Paul V in 1614. Alberto tried to coordinate and regularize widely varying ritual practices in different dioceses, and tried to ground his instructions not on contemporary practice or on the many private rituals in use during his day, but on patristic authority and the authority of great contemporaries. Thus, in the *Liber Sacerdotale*, we have many references to Aquinas' *Summa* and his commentary on the *Sentences*, to canon law, and to Guido da Baysio's *Rosarium*. Echoing the *Rosarium*, Alberto says, "If a monster is to be baptized, it is prudent to baptize one after another. Thus, whenever two heads or two bodies appear, satisfy necessity in the first instance and then say to the one following, 'If you be not baptized . . .' "[13]

Something of a synthesis between the interest in form shown by the civil jurists and the interest in the soul shown by the canonists is effected by the canonist Alphonzo à Carranza, who seems to be drawing on legal opinion when he raises the question of "whether a monstrous birth can and ought to be baptized." He concludes that "those having human form can and ought to be washed by holy bap-

tism and those truly monstrous, which lack rational souls, not."[14] Though it would be rash to infer too much about the humanity of monstrous races from what medieval jurists had to say about individual anomalies, we can conclude that *monstrum* came to be defined indirectly as something that could have both a soul and a legal status, and therefore partake of humanity from the social and theological points of view.

Certain medieval authors raised in various ways the issue of the races' humanity, but for one reason or another they did not explore this question deeply, relying in the main on the authoritative figure of Saint Augustine, who said—though without much conviction— that if they were descended from Adam they were men. But what of their place in the hierarchical structures of the great Dominican encyclopedists? In Thomas of Cantimpré and in Vincent of Beauvais, who followed him closely, various categories of natural life are discussed. The section in Thomas entitled "Concerning Monstrous Men," for instance, indicates that the Plinian races were distinct from the animals, birds, fish, and even sea monsters, each of which is treated in a separate book.

Thomas, though separating the races generically from other creatures by placing them in a book of their own, thinks that they probably do not have souls: "Although by some acts they seem outwardly to have reason, yet they do not have the physical organization necessary to allow intellectual reason to be informed by sense perception."[15] He is convinced that since these beings resemble men outwardly, they must do so inwardly as well, but he seems to suggest that about all we can grant them is that they stand slightly higher in the scale of creation than other animals. The questions of why God created them at all and of why they differ so much from men and other animals he does not try to answer.

Two other widely known works of encyclopedic scope, though not Dominican, show the same reluctance to take a firm stand on the humanity of the monstrous races and the reason for their existence. Lambert of Saint Omer, in his *Liber Floridus*, raises the question of precisely what God had made during the first six days of the world, and notes that among the ordinary animals were created Cynocephali, Cycropides, Pygmies, Antipodes, Panotii, Hippopodes, and Cynopodes. These beings are all called "animantia," a word usually denoting animals as opposed to men, even though Pygmies and Antipodes have no animal features.[16] Bersuire's *Reductorium Morale,* in addition to its etymologies and *distinctiones*, contains a section on animals in Scripture (Book 10) which considers among other crea-

tures the Pilosus or hairy wild man. "Pilosus," says the author, "is a wild man . . . and they appear to be men."[17] He explains, however, that Pilosi are monstrous animals, lacking sense and the use of reason, though it should be noted that this explanation was conditioned by his desire to draw a *moralitas* from their reputed lustfulness. For Bersuire they represented men who denied their rational faculties in their abandonment to brute passion. In his geographic fourteenth book on the Ethiopians, he tells us that in the Brixon River "are men or beasts having human form."[18] The material on Pilosi is obviously written from the moralist's rather than the natural historian's point of view, and Bersuire is more concerned with the homiletic possibilities of the monster than with its actual existence and classification. That he was not truly interested in an analysis of the races of the Brixon is indicated by his "men or beasts," where the "or" seems to give equal weight to both possibilities.

Through an irony of history, treatments of the races' position in the universe are not found where we might expect—among the natural historians—but in a somewhat surprising place: among considerations of the beauty and harmony of the universe in writers interested in aesthetics. A good statement of the ornamental function of Plinian peoples in the cosmos appears in the *Supplementum Chronicorum* of the Augustinian theologian and historian, Giacomo Filippo Foresti (b. 1434). Following a discussion of the diversity of men created by the building of the Tower of Babel and its aftermath, the author observes, "There were also many kinds of monstrous men produced in various places . . . Indeed, God Himself, since He knew the proportions of likeness and diversity to employ in creating the beauty of the universe, certainly wished to produce monstrous men in the world."[19] It is clear that Foresti regarded the full panoply of Plinian races as part of God's plan, because he lists Sylvestres, Androgines, Arimaspians, Astomi, Athlantes, Chelonophagi, Tanephi, Himantopodes, Hippopodes, Neuri, Panotii, Pygmies, Cyclopes, Sciritae, Troglodytes, Monoceri, Monoculi, and men with their eyes on their shoulders.

Saint Augustine, in developing his idea of *concordia discors,* provided a base for later aesthetic treatments of the races, though he himself did not apply the idea to Plinian peoples.[20] In his *De Ordine,* for instance, he explained how things that we might consider to be evil or grotesque contribute to the beauty of the universe, and gave as an example a cockfight in a village field: "The heads thrust forward intently, the raised hackles and vehement blows . . . there is nothing there not decorous." Though the winner may be "deformed in voice

and motion," Augustine said, "what is sweeter to us or more fitting or agreeable than the combat of these cocks?"[21]

The value of contrast was, of course, only one side of Augustine's aesthetic theory. It was complemented by his ideas concerning harmonious proportion and the mean, ideas that were also applied to the monstrous races. Some authors, like the person who wrote the spurious seventh book added to Hugh of Saint Victor's *Didascalicon*,[22] tried to combine the two approaches. In a classification of wonders analogous to that in Gervase of Tilbury's *Otia Imperialia*, Pseudo-Hugh explained that some things are remarkable because their scale exceeds the mean or falls below it: "Thus we marvel at giants among men." Other things give pleasure by their harmonious proportions. Sometimes we prefer the bizarre, sometimes the habitual, sometimes unity, sometimes multiplicity. Thus the writer can affirm the beauty not only of things that show order in their formal proportions, but also of things monstrous or ridiculous (ch. 11, p. 820).

In the *Secrets of Women,* a commentator on the text carries this line of reasoning one step further to provide a rationale for God's creation of monsters. He observes, "We call a monster that which shows itself to the beholders because the eye delights in and admires monsters." In answer to the question "Why are monsters made?" he notes that naturalists say they are created "to embellish and to decorate the universe. For they say that just as diverse colors existing together in a wall decorate this wall, so indeed, diverse monsters embellish this world."[23]

Perhaps the most striking application of this idea to the Plinian races occurs in Alexander of Hales' *Summa Theologica,* at the end of a long and interesting discussion of their humanity. Alexander quotes Saint Augustine on the need for aesthetic contrast in the world and applies the idea to monstrous men: "So, just as beauty of language is achieved by a contrast of opposites . . . the beauty of the course of the world is built up by a kind of rhetoric, not of words but of things, which employs the contrast of opposites."[24]

The thoroughgoing treatment given the Plinian races in Alexander's *Summa* recommends this work to our attention for other reasons besides its use of aesthetics. Alexander of Hales was a Franciscan master at Paris in the early thirteenth century. The *Summa* that bears his name may have been the work of a group of Franciscan theologians under his direction, but for convenience I shall speak of "Alexander" as its author.[25]

The portion concerning monstrous men appears in the second tractate of *Inquisitio* 4, *De Homine*, where the human body is consid-

ered in its relation to the body of Adam. Alexander repeats Saint Augustine's question as to whether the Plinian races can have descended from the first man. He then answers yes, that monsters such as Augustine lists "are propagated from the body of the first man" for three reasons (p. 574). First, Augustine says so (argument from authority). Second, he generalizes from the individual birth to the race (and in this he is simply following Augustine and Isidore): "Just as monstrous births are reckoned among us in the human race, so therefore there are monstrous races among mankind" (p. 574). Third, both ordinary and deviant humans can be propagated from the same source and partake of the same humanity. The simile Alexander uses for this argument is rather peculiar: "At one time a teacher writes correctly and at another time not; and a physician sometimes gives a correct prescription and at other times not; but either this way or that way, what they do pertains to writing and to medicine. By a similitude, therefore, whether a thing be rightly or not rightly propagated from human nature, nonetheless it belongs to human nature" (p. 574). Whatever this passage may say about the parentage of the races, it does point up the difficulty posed by these beings for people who were convinced that they were not merely different, but "wrong."

Alexander lists seven objections to his placing monstrous men among the descendants of Adam, and replies to each. These overlap somewhat, but the principal objection is that monstrous men are not like the first man. Indeed, if we are looking for likenesses, apes are more like men than are many of the monstrous races. Moreover, a creature with the head of a dog or other members more properly belonging to an animal is not likely to have a rational soul; and a creature with no head at all, like the Blemmyae, lacks one of the four chief organs by which to identify a human being, namely the brain.[26] Such creatures cannot, therefore, be of our species.

In dealing with these objections Alexander relies heavily on the authority of Saint Augustine, but also benefits from the tools of Aristotelian analysis. He reasserts that the Cynocephali and the Blemmyae are men, though apes may appear more manlike, pointing out that these are extreme examples and that most of the Plinian races are more normal. Headless creatures, of course, could not be men unless there were some other organs in their bodies that carried out the duties of the head, nor does Alexander find it probable that Cynocephali could be men with heads in all respects like those of dogs. More likely, he says, they have a doglike manner of speech or

pronunciation. The most important quality, however, is not the external arrangement of organs, but the inner order,

as is evident in the bear, which flayed has exterior members extremely similar to the members of men; and it is said of the pig that it has intestines similar in arrangement to those of men—nay indeed even between men and plants are there similarities in the external organs, just as is seen in the example of the mandrake . . . yet for all this it is the internal congruence of the body with the soul and its inner organization which makes men men. (p. 576)

This same inner order not only distinguishes men from beasts, but also creates the potential for monstrosity. For only men with a rational soul can suffer the disordering effects of sin. Animals who do not know right from wrong cannot do so, "but by divine justice, in punishment for the disordering and deforming of the soul through guilt, disorder and deformity invade the body" (p. 576). The idea that deformity was a punishment for sin was part of the folkloristic tradition. Alexander's Summa is unique, however, in turning this idea to the service of an argument for the races' humanity. In effect it says that the monstrous races are men because only men are capable of becoming monstrous.

Alexander adds that the contrast between deformed and undeformed men is important in the larger scheme of things. Both morally and aesthetically the monstrous races help us appreciate the finer humanity of those who resemble more closely the first man. It is here that Alexander quotes Saint Augustine on the "rhetoric, not of words but of things" which contributes to the beauty of the universe. Surprisingly, however, he does not include plant and animal curiosities among those things that embellish the creation.

If it is said that by the same token monstrosities in the plant and animal kingdoms adorn the universe as well, I say that this is not so because the beauty of the universe is found primarily in rational creatures. By their contrast with human monstrosities, rational creatures are made more praiseworthy and of greater beauty and they are the greatest adornment of the universe. And the harmonious beauty of rational creatures unites with the ornament of monstrous men to provide a special kind of beauty coming from the blending of opposites. (p. 576)

Although the Summa of Alexander of Hales grants human status to the races, it cannot be said to take a warm or welcoming view of them. Their deformity identifies them as men, but also as sinners, and their place in the creation is seen only as that of a foil to the beauty of the rest of mankind.

Other scholastic thinkers deny even this inferior level of humanity to the monstrous races, or grant humanity on different grounds, de-

ducing from the social customs of a certain class of creatures that they must be rational. Of particular interest to us are works in which one race receives extended attention. We shall consider three such works, ranging in time from the Carolingian period to the decline of scholasticism. The first is the letter of Ratramnus of Corbie to his friend Rimbert, discussing the Cynocephali. The next is Albert the Great's commentary on Aristotle's *De Animalibus* concerning Pygmies. And the last is the *quodlibet* entitled "Whether Pygmies Be Men" in a collection of *quodlibeta* by Peter of Auvergne.

Ratramnus was a French Benedictine and student of Paschasius Radabert. His pastoral letter to Rimbert belongs to the genre of dialogues between master and pupil, and its subject calls to mind the *Quaestiones Naturales* of Adelard of Bath and some of the natural history discussion in the Adrian and Epictetus dialogues. These works were probably the most serious attempts before the work of Albert the Great to explore, mostly by deduction but sometimes by empirical observation as well, the nature of the physical universe.

"You wonder," wrote Ratramnus to his correspondent, "what you should believe about the Cynocephali—namely whether they are born of the line of Adam and if they have brute souls."[27] Ratramnus promises to answer these questions and attempts to do so mainly by deductive reasoning. "If the Cynocephali are human," he says,

no one can doubt that they descended from the progeny of the first man. But if they are reckoned of animal species, they take only the name and not the nature of man. They are better classed among beasts than men, since the form of their heads and their bark like a dog shows them more similar to beasts than to men. The head of man is rounded, turned to look at the heavens; the head of the dog is oblong, curved to look at the earth. And men speak while dogs bark. Yet you claim the Cynocephali are for all this better seen to exhibit human reason than bestial sensibility. For example, they form a society and live in villages; they cultivate fields and harvest crops; they cover their private parts through human modesty rather than exposing them like beasts; and for garments they use not merely skins but true clothes by which they indicate their modesty. All of this leads you to believe that they possess a rational soul.

The arguments invoked here are familiar ones. That man was made so that he could behold the sky or home of reason whereas the irrational animal faces the earth or material world as he walks is a belief as old as Plato; we find a sharply defined patristic expression of it in Basil's *Homilies on the Hexameron*: "Cattle are terrestrial and bent towards the earth. Man, a celestial growth, rises superior to them as much by the mould of his bodily conformation as by the dignity of his soul. What is the form of quadrupeds? Their head is bent towards the earth and looks towards their belly."[28] Similarly Rimbert's argu-

ment that the Cynocephali form a *polis* and have laws by con-
sensus—"where some law is held by consensus the intellect is pre-
sent" (p. 156)—reminds us of Aristotle's *Politics*. To sow the soil and
to weave cloth, moreover, are "arts" and the "knowledge of an art is
not conceded except to a rational soul" (p. 156).

Finally, as we might expect from persons of Ratramnus' and Rim-
bert's training, the moral aspect of the use of clothing is one of the
most important factors in determining rationality and humanity.
Such views go back to Genesis 2:25 and 3:7, where the prelapsarian
nakedness of Adam and Eve and their postlapsarian shame and
creation of clothing are recounted. Expositors of Genesis had long
believed that the first parents' sudden awareness of nakedness and
shame was passed on—like original sin—to their descendants, so
that all rational men are innately ashamed of their nakedness. Saint
Augustine, for example, notes that ever since the Fall, "this habit of
concealing the pudenda has been deeply ingrained in all peoples, de-
scended, as they are, from the original stock."[29] Man's clothes-mak-
ing impulse is accordingly an emblem of the Fall, distinguishing him
from animals lacking reason, self-consciousness, and moral aware-
ness. Ratramnus agrees that "to cover the privates is an act that
comes when the soul can rationally judge between turpitude and
modesty. And no one can blush unless he has an awareness of deco-
rum. That all the points you, Rimbert, have made so far belong to the
rational soul, no rational person can deny." He then offers a sum-
mary of them: "To distinguish between propriety and turpitude, to
act by knowledge and art, to establish laws by peace and concord, all
this cannot be done without reason" (p. 156).

Though he seems to be convinced of the Cynocephali's rationality,
Ratramnus hedges a little by making his opinion contingent upon the
authenticity of Rimbert's experience with Dog-Heads. "With regard
to the points I have made," he says, "since you say you have seen
these things among the Cynocephali, all this testifies to a rational
mind." Foreshadowing Alexander of Hales, he concludes, though not
enthusiastically, "that those beings of whom we speak should better
be considered men than beasts" (p. 156).

To support this position, Ratramnus adduces a variety of author-
ities. The domestication of animals by the Dog-Heads, for example,
was according to Genesis a sign of humanity. And, interestingly,
though the dog-headed Saint Christopher motif was not common in
the West, Ratramnus cites an early passion of the saint in which this
detail appears: that the Cynocephali are more men than animals "is
seen in the book of the martyrdom of Saint Christopher, who is

known to have been of this race of men" (p. 156). Next he claims that
"support from popular opinion is also found." Finally he cites Isi-
dore's chapter on portents, offering a key quotation and then noting
that Isidore "showed clearly that Cynocephali came from the line of
the first man" (p. 156).

Social organization and customs appear to have been decisive fac-
tors in Ratramnus' weighing of the Cynocephali. Indeed, it is quite
likely that stories of the social behavior of apes or baboons, which
we know to have been at the source of the legend, were what first at-
tracted the interest of thinkers like Ratramnus and Rimbert.

Yet similar behavior on the part of another race, the Pygmies,
failed to convince Albert the Great of their humanity several cen-
turies later. Pygmies are one of the oldest of the monstrous races.
They are mentioned as early as Homer, where we learn that they
warred with cranes.[30] One explanation for this traditional hostility
was that a beautiful Pygmy maiden named Gerana had been meta-
morphosed by Hera into a crane.[31] Another more prosaic reason was
that they vied with cranes for the same food. Nonnosus wrote of
them that they were "beings of human form and appearance of very
small stature and with black skin; they were entirely covered with
thick hair. The men were followed by their women, similar to them,
and children, still smaller. All were naked. There was nothing savage
or brutal in their faces and they had a human speech but it was un-
known to their neighbors. They lived on shellfish and fish and were
timid."[32]

Contributing to their special position among the other monstrous
races was the fact that Pygmies occur in the Bible. In Ezekiel 27:11, a
lament for the city of Tyre, they are listed among the many races
who contributed to the city's wealth and renown: "And Pygmies
were in thy towers: they hanged their shields upon thy walls round
about; they have made thy beauty perfect." The Hebrew word gam-
madim, which Jerome translates as "Pygmies," caused some conster-
nation among medieval commentators because it went against their
training to consider these beings as men, accepting them in an honor-
ific and serious role. The Pantheologus of Peter of Cornwall (fl. c.
1200), a collection of biblical distinctiones, avoids the problem of
their size and simply calls them (following the Glossa Ordinaria):
"Pygmies, that is, archers, and most prompt to war," but the author
concludes that "they figure heretics."[33] Unfortunately, their military
attainments were not enough to afford them human status in the
opinion of the commentators. Hugh of St. Cher is concerned about
the decorum of their appearance on the walls and towers of Tyre,

"just as dwarfs are used in this way for sport."[34] And in Robert Holkot's preacher's aid, the *Convertimini*, which takes its title from Joel 2:12, the author can only conclude that Pygmies were placed on the walls of Tyre "in derision of the enemy."[35]

Pygmies were also interesting to medieval people because, from their size, they were imagined to represent a stage in man's development and so to be more closely related to western Europeans than other monstrous races. Nicole Oresme, for example, cites Aristotle's *De Animalibus* on the various stages in the development of the embryo from sperm, to a fungus-like shape, to that of an unshaped animal, to the shape of an ape, and finally—one stage before the fully human configuration of the fetus—the shape of a Pygmy.[36] This sequence, though imagined as taking place *in utero,* is analogous to the hierarchy of the creation in the Great Chain of Being. The Pygmies' place in such a hierarchy was of great interest to medieval thinkers.

One especially rich locus for study is the collection of references to this race made by Albert the Great in his running commentary on the *De Animalibus;* from it we can extrapolate a good deal about the views of this most important of the medieval natural scientists concerning the human status of the races in general. Albert places Pygmies above apes but a step below men in the Chain of Being, convinced that despite their physical and social similarities to men, they lack true reason. Even the possession of language is not enough to qualify them for a place in the human family. "Pygmies do not speak through reason but by the instinct of nature,"[37] says Albert, explaining that their speech is an instinctual act rather like the cries of animals or of infants. Indeed, he feels that "speech motivated by the intellect is appropriate to man alone ... and if some other species similar to man speaks like the Pygmy, this results from the acts of the simple imagination and not from the actions of the intellect."[38]

As for the social customs and use of clothing which Ratramnus admired in the Cynocephali, Albert dismisses them as mere mimicry without understanding. "Certain animals," he says, "are called Pygmies ... but they do not have the use of reason, nor modesty, nor feelings of honor. They do not revere justice, nor practice the virtues of the republic. They imitate men in many things and have words and speech, but have them imperfectly."[39]

Toward the end of his version of the *De Animalibus*, Albert develops his views on this race at great length, introducing a new concept into the discussion, for he talks about the abilities of various creatures to control instinct by reason and to learn from teaching. He calls this ability *"disciplinitas."* Although it exists in many animals

in a primitive form—for example, the elephant can bend its knees before a king and a weasel can take endive as an antidote against poison while fighting with the serpent—these evidences of learning ability do not attain the level of an *ars*, which Albert feels requires reason and the ability to formulate universals.

Disciplinitas, then, gives the various animals their places in a hierarchical chain of mutable being in which those members of creation possessing the least of it are at the bottom and those with the most— the ape and the Pygmy—at the top, just below man. The key passage for our understanding of the Pygmy's position with respect to man comes in Book 21 of the *De Animalibus*, in a discussion of reason and learning. "After man," says Albert,

the Pygmy is the most perfect of animals. Among all the others, he makes most use of memory and most understands by audible signs. On this account he imitates reason even though he truly lacks it. Reason is the power of the soul to learn through experience out of past memories and through syllogistic reasoning, to elicit universals and apply them to similar cases in matters of art and learning. This, however, the Pygmy cannot do; the sounds he takes in by his ear, he cannot divide into sound and meaning. Though the Pygmy seems to speak, he does not dispute from universals, but rather his words are directed to the particulars of which he speaks. Thus, the cause of his speech is as a shadow resulting from the sunset of reason. Reason is twofold. One part is its reflection of the particulars of sense experience and memory, the other the universals derived from the particulars of the first part, which is the principle of all art and learning. The Pygmy does not have even the first of these two parts of reason, and so does not have even the shadow of reason. Accordingly, he perceives nothing of the *quiddities* of things, nor can he comprehend and use the figures of logical argumentation.[40]

Albert's ethnocentrism here is striking. Beginning from the premise that Pygmies are inferior to man, he can see their manlike behavior only as an imitation or shadow of the real thing. And what is it that they lack? True reason, according to Albert, includes the ability to formulate syllogisms and to argue from universals—in other words, to think like a western European scholastic. Any other mode of thought is, in his view, inadequate to an appreciation of reality. The Pygmy, therefore, who speaks from the perception of particulars rather than universals, must be inferior. His way of thinking is a mark, not of cultural difference, but of subhumanity.

Related to the Pygmy's lack of *disciplinitas* is his lack of art. Here again Albert's reasoning springs from his theological conviction that man must be uppermost in the scale of being; the visual arts, literature, and skills of the West are for him the *ars* necessary to true humanity. He does not concern himself with the possible existence of a native Pygmy *ars*, but argues from the absence of a European one.

Men—that is, Europeans—use their hands as instruments of civilized skills based on universals, in the act of tempering swords in a furnace, for example. The technique will always produce a series of hard blades if certain rules are followed. The Pygmy, however, although using the hand for many purposes, does not do so in the service of an *ars*. Albert observes, moreover, that this creature does not use the rhetoric of persuasion in speech or poetry. And on this account he remains in the wilderness, caring nothing for civilization (2.13, pp. 1328–1329).

Albert speaks deductively about this race, without saying anything very concrete about its habits and social organization. A much more inductive treatment of the Pygmy as a social being is to be found in the work of Albert's fellow scholastic, Peter of Croc or of Auvergne (d. 1304).[41] Coming to Paris from Auvergne, he was a follower of Thomas Aquinas and wrote an ending for Thomas' unfinished commentary on the *Politics* of Aristotle, commenting as well upon a number of other Aristotelian and pseudo-Aristotelian works. Though Peter always had close relations with the Dominican milieu, he seems never to have been a member of the order. His most original contribution to the thought of his age was a group of six *quodlibeta*, of which the fourteenth question in the last series was entitled "Whether Pygmies Be Men."

Quaestiones disputatae were, with the *lectio*, the basic tools of medieval education,[42] for, as Peter Cantor observed, the study of Scripture consisted of preaching, reading, and disputation.[43] First the master gave a lecture on some aspect of an authoritative text, and then the students debated *pro* and *contra* with him, or often, with *bachelarii* overseen by the masters. By 1200, most of Aristotle's major works were available to Latin readers and gave to the dialectical structure of the *quaestio* the substantial resources of Aristotelian logic and philosophic analysis, with their elaborate terminology based on delicate distinctions of meaning, passion for order, and fascination with the categories of substance, accident, and relation. Such *quaestiones* became the mainstay of scholastic philosophy and theology, especially at Paris during the thirteenth and fourteenth centuries, and were used as the basis for commentary on Aristotle's work as well. *Quaestiones disputatae* like those of Aquinas were published, widely read, and even parodied, as we see from Rabelais's *Gargantua* where we learn how Gargantua came to Paris and got a list of the books in the Library of Saint Victor. Among them was one with the magnificent and untranslatable title: "Quaestio subtilissima, utrum Chimera in vacuo bombinans possit comedere secundas in-

tentiones, et fuit debatuta per decem hebdomadas in concilio Constantiensi."[44]

The first word of Peter's title, "*utrum*," "whether" this or that, was also characteristic of the type of *quaestio* called the *quodlibet*, which commonly consisted of an objection to a given thesis, a solution, and then a refutation of the arguments *contra*. The word "*utrum*" indicated that the problem was posed with the possibility of an alternative point of view and usually suggested an opposition or contradiction.[45] Unlike other *quaestiones* held regularly during the academic year, the *quodlibeta* were extraordinary *disputationes* held at Christmas and Easter in which a variety of subjects for debate might be proposed by students, teachers, or even members of the audience, hence the name *quodlibet* or "what you will."[46] Here the master or the bachelor replied to the various problems raised and then a day or so later suspended courses and tried to arrange the subjects proposed—sometimes as many as thirty—in various categories and resolve the problems raised. This was called the *determinatio*. *Quodlibetal* sessions first appeared in the faculty of theology at Paris around 1230 and soon spread to the other faculties of arts, law, and medicine, and from there to Oxford, Bologna, and Cologne.

Peter of Auvergne's *quodlibet*, "Whether Pygmies Be Men," was probably posed and "determined" by him in 1301; undoubtedly it was inspired by Albert's discussion in the *De Animalibus*. It proceeds, typically enough, by first presenting the position contrary to that of the speaker. The initial premise examined is whether two things that agree in form agree in nature. Pygmies agree with man entirely in figure and in individual members; therefore they should share the same human nature.

The familiar social arguments applied by Ratramnus to the Cynocephali come next. When the sun rises in the region where the Pygmies live, they move about, applauding its rising and showing reverence. This act demonstrates that they have religious beliefs. Furthermore, they use arts, as is evident from their warfare with the cranes, and in sowing the earth they rejuvenate nature. Through these arts they exhibit a grasp of universals, which shows them to have the *ratio* by which man is distinguished from animals.

Peter presents his arguments in response to such claims. The nature of man is such that he has a moral sense and a desire for respectability. He is, as well, modest by nature. Since these qualities are not found in Pygmies, these beings cannot be said to be men.

The small size of the Pygmies also disqualifies them from membership in the human race. Citing Aristotle, Peter recalls that man, like

the rest of creation, is subject to certain limits in his size. At the lower end of the scale, just as the smallness of a fire is naturally limited, or the smallness of a plot of land, so is the size of a man. There is likewise limitation at the upper end of the scale. If we take a man of middle stature as exemplifying the nature of the species with respect to size, the Pygmy is deficient by more than seven times, for Pygmies are about half a cubit tall, whereas a middle-sized man is four cubits or more in height. A Giant might exceed the middle-sized man only three or four times. It follows from this that the Pygmy deviates more from the mean than does the Giant. Therefore, Peter concludes, Pygmies do not belong to the human race.

He next attacks the argument that nature follows form, pointing out that though the figures may agree, this does not show agreement in the natures of two species. The wolf, the fox, and the dog agree in form, for example, yet they do not have one and the same nature; likewise the horse, mule, and ass are similar in form, yet clearly are of different natures.[47]

In answer to the claim of religious behavior Peter says that the rising sun warms the Pygmies' bodies by its virtue and expands their vital spirits, causing them to move at the pleasure of these sensations and seem to applaud the sun. Interestingly, Peter's argument on this point is more empirical than that of Albert, who stressed the imitative side of Pygmy activity. Peter observes that such seemingly religious behavior is found in many other animals and even in plants, which open when the sun ascends to the zenith and close tightly when it descends. He concludes that such conduct does not proceed from the rational intellect which creates universals in man, but rather from the senses and from the particulars perceived by them.

From the fact that the Pygmies war with cranes we cannot conclude that they are men, since other animals who are clearly not men fight for food or for mates. As to the argument that, in sowing, the Pygmies provide for their futures and renew nature, this behavior too is found in other animals—for example, the ant and the bee, who provide for the future. Thus, if Pygmies throw seed into the soil, they may be doing it from a particular impulse rather than a universal idea. But, Peter concludes skeptically, "it is not certain that they really do this, since the merchants who carry them off as slaves to our part of the world often make up untrue stories about them. They alter the Pygmies, depiliating, painting, and ornamenting them, in order better to sell them, as I have heard from those who have bought them and carried them to these regions."[48] A reference to information gathered from the slave trade is natural for this author,

who had also commented on Aristotle's *Politics*, with its key statements for the justification of slavery in the Middle Ages.[49] Indeed it reminds us that western European contacts with African peoples at this time were usually through the medium of the slave trade, and that such a medium carried with it a built-in bias concerning the status of the captive race.

Peter's denial of human status to the Pygmies is one of the most sweeping rejections to be given a Plinian people by any scholastic thinker. To the arguments of his predecessors concerning form, reason, social organization, arts, and morality he adds the Aristotelian consideration of scale. Only one major argument is missing from this *quodlibet*, namely the aesthetic need for monstrous men in the universe. Even such an argument would not be incompatible with Peter's case, so long as the primacy of Western man over his foils was maintained. In short, for Peter as for the other Aristotelian thinkers we have considered, it was not possible to grant full and equal humanity to an alien race. Alexander of Hales had grudgingly admitted that a monstrous race could have a human nature even if it were "not rightly propagated," but asserted that the races were deformed by sin. Ratramnus, who viewed them in a more favorable light, was still far from enthusiastic, merely conceding that if what he heard was true, they should "better be considered men than beasts." Albert the Great went to considerable lengths to show that, despite their many abilities, Pygmies had but the shadow of reason. As long as the definition of "man" was based upon a Western model, the monstrous races could only be assigned a subordinate place in the Chain of Being.

Epilogue

As western Europeans shifted their attention from the wonders of Africa and India to the more recent discoveries in the New World, we might expect a corresponding decline in the importance of the monstrous races. Such, indeed, proved to be the case. The decline, however, was gradual and took place in two stages. First, the monstrous men of antiquity were reduced to a single figure, the hairy wild man, and second, this figure became conflated with the aboriginal peoples found in the New World.

The obsolescence of Pliny's monstrous men can be traced to a period well before the voyages of Columbus. As early as the great missionary expeditions we find writers who show a certain skepticism about these peoples. John de Marignolli opens his discussion of Eastern monstrous races with the familiar passage from *The City of God*, but in contrast to writers like Alexander of Hales he tests Augustine's words against his own experience. In his day, he remarks, a hairy girl had been born near Florence, yet there was no hairy race in Tuscany. Though he was "a most curious wanderer of all the provinces of the Indies," having been to Ceylon, the site of Paradise, and having seen with his own eyes the regions where Adam and Eve dwelt, yet he could never determine for a fact that the monstrous races of men existed. Indeed, he was often questioned by Easterners whom he met in his travels as to where these races could be located. The truth of the matter, John concludes, is that there are no nations of monstrous men, though there may be an individual monster here and there. The legendary races are only fictions and distortions of actual customs. Indians, for example, who commonly go about naked save for an umbrella—such as he himself carried in Florence—to

ward off the sun from their heads, were figuratively described by poets as having a single foot.[1]

Although skeptical travelers even at the height of the monstrous races' popularity questioned their existence on the grounds of simple common sense, this attitude grew widespread in the fifteenth and sixteenth centuries—not only from the impact of new discoveries and interest in the Americas, but also from the force of Renaissance empiricism generally. Rabelais, in a parody of the tall travel tale, has Gargantua pass from the land of Satin to the Island of Tapestry. Here he finds a person called Hearsay whose gullet holds seven tongues and who has as many ears as Argos had eyes. "Around him I saw an incredible number of attentive men and women who held a mappamonde and spoke elegantly of prodigies ... and of Troglodytes, of Himantopodes, of Blemmyae, of Cannibals, and the like. There I saw Pliny, Solinus, Albert the Great, and Haytoun of Armenia writing beautiful lies."[2] As this passage suggests, the races were fated to become nostalgic figures, reminiscent of an earlier age, although they survived for a time in the work of the most conservative writers and geographers. One of the last to take them seriously was Cornelius Gemma, who saw in their diversity a symbol of man's degeneration from his original unity with God. In 1575 he wrote: "Shortly after the Flood and the confusion of tongues at Babel were born some men of a completely savage appearance and manner of life ... Androgynes, Icthiophagi, Hippopodes, Sciopods, Himantopodes, Cyclopes ... Pygmies, Giants, Acephali, Cynocephali, Astomi, Panotii, and Anthropophagi. *It is not necessary to go to the New World to find beings of this sort,* for most of them, and others more hideous, can be found right among us" (emphasis added).[3] Despite Cornelius' claim that the Old World was source enough of monstrous men, his contemporaries on the whole had given up expecting to find any there. Increased travel to Africa and the East had made these regions more familiar. But the New World, still virtually unexplored, offered intriguing possibilities.

Expectations of finding all or most of the Plinian races in the New World lived on well into the period of scientific geography. Eldred Jones has seen African travel in the Renaissance as a process of shedding Plinian glasses, and we can say much the same of travel to the Americas.[4] When Columbus made his first voyage in 1492, he met the natives of Guyana and was very surprised to find that they were not physically monstrous, in the sense that we have used this word. Columbus insists over and over again on their physical attractiveness by the standards of his own world. Thus he notes that the In-

dians are "very well built, of very handsome bodies and very fine faces ... They are generally fairly tall and goodlooking, well built."[5] Later, in the Letter to the Sovereigns, Columbus reassures Ferdinand and Isabella that there are no monstrous men in America, only *savage men*. "In these islands I have so far found no human monstrosities, as many expected, on the contrary, among all these people good looks are esteemed ... Thus I have neither found monsters nor had any report of any, except ... a people ... who eat human flesh ... they are no more malformed than the others."[6]

That the discoverers' expectations of Plinian peoples in the New World were widely shared by the European public is shown by some of the popularizing and panegyrical works which informed armchair travelers of the results of these voyages to the "Indies." For example, Dati's Italian verse adaptation of the Letter to the Sovereigns in 1493 went through four later editions. This poetic version of the letter had two sequels, for Dati also wrote two songs of the Indies, which, as one student explained, provided a "supplement of satisfying fantasy to the disappointing reality of Columbus's letter."[7] Dati, who apparently had designed his poems for minstrel recitation in the marketplace, was unsympathetic to the new currents of Renaissance humanism and preferred the older Plinian anthropology.[8] Dati's songs imposed upon the New World the vast myth of Prester John; his Second Song provided a long catalog of the monstrous races, taking up more than half of the poem's fifty-nine ottava rima stanzas. The whole tract is sumptuously illustrated with woodcuts designed by Dati himself in the form of menu pictures similar to those we saw in the fifteenth-century fantasies of Eastern travel.[9] He begins his discussion with the usual homage to *The City of God* and itemizes the Plinian races in the stanzas following. Perhaps the most striking thing about the *Secondo cantare dell' India* is how little fresh material it contains; most of it comes not from the New World but from Foresti's *Chronicon*, and the author was obviously content to let his Plinian glasses keep him from the full impact of the discoveries.

In short, the existence of the Plinian races, tied as it was to a vast body of geographic thought from antiquity and the early Middle Ages, succumbed slowly to the more objective anthropology of the Renaissance because people *wanted* to find these races in the New World and were somewhat disappointed when they did not.[10]

Not only Columbus, but other explorers looked for the races in the Americas. In 1522 Cortez sent back to Charles V some bones supposed to be those of Plinian Giants,[11] and Diego Velasquez told Cortez to seek the Panotii and Cynocephali on his travels.[12] In some

cases, the Plinian peoples were simply exported to the New World. In 1540 Francesco de Orellana called the Amazon by a name familiar to him from the Eastern travel tale, and we find Cynocephali carved on a fountain in the Franciscan convent of Tepaca in Puebla—copied, no doubt, from model books whose sources had been the very illustrations we have been examining.[13]

The actual inhabitants of the New World did not fit easily into the categories of most of the Plinian races, but there was one figure with whom they were often identified. This was the hairy wild man or savage man, not an original Plinian monster but a descendant of several, who begins to appear more and more frequently in European art and literature of the late Middle Ages. Richard Bernheimer describes this being as

a hairy man curiously compounded of human and animal traits, without, however, sinking to the level of an ape. It exhibits upon its naked human anatomy a growth of fur, leaving bare only its face, feet, and hands, at times its knees and elbows, or the breasts of the female of the species. Frequently the creature is shown wielding a heavy club or mace, or the trunk of a tree; and, since its body is usually naked except for a shaggy covering, it may hide its nudity under a strand of twisted foliage worn around the loins.[14]

This creature possesses many of the features of earlier monstrous peoples—hairiness, nudity, the club or tree branch—features that imply violence, lack of civilized arts, and want of a moral sense. The wild man is usually shown in a wooded setting, far from the abode of normal men. By metonymy he has come to represent all of the races, or at least the memory of all the others. His appearances in late medieval literature are most common in German works, where he is a kind of folk monster who carries off women, and in Alexander romances, where he is one of the hostile tribes encountered by the conqueror. In English folklore he is the wodewose or woods dweller, clothed in leaves. Spenser's Salvage Man is the most fully developed form of the hairy wild man in English, with counterparts in the literature of the Spanish Renaissance. In art, the compulsion of Western men to civilize what is rude and to dominate what is wild finds symbolic expression in countless pictures of the savage man or woman holding up a shield or escutcheon displaying someone else's arms.[15] The wild men were also domesticated as a decorative motif, supporting titles and signs or even being featured in them. Hanging outside an inn mentioned by an anonymous traveler to Jerusalem in 1480 was a signboard indicating "Our lodging, the establishment of master John of Liège, at the sign of the wild man."[16]

The wild men and women who lounge in a fifteenth-century Flem-

58. Hairy wild man and woman. Window roundel, Flemish, Fitzwilliam Museum, Cambridge, c. 1450.

ish window roundel at the sides of the owner's armorial bearings (Figure 58) have a long history in legend and blazonry. Their hair or fur now shows the touch of civilization, being waved and soigné in keeping with the decorative function of its owners. In such heraldic scenes wild men have become the servitors of civilized men, their violence now harnessed to guard and support a symbol of chivalry. It is not surprising that this Old World image should be applied to the natives of the Americas. We see it symbolically in the depiction of wild men supporting the arms of empire—the armorial bearings of Charles V—at Tlaxcala in Mexico.[17] However, more than a visual image informed the colonialists' perception of the Indians of the New World as natural slaves.

The pattern of Western conquest and subjugation in Eastern lands was part of the European heritage in the legends of Alexander. Illus-

59. Blemmyae. Råby Church, Denmark, fifteenth century, now destroyed.

trated romances, so popular at the end of the Middle Ages, show as one of Alexander's important adventures in India his military subjugation of the hairy wild men and similar races. Such scenes quickly became part of the stock iconography of German and French Alexander cycles. In Bodley 264 Alexander and his men fight two hairy giants (fol. 36v) and in MS Harley 4979 Alexander burns a wild man because he lacks reason.

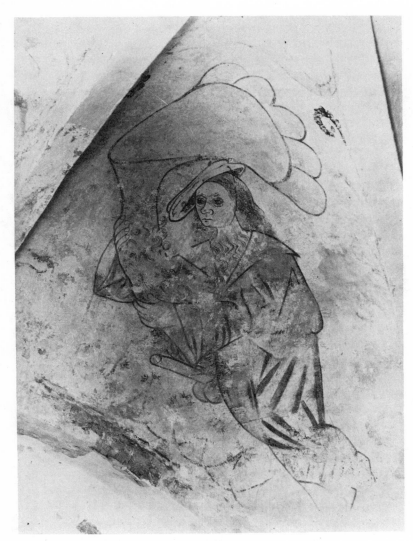

60. Sciopod. Råby Church, now destroyed.

Though the moral defects of savage men were more often implied than spelled out, these were clearly uppermost in the minds of those who set out to conquer or to "civilize" them. Immodest dress and sexual license, two traits that had long offended the West in its dealing with Plinian peoples, were assumed to characterize the New World savages as well. The Indians of the West thus might be said to have inherited their immorality from the monstrous races of the

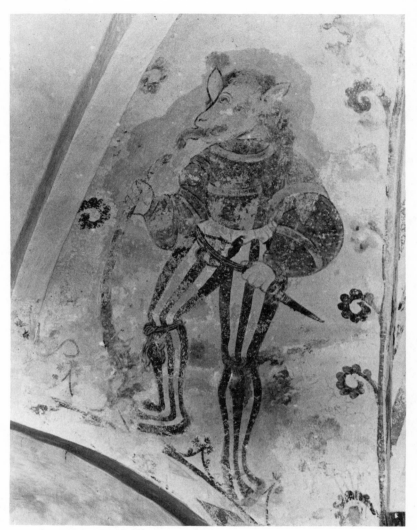

61. Cynocephalus. Råby Church, now destroyed.

East, by way of the hairy wild man, who, as Bernheimer has so well shown, often displayed unbridled and aggressive sexuality (pp. 121–175).

A striking example of the way in which Europe viewed the mores of Plinian races can be found in a group of frescoes (c. 1500) in Råby church, Denmark. In 1918 these scenes were whitewashed over, as being inappropriate for the interior of a church, but photographs of them remain. They present two aspects of the monstrous races—

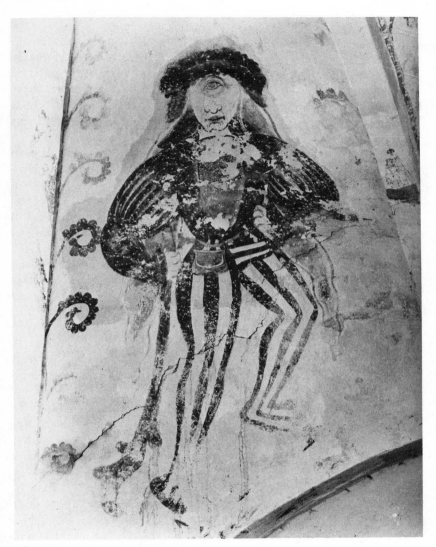

62. Cyclops. Råby Church, now destroyed.

their sexual vitality and their reduction to the stature of amusing, or-
namental figures like the shield-bearing wild men. The first scene
shows a Blemmyae (Figure 59) who covers his sex in a way designed to
attract our attention to it; his remarkable hairiness and boar's tusks
accentuate his bestiality, and he holds what may be a drinking horn.
The Sciopod (Figure 60), clothed in a scholar's robe, is only slightly

less libidinous; aside from his prominent sexual organs, we see his hairy leg and the thick chest hair showing at his open neckline. A Cynocephalus (Figure 61) and a Cyclops (Figure 62), foppishly dressed, complete the cycle; one eats a snake and the other leans on the traditional club of the savage man. A recent student of these paintings has suggested that they symbolized wicked and un-Christian habits, and that it was probably as a warning against sinfulness that such pictures gained a place in Danish churches.[18]

Scandinavian fresco painters denatured the wildness and sexuality of their monstrous men by making them into ornamental caricatures. These qualities in New World monsters, however, were dealt with in more direct ways by an important Aristotelian thinker of the sixteenth century, Juan Ginés de Sepúlveda, who in 1550 engaged in a famous argument with Bartolomeo de Las Casas on the correct methods of propagating Christianity and Spanish capitalism in the New World. De Las Casas argued for peaceful conversion to Christianity of the New World wild men by benign treatment, while Sepúlveda countered that these men—if they were not more beasts than men—were the natural slaves of whom Aristotle spoke, and that their servitude to the conquerors and their conversion should be induced by force.

Sepúlveda stressed as part of his argument the Indians' sinful or perverted sexuality and their unchecked appetites, clearly modeling these New World savages upon the Old World wild men. His observations bear strong echoes of Albert the Great on the subject of the Pygmies. "In prudence, talent, virtue, and humanity they are as inferior to the Spaniards as children to adults, women to men, as the wild and cruel to the most meek, as the prodigiously intemperate to the continent and temperate, that I have almost said, as monkeys to men."[19] Sepúlveda extolls the virtues of the Spaniards who are as fit to rule over Indians as Greeks over Barbarians: "Now compare their gifts of prudence, talent, magnanimity, temperance, humanity, and religion with those little men [homunculos] in whom you will scarcely find traces of humanity; who not only lack culture but do not even know how to write, who keep no records of their history . . . and who do not have written laws but only barbarous institutions and customs . . . What can you expect from men who were involved in every kind of intemperance and wicked lust and who used to eat human flesh?" (p. 85). Finally, in an argument which must surely be drawn from Albert the Great, the Spanish author denies the Indians the *disciplinitas* of an *ars*: "But even though some of them show a talent for certain handicrafts, this is not an argument in favor of a more

human skill, since we see that some small animals, both birds and spiders, make things which no human industry can imitate completely" (p. 85). Arguments once applied in the classrooms of thirteenth-century Paris are here being invoked to justify Spanish actions in the New World. Sepúlveda has in effect exported late medieval attitudes toward the races and transmogrified the Indians of the Americas into Cynocephali, Pygmies, and wild men. The myths of the monstrous races, though geographically obsolete, were too vital to discard. They provided a ready and familiar way of looking at the native people of the New World.

NOTES INDEX

Abbreviations

AHDLMA	*Archives d'Histoire Doctrinale et Littéraire du Moyen Age*
AJA	*American Journal of Archaeology*
AJP	*American Journal of Philology*
ASE	*Anglo-Saxon England*
BL	British Library, London
BN	Bibliothèque Nationale, Paris
CGL	*Corpus Glossariorum Latinorum,* ed. G. Loewe and G. Goetz (Leipzig, 1889–1891)
CSEL	*Corpus Scriptorum Ecclesiasticorum Latinorum*
EETS:ES	Early English Text Society: Extra Series
EETS:OS	Early English Text Society: Original Series
GL	*Glossaria Latina,* ed. W. M. Lindsay et al. (rpt. Hildesheim, 1965)
HLQ	*Huntington Library Quarterly*
JHI	*Journal of the History of Ideas*
LCL	Loeb Classical Library
MGH	Monumenta Germaniae Historica
MLN	*Modern Language Notes*
MLR	*Modern Language Review*
MS	*Mediaeval Studies*
PG	*Patrologia Graeca,* ed. J. P. Migne (Paris, 1857–1886)
PL	*Patrologia Latina,* ed. J. P. Migne (Paris, 1844–1864)
PLL	*Papers on Language and Literature*
PMLA	*Publications of the Modern Language Association of America*
PO	*Patrologia Orientalis,* ed. R. Graffin et al. (Paris and Turnhout, 1907–)
PQ	*Philological Quarterly*
P–W	*Paulys Real-Encyclopädie der Klassischen Altertumswissenschaft,* ed. G. Wissowa (Stuttgart, 1893–)
RTAM	*Recherches de Théologie Ancienne et Médiévale*

Notes

Names of medieval writers and titles of their works are given in their shortest familiar form, and Anglicized wherever possible. Abbreviations in quotations from medieval manuscripts and early printed books have been silently expanded. When possible, I use Loeb Classical Library translations of Greek and Roman authors; translations of medieval texts are mine unless otherwise indicated. Middle English quotations have been modernized. In these notes appear the originals for translated passages that are unpublished or difficult to find.

INTRODUCTION

1. Rudolf Wittkower, "Marvels of the East," *Journal of the Warburg and Courtauld Institutes* 5 (1942): 159–197. Though quite brief, the recent study by Bruno Roy, "En marge du monde connu: Les races de monstres," in Guy-H. Allard et al., eds. *Aspects de la marginalité au Moyen Age* (Montreal, 1975), pp. 71–81, is very helpful. The suggestive study by Claude Kappler, *Monstres, démons et merveilles à la fin du Moyen Age* (Paris, 1980), confines itself to printed sources and woodcut illustrations. Richard Bernheimer, *Wild Men in the Middle Ages* (Cambridge, Mass., 1952), and K. Basford, *The Green Man* (Ipswich, 1977), deal with figures not usually located in the East.

2. A representative example is Heinz Mode, *Fabulous Beasts and Demons* (London, 1975). Far more substantial are V.-H. Debidour, *Le Bestiaire sculpté en France* (Mulhouse, 1961), and J. Baltrušaitis, *Réveils et prodiges* (Paris, 1960). The latter is chiefly interested in the impact of Eastern forms upon Western artists, and does not distinguish between individual polymorphs and the traditional peoples of the East. In this respect he follows G. C. Druce, "Some Abnormal and Composite Human Forms in English Church Architecture," *Archaeological Journal* 72, 2nd ser. (1915): 135–186, who uses the words "prodigy" and "monster" interchangeably; as well as G. Jeanneney, "La Tératologie dans l'art," *La Chronique Médicale* 30 (1923): 129–38, and Robert-Pierre

Fricaud, *Les Malades et les monstres dans la sculpture médiévale* (Bordeaux, 1933).

3. *La Nature et les prodiges*, Travaux d 'Humanisme et Renaissance, vol. 158 (Geneva, 1977).

4. C. Taruffi, *Storia della teratologia*, vol. 1 (Bologna, 1881).

5. Vincent of Beauvais, *Speculum Naturale* (Douai, 1624), 1.31.118, pp. 2387-88.

6. Gustave Flaubert, *La Tentation de St. Antoine*, in A. Thibaudet and R. Dumesnil, eds., *Oeuvres* (Paris, 1951-1952), 1:193.

1. THE PLINIAN RACES

1. See Max Cary and E. H. Warmington, *The Ancient Explorers* (Baltimore, 1963); Lionel Casson, *The Ancient Mariners* (New York, 1964); John Boardman, *The Greeks Overseas* (Baltimore, 1964); and Rhys Carpenter, *Beyond the Pillars of Heracles* (New York, 1966).

2. The best edition of Ctesias is R. Henry, ed., *Ctésias, La Perse, L'Inde: Les Sommaires de Photius* (Brussels, 1947). For biographical information see Henry, pp. 4-8, and F. Jacoby, "Ktesias," in P-W 11 (1922): 2032-73. Johnston Alexander Bowman, "Studies in Ctesias" (diss., Northwestern University, 1938), discusses his connection with Herodotus, pp. 1-7. For an English version of the *Indika*, see John Watson McCrindle, tr., *Ancient India, as Described by Ktesias the Knidian* (rpt. New Delhi, 1973). Both Hugh George Rawlinson, *Intercourse between India and the Western World from the Earliest Times to the Fall of Rome* (Cambridge, 1926), pp. 26-32, and R. C. Majumdar, *The Classical Accounts of India* (Calcutta, 1960), p. xi, treat Ctesias harshly. The English antiquary Edward Tyson hinted at what other ages must have found attractive in Ctesias when he said that "he tells his Story roundly; he no way minces it; his Invention is strong and fruitful; and that you may not in the least mistrust him, he pawns his word, that all that he writes, is certainly true." *A Philological Essay Concerning the Pygmies of the Ancients* (1699), ed. Bertram Windle (London, 1894), p. 20.

3. A. M. Harmon, ed. and tr., *Lucian*, LCL (London and New York, 1921), vol. 1,1.3, p. 251.

4. A convenient edition of Megasthenes is that of E. A. Schwanbeck, ed., *Megasthenis Indica* (rpt. Amsterdam, 1966). For biographical information see O. Stein, *P-W* 15 (1931): 230-323. Favorable opinions of his reliability as an observer of Indian life and customs are offered by Truesdell S. Brown, "The Reliability of Megasthenes," *AJP* 76 (1955): 18-33, and Rawlinson, *Intercourse*, pp. 33-68, and an unfavorable one by R. C. Majumdar, "The Indika of Megasthenes," *Journal of the American Oriental Society* 78 (1958): 276. I use the English version by John Watson McCrindle, ed. and tr., *Ancient India as Described by Megasthenes and Arrian* (rpt. New Delhi, 1972).

5. See the texts in A. Giannini, ed., *Paradoxographorum Graecorum Reliquiae* (Milan, 1966).

6. On the mathematical concerns of the Greek geographers, see James Oliver Thomson, *History of Ancient Geography* (Cambridge, 1948), chs. 5, 11; E. H. Bunbury, *A History of Ancient Geography* (rpt. New York, 1959), vol. 1, ch. 16 and vols. 2, 17, 28; and Aubrey Diller, "The Ancient Measurement of the Earth," *Isis* 40 (1949): 6-9.

7. C. Müller, ed., *Geographi Graeci Minores* (rpt. Hildesheim, 1965),

1:564-565. On the literary nature of geographical description among the Greeks and Romans, see Albrecht Dihle, "The Conception of India in Hellenistic and Roman Literature," *Proceedings of the Cambridge Philological Society* 190, n.s. 10 (1964): 17-19, and F. W. Walbank, "The Geography of Polybius," *Classica et Mediaevalia* 9 (1947): 155-182.

8. The best guides for the literature of Alexander in late antiquity and the Middle Ages are those of D. J. A. Ross, *Alexander Historiatus* (London, 1963), and W. J. Aerts et al., eds., *Alexander the Great in the Middle Ages* (Nijmegen, 1978).

9. W. W. Boer, ed., *Epistola Alexandri ad Aristotelem* (rpt. Meisenheim am Glan, 1973), and Ross, *Alexander,* pp. 27-28.

10. See H. Omont, "Lettre à l'Empereur Adrien sur les merveilles de l'Asie," *Bibliothèque de l'Ecole des Chartes* 74 (1913): 507-515, and Ross, *Alexander,* pp. 32-33.

11. See H. N. Wethered, *The Mind of the Ancient World: A Consideration of Pliny's Natural History* (London and New York, 1937), and William H. Stahl, *Roman Science* (Madison, Wis., 1962), pp. 101-119. I use the edition by H. Rackham, ed. and tr., *Pliny: The Natural History,* LCL (Cambridge, Mass., and London, 1961). A recent study of Pliny is that of Robert Lenoble, *Esquisse d'une histoire de l'idée de nature* (Paris, 1968), pp. 137-213.

12. See, for example, Charles G. Nauert's study of medieval and Renaissance commentaries on the *Natural History,* "C. Plinius Secundus (Naturalis Historia)," in Paul Oskar Kristeller, ed., *Catalogus Translationum et Commentariorum: Mediaeval and Renaissance Translations and Commentaries* 4 (Washington, D.C., 1979), pp. 296-422.

13. On this problem see J. André, "Virgile et les Indiens," *Revue des Etudes Latines* 27 (1949): 157-163, and Albrecht Dihle, "Der fruchtbare Osten," *Rheinisches Museum für Philologie* 105 (1962): 97-110. Marco Polo, in *Il Milione,* ed. L. F. Benedetto (Florence, 1928), 194:209, had called Abyssinia middle India, and Jordanus in his *Mirabilia Descripta: Les merveilles de l'Asie,* ed. Henri Cordier (Paris, 1925), p. 86, called Ethiopia the third India, the first two being India to the west and east of the Ganges. On actual Roman knowledge of Ethiopia, see R. Avelot, "L'Afrique Occidentale au temps des Antonins," *Bulletin de Géographie Historique et Descriptive,* 1908, pp. 37-75; T. Simar, "La Géographie de l'Afrique centrale dans l'antiquité et au Moyen Age," *Revue Congolaise* 3 (1912): 81-102, and S. Detlefsen, *Die Geographie Afrikas bei Plinius und Mela und ihre Quellen* (Berlin, 1908).

14. W. B. Anderson, ed. and tr., *Sidonius: Poems and Letters,* vol. 1, LCL (Cambridge, Mass., 1936), 11.106, p. 209; and G. R. Woodward and H. Mattingly, eds. and trs., *St. John Damascene: Barlaam and Ioasaph,* LCL (Cambridge, Mass., 1937), p. 3.

15. A partial catalog of the races is offered by Ivar Hallberg, *L'Extrême Orient dans la littérature et la cartographie de l'Occident des XIIIe, XIVe, et XVe siècles* (Göteborg, 1906), and can be consulted for locations in Pliny and other compilers.

16. See for description N. R. Ker, *Medieval Manuscripts in British Libraries* 1 (Oxford, 1969), pp. 283-285. This bestiary, formerly Sion College, London MS Arc. L. 40. 2/L. 28, was recently sold at auction. See *Sotheby's Catalogue of Important and Valuable Printed Books and MSS: The Property of Sion College,* June 13, 1977. I am indebted to Linda Voigts for calling this sale to my attention, and to J. M. Owen, Librarian of Sion College, for permission to photograph the manuscript.

17. W. M. Lindsay, ed., *Isidori Hispalensis . . . Etymologiarum . . . Libri* (Oxford, 1957), 11.3.12.

18. See Eric G. Millar, *The Library of A. Chester Beatty: A Descriptive Catalogue* (London, 1927-1938), vol. 2, pl. 191 and pp. 244-254.

19. Rendel Harris, ed. and tr., *The Voyage of Hanno* (Cambridge, 1928), 18, p. 27.

20. Solinus in T. Mommsen, ed., *C. IVLii Solini Collectanea Rervm Memorabilivm* (Berlin, 1958), shows a little less skepticism: "Maritimos Aethiopas quaternos oculus dicunt habere" (30: 131). On this author see Mommsen's introduction and also Stahl, *Roman Science*, pp. 136-142. On his reshaping of Pliny's material on the monstrous races see Hermann Walter, "C. Julius Solinus und seine Vorlagen," *Classica et Mediaevalia* 24 (1963): 86-157.

21. Homer, *Iliad* 3.6; and Herodotus, *Histories*, tr. A. D. Godley, vol. 1, LCL (Cambridge, Mass., and London, 1920), 2.32.6. See also Frank M. Snowden, Jr., *Blacks in Antiquity: Ethiopians in the Greco-Roman Experience* (Cambridge, Mass., 1970), p. 166. The scenes of Pygmies as crocodile hunters which appear in Pompeian frescoes seem to reflect actual hunting practices of these people. See W. B. McDaniel, "A Fresco Picturing Pygmies," *AJA* 36 (1932): 260-271, pl. 9.

22. See V. J. Harward, *The Dwarfs of Arthurian Romance and Celtic Tradition* (Leiden, 1958), and Jacques de Vitry, *Historia Orientalis* (rpt. Meisenheim am Glan, 1971), ch. 92, p. 215. See on this author J. F. Hinnebusch, ed., *The Historia Occidentalis of Jacques de Vitry* (Fribourg, 1972), for biographical and bibliographical details.

23. One thinks in this context of what Paul Zumthor, *Essai de poétique médiévale* (Paris, 1972), calls the "mobilité essentielle du texte médiévale . . . l'oeuvre ainsi conçue, est par définition dynamique. Elle croît, se transforme, et décline" (p. 73).

24. Curt J. Wittlin, "Synchronic Etymologies of Ethnonyms as Cause of the Traditional Belief in Monstrous Races," in *Second Language Teaching 75: Proceedings of the Twenty-Sixth Annual Meeting of the Pacific Northwest Council on Foreign Languages* (Vancouver, 1975), pp. 268-273, has some interesting theories on the creation of new races through etymological confusion.

25. *Natural History* 7.2.23, p. 520: "hominum genus qui Monocoli vocentur." A good example of this process of creative misreading may be seen in the Rothschild Canticles, a fourteenth-century Netherlandish manuscript (no. 404) in the Beinecke Library, Yale. The manuscript was described by M. R. James in *Description of an Illuminated Manuscript of the XIIIth Century in the Possession of Bernard Quaritch* (London, 1904), and more recently by Walter Cahn and James Marrow in "Medieval and Renaissance Manuscripts at Yale: A Selection," *Yale University Library Gazette* 52 (1978): 202-203. A portion of the manuscript dealing with the monstrous races shows a Sciopod standing on his gigantic foot rather than, as usual, holding it above his head. The text for the picture speaks of those who "currit cum uno crure monorulus [read *monoculus*] erit et vocabitur ciclops," fol. 113v. The manuscript may once have been owned by Jeanne de Valois, c. 1290-1353.

26. The parallel Latin and French texts are published by Alfons Hilka, "Ein uer (altfranzösischer) Text des Briefs über die Wunder Asiens," *Zeitschrift französische Sprache und Literatur* 46 (1923): 100.

Hilka, "Ein neuer," p. 101.

David Barrett and Michael McCann, "Discovered: Two-Toed Man," *Times Magazine* (London), January 13, 1980, pp. 28-31.

29. Hermann Stadler, ed., *Albertus Magnus de Animalibus Libri XXVI,* in *Beiträge zur Geschichte der Philosophie des Mittelalters* 15 (Münster, 1916), 2. 1. 4, p. 247. Solinus anticipates this rational explanation: "Cynocephali . . . sunt e numero simiarum" (Mommsen, *Collectanea* 27, p. 128). On the whole matter of the ape in antiquity and the Middle Ages, see the fascinating study by H. W. Janson, *Apes and Ape Lore* (London, 1952), especially ch. 3, which deals with the ape in medieval scientific writing.

30. *Historiae Ecclesiasticae* 1.7 PG 86, 2438. See K. Sethe, "Blemyes," in *P-W* 3.1 (1897): 566–568, and Snowden, *Blacks in Antiquity,* pp. 136, 138.

31. See Xenophon, *Anabasis* 4.5, 26f, and Archilochus 42, in M. L. West, ed., *Iambi et Elegi Graeci* (Oxford, 1971) 1:19. On the whole subject see Wolfgang Röllig, *Bier im alten Mesopotamien* (Berlin, 1970). I am grateful to David Sider for these references. See also H. Hosten, "The Mouthless Indians of Megasthenes," *Journal and Proceedings of the Asiatic Society of Bengal,* n.s. 8 (1912): 293.

32. Though the focus is chiefly on post-Renaissance attitudes toward India, Partha Mitter's *Much Maligned Monsters: History of European Reactions to Indian Art* (Oxford, 1977), pp. 1–16, makes some interesting observations about medieval responses to Indian religious statuary.

2. A MEASURE OF MAN

1. On this point see Annie Dorsinfang-Smets, "Les Etrangers dans la société primitive," *L'Etranger* (*Recueils de la Société Jean Bodin*) 9 (1958): 60.

2. See John Gilissen, "Le Statut des étrangers," *L'Etranger* 9 (1958): 10.

3. See on this subject, H. C. Baldry, *The Unity of Mankind in Greek Thought* (Cambridge, 1965), pp. 4, 10.

4. The *periegesis* or *periplus* in antiquity followed the order of cities, peoples, and the like as a sailor would encounter them in traveling the coasts. See F. Gisinger, "Periplus," *P-W* 19.1 (1937): 839–850. The earliest example is the lost treatise of Hecataeus of Miletus, c. 500 B.C., on which see Lionel Pearson, *Early Ionian Historians* (Oxford, 1939), pp. 30, 34ff. Scylax of Caranda, an explorer for Darius, has a *periplus* in the fourth century associated with his name. The author described gigantic Ethiopians, and bearded, hairy, and extremely attractive men; see C. Müller, ed., *Geographi Graeci Minores* (rpt. Hildesheim, 1965), 1.54, p. 94.

5. See Agatharcides of Cnidos, *De Mari Erythraeo,* in Müller, *Geographi Graeci* 1.40, pp. 134f; 51, p. 142; 55, pp. 146f; 60, pp. 152f. Even Saint Jerome, in the *Adversus Jovinianum* 2.7, discusses at length the unusual things distant races eat, mentioning Troglodytes, Scythians, and Icthiophagi, *PL* 23, 294–297.

6. Arsène Soukry, ed. and tr., *Géographie de Moïse de Corène* (Venice, 1881), 4.7–8, pp. 28–29. On the whole subject see Clarence J. Glacken, *Traces on the Rhodian Shore* (Berkeley and Los Angeles, 1967), p. 21.

7. These miniatures, from Paris BN Fr. 2810, a fifteenth-century manuscript made for John the Fearless, Duke of Burgundy, have been published by H. Omont, *Livre des Merveilles: Reproduction des 265 miniatures du manuscrit français 2810 de la Bibliothèque Nationale,* 2 vols. (Paris, 1907). The manuscript, dating from 1403, contains a variety of Eastern travel texts: Marco Polo, Oderic of Pordenone, Letters of the Khan to Pope Benedict XII, John of Cor, Archbishop of Sultanieh's "Book of the State of the Great Kahn," Mandeville, Haytoun of Armenia's "Flowers of History," and an itinerary by Ricoldo de

Monte Croce. The makeup of the manuscript has been discussed and portions published by Louis de Backer, *L'Extrême Orient au Moyen Age* (Paris, 1877). Mandeville occupies folios 141r-225v. On Mandeville see J. W. Bennett, *The Rediscovery of Sir John Mandeville* (New York, 1954), and, more recently, Donald Howard, "The World of Mandeville's Travels," *Yearbook of English Studies* 1 (1971): 1-17; C. W. R. D. Moseley, "The Metamorphoses of Sir John Mandeville," *Yearbook of English Studies* 4 (1974): 5-25; and Christian K. Zacher, *Curiosity and Pilgrimage* (Baltimore and London, 1976), pp. 130-157.

8. M. C. Seymour, ed., *The Metrical Version of Mandeville's Travels*, EETS: OS 269 (London, 1973), ll. 2506-2509; 2511-2513; 2517; 2529-2531.

9. P. Hamelius, ed., *Mandeville's Travels*, EETS: OS 153 (rpt. London 1960, 1961), ch. 33, p. 198.

10. See on the Greek sense of this word J. Jüthner, *Hellenen und Barbaren aus der Geschichte des Nationalbewusstseins* (Leipzig, 1923), and H. H. Bacon, *Barbarians in Greek Tragedy* (New Haven, 1961). For its changing sense among Latin-speaking peoples, see W. R. Jones, "The Image of the Barbarian in Medieval Europe," *Comparative Studies in Society and History* 13 (1971): 376-407. Saint Augustine observed that "the diversity of languages separates one man from another. For if two men, each ignorant of the other's language, meet and are compelled by some necessity not to pass on but to remain together, then it is easier for dumb animals, even of different kinds, to associate together than for them, though both are human beings. For where they cannot communicate their views to one another, merely because they speak different languages, so little good does it do them to be alike by endowment of nature, so far as social unity is concerned, that a man would rather have his dog for company than a foreigner." William Chase Greene, ed. and tr., *Saint Augustine: The City of God*, vol. 6, LCL (Cambridge, Mass., and London, 1959), 19.7, p. 149.

11. Rendel Harris, *The Voyage of Hanno* (Cambridge, 1928) 11, p. 26: "The coast . . . was at every point occupied by Ethiops; . . . their talk was unintelligible even to our Lixite friends."

12. Soukry, *Géographie*, 6.34, p. 56.

13. See Guy De Poerck, "Le Corpus Mandevillien du MS Chantilly 699," in G. De Poerck et al., eds., *Fin du Moyen Age et Renaissance: Mélanges de philologie française offerts à Robert Guiette* (Anvers, 1961), pp. 31-32.

14. Riccardo Quadri, ed., *Anonymi Leidensis de Situ Orbis Libri Duo* (Padua, 1974), 2.5.15, p. 49.

15. Saint Ambrose, *De Cain et Abel*, 1.1, PL 14, 317.

16. Philip Levine, ed. and tr., *Saint Augustine: The City of God*, vol. 4, LCL (London and Cambridge, Mass. 1966), 15.1, pp. 413-415.

17. This miniature was published by A. de Laborde, *Les Manuscrits à peintures de la Cité de Dieu de Saint Augustin*, 3 vols. (Paris, 1909), vol. 2, pl. 94. See vol. 1, pp. 423-448, for discussion.

18. Huguccio of Pisa, *Magnae Derivationes*, Vat. Reg. Lat. 1627, fol. 144: "et dicitur sic quasi monstruosa quia qui eam movit et induitur in ferarum habitum transformatur. Unde mastrucatus . . . mastruca indutus."

19. Alice M. Colby-Hall, *The Portrait in Twelfth-Century French Literature* (Geneva, 1965), p. 171.

20. See Paul Salmon, "The Wild Man in 'Iwein' and Medieval Descriptive Technique," *MLR* 56 (1961): 520-528.

21. See Roger Sherman Loomis, *Arthurian Legends in Medieval Art* (New York, 1938), fig. 161.

22. Aimon de Varennes, *Florimont*, ed. Alfons Hilka (Göttingen, 1932), l. 3197, p. 124.

23. See for examples J. Campion et al., eds., *Sir Perceval of Gales* (Heidelburg, 1913), l. 2018; A. S. Cook, ed., *Sir Eglamour* (New York, 1911), l. 308; S. J. Herrtage, ed., *Sir Ferumbras*, EETS:ES 34 (rpt. London, 1966) l. 4653; Emil Hausknecht, ed., *The Sowdone of Babylone*, EETS:ES 38 (London, 1881), l. 2919; and W. W. Skeat, ed., *The Romans of Partenay*, EETS:OS 22 (London, 1899), l. 4177.

24. Munich Staatsbibliothek CLM 18158 (Tegernsee) fol. 63, eleventh century. See also a Benedictine antiphoner from Suabia, Karlsruhe Bad. Landesbibliothek Aug. Perg. 60, fol. 2r. These miniatures are discussed by Gérard Cames, *Allégories et symboles dans l'Hortus Deliciarum* (Leiden, 1971), pp. 117–120; the second example appears as pl. 63, fig. 117. A miniature depicting the choleric temperament in BL Add. 17987, fol. 88r, shows a man beating a woman with a club. It has been published by Fritz Saxl and Hans Meier, *Catalogue of Astrological and Mythological Illuminated Manuscripts of the Latin Middle Ages* (London, 1953), vol. 3.2, pl. 88, Fig. 228.

25. See on this subject A. A. Barb, "Cain's Murder-Weapon and Samson's Jawbone of an Ass," *Journal of the Warburg and Courtauld Institutes* 35 (1972): 386–389, which gives a comprehensive bibliography.

26. This is BN Paris Lat. 8846, fol. 1v, end of the twelfth century.

27. H. Rackham, ed. and tr., *The Nicomachean Ethics*, by Aristotle, LCL (Cambridge, Mass., and London, 1962), 2.6.5.9–14, pp. 91, 93, 95.

28. Edgar de Bruyne, *Études d'esthétique médiévale* (Bruges, 1946), pp. 135–141. See also Katherine George, "The Civilized West Looks at Primitive Africa: 1400–1800. A Study in Ethnocentrism," *Isis* 49 (1958): 62–72.

29. See Glacken, *Traces on the Rhodian Shore*, p. 17, and Baldry, *The Unity*, pp. 17, 167.

30. For good general discussions of climatic theory, see Glacken, *Traces on the Rhodian Shore*, pp. 80–115; Marian J. Tooley, "Bodin and the Mediaeval Theory of Climate," *Speculum* 28 (1953): 64–83, especially 64–70; and Frank M. Snowden, Jr., *Blacks in Antiquity: Ethiopians in the Greco-Roman Experience* (Cambridge, Mass., 1970), pp. 172–176.

3. AT THE ROUND EARTH'S IMAGINED CORNERS

1. Robert Belle Burke, tr., *The Opus Majus of Roger Bacon* (New York, 1962), 1.1.5, p. 159. Mesue, the tenth-century Arabic author of a work on simples, had claimed that place was the key to all things relating to generation and that it gave forms and properties to things; *Canones vniversales divi Mesue* (Venice, 1513), sig. A, fol. vi verso. See also the important discussion by Albert the Great in Sister Jean Paul Tilmann, tr., *An Appraisal of the Geographical Works of Albertus Magnus* (Ann Arbor, 1971), *De Natura Locorum* 1.5, p. 47.

2. See George H.T. Kimble, *Geography in the Middle Ages* (London, 1938), p. 187.

3. For an extreme moral view of geographic space, see the maps of the Italian scholar Opicinus de Canistris (1296–1336), which made land masses into stylized and demonic shapes. See R. Salomon, ed., *Opicinus de Canistris, Weltbild und Bekenntnisse eines Avignonesischen Klerikers des 14. Jahrhunderts* (London, 1939), as well as his more recent and very fascinating study, "A Newly Discovered Manuscript of Opicinus de Canistris," *Journal of the War-*

burg and Courtauld Institutes 16 (1953): 45–57, especially p. 51 and plates 13, 14, and 15.

4. See Michael C. Andrews, "The Study and Classification of Medieval Mappae Mundi," *Archaeologia* 75 (1926): 65. For a good survey of the literature of maps see Leo Bagrow, *History of Cartography* (rev. ed. R. A. Skelton, Cambridge, Mass., 1964); Dana B. Durand, *The Vienna-Klosterneuburg Map Corpus of the Fifteenth Century* (Leiden, 1952), pp. 13–20; and Anna-Dorothee von den Brincken, " '. . . ut describeretur universus orbis.' Zur Universalkartographie des Mittelalters," *Miscellanea Mediaevalia* 7 (1970): 249–278, and "Mappa mundi und Chronographia," *Deutsches Archiv für Erforschung des Mittelalters* 24 (1968): 118–186.

5. See Marcel Destombes, *Mappemondes* A.D. *1200–1500: Monumenta Cartographica Vetustioris Aevi*, vol. 1, (Amsterdam, 1964), p. 3.

6. "Azie vers orient . . . Affrique et Europe vers occident, et Affrique devers l'equinocial, et Europe devers septentrion. Et entre cest deux parties est la mer de Midterre." Lillian M. McCarthy, ed., "Maistre Nicole Oresme, traité de l'espere" (diss., University of Toronto, 1943), ch. 31, p. 205. McCarthy bases her edition on Paris BN. Fr. 1350 as the best of the Oresme manuscripts. On this important author see Marshall Clagett, "Nicole Oresme and Medieval Scientific Thought," *Proceedings of the American Philosophical Society* 108 (1964): 298–309, for bibliography. Also helpful are the recent studies by Bert Hansen, "Nicole Oresme and the Marvels of Nature" (diss., Princeton University, 1974), and Eugenia Paschetto, *Demoni e prodiga: Note su alcuni scritti di Witelo e di Oresme* (Turin, 1978).

7. "Un T dentro ad un O mostra il disegno / Come in tre parti fu diviso il Mondo." G. C. Galletti, ed., *La Sfera di F. Leonardo di Stagio Dati* (Florence, 1859), bk. 3, p. 9. and Destombes, *Mappemondes*, pp. 249–251.

8. William Harris Stahl, ed. and tr., *Commentary on the Dream of Scipio*, by Macrobius (New York, 1966), ch. 5, pp. 201–202, and Stahl, *Roman Science* (Madison, Wis., 1962), pp. 158–169.

9. See Destombes, *Mappemondes*, pp. 40–42 and 79–80, and G. Menéndez-Pidal, (Mozárabes y Asturianos," *Boletin de la Real Academia de la Historia* 134 (1954): 137–291, which includes in the form of line drawings most of the Beatus maps with rubrics. The most recent study is Peter K. Klein, *Der ältere Beatus-Kodex, Vitr. 14-1 der Biblioteca Nacional zu Madrid: Studien zur Beatus-Illustration und der spanischen Buchmalerei des 10. Jahrhunderts* (Hildesheim and New York, 1976).

10. Plato, too, makes the earth spherical in *Phaedo* 108–109. Interestingly, Bede had no trouble accepting the spherical concept, remarking in the *De Natura Rerum* that the earth was spherical (3, *PL* 90, 192) and that "orbem terrae dicimus" (ch. 46, 264). The best general study of this subject is that of Charles W. Jones, "The Flat Earth," *Thought* 9 (1934): 296–307. For scholastic attitudes toward the sphericity of the earth, see Ida Gobbo, "Il pensiero geografico di S. Alberto Magno," *Università degli studi di Torino Facoltà di Magistero: Scritti vari* 1 (1950): 369–377, and P. Mandonnet, "Les idées cosmographiques d'Albert le Grand," *Revue Thomiste* 1 (1893): 46–64.

11. Chief among them was Cosmas Indicopleustes, fl. c. 535. See W. Wolska-Conus, *La Topographie chrétienne de Cosmas Indicopleustès*, in *Théologie et Science au VIe Siècle* (Paris, 1962), pp. 113–218.

12. See Mandonnet, "Les Idées," pp. 58f.

13. See Lynn Thorndike, tr., *The Sphere of Sacrobosco and its Commentators* (Chicago, 1949).

14. The Ghent manuscript of Lambert's work has been sumptuously edited by A. Derolez, *Liber Floridus* (Ghent, 1968). See also his *Liber Floridus Colloquium* (Ghent, 1973).

15. For handlists of maps in Bartholomaeus, Isidore, Bede, Gautier, and William of Conches, see Destombes, *Mappemondes*, passim.

16. Jacques de Vitry, *Historia Orientalis* (rpt. Meisenheim am Glan, 1971), ch. 92, p. 215. Pierre Bersuire speaks of a mappamundi as the fourth of his works in the prologue to his translation of Livy. See René A. Meunier, "Le Livre des 'Merveilles du monde' de Pierre Bersuire," *Annales de l'Université de Poitiers*, d.s. 3 (1950), p. 105, and more recently Charles Samaran, "Pierre Bersuire," in *Histoire Littéraire de la France* (Paris, 1962), vol. 39, p. 418, and J. Engels, "Berchoriana I" and "Berchoriana I: Suite," *Vivarium* 2 (1964): 62–124.

17. "Sine mapa mundi ea, que dicuntur de filiis ac filiis filiorum Noe et que IIIIor monarchis ceterisque regnis atque provincias tam in divinis quam in humanis scripturis, non tam difficile quam impossible dixerim ymaginari aut mente posse concipere. Requiritur autem mapa duplex, picture et scripture. Nec unum sine altero putes sufficere, quia pictura sine scriptura provincias seu regna confuse demonstrat, scriptura vero non tamen sufficienter sine adminiculo picture provinciarum confinia per varias partes celi sic determinat, ut quasi ad oculum conspicui valeant." The prologue occurs in Vat. Lat. 1960, fol. 13. On Paulinus see Alberto Ghinato, *Fr. Paolino da Venetia OFM, Vescovo di Pozzuoli* (Rome, 1951) and von den Brincken, " '... ut describeretur universus orbis,' " pp. 260–263, 272.

18. W. M. Lindsay, ed., *Etymologiarum Libri* (Oxford, 1957), 9.2.105. The Hippocratic *Airs, Waters, Places*, in which this concept is developed at length, was not generally known in the West until after the ninth century.

19. Churchill Babington, ed., *Polychronicon Ranulphi Higden*, Rolls Series 41 (London, 1865; rpt. 1964), 1.34, p. 361, Trevisa's translation. The best study of Ranulf is John Taylor, *The 'Universal Chronicle' of Ranulf Higden* (Oxford, 1966).

20. See Destombes, *Mappemondes*, pp. 168–170, for discussion and bibliography. See also Bagrow, *A History*, p. 45, and von den Brincken, " '... ut describeretur universus orbis,' " p. 268 and pl. 1.

21. Lindsay, *Etymologiarum* 14.3.21.

22. Rhabanus Maurus, *De Universo* 12.4, PL 111, 339.

23. Hugh of St. Cher, *Opera Omnia in Universum Vetus et Novum Testamentum* (Venice, 1732), vol. 2, fol. 189. An interesting blend of science and theology can be seen in the way in which Jerusalem was made the literal center of the world with the Church of the Holy Sepulcher as its still point. An English pilgrim, William Wey, wrote an itinerary of his trip to Jerusalem in which he mentions bringing back a souvenir map of the Holy Land "wyth Jerusalem in the myddys." See B. Bandinel, ed., *The Itineraries of William Wey* (London, 1857), p. xxix. Adamnan in his *De Locis Sanctis*, ed. Denis Meehan, *Scriptores Latini Hiberniae* 3 (Dublin, 1958), 1.11, p. 57, speaks of "a very high column which stands in the centre of the city ... It is remarkable how this column ... fails to cast a shadow at midday during the Summer solstice, when the sun reaches the center of the heavens ... And so this column ... proves Jerusalem to be situated at the centre of the world ... and its navel." Another pilgrim, Bernard the Wise, c. 870, says that there are four main churches in Jerusalem whose walls all enclose an unroofed porch. Four chains come from each church to join in a point over the center of the world. See J. H. Bernard, tr., *The Itinerary of Bernard the Wise*, Palestine Pilgrims Text Society 3 (rpt. New

York, 1971), 11, p. 8. The fourteenth-century Moslem historian Ibn Khaldun was presumably adapting this idea when he made Mecca the center of the earth. See F. Rosenthal, tr., *The Muqaddimah* (Princeton, 1967) vol. 2, p. 249 f. How to square the mathematical geography of Ptolemy with a central placement of Jerusalem posed a problem for Christian geographers. Though it is placed "rather more towards the east," Pseudo-Moses of Chorene said, "according to the calculations of Ptolemy," through a process of mathematical juggling he was able to keep Jerusalem in the center (Arsène Soukry, ed., *Géographie de Moïse de Corène* (Venice, 1881), 1:14–15. Needless to say, genuinely scientific geographers of the later Middle Ages held no brief for this theological interpretation. The cosmographer Pierre d'Ailly speaks of "the fallacy of the common opinion that Jerusalem is situated in the midst of the earth, to conform with the Psalm 73.12." See Edwin F. Keever, tr., *Petrus Ailliacus: Imago Mundi* (Wilmington, N.C., 1948), ch. 15, p. 19. Edmond Buron, ed. and tr., *Ymago Mundi*, by Pierre d'Ailly, 3 vols. (Paris, 1930), 1:37–113, discusses d'Ailly's life and work. Mandeville tried to see the problem as a metaphor, saying that Jerusalem "is the herte and the myddes of all the world, wytnessynge the philosophere that seyth thus: Virtus rerum in medio consistit." P. Hamelius, ed., *Mandeville's Travels*, EETS:OS 153 (rpt. London, 1960, 1961), prologue, p. 1.

24. See A. R. Anderson, *Alexander's Gate, Gog and Magog, and the Inclosed Nations* (Cambridge, Mass., 1932). On the concept among Islamic geographers, see André Miquel, *La Géographie humaine du monde musulman jusqu'au milieu du XIe siècle: Géographie et géographie humaine dans la littérature arabe des origines à 1050*, pt. 2: *Géographie arabe et représentation du monde: La terre et l'étranger* (Paris and The Hague, 1975), ch. 9, pp. 483–513.

25. See Fritz Saxl, "Illustrated Mediaeval Encyclopaedias 2: The Christian Transformation," in *Lectures* (London, 1957), pp. 243–244, and Jacques Fontaine, ed. and tr., *Isidore de Seville: Traité de la Nature* (Bordeaux, 1960), ch. 102, pp. 216–217 and fig. 5. A Mundus Annus Homo design incorporating monstrous races occurs in the rose window of the cathedral at Lausanne. There a central Christ is surrounded by interlaced circles containing personifications of seasons, winds, elements, and constellations. At the outer edge of the cosmos are circles containing an Ethiopian, a Blemmyae, a Pygmy, a Sciopod, and a Cynomolgus, among others. See Ellen J. Beer, *Die Rose der Kathedrale von Lausanne und der Kosmologische Bilderkreis des Mittelalters* (Bern, 1952) and the same author's *Die Glasmalereien der Schweiz: Corpus Vitrearum Medii Aevi: Schweiz I* (Basel, 1956), plates 32a–34. She discusses the monstrous races in the rose in *Die Glasmalereien*, pp. 53–55. In a different medium, a pavement at the cathedral of Casale Monferrato in Lombardy followed a similar scheme. During restoration of the cathedral, fragments of a cosmological pavement were found depicting an Acefalus (Blemmyae), an Antipode, and a Pygmy struggling with a crane. The Casale pavement was published in a watercolor by P. Toesca, *La pittura e la miniatura nella Lombardia* (Milan, 1912), fig. 60. See Arthur Kingsley Porter, *Lombard Architecture* (New Haven, 1916), 2:244–256, and Noemi Gabrielli, *L'Arte a Casale Monferrato dal XI al XVIII secolo* (Turin, 1935), pp. 173–176, for dating and discussion. On cosmological mosaics in general see Ernst Kitzinger, "World Map and Fortune's Wheel: A Medieval Mosaic Floor in Turin," *Proceedings of the American Philosophical Society* 117 (1973): 344–373.

26. This map is discussed by Destombes, *Mappemondes*, pp. 197–202. See also Bagrow, *A History*, pp. 48–50. Supplementing Destombes are G. R. Crone,

"New Light on the Hereford Map," *Geographical Journal* 131 (1965): 447-462, and A. L. Moir, *The World Map in Hereford Cathedral* (Hereford, 1979).

27. This map was published by Konrad Miller, *Die Ebstorfkarte* (Stuttgart, 1896). His facsimile is not completely satisfactory. A convenient color picture appears in Bagrow, *A History*, pl. E, but to my knowledge there is no large-scale photographic reproduction. Hanno Beck, *Geographie* (Munich, 1973), p. 417, notes that a painter, Rudolf Wieneke, did a 2.5:1 reproduction of the map. The only pictures that give a sense of the Ebstorf map's peculiar charm are those published by Otto Stollt, "Eine Weltchronik im Bild: Die Ebstorfer Weltkarte," *Westermann's Monatshefte*, September 1955, pp. 55-60. For general discussion and bibliography see Destombes, *Mappemondes*, pp. 194-197, and Armin Wolf, "Die Ebstorfer Weltkarte als Denkmal eines mittelalterlichen Welt-und Geschichtsbildes," *Geschichte in Wissenschaft und Unterricht* 8 (1957): 204-215. On the possibility of authorship by Gervase of Tilbury see Bagrow, *A History*, pp. 48-49. The tortuous argument for a date in the 1370s made by Werner Ohnsorge, "Zur Datierung der Ebstorfer Weltkarte," *Niedersachsisches Jahrbuch für Landesgeschichte* 33 (1961): 173, is untenable on paleographic and stylistic grounds.

28. Moir, *The World Map*, p. 24. This point is interestingly discussed, with parallels, by Wolf, "Die Ebstorfer Weltkarte," pp. 210 f.

29. See also Hugo Rahner, *Greek Myths and Christian Mystery* (London, 1963), pp. 50-58.

30. Richard of Haldingham depicts Augustus Caesar assigning the task of surveying the Roman Empire to his *agrimensores*, a process that resulted in the map made by Vipsanius Agrippa between 30 and 12 B.C. and was responsible for the geographical features of both of our maps. Trade and military routes were added later from Roman itineraries.

31. For a good overview and bibliography of this subject see Dorothee Metlitzki, *The Matter of Araby in Medieval England* (New Haven and London, 1977), pp. 197-210 and notes.

32. For general surveys of late antique and medieval attitudes toward the Antipodes see Armand Rainaud, *Le Continent austral* (Paris, 1893), pp. 19-167; G. Boffito, "La leggenda degli antipodi," in *Miscellanea di Studi Critici Edita in Onore di Arturo Graf* (Bergamo, 1903), pp. 583-601; and P. Gilbert, "Le Pape Zacharie et les Antipodes," *Revue des Questions Scientifiques* 12 (1882): 478-503. P. Delhaye, ed., *Le Microcosmus de Godefroy de Saint Victor* (Lille and Gembloux, 1951), prints a number of patristic and medieval texts relating to this question.

33. A. Dick, ed., *Martianvs Capella* (Stuttgart, rpt. 1969), bk. 6, p. 298. On this author see William H. Stahl et al., *Martianus Capella and the Seven Liberal Arts* (New York, 1971), vol. 1, pp. 1-40. Volume 2, *The Marriage of Philology and Mercury* (New York, 1977), contains the first English version ever made of this work.

34. Lindsay, *Etymologiarum* 11.3.24.

35. Cambridge University Library, MS Kk. 4.25, fol. 52r: "Antipodes in Libia plantas versus habent post crura, et octenos digitos in plantis, fabulose autem coniectant quidam antipodes ex eo dictos. quod contrarii sunt uestigiis nostris, ut quasi sub terris positi, adversa pedibus nostris calcent uestigia, quod nulla ratione credendum est, quia nec soliditas nec centrum terre haec patitur."

36. Eva Matthews Sanford and William M. Green, eds. and trs., *Saint Augustine: The City of God*, vol. 5, LCL (London and Cambridge, Mass., 1965), 16.9, p. 51.

37. "Ceste opinion n'est pas a tenir, et n'est pas bien concordable a nostre foy, car la loy Jhesucrist a este preschie par toute terre habitable. Et selon ceste opinion, telles gens ne n'auroient oncques oy parler ne pouuoient estre subges a l'eglise de Romme." McCarthy, "Maistre Nicole Oresme," ch. 30, p. 196.

38. Published by A. de Laborde, *Les Manuscrits à peintures de la Cité de Dieu de Saint Augustin,* 3 vols. (Paris, 1909), vol. 3, pl. 102c; discussed in vol. 2, p. 443.

39. "Eziopia ubi sunt gentes diverso vultu et monstruosa specie orribilis preversa usque ad fines Egipti." A free rendering of Isidore, Lindsay, *Etymologiarum* 14.5.14.

40. "Deserta terra vicina soli ad ardore incognita nobis." Ibid., 14.5.17.

41. "Orbis quarta pars trans oceanum interior est qui solis ardore incognita nobis est cuius finibus antipotas babuloso est inabitare produntur." This map and its rubrics have been published in the magnificent edition of Jaime Marquis Casanovas et al., *Sancti Beati a Liebana in Apocalypsin Codex Gerundensis* (Olten and Lausanne, 1962), fol. 54v–55r. Interestingly, Pseudo-Moses of Chorene, writing about the same time this map was made, is very skeptical about what is to be found in the *terra incognita:* "They say that near the *terra incognita* live man-bodies, half-bodies, two-faces, six-handers . . . dragon-feet, half-birds, half-men, headless men, dog-headed men, and the like. For my part these things are completely incredible; others can believe them if they wish." Soukry, *Géographie* 7.38, p. 62.

42. "Scopodum fertur habitare singulis cruribus et celeritate mirabili quos inde sciopodas greci vocant eo quod per estum in terra resupini jacentem pedem suor magnitudinem adumbrentur." After Isidore, in Lindsay, *Etymologiarum* 11.3.23.

43. W. R. Paton, ed. and tr., *Polybius: The Histories,* vol. 2, LCL (London and New York, 1922), 4.21, p. 351.

44. Albumazar, *Introductorium in Astronomiam* (Augsburg, 1485), 2.2, sig. f, 4v–5. A score of astrological works by Albumazar were translated into Latin during the Middle Ages; the *Introductorium* cited here was the most popular. On this author see F. J. Carmody, *Arabic Astronomical and Astrological Sciences in Latin Translation* (Berkeley and Los Angeles, 1956), pp. 88–101, and R. Lemay, *Abu Ma'shar and Latin Aristotelianism in the Twelfth Century* (Beirut, 1962).

45. Tilmann, *An Appraisal,* p. 47.

46. See Miquel, *La Géographie humaine,* pt. 2, pp. 56–70.

47. See Owsei Temkin, *Galenism* (Ithaca, New York, 1973).

48. W. H. S. Jones, ed. and tr., *Hippocrates with an English Translation,* vol. 1, LCL (Cambridge, Mass., 1948), 12, p. 105. On Latin versions of this work see Pearl Kibre, "Hippocratic Writings in the Middle Ages." *Bulletin of the History of Medicine* 18 (1945): 394, and, more recently, her "Hippocrates Latinus: Repertorium of Hippocratic Writings in the Latin Middle Ages," *Traditio* 31 (1975): 123–126.

49. W. H. S. Jones, *Hippocrates,* vol. 4, LCL (London and New York, 1931), 2.37, p. 299.

50. Jones, *Hippocrates* 1.12–13, pp. 107–111.

51. See H. Rackham, ed. and tr., *Aristotle: Politics,* LCL (Cambridge, Mass., and London, 1967), 7.6, p. 567.

52. See W. S. Hett, ed. and tr., *Aristotle: Problems,* LCL (London and Cambridge, Mass., 1936), 14.1, p. 317. On the *Problemata* in the Middle Ages see

Brian Lawn, *The Salernitan Questions* (Oxford, 1963), p. 3 and n. 4 for bibliography.

53. On this subject see generally K. Trüdinger, *Studien zur Geschichte der Griechischrömischen Ethnographie* (Basel, 1918); E. Honigmann, *Die sieben Klimata* (Heidelberg, 1929); and Miquel, *La Géographie humaine* pt. 2, pp. 56–70. Apparently al-Khwarizmi, a court astronomer in Baghdad, first adapted this Ptolemaic concept to Arab geography. See Metlitzki, *The Matter of Araby*, pp. 22, 24, and Carmody, *Arabic . . . Sciences*, pp. 46–48, on Western knowledge of this author, as well as Marian J. Tooley, "Bodin and the Mediaeval Theory of Climate," *Speculum* 28 (1953): 68–70, on zones generally. As might be imagined, the seven climates were quickly keyed to the seven planets and both came to have a share in causing the differences among races. Bacon points out that a particular cause of variation among peoples is "the diversity of the fixed stars above the heads of the inhabitants . . . by means of these stars do natural things vary in different regions." Burke, *Opus*, 4.16, p. 395. According to Cecco D'Ascoli, "You know that there are seven climates, and seven planets dominate them . . . Those living in a clime in which a planet is dominant incline towards the nature of the dominant planet." Thorndike, *The Sphere*, ch. 1, p. 374–375. Races were assigned to the climes; in the first, for example, were located Indians, Ethiopians, and Moors. Henry R. Luard, ed., *Matthaei Parisiensis Chronica Majora*, Rolls Series 57 (London, 1877), pt. 4, p. 120. An excellent example of a seven-climate map is given in John of Wallingford's *Chronicon*, c. 1258; it is in BL Cotton Julius D. vii, fol. 46.

54. Tilmann, *An Appraisal*, 1.11, pp. 77; 2.3, p. 104.

55. James F. Dimock, ed., *Giraldi Cambrensis: Topographia Hibernica*, Rolls Series 21 (London, 1867), 1.37, p. 70. See also Nicole Oresme, who notes that the peoples of the East are "less noble, for many parts of their region are dangerous because of the disturbance and irregularity of the air, the contamination of the water, and the poisonous nature of the various kinds of snakes and other animals." *Le Livre du ciel et du monde*, ed. and tr. A. D. Menut and A. Denomy (Madison, Wis., 1968), 2.7, fol. 88b, p. 351.

56. W. Wattenbach, ed., *Die Apologie des Guido von Bazoches* (Berlin, 1893), p. 24: "Gallia sola monstra non habuit, sed viris semper potentibus, fortibus et eloquentissimus habundavit." See also Jerome, *Contra Vigilantium*, in *PL* 23, 339. Similar sentiments occur elsewhere in Bazoches. See H. Adolfsson, ed., *Liber Epistularum Guidonis de Basoches* (Stockholm, 1969), passim, and Pierre d'Ailly's panegyric to France in Buron, *Ymago Mundi*, 1:103.

57. Carin Fahlin, ed., *Chronique des ducs de Normandie*, by Benoît (Lund, 1951) 1:vi, believes that this twelfth-century author is the same person as Benoît de Sainte-Maure.

58. The chronicler Benoît's digression on climate and the hideous races of the South calls to mind a somewhat similar digression in the *Roman de Troie* of Benoît de Sainte-Maure. In a passage on the cloak of Briseide, made by an oriental necromancer, the author takes the opportunity to speak of marvels of the East and of the "Gent sauvage d'une contree / Qui Cenocefali ont nom,— / Lait sont e d'estrange façon,—." Ed. Léopold Constans (Paris, 1906), 2.11.13372–74, p. 295.

59. Fahlin, *Chronique* 1.11. 185–203, pp. 6–7.

60. *Ibid*, 11. 131–132, 136–140, p. 5.

61. *Ibid*, 11. 141–143, p. 5.

62. F. E. Robbins, ed. and tr., *Ptolemy: Tetrabiblos*, LCL (London and Cambridge, Mass., 1964), 2.2.56–58, pp. 120–127. A Latin version of this work made

about 1150 was known as the *Quadripartitum*. See, for example, *Liber Ptholomei quattuor tractatuum . . . et commento Haly* (Venice, 1484), bk. 2, ch. 2, no folio, no signature for the passage in question. On the *Quadripartitum* generally see O. Neugebauer, *The Exact Sciences in Antiquity* (Princeton, 1952), pp. 54–57, and Carmody, *Arabic . . . Sciences*, pp. 15–21. There was a French translation made for Charles the Fifth from the Latin version of Egidius de Thebaldis in 1260, made in turn from an Arabic text done for Alfonso the Wise with the aid of Judah ben Levy. This Latin text is the one printed by Ratdolt in 1484. The idea in Ptolemy also occurs in the Arab geographers; see Miquel, *La Géographie humaine*, pt. 2, p. 144.

63. Tilmann, *An Appraisal*, 2.3, p. 101.

64. Paulinus of Nola, for example, had claimed that the Ethiopians were black not from the heat of the sun but were burned black with vices and dark with sin. See Carmen 28 in G. de Hartel, ed., *S. Pavlini Nolani Opera Pars II, Carmina*, in *CSEL* (Vienna, 1894), 30.302, ll. 249–250. See generally Frank M. Snowden, Jr., *Blacks in Antiquity: Ethiopians in the Greco-Roman Experience* (Cambridge, Mass., 1970). See also G. K. Hunter, "Othello and Colour Prejudice," *Proceedings of the British Academy* 53 (1967): 139–163; P. J. Heather, "Colour Symbolism: Part II," *Folk-Lore* 60 (1949): 208–216; and Francis Gummere, "On the Symbolic Use of the Colors Black and White in Germanic Tradition," *Haverford College Studies* 1 (1889): 112–162, for further examples.

65. For *anti-effictiones* in the rhetorical tradition see the *Alda* of William of Blois, ed. M. Wintzweiller, in Gustave Cohen, *La "Comédie" Latine en France au XIIe siècle* (Paris, 1931), 1:6–7, and Matthew of Vendôme, *Ars Versificatoria*, where the beautiful Helen is contrasted with the hideous Beroe, in *Les Arts poétiques du XIIe et du XIIIe siècle*, ed. Edmond Faral (Paris, 1924), pp. 129–132. Additional examples are listed by Edgar de Bruyne, *Etudes d'esthétique médiévale* (Bruges, 1946), pt. 3, pp. 191f. See generally Paul Michel, *Formosa Deformitas* (Bonn, 1976), pp. 59–60. An *anti-effictio* dealing with a black woman can be found in "To Ane Blackamoor," by the Middle Scots poet William Dunbar. A rationalization for the large number of unattractive features Benoît gives to the Ethiopian is provided by Alice Colby-Hall's observation that it is a medieval "aesthetic principle that excess and ugliness are synonymous." See *The Portrait in Twelfth-Century French Literature* (Geneva, 1965), p. 79. She discusses the use of black skin in *effictiones* of ugliness on p. 85.

66. Harent of Antioch, *Le Livre des merveilles du monde*, Pierpont Morgan Library MS 461, c. 1450. "Item en ethioppie sont autres gens qui sont appelle blemmis . . . Et sont plains de moult grant cruaulte. Toutt ceste gent cy nont / nul usaige de royson mais ont meurs et conditions bestielles et toutes estranges a corps humain" (fols. 27–27v). It has not been generally recognized that the order of the chapters of Morgan 461, and much of their contents— minus his moralizations—are taken from the fourteenth book of Pierre Bersuire's *Reductorium Morale*, called *De Nature Mirabilibus* or *Descriptio Mundi*. See Samaran, "Pierre Bersuire," for a discussion of bk. 14, pp. 326–335. A French manuscript c. 1440 in the Durrieu collection at Coulommiers seems to be identical to Morgan 461, cf. fol. 36. As *Le Secret de l'hystoire naturelle*, the work went through seven printed editions from 1504 to 1534. Ironically, Céard was unaware of its origins in Bersuire's work, and devoted twenty pages to it as a book heralding "l'aube du XVIe siècle" (*La Nature et les prodiges*, pp. 60–71).

67. This map, Biblioteca Vaticana Pal. Lat. 1362b, was published by Konrad

Kretschmer in "Eine neue mittelalterliche Weltkarte der vatikanischen Bibliothek," *Zeitschrift der Gesellschaft für Erdkunde zu Berlin* 26 (1891), pp. 371–406 and pl. 10. See also Durand, *The Vienna-Klosterneuburg Map Corpus*, pp. 209–213, and Destombes, *Mappemondes*, pp. 212–214.

68. Keever, *Petrus Alliacus*, ch. 12, pp. 16–17.

4. MISSIONARIES AND PILGRIMS AMONG THE MONSTROUS RACES

1. Eva Matthews Sanford and William M. Green, eds., *The City of God*, by Saint Augustine, vol. 5, LCL (London and Cambridge, Mass., 1965), 16.8.

2. Sermo 37 of the *Ad Fratrem in Eremo* collection appears in *PL* 40, 1301–1304. The forger has in the past been associated with the twelfth-century Belgian preacher Geoffrey Babion, but see Jean Becquet in *Dictionnaire de spiritualité* (Paris, 1967), 6:229–231, and Jean-Paul Bonnes, "Un des plus grands Prédicateurs du XIIe siècle: Geoffroy du Loroux, dit Geoffrey Babion," *Revue Bénédictine* 56 (1945–1946): pp. 178–179.

3. In a poem in its praise, Giuliano Dati explains that part of the fascination of Prester John's empire was that it contained monstrous men, whom "many desire to see / because the eye delights in novelties." Achille Neri, ed., *La Gran Magnificenza del Prete Janni*, by Giuliano Dati, in *Il Propugnatore* 9 (1876): stanza 48, p. 161. See Leonardo Olschki, "I 'Cantari dell' India' di Giuliano Dati," *La Bibliofilia* 40 (1938): 289–316.

4. Vsevolod Slessarev, *Prester John: The Letter and the Legend* (Minneapolis, 1959), p. 68. Authorship is discussed pp. 25–54. For an account of how the legendary Prester John was identified with Genghis Khan, and of papal attempts to mobilize the Mongols against Islam in the mid-thirteenth century, see R. W. Southern, *Western Views of Islam in the Middle Ages* (Cambridge, Mass., 1962), pp. 44–47, and Gian Andri Bezzola, *Die Mongolen in abendländischer Sicht, 1220–1270: Ein Beitrag zur Frage der Völkerbegegnungen* (Bern and Munich, 1974). To Bezzola should be added Charles W. Connell, "Western Views of the Origin of the 'Tartars': An Example of the Influence of Myth in the Second Half of the Thirteenth Century," *Journal of Medieval and Renaissance Studies* 3 (1973): 115–137, which has an excellent bibliography. On the envoys sent by the pope see Igor de Rachewiltz, *Papal Envoys to the Great Khans* (Palo Alto, Calif., 1971).

5. Hugh of St. Cher, *Opera Omnia in Universum Vetus et Novum Testamentum* (Venice, 1732), vol. 2, fol. 50v. See also on this point James Marrow, "*Circumdederunt Me Canes Multi*: Christ's Tormentors in Northern European Art of the Late Middle Ages and Early Renaissance," *Art Bulletin* 59 (1977): 174–178.

6. See Sirarpie Der Nersessian, *L'Illustration des psautiers grecs du Moyen Age, II: Londres, Add. 19352* (Paris, 1970).

7. For a survey of recent scholarship see Kenneth Bruce Welliver, "Pentecost and the Early Church: Patristic Interpretation of Acts 2" (diss., Yale, 1961). On the names of the "nations" see J. A. Brinkman, "The Literary Background of the 'Catalogue of the Nations,' " *Catholic Biblical Quarterly* 25 (1963): 426.

8. I have found especially helpful on this subject Sirarpie Der Nersessian, *Manuscrits arméniens illustrés* (Paris, 1937), p. 130; André Grabar, "Sur les sources des peintres byzantins des XIIIe et XIVe siècles," *Cahiers Archéologiques* 12 (1962), especially pp. 358–363; and Miltos Garidis, "La Représentation des 'nations' dans la peinture post-byzantine," *Byzantion* 39 (1969): 86–103.

226 NOTES TO PAGES 63–65

9. MS Plut. 7.32, Biblioteca Laurenziana, Florence. This miniature has been published by George Galavaris, *The Illustrations of the Liturgical Homilies of Gregory Nazianzenus* (Princeton, 1969), pl. 49, fig. 262, pp. 218–220. Other examples of this black and white pairing are Leningrad Library MS Gr. 21, tenth century, in Grabar, "Les Sources," fig. 2; a fresco from Toqale, Cappadocia, eleventh century; Church of Manastir in Macedonia, 1271, in Grabar, "Les Sources," p. 359; BN, MS Gr. 510, homily 2; BL, Harley MS 1810; and BL, Egerton MS 1139.

10. Hugh of St. Cher, *Opera Omnia*, vol. 7, fol. 281r. See also M. L. W. Laistner, ed., *Bedae Venerabilis: Expositio Actuum Apostolorum et Retractatio* (Cambridge, Mass., 1939), p. 16. The key passage behind this thinking is from Saint Augustine, *The City of God* 16, ch. 4–5.

11. J. Lutz and P. Perdrizet, eds., *Speculum Humanae Salvationis* (Leipzig, 1909), pl. 67. The typological interpretation appears as ch. 34, p. 71 in vol. 1. A. Borst, *Der Turmbau von Babel* (Stuttgart, 1957–1963), vol. 2.2, is the most useful work on this subject.

12. Rhabanus Maurus, *Commentaria in Genesim*, in PL 107, bk. 2, 544.

13. Jacques de Vitry, *Historia Orientalis* (rpt. Meisenheim am Glan, 1971), ch. 5, p. 10. This etymologizing seems to originate with Isidore of Seville; see W. M. Lindsay, ed., *Etymologiarum Libri* (Oxford, 1957), 9.2.57: "Ipsi Agarini ab Agar; qui, et diximus, perverso nomine Saraceni vocantur." See also Alcuin, epistola 14, in E. Dümmler, ed., *Alcuini Epistolae* in P. Jaffé, ed., *Monumenta Alcuiniana* (Berlin, 1873), p. 167; Louis Duchesne, ed., *Le Liber Pontificalis* (Paris, 1886), 1:401; J. M. Wallace-Hadrill, ed. and tr., *The Fourth Book of the Chronicle of Fredegar with Its Continuations* (London, 1960), p. 93; and generally, R. W. Southern, *Western Views of Islam in the Middle Ages* (Cambridge, Mass., 1962), pp. 15–18, and Norman Daniel, *Islam and the West* (Edinburgh, 1960), pp. 79–80, 128.

14. J. Bédier, ed., *La Chanson de Roland* (Paris, 1947), ll. 1916–1918, 1932–1934. See also William Wistar Comfort, "The Literary Rôle of the Saracens in the French Epic," *PMLA* 55 (1940): 633. Examples of the Saracen as a black man abound in the English romances; see for example S. J. Herrtage, ed., *Roland and Vernagu*, EETS:ES 39 (London, 1882), l. 483, and S. J. Herrtage, ed., *Sir Ferumbras*, EETS:ES 34 (rpt. London, 1966), l. 2785. On this sort of caricature see Jürgen Brummack, *Die Darstellung des Oriente in den deutschen Alexandergeschichten des Mittelalters* (Berlin, 1966), pp. 155–163.

15. See Chapter 3, n. 64. The devil frequently appears to monks in the guise of an Ethiopian. See G. K. Hunter, "Othello and Colour Prejudice," *Proceedings of the British Academy* 53 (1967): 139–163, for a list of examples.

16. Arpád P. Orbán, "Anonymi Tuetonici *Commentum in Theodoli Eclogam*," *Vivarium* 11 (1973): 6–7. On the tradition of these commentaries see Betty Nye Quinn, "Ps. Theodulus," in Paul Oskar Kristeller, ed., *Catalogus Translationum et Commentariorum: Mediaeval and Renaissance Translations and Commentaries*, vol 2 (Washington, D.C., 1971), pp. 383–408, especially 398–400.

17. J. Fraipont, ed., *Sancti Fvlgenti Episcopi Rvspensis Opera*, in Corpvs Christianorvm (Turnhout, 91, 1976), epistola 11.2, p. 360.

18. See Lillian H. Hornstein, "The Historical Background of *The King of Tars*," *Speculum* 16 (1941): 404–414. The *Tars* romance is summarized in J. Burke Severs, ed., *A Manual of the Writings in Middle English* (New Haven, 1967), pp. 130–131. R. Morris, ed., *Cursor Mundi*, EETS:OS 62 (London, rpt. 1961), tells the story of four deformed black Saracens who come to King David;

he touches them with branches of the Tree of Jesse and "all as milk their hide becomes" (l. 8120, p. 468).

19. *Salviani Libri,* ed. C. Halm, *MGH: Scriptores auct. ant.,* 1.1 (rpt. Berlin, 1961), *De Gubernatione Dei,* 5.4, pp. 58–59.

20. Saint Augustine, *Ennarrationes in Psalmos,* in B. M. Perez, ed., *Obras de San Agustin* (Madrid, 1965), 20.2: 886–887.

21. Hugh of St. Cher, *Opera Omnia,* vol. 2, fol. 182r.

22. See W. Muir, ed., *The Apology of Al-Kindy* (London, 1887), and J. Kritzeck, *Peter the Venerable and Islam* (Princeton, 1964), pp. 101–107. On the translation of the Koran, see Marie-Thérèse d'Alverny, "Deux traductions latines du Coran au Moyen Age," *AHDLMA* 22–23 (1947–1948): 69–131.

23. See the excellent discussion of this theme by Dorothee Metlitzki, *The Matter of Araby in Medieval England* (New Haven and London, 1977), pp. 179–187.

24. Baltimore, Walters Art Gallery, MS 539. This miniature is published and discussed by Sirarpie Der Nersessian, *Armenian Manuscripts in the Walters Art Gallery* (Baltimore, 1973), pp. 10–30 and fig. 131; see especially p. 21.

25. BN, Syriac collection, MS 344. This manuscript is discussed by Jules Leroy, *Les Manuscrits syriaques à peintures conservés dans les bibliothèques d'Europe et d'Orient* (Paris, 1964), vol. 1, p. 417. On this figure type see Hugo Buchthal, "A Miniature of the Pentecost from a Lectionary in Syriac," *Journal of the Royal Asiatic Society of Great Britain and Ireland* (1939): 613–615. The miniature is discussed briefly by F. Macler, *Miniatures arméniennes* (Paris, 1913), p. 26.

26. See M. Diaz y Diaz, "Los textos antimahometanos más antiguos en codices españoles," *AHDLMA* 37 (1970): 149–164, especially pp. 153 and 157–159; and Alan of Lille, *De fide catholica contra haereticos* 4, *PL* 210, 421. For the story of the pigs see G. Cambier, ed., *Embricon de Mayence: La vie de Mahomet* (Brussels, 1962), pp. 88–89, and "Matthew" of Westminster, *Flores Historiarum,* ed. H. R. Luard, Rolls Series 95.1 (London, 1890), p. 301. On the authorship of the *Flores* see Antonia Gransden, "The Continuations of the *Flores Historiarum* from 1265 to 1327," *MS* 36 (1974): 472–492 and the same author's *Historical Writing in England c. 550–c.1307* (Ithaca, N.Y., 1974), p. 357, n. 7; p. 378, n. 167. I am indebted to Marie-Thérèse d'Alverny for information about the biographies of Mahomet.

27. See A. Mancini, "Per lo studio della leggenda di Maometto in Occidente," *Rendiconti della R. Accademia Nazionale dei Lincei* 10 (1934): 325–349.

28. Carl Wahlund and Hugo von Feilitzen, eds., *Les Enfances Vivien* (Uppsala and Paris, 1895), p. 35, l. 526. See also L. Gnädinger, *Hiudan und Petitcreiu: Gestalt und Figur des Hundes in der mittelalterlichen Tristandichtung* (Zurich, 1971), pp. 9–16, for medieval views, positive and negative, of dogs.

29. G. V. Smithers, ed., *Kyng Alisaunder,* EETS:OS 227 (London, 1952), ll. 1924, 1926–1927. Beatrice White, "Saracens and Crusaders: From Fact to Allegory," in D. Pearsall et al., eds., *Medieval Literature and Civilization* (London, 1969), pp. 170–191, gives other examples from English romances.

30. Borgia Collection, Vatican Library. The map has been published by Marcel Destombes, *Mappemondes* A.D. *1200–1500: Monumenta Cartographica Vetustioris Aevi,* vol. 1 (Amsterdam, 1964), pl. 29, discussed on pp. 239–241.

31. For a recent bibliography of the apocryphal Acts of the Apostles see Edgar Hennecke, *New Testament Apocrypha,* ed. and tr. R. Wilson et al. (Philadelphia, 1965), 2:167.

32. See Eusebius, *Historia Ecclesiastica* 3.1, *PG* 20, 215.

33. E. A. Wallis Budge, tr., *The Contendings of the Apostles* (Oxford, 1935), pp. 171–172; quotations following are from pp. 173–175. This version is a sub-form of the much more widely known Acts of Andrew and Matthaeus among the cannibals, of which there were examples in Greek, Syriac, Ethiopic, Coptic, and Anglo-Saxon. See Hennecke, *New Testament Apocrypha,* 2: 397, 576, where tentatively he dates the Greek version in the sixth century. See also Francis Dvornik, *The Idea of Apostolicity in Byzantium and the Legend of the Apostle Andrew* (Cambridge, Mass., 1958), and J. Flamion, *Les Actes Apocryphes de l'Apôtre André* (Louvain, 1911), pp. 310–319. On the particular legend given in the *Contendings of the Apostles* see R. A. Lipsius, *Die Apokryphen Apostelgeschichten und Apostellegenden* (Braunschweig, 1883), 1:621; and I. Guidi, "Gli Atti apocrifi degli Apostoli nei testi copti, arabi ed etiopici," *Giornale della Società Asiatica Italiana* 2 (1888). Guidi believes that Greek apocrypha were translated into Coptic in the fifth or sixth century and thence into Arabic about 1250 and into Ethiopic about 1370 (see pp. 2–3, 14).

34. Hugh of St. Cher, *Opera Omnia,* vol. 2, fol. 40v.

35. On Saint Mercurius generally see Stéphane Binon, *Essai sur le cycle de Saint Mercure,* in *Bibliothèque de l'Ecole des Hautes Etudes: Sciences Religieuses* 53 (Paris, 1937); idem, *Documents grecs inédits relatifs à S. Mercure de Césarée* (Louvain, 1937); E. Amélineau, *Les Actes des martyres de l'église Copte: Etude critique* (Paris, 1890), pp. 16–17; and H. Delehaye, *Les Légendes grecques des saints militaires* (Paris, 1909), pp. 91–101, 234–242.

36. René Basset, ed. and tr., *Le Synaxaire Arabe Jacobite,* in *PO* 3 (Paris, 1909), sections 261–263, pp. 337–339; Jacques Forget, ed. and tr., *Synaxarium Alexandrinum,* in *Corpus Scriptorum Christianorum Orientalium: Scriptores Arabici* 3.18.1 (Rome, 1921). pp. 152–153; E. A. Wallis Budge, ed. and tr., *The Book of the Saints of the Ethiopian Church* (Cambridge, 1928), 3:776f; and A. Piankoff, "Saint Mercure Abou Seifein et les Cynocéphales," *Bulletin de la Société d'Archéologie Copte* 8 (1942): 17–24. The legend of Mercurius was of particular interest to south Italian writers such as Landulf of Benevento, who composed a long passion in verse early in the twelfth century. See Vittorio Giovardi, *Acta Passionis et Translationis Sanctorum Martyrum Mercurii* (Rome, 1730), pp. 33–45, and Peter de Natalibus, *Catalogvs Sanctorvm ex Variis Voluminibus Selectus* (Lyons, 1542), 10.106, fol. cliii verso.

37. Published and discussed by A. Piankoff, "Thomas Whittemore: Une peinture datée au monastère de Saint-Antoine," *Les Cahiers Coptes* 7–8 (1954): 21, fig. 1.

38. William Dudley Foulke, tr., *Paul the Deacon: History of the Langobards* (Philadelphia, 1907), 1.11, p. 20.

39. See generally Alexandre Masseron, *Saint Christophe* (Paris, 1933), and the extensive bibliography in Giulio Ansaldi, *Gli affreschi della basilica di S. Vincenzo a Galliano* (Milan, 1949), pp. 93–102.

40. J. Fraser. "The Passion of St. Christopher," *Revue Celtique* 34 (1913): 309. See also H. Gaidoz, "Saint Christophe à tête de chien en Irlande et en Russie," *Mémoires de la Société Nationale des Antiquaires de France* 76 (1924): 192–218. The Cynocephalus, probably by way of Alexander legends, is a common figure in early Irish imaginative literature. See, for example, Gerard Murphy, tr., *Duanaire Finn: The Book of the Lays of Fionn,* Irish Texts Society, Pt. 2 (London, 1933), sec. 38, p. 27. For possible avenues of transmission see Martin McNamara, *The Apocrypha in the Irish Church* (Dublin, 1975).

41. George Herzfeld, ed., *An Old English Martyrology,* EETS:OS 116 (London, 1900), p. 67.

42. *Acta Sanctorum* 32. 6, July 25, p. 146 (rpt. Brussels, 1965–70). A franco-provençal *passio* gives much the same account but stresses the conversion theme and the idea that salvation is not limited to Western Europeans: "Et per co que nos conoissam et sapam que nostre seigner Deus Jhesu Crist non aïde tant solement los crestins, mais ceuz qui ant cor de convertir a lui, uns qui fut d'estrangi region, qui avoit mout espavantablo visago et come testa de chin." In A. Mussafia, "Zur Christophlegende," *Sitzungsberichte der Philosophisch-historischen Klasse der Kaiserlichen Akademie der Wissenschaften* 129 (1893): 41–42.

43. The lives have been published as "Vita et Passio Sancti Cristophori Martyris," in K. Strecker, ed., *Poetarvm Latinorvm Medii Aevii: MGH: SS* (Leipzig, 1937), 5.1, pp. 67–68, and "Passio Sancti ac Beatissimi Martyris Cristofori Rithmice Conposita" in K. Strecker, ed., *Poetae Latini Aevi Carolini MGH: SS* (rpt. Berlin, 1964), 4.2, pp. 809, 814. On Walter's *passio* see Masseron, *Saint Christophe*, pp. 110–117, and *Bibliotheca Hagiographica Latina* (Brussels, rpt. 1949), A–I, 1764–1780, pp. 266–268.

44. For a recent survey of the dog-headed Saint Christopher in Christian art of the East see Walter Loeschcke, "Neue Studien zur Darstellung des tierköpfigen Christophoros," *Erste Studien-Sammlung*, in *Beiträge zur Kunst des Christlichen Ostens* 3 (Recklinghausen, 1965), pp. 37–88, with a large assortment of plates of seventeenth- through nineteenth-century icons. This paper recapitulates the author's earlier articles on the subject and is more readily available.

45. Published and discussed by P. M. C. Kermode, *Manx Crosses* (London, 1907), pp. 6, 134–136, and plates 22–61; 23–62; 23–63; 24–64a.

46. See Philip M. Johnston, "Mural Paintings in Cornish Churches," *Journal of the Royal Institute of Cornwall* 15 (1903): 151–153, and 16 (1905): 392–394; and John Salmon, "St. Christopher in English Medieval Art and Life," *Journal of the British Archaeological Association*, n.s. 41 (1936): 95–96.

47. This point was made about Saint Mercurius by Piankoff, "Saint Mercure," p. 18, and in greater detail about Saint Christopher by Zofia Ameisenowa, "Animal-Headed Gods, Evangelists, Saints, and Righteous Men," *Journal of the Warburg and Courtauld Institutes* 12 (1949): 43–44: "The facts would seem to be that round the Christianus of the Acts of Bartholomew, who was renamed Christopher, a legend was created and that, by process of elaboration, this legend led to the composition of the *Passio Scti. Christophori.*"

48. On the relation of the apocryphal Acts and Hellenistic travel romances see Rudolf Helm, *Der antike Roman* (Göttingen, 1956), pp. 53–61, and Rosa Söder, "Die apokryphen Apostelgeschichten und die romanhafte Literatur der Antike," in *Würzburger Studien zur Altertumswissenschaft* 3 (1932).

49. See n. 4 above.

50. See Leonardo Olschki, *Marco Polo's Precursors* (Baltimore, 1943); J. Richard, "L'Extrême-Orient Légendaire au Moyen Age: Roi David et Prêtre Jean," *Annales d'Ethiopie* 2 (1957): 225–242; Francis M. Rogers, *The Quest for Eastern Christians: Travels and Rumor in the Age of Discovery* (Minneapolis, 1962); Manuel Komroff, ed. and tr., *Contemporaries of Marco Polo* [includes William of Rubruck, John of Plano Carpini, and the journal of Oderic de Pordenone] (London, 1929); Ugo Monneret de Villard, *Il libro della peregrinazione nelle parti d'Oriente di Frate Ricoldo da Montecroce* (Rome, 1948); Henri Cordier, ed., *Mirabilia Descripta*, by Jordanus Catalani (Paris, 1925); A. Bacchi della Lega, ed., *Libro d'oltramare 1346–1350*, by Niccolo di Poggibonsi in *Studium Biblicum Franciscanum* (Jerusalem, 1945); and Claude Sutto, "L'Image du

monde à la fin du Moyen Age," in Guy-H. Allard, ed., *Aspects de la marginalité au Moyen Age* (Montreal, 1975), pp. 59–68.

51. See Victor Terret, *La Sculpture bourguignonne aux XIIe et XIIIe siècles: Ses origines et ses sources d'inspiration: Cluny* (Paris, 1914); Francis Salet and Jean Adhémar, *La Madeleine de Vézelay: Etude iconographique* (Melun, 1948); R. B. C. Huygens, ed., *Monvmenta Vizeliacensia: Textes relatifs à l'histoire de l'Abbaye de Vézelay*, Corpvs Christianorvm: Continuatio Medieualis 42 (Turnhout, 1976); and V. Saxer, *Le Dossier vézelien de Marie Madeleine*, Subsidia Hagiographica 57 (Brussels, 1975). Owing to its placement and to the great doors of the porch, the tympanum is extremely difficult to photograph well, and only for a brief period is the sun in the correct position. For a good set of photographs of Vézelay in its environment see E. M. Janet Le Caisne, *Vézelay* (Paris, 1962).

52. The question of whether this tympanum is a Mission of the Apostles or a Pentecost was raised by Emile Mâle, *L'Art religieux du XIIe siècle en France* (Paris, 1928), pp. 326–332; Mâle favored a Pentecost. The issue was rehandled by Abel Fabre, "L'Iconographie de la Pentecôte," *Gazette des Beaux-Arts*, ser. 5.8 (1923): 33–42, and more convincingly, in favor of the Mission, by Adolf Katzenellenbogen, "The Central Tympanum at Vézelay: Its Encyclopedic Meaning and Its Relation to the First Crusade," *Art Bulletin* 26 (1944): 141–151.

53. Salet and Adhémar, *La Madeleine*, pp. 164–165.

54. Ibid. pp. 132–134.

55. Terret, *La Sculpture*, pp. 21–24. Léopold Delisle, *Inventaire des manuscrits de la Bibliothèque Nationale: Fonds de Cluni* (Paris, 1884), publishes a twelfth-century catalog of the library there. It contains eight items that speak of the monstrous races: no. 20, Orosius; no. 29, Solinus; no. 30, the *Epitome* of Pompeius Trogus; no. 365, *Libri Pronosticon et Ratiocinatio Dindimi et Alexandrum de Gente Brachmanorum*; no. 392, Isidore of Seville, *Etimologiarum*; no. 451, *Vita Alexandri Macedonis*; no. 514, Pliny, *Naturis Rerum*; and no. 528, *Liber Alexandri Macedonis*, pp. 337–373.

56. Respectively, fols. 23r, 19v, and 33r. On this subject see Katzenellenbogen, "The Central Tympanum," p. 147.

57. See Maurice Halbwachs, *La Topographie légendaire des Evangiles en Terre Sainte* (Paris, 1941).

58. G. R. Crone, *The World Map by Richard of Haldingham* (London, 1954), p. 22.

59. G. R. Crone, "New Light on the Hereford Map," *Geographical Journal* 131 (1965): 451.

60. Ibid.

61. Ibid., p. 452.

62. Ibid.

63. George Zarnecki, *Later English Romanesque Sculpture 1140–1210* (London, 1953), p. 12.

64. "Mappa dicitur forma. Inde mappa mundi id est forma mundi. Quam Julius Caesar missis legatis per totius orbis amplitudinem primus instituit; regiones, prouincias, insulas, ciuitates, . . . montes, flumina quasi sub unius pagine uisione coadunauit; que scilicet non paruam prestat legentibus utilitatem, uiantibus directionem rerumque uiarum gratissime speculationis directionem." Konrad Miller, *Die Ebstorfkarte* (Stuttgart, 1896), 5:8.

65. Ernst Sackur, ed., "PseudoMethodius" in *Sibyllinische Text und Forschungen* (Halle, 1898), ch. 3, p. 64. Nimrod is there called "Nembroth." For an interesting late medieval treatment of Nimrod see Dante, *Inferno* 31, ll. 67–82,

where he is a giant who speaks an unintelligible language and is described by Virgil as "Nembrot per lo cui mal coto / pur un linguaggio nel mondo non s'usa."

66. For a collection of texts and a bibliography on this subject see R. E. Kaske, "*Beowulf* and the Book of Enoch," *Speculum* 46 (1971): pp. 422–431.

67. An hil fer in the lond of ynde
 that hatte the grene ravens hille
 and hath the name for this skille
 Noe sente the raven forto se
 if any lond mighte owhere be.
 therynne woneth folke of wondre chere
 y made of body as we ben here
 but her visages to loke upon
 beth liche houndes euerichon.

This romance, translated from French prose into English verse, is ascribed by early authors to Hugh of Campedene; it is in BL MS Lansdowne 793, fols. 5–5v. For description see H. L. D. Ward, *Catalogue of Romances in the Department of Manuscripts in the British Museum* (London, 1883), 1:915–917.

68. On the complex problem of authorship see Kurt Hillkowitz, *Zur Kosmographie des Aethicus*, vol. 2 (Frankfort am Main, 1973), who denies Virgil authorship. Another dissenting voice is that of Maartje Draak, "Virgil of Salzburg versus 'Aethicus Ister,' " in *Dancwerc opstellen aangeboden aan Prof. Dr. D. Th. Enklaar* (Groningen, 1959), pp. 41–42, who believes the author to be neither Virgil nor an Irishman.

69. Crone, *The World Map*, p. 6, called attention to the connection with Adam of Bremen.

70. H. Wuttke, ed., *Cosmographia* (Leipzig, 1853), 2.38, p. 15. A facsimile of the Leiden MS has been published by T. A. M. Bishop, ed., *Aethici Istrici Cosmographia Vergilio Salisburgensi Rectius Adscripta* (Amsterdam, 1966). The passage may also have influenced Albert the Great, *De Animalibus:* "Vultus quidem similis est cani, sed totum residuum corpus maius est fortius quam canis: et haec sunt quae in Mappa mundi canini homines vocantur." See ch. 1, n. 29.

71. Jane A. Leake, *The Geats of 'Beowulf'* (Madison, Wis., 1967), p. 16, has well observed that "Scythia . . . is a vague designation, shifting according to an author's conception of it, but consistently described in terms of its coldness, its remoteness, its extension to the unknown and ultimate reaches of land in the north."

72. Francis J. Tschan, ed. and tr., Adam of Bremen, *History of the Archbishops of Hamburg-Bremen* (New York, 1959), bk. 4, p. 200. There is an echo of this idea in Jordanus, who places the Amazons more traditionally in East Africa south of Abyssinia, where the men and Amazons live together for a fortnight; male children are sent to the men, female children are retained. Nearby are many other different islands in which the men are Cynocephali but the women are said to be beautiful (Cordier, *Mirabilia Descripta*, pp. 87–88). On Adam's northern geography see Leake, *The Geats*, pp. 75–79, and J. Svennung, *Belt und Baltisch: Ostseeische Namenstudien* (Uppsala and Wiesbaden, 1953), pp. 50–76. On classical and medieval knowledge of the North see Fridtjof Nansen, *In Northern Mists*, tr. A. G. Chater (rpt. Westport, Conn., 1970), 1:7–202. The shift of the races to a northern habitat is treated by Eva Matthews Sanford, "Vbi Lassvs Deficit Orbis," *PQ* 13 (1934): 367. Norman Smith has called to my attention a poem by Gasparus Bruschius in Sebastian Münster,

Cosmographiae Uniuersalis, bk. 4 (Basel, 1550), p. 905, which argues that
Africa has lost first place as a mother of monsters to Crakow: "Africa nuper
erat monstrorum mater & author / . . . Ne tamen omnino generentur nulla per
orbem / dant nova Sarmaticae iam quoque monstra plagae, / Inter pluraque
me populosa Cracouia nuper / Aedidit ad ripas Vistula clare tuas."

73. E. G. Stanley, ed., *The Owl and the Nightingale* (rpt. Manchester, 1972),
ll. 1004-14. On this poem see K. Hume, *The Owl and the Nightingale: The
Poem and Its Critics* (Toronto and Buffalo, N.Y., 1975), pp. 6, 120.

74. A. L. Moir, *The World Map in Hereford Cathedral* (Hereford, 1979), p. 8.

75. Miller, *Die Ebstorfkarte,* "Quarum nomina pauca et situs in figura mundi
inuenies, si inspicere procures." "De elefantis satis inuenies iuxta montes, qui
Septem Fratres appellati sunt . . . Si inquiris, poteris inuenire" (8:19, 22). Ele-
phants were of extraordinary interest to medieval men; they are often coupled
with the monstrous races, especially in Alexander literature. See G. C. Druce,
"The Elephant in Medieval Legend and Art," *Archaeological Journal* 76 (1919):
1-73; F. C. Sillar and R. Meyler, *Elephants Ancient and Modern* (London, 1968);
Wilma George, *Animals and Maps* (London, 1969); Joan Lloyd, *African Ani-
mals in Renaissance Literature and Art* (Oxford, 1972); and Francis Klin-
gender, *Animals in Art and Thought to the End of the Middle Ages* (Cam-
bridge, Mass., 1971).

5. CAIN'S KIN

1. On the Six Ages idea see Karl Heinrich Krüger, *Die Universalchroniken,*
Typologie des sources du Moyen Age occidental 16 (Turnhout, Brépols, 1976),
pp. 26-27; A. Luneau, *L'Histoire du salut chez les pères de l'église: La doctrine
des ages du monde* (Paris, 1964); and R. Schmidt, "Aetates Mundi," *Zeitschrift
für Kirchengeschichte* 67 (1955-56): 288-317.

2. Paul E. Beichner, ed., *Aurora Petri Rigae Biblia Versificata* (Notre Dame,
Ind., 1965), vol. 1, pp. 34-35, ll. 197-202.

3. See Louis M. Myers, "Universal History in the Twelfth Century," *HLQ* 5
(1942): 162. On the chronicle form see B. Guenée, "Histoires, annales, chroni-
ques: Essai sur les genres historiques au Moyen Age," *Annales, Economies,
Sociétés, Civilisations* 28 (1973): 997-1016; Krüger, *Die Universalchroniken,* pp.
39, 43-45; Eva Matthews Sanford, "The Study of Ancient History in the Middle
Ages," *JHI* 5 (1944): 21-43; and V. H. Galbraith, *Historical Research in Medie-
val England* (London, 1951). Especially valuable recent studies are Benoît La-
croix, *L'Historien au Moyen Age* (Montreal and Paris, 1971), and Beryl Smal-
ley, *Historians in the Middle Ages* (London, 1974).

4. See W. Levison, *England and the Continent in the Eighth Century* (Ox-
ford, 1946), pp. 132-173.

5. Hayden White, "The Forms of Wildness," in Edward Dudley and Maxi-
millian Novak, eds., *The Wild Man Within: An Image in Western Thought
from the Renaissance to Romanticism* (Pittsburgh, 1972), p. 14.

6. For an interesting adaptation of this idea to the alliance between the
fallen angels and the daughters of men see Sulpicius Severus (A.D. 360-425)
Chronicorum 1.2: "From their alliance giants are said to have sprung. For the
mixture with them of beings of a different nature, as a matter of course, gave
birth to monsters." C. Halm, ed., *Sulpicii Severi: Libri qui Supersunt,* in *CSEL* 1
(rpt. New York, 1962), p. 5.

7. *De Trinitate,* ed., W. J. Mountain and F. Glorie, Corpvs Christianorvm 50 (Turnhout, 1968), 7.4.7, p. 255.

8. Bodleian MS Can. Misc. 328, fol. 102v: "Et ideo cum dicuntur diversa genera hominum monstruosorum in diversis terris per hoc cognoscendum est si sunt homines unde si raciocinantur quacumque formam corporis habeant non est curandum." On this author see B. Roth, *Franz von Mayoronis OFM: Sein Leben, seine Werke* (Werl, 1936). On the tradition of these commentaries see T. Van Bavel, ed., *Répertoire bibliographique de Saint Augustin 1950-1960,* Instrvmenta Patristica 3 (The Hague, 1963), pp. 2087-2101.

9. On this subject see George Herzfeld, ed., *An Old English Martyrology,* EETS:OS 116 (London, 1900), pp. xxxiv-xxxv; R. J. Menner, ed., *The Poetical Dialogues of Solomon and Saturn* (New York, 1941), for example n. 203, pp. 121-123; and A. S. Cook, "Old English Literature and Jewish Learning," *MLN* 6 (1891): 142-153. For the later Middle Ages the best general account is Aryeh Grabois, "The *Hebraica Veritas* and Jewish-Christian Intellectual Relations in the Twelfth Century," *Speculum* 50 (1975): 613-634. Grabois points out, however, that there is "considerable evidence for intellectual contacts between Jews and Christians in the Carolingian period," p. 615. On Peter Comestor see, for his sources, F. Stegmüller, *Repertorium Biblicum Medii Aevi* (Madrid, 1950-1976), 4:280-300; and R. M. Martin, "Notes sur l'oeuvre littéraire de Pierre le Mangeur," and A. Landgraf, "Recherches sur les écrits de Pierre le Mangeur," both *RTAM* 3 (1931): 54-66, 292-306, 341-372. See also S. Daly, "Peter Comestor: Master of Histories," *Speculum* 32 (1957): 62-73, and E. Shereshevsky, "Hebrew Traditions in Peter Comestor's *Historia Scholastica,*" *Jewish Quarterly Review* 59 (1969): 268-289.

10. See F. H. Colson, ed. and tr., *De Opificio Mundi* by Philo, LCL (Cambridge, Mass., and London, 1929), pp. 47-49.

11. Louis Ginzberg, *The Legends of the Jews* (Philadelphia, 1909), 1:60.

12. Kathryn Smits, ed., *Die frümittelhochdeutsche Wiener Genesis* (Berlin, 1972), 26.8, pp. 135-137. On this work see Brian Murdoch, *The Fall of Man in the Early Middle High German Biblical Epic* (Göppingen, 1972), pp. 1, 166; D. Hensing, *Zur Gestaltung der Wiener Genesis* (Amsterdam, 1972); and S. Beyschlag, *Die Wiener Genesis: Idee, Stoff und Form* (Vienna, 1942). The passage in question is discussed by R. A. Wisbey, "Marvels of the East in the Wiener Genesis and in Wolfram's *Parzival,*" in William Robson-Scott, ed., *Essays in German and Dutch Literature* (London, 1973), pp. 1-41.

13. Esther C. Quinn, *The Quest of Seth for the Oil of Life* (Chicago, 1962).

14. *Lucidarius* 1.15, PL 172, 119-120.

15. Karl Bartsch, ed., *Reinfrid von Braunschweig* (Tübingen, 1871), pp. 574-575, ll. 19700-739. On this work see Beat Koelliker, *Reinfrid von Braunschweig* (Bern, 1975). For an interesting connection between man's acts and changes in physical nature see I. W. Raymond, tr. *Seven Books of History against the Pagans,* by Orosius (New York, 1936), 2.1, p. 72: "There is no person living today, I think, who does not acknowledge that God created man in this world. Hence, whenever man sins, the world also becomes subject to censure, and owing to our failure to control the passions that we ought to restrain, this earth on which we live is punished by having its animal life die out and its crops fail."

16. An eleventh-century reworking into hexameters of Isidore's book on portents from the *Etymologiae* opens with the gloomy assertion that "alas, the human race, through various crimes, created monstra, which took awesome forms." Christian Hünemörder, ed., "Isidorus Versificatus: Ein anonymes

Lehrgedicht über Monstra und Tiere aus dem 12. Jahrhundert," *Vivarium* 13 (1975): 106. Touches of hostility toward the races are evident in the way the poet approaches his text. Hence, regarding the Cyclops, called Agriophagus by Isidore, we learn his "cibus est homines." And Isidore's morally neutral Androgyne is called by the poet "prodigium miserum" (pp. 107–108). Closely related to this poetic translation of Isidore is the fourteenth- or fifteenth-century prologue to a poem of pseudo-Ovidian wonders; the earliest manuscript of the work is of eleventh-century Italian provenance. It says, "Vicious is the ignoble monster!" M. R. James, ed., "Ovidius de Mirabilibus Mundi," in *Essays and Studies presented to William Ridgeway on his Sixtieth Birthday* (Cambridge, 1913), p. 297. On the authorship of this work see J. G. Préaux, "Thierry de Saint-Trond: Auteur du poème pseudo-ovidien *De Mirabilibus Mundi*," *Latomus* 6 (1947): 353–366. See also Christian Hünemörder, "Das Lehrgedicht 'De Monstris Indie' (12. Jh.): Ein Beitrag zur Wirkungsgeschichte des Solinus und Honorius Augustodunensis," *Rheinisches Museum für Philologie*, n.s 119 (1976): 267–284.

17. This interpolation is discussed by Wisbey, "Marvels of the East," pp. 9–10.

18. Beichner, *Aurora Petri Rigae Biblia Versificata*, vol. 1, p. 41, l. 365.

19. "Si commederis de illa herba fructum concipietis" (fol. 113).

20. "Adam prohibuit omnibus filiabus suis ne commederent ab illa herba, ac tamen comederunt hinc processerunt semi homines qui concipiebantur ab herbis, ergo habent animas quasi bestie" (fol. 114v).

21. George Kane, ed., *Piers Plowman: The A Version* (London, 1960), 10.151, p. 389. Cain kills Abel while wearing a Jew's hat as a symbol of the Old Law in Pierpont Morgan MS 739, fol. 9v, discussed by Ruth Mellinkoff, *The Horned Moses in Medieval Art and Thought* (Berkeley, 1970), p. 129. Pearl F. Braude, " 'Cokkel in Oure Clene Corn': Some Implications of Cain's Sacrifice," *Gesta* 7 (1968): 15–28, has developed an interesting tradition in which Cain is a symbol of heresy.

22. See V. Aptowitzer, *Kain und Abel in der Agada* (Vienna and Leipzig, 1922).

23. Harry Sperling and Maurice Simon, trs., *The Zohar* (London, 1931), 1.54a, p. 172.

24. Gerald Friedlander, tr., *Pirkê de-Rabbi Eliezer* (rpt. New York, 1965), ch. 21, p. 150; ch. 22, p. 158. On this material see J. M. Evans, *Paradise Lost and the Genesis Tradition* (Oxford, 1968), pp. 36–37, 55; and H. L. Strack, *Introduction to the Talmud and Midrash* (Philadelphia, 1931), pp. 201–233. Examples of the idea can be found in Latin Catharist texts. See Edina Bozóky, ed., *Le Livre secret des Cathares: Interrogatio Iohannis* (Paris, 1980), pp. 135–136.

25. *The Zohar*, 1.37a, p. 138.

26. For a bibliography of the various Adam apocrypha and their Latin translations see Stegmüller, *Repertorium*, 1:25–34. The passage quoted here is from Oxford, Bodley MS 596, ed. C. Horstmann, "The Lyfe of Adam," in *Archiv für das Studium der neueren Sprachen und Litteraturen* 74 (1885): 348.

27. E. A. Wallis Budge, ed., *The Book of the Cave of Treasures* (London, 1927), pp. 72–74, 76.

28. Jacques Issaverdens, *The Uncanonical Writings of the Old Testament* (Venice, 1901), p. 59.

29. Rupert of Deutz, *De Trinitate*, in PL 167, 335.

30. For an enlarged picture of the horns see Denis Grivot, *Le Monde d'Autun*

(Paris, 1960), p. 9. See generally G. Sanoner, "Iconographie de la bible d'après les artistes de l'antiquité et du Moyen Age: Travaux de Caïn et d'Abel," *Bulletin Monumental* 80 (1921): 212–238; and Paul-Henri Michel, "L'Iconographie de Caïn et Abel," *Cahiers de Civilisation Médiévale* 1 (1958): 194–199.

31. R. A. S. Macalister, ed. and tr., *Lebor Gabála Erenn: The Book of the Taking of Ireland,* pt. 1, Irish Text Society 34 (Dublin 1932, 1938), 4.39, p. 87; 4.40, p. 89. On this work see Martin McNamara, *The Apocrypha in the Irish Church* (Dublin, 1975), p. 21. See also K. Hughes, *Early Christian Ireland: Introduction to the Sources* (Ithaca, N.Y., 1972), pp. 281–283, and Myles Dillon, "Lebor Gabála Erenn," *Journal of the Royal Society of Antiquaries of Ireland* 86 (1956): 62–72.

32. See Ruth Mellinkoff, "Cain's Monstrous Progeny in *Beowulf*: Part I, Noachic Tradition," *ASE* 8 (1979): 143–162, and "Part II, Post-Diluvian Survival," *ASE* 9 (1980): 183–197.

33. Issaverdens, *The Uncanonical Writings,* p. 60.

34. See ch. 2, n. 18.

35. Jerome, *Epistola* 36.4–5, *PL* 22, 454–455.

36. The major patristic references are Rhabanus Maurus, *Commentariorum in Genesim Libri* 2.1–2, *PL* 107, 506–509; his *De Universo* 2.1, *PL* 111, 33; and the *Glossa Ordinaria,* in *PL* 113, 101–102. A good summary is that of E. Reiss, "The Story of Lamech and Its Place in Medieval Drama," *Journal of Medieval and Renaissance Studies* 2 (1972): 35–48. See also Shereshevsky, "Hebrew Traditions," pp. 273–274.

37. James H. Lowe, tr., *"Rashi" on the Pentateuch: Genesis* (London, 1928), p. 89.

38. Budge, *The Book of the Cave of Treasures,* p. 78. Appropriately enough, Lamech, who lives in perpetual night, kills his forebear Cain, for as Augustine remarked on Psalm 48, "Occidit Cain iniustus Abel iustum in nocte." B. M. Perez, ed., *Ennarrationes in Psalmos,* by Saint Augustine, 2.48.2.11, in *Obras de San Agustin* (Madrid, 1965), p. 200.

39. BL Egerton 1894. See M. R. James, *Illustrations of the Book of Genesis* (Oxford, 1921), fol. 3a, p. 12; the rubric speaks of Cain shot "en lieu dun autre beste." A similar version of the legend in *The History of Roger,* BN Fr. MS 20125, fol. 7v, has Cain mistaken for "une beste sauuage."

40. John Rylands Library MS Fr. 5. The scene has been published by Robert Fantier, *La Bible historiée toute figurée de la John Rylands Library* (Paris, 1924), pl. 24. Fantier discusses the change in hairstyle, pp. 16–17.

41. See Richard Stettiner, *Die illustrierten Prudentius-Handschriften: Tafelband* (Berlin, 1905), pl. 11.3 and pl. 78, where the entire figure is covered and described by flammiform shapes. See also Helen Woodruff, "The Illustrated Manuscripts of Prudentius," *Art Studies: Medieval Renaissance and Modern* 7 (1929): 35, 51. On Esau see Saint Jerome, *Commentaria in Ezechielem* 11.25, *PL* 25, 334, and Saint Ambrose, *De Cain et Abel* 1.1, *PL* 14, 317.

42. I use the translation of James Carney, *Studies in Irish Literature and History* (Dublin, 1955), p. 103.

43. Ibid., pp. 109–110.

44. This work was edited by R. I. Best and Osborn Bergin as *Lebor Na Huidre: Book of the Dun Cow* (Dublin, 1929). There is a good discussion of it in McNamara, *The Apocrypha,* pp. 30–32. To the bibliography given there should be added Hughes, *Early Christian Ireland,* pp. 273–274.

45. M. C. Dobbs, ed., *Ban-Shenchus,* by Gilla Mo Dutu, in *Revue Celtique* 47 (1930): 290.

46. K. Mulchrone, ed., *Book of Lecan* (Dublin, 1937), fol. 22v.

47. Macalister, *Lebor Gabála Erenn* 6.53, p. 107.

48. Charles Donahue, "Grendel and the *Clanna Cain*," *Journal of Celtic Studies* 1 (1950): 173.

49. Ibid., p. 174.

50. Ranulf Higden, *Polychronicon*, vol. 2, bk. 2, p. 221.

51. See generally Jack P. Lewis, *A Study of the Interpretation of Noah and the Flood in Jewish and Christian Literature* (Leiden, 1968), and Don Cameron Allen, *The Legend of Noah* (Urbana, Ill., rpt. 1963).

52. *Liber de Nominibus Hebraicis*, in PL 23, 777.

53. Angelomus, *Commentarius in Genesin*, in PL 115, 162.

54. A fascinating apocryphal explanation of the curse appears in a gloss to Riga's *Aurora*. Continence had been ordered for all on the ark, but Ham, by the aid of a magic demon, slept with his wife. His father, however, saw his footprints the next day and enmity grew between them. As a punishment, Ham got a black skin. See Francis Lee Utley, "Noah's Ham and Jansen Enikel," *Germanic Review* 16 (1941): 241-249. See also Lewis, *A Study*, pp. 153-154.

55. Just as Noah and his line continued the family of Abel and Seth after the Flood, making the city of God on earth, so Ham continued the line of Cain, making the city of man, as we see in Bishop Otto of Freising, who reworks the biblical story to eliminate one of Noah's sons and establish a sharper opposition between the "heavenly" and "earthly" brothers. When drunken Noah strips himself naked, "one of his sons seeing him thus mocked him; the other covered him. Accordingly these two brothers were, after the Flood, the first citizens of the cities which constitute the theme of my book." C. C. Mierow, tr., *Otto of Freising: The Two Cities* (rpt. New York, 1966), 1.4, p. 127.

56. B. Carra de Vaux, ed. and tr., *L'Abrégé des merveilles* (Paris, 1898), ch. 6, p. 99, and 7, p. 137. On this work see Miquel, *La Géographie humaine*, 35 and p. 255. Part 2, *Géographie Arabe*, discusses the problem with reference to Masoudi's *Fields of Gold* and similar texts, pp. 101, 141-144. See also Ginzberg, *Legends*, 1:66, and Paul Isaac Hershon, tr., *A Rabbinical Commentary on Genesis (Rabbi Jacob)* (London, 1885), p. 55, where Noah says to Ham, "Thy children shall be dark and black." This work, compiled in 1693, is based on much earlier sources.

57. See Charles Verlinden, *L'Esclavage dans l'Europe médiévale* (Bruges, 1955).

58. Ambrose, *Commentaria in Epistolam ad Philippenses*, in PL 17, 409.

59. Macalister, *Lebor Gabála Erenn* 9.81, p. 137.

60. Walter Suchier, ed., *Adrian und Epictitus* (Tübingen, 1955), p. 116. On this work see L. W. Daly and W. Suchier, *Altercatio Hadriani Augusti et Epicteti Philosophi* (Urbana, Ill., 1939), pp. 71, 75. The late-thirteenth-century Cambridge bestiary, in a section on the Six Ages, derives various orders of society from the patriarchs, "servi de Cham," fol. 12.

61. "Ainsi peut sen veoir comment la lignee de Cham fut meschante car dicelle descendirent les servitudes." Raoul de Presles, *Cy commence la table du premier liure de monseigneur saint augustin de la cité de dieu*, (Abbéville, 1486), 2.16.4. On this author see A. de Laborde, *Les Manuscrits à peintures de la Cité de Dieu de Saint Augustin*, 3 vols. (Paris, 1909), 1:27-40.

62. Georg Gerster records a recent conversation he had with a Tuareg who claimed that " 'the black race ... suffers the curse of Ham ... [who] turned black.' " Gerster, "River of Sorrow, River of Hope," *National Geographic* 148 (August, 1975): 174. Unfortunately, the article of Albert Perbal, "La Race nègre

et la malédiction de Cham," *Revue de l'Université d'Ottawa* 10 (1940): 157 does not do justice to this subject.

63. *Liber Armorum* in William Blades, ed., *Boke of Saint Albans* (London, 1881), sig. ai (verso)-aii. We find the idea in Honorius of Regensburg, *De Imagine Mundi* 3.2, *PL* 172, 166, and in the *Cursor Mundi*, ll. 2135–36.

64. Albert B. Friedman and Norman T. Harrington, eds., *Ywain and Gawain*, EETS:OS 254 (London, 1964), p. 16, l. 559.

65. H. Wuttke, ed., *Cosmographia* (Leipzig, 1853), 5.59, p. 40.

66. M. N. Adler, tr., *The Itinerary of Benjamin of Tudela* (London, 1907), p. 68. On this author see Richard Hennig, *Terrae Incognitae* (Leiden, 1950), 2:433–437.

67. Franz Blatt, ed., "Die lateinischen Bearbeitungen der Acta Andreae et Matthiae apud anthropophagos," *Beihefte zur Zeitschrift für die Neutestamentliche Wissenschaft* 12 (1930): 126.

68. This is Fitzwilliam Additional MS 23, French, fifteenth century: "Si vous diray premierment pour quoy on lapelle le grant Caan, vous deves savoir que tout le monde fut destruit par le fluue de Noel fors Noe, sa feme et ses enfans. Noe avoit iii filz, Sem, Cham, et Japhet ... Ceulx iii freres saisirent toute la terre, et cellui Caam aprist la meilleur partie pour sa cruaulte qui est appellee Assie, Sem prist Aufrique ... et pour cause de ces iii freres Caam fu le plus grant et le plus puissant et de lui descendirent plus de generacions que les autres ... Et avece les ennemis [d'enfer] venoient souuent chouchier avec les femes de sa [Nimrod's] generacion et engendroient diversses gens [monstres] et tres deffigures, aucuns geans a pie de cheval ... aucuns a grans oreilles, aucuns a un oueil et autres membres deffigures et de ceste generacion de Chaam sont venues les paiennes gens et les diversses gens qui sont es isles de mere par tout Inde." Fols. 144–145.

69. B. Colgrave, ed., *Felix's Life of Saint Guthlac* (Cambridge, 1956), p. 106.

70. Suchier, *Adrian und Epictitus*, p. 60. See also O. Schultz-Gora, ed., *Folque de Candie*, by Herbert le duc de Danmartin (Dresden, 1909–1915), vol. 2, p. 212, l. 14138: "Dolens sont li paien du lignage Caÿn."

71. See M. C. Seymour, ed., *The Metrical Version of Mandeville's Travels*, EETS:OS 269 (London, 1973), app. B, pp. 193–197, for a good account of the manuscripts.

72. O. F. Emerson, "Legends of Cain, Especially in Old and Middle English," *PMLA* 21 (1906): 831–929; Nora K. Chadwick, "The Monsters and *Beowulf*," in Peter Clemoes, ed., *The Anglo-Saxons* (London, 1959), pp. 171–203; Kenneth Sisam, *Studies in the History of Old English Literature* (Oxford, 1962); Robert E. Kaske, "The *Eotenas* in *Beowulf*," in Robert Creed, ed., *Old English Poetry: Fifteen Essays* (Providence, 1967), pp. 285–310; Margaret E. Goldsmith, *The Mode and Meaning of "Beowulf"* (London, 1970); Niilo Peltola, "Grendel's Descent from Cain Reconsidered," *Neuphilologische Mitteilungen* 73 (1972): 284–291; and Stephen C. Bandy, "Cain, Grendel, and the Giants of *Beowulf*," *PLL* 9 (1973): 235–249.

73. F. Klaeber, ed., *Beowulf* (London, 1963).

74. J. Zupitza, ed., *Beowulf, Facsimile from ... British Museum MS. Cotton Vitellius A. xv*, EETS:OS 245 (London, rpt. 1967), p. 6. Interestingly Shem and Seth are confused twice in a manuscript of Alcuin's *Interrogationes*, though the particular responses in question were apparently not in the MS used by Aelfric when he translated this work. In BN Paris Lat. 2384, fol. 91v, the last three letters of Seth's name are pointed out and *em* written in anothɛr, darker hand; this is a ninth- or tenth-century manuscript containing a patristic mis-

cellany. See Alcuin, *Interrogationes et Responsiones in Genesin* 96 PL 100, 526, and G. E. MacLean, "Aelfric's Version of *Alcuini Interrogationes Sigeuulfi in Genesin*," *Anglia* 6 (1883): 425–429.

75. Goldsmith, *Mode and Meaning*, p. 102.

76. In the *Book of Jubilees*, ch. 7, p. 24, in R. H. Charles, ed., *The Apocrypha and Pseudepigrapha of the Old Testament* (Oxford, 1976), vol. 2, we learn that after the curse, Ham "parted from his father . . . and he built for himself a city." Contrast this with the idea of Noah as the starter of a new line in a homily associated with the name of Gregory of Elvira, *Arca Noe*, ed. A. Wilmart, in *Revue Bénédictine* 26 (1909): 5–11.

77. Macalister, *Lebor Gabála Erenn*, 6.53, p. 107.

78. Goldsmith, *Mode and Meaning*, pp. 97, 107. In this connection, Robert Kaske has argued persuasively for the poet's familiarity with a Latin text of the apocryphal *Book of Enoch*, a work that may have appealed to the poet's interest in species corruption and monstrosity, as well as in giants. See R. E. Kaske, "*Beowulf* and the Book of Enoch," *Speculum* 46 (1971): 421–425. On the giants as the progeny of the sons of God, see Shereshevsky, "Hebrew Traditions," p. 275; and Nicolas Kiessling, *The Incubus in English Literature* (Pullman, Wash., 1977), pp. 10–11 and notes. For patristic interpretation of the theme, see Donat Poulet, "The Moral Causes of the Flood," *Catholic Biblical Quarterly* 4 (1942): 293–303.

79. Avitus of Vienna, *De Mosaicae Historiae Gestis*, bk. 2, PL 59, 331–332.

6. SIGNS OF GOD'S WILL

1. See Jean Céard, *La Nature et les prodiges* (Geneva, 1977), pp. 7–12; A. Bouché-Leclercq, *Histoire de la divination dans l'antiquité* (Paris, 1879–1882); Raymond Bloch, *Les Prodiges dans l'antiquité classique* (Paris, 1963), pp. 79–84; and A. Caquot and M. Leibovici, eds., *La Divination* (Paris, 1968), 1: 157–232.

2. See E. de Saint-Denis, "Les Enumérations de prodiges dans l'oeuvre de Tite-Live," *Revue de Philologie* 16 (1942): 126–142, and Bloch, *Les Prodiges*, pp. 115–116.

3. Herodotus, *Histories*, tr. A. D. Godley, vol. 3, LCL (Cambridge, Mass., and London, 1922), 7.57.

4. Aubrey Gwyn, ed., *The Writings of Bishop Patrick 1074–1084*, Scriptores Latini Hiberniae (Dublin, 1955), p. 57, ll. 1–3.

5. W. M. Lindsay, ed., *Etymologiarum Libri* (Oxford, 1957) 1.39, para 1–5. See on this subject Roswitha Klinck, *Die Lateinische Etymologie des Mittelalters* (Munich, 1970), which has an excellent bibliography.

6. See Myra L. Uhlfelder, ed., *De Proprietate Sermonum Vel Rerum*, in *Papers and Monographs of the American Academy in Rome* 15 (1954): 1–11, and G. Brugnoli, *Studi sulle Differentiae Verborum* (Rome, 1955).

7. See W. M. Lindsay, review of *Glossaria Latina*, in *Bulletin du Cange* 3 (1927): 95–100, and G. Goetz, *De Glossariorvm Latinorvm Origine et Fatis*, in CGL 1.

8. Charles Johnson, tr., *The De Moneta of Nicholas Oresme* (London, 1956), ch. 16, p. 25.

9. See Carl Thulin, "Synonyma Quaedam Latina," in *Commentationes Philologae in Honorem Iohannis Pavlson* (Göteborg, 1905), pp. 194–213; A. Funck, "Lateinisch Prodigium," *Indogermanische Forschungen* 2 (1893): 367–368;

Bouché-Leclercq, *Histoire de la divination*, 4:75; and Franklin B. Krauss, *An Interpretation of the Omens, Portents, and Prodigies Recorded by Livy, Tacitus, and Suetonius* (Philadelphia, 1930), pp. 31-34.

10. See *Glossae Latinograecae et Graecolatinae*, in *CGL* 2 (Leipzig, 1888), Paris BN MS Lat. 7651, p. 130, and BL MS Harley 5792, p. 453. On *teras* see P. Stein, *TEPAΣ* (Marburg, 1909), for classical treatments, and more recently Bloch, *Les Prodiges*, pp. 15-16. The tenth-century Souda lexicon says essentially what Oresme did. See Ada Adler, ed., *Svidae Lexicon* (Leipzig, 1935), pt. 4, p. 525, item 325. For a brief history of this very important work see P. Henry, "Suidas: Le Larousse et le Littré de l'antiquité grecque," *Etudes Classiques* 6 (1937): 155-162. For the current view that the name is not that of the author but an acrostic for a title, see Henri Grégoire, "Suidas et son mystère," ibid., pp. 346-355.

11. See de Saint-Denis, "Les Enumérations," p. 141; Bloch, *Les Prodiges*, p. 84; Krauss, *An Interpretation*, pp. 31-34; and Bouché-Leclercq, *Histoire de la divination*, 4:77.

12. H. Keil, ed., *De Differentiis Vocabulorum*, by Fronto, in *Grammatici Latini* (rpt. Hildesheim, 1961), 7:520. Note that the *differentiae* appear verbatim in the fourth-century *Artis Grammaticae Libri* of Charisius, ed. K. Barwick (Leipzig, 1964).

13. W. M. Lindsay, ed., *Festus*, in *GL*, vol. 4 (rpt. Hildesheim, 1965), 260.122 and 274.146. Festus was epitomized by Paul the Deacon in the eighth century.

14. W. M Lindsay, ed., *De Differentia*, in *Nonii Marcelli: De Conpendiosa Doctrina* (Leipzig, 1964), pp. 701-702. One group of late *differentiae* distinguishes among all four on the grounds of time; *ostenta* and *monstra* show the present, *prodigia* and *portenta* the future. See Probus in Keil, *Grammatici Latini*, 4:200, and K. Barwick, "Die sogenannte Appendix Probi," *Hermes* 54 (1919): 409-422.

15. For some contextual uses see Pliny, *Natural History*, tr. H. Rackham, vol. 2, LCL (Cambridge, Mass., and London, 1942), bk. 7, p. 512; and Tacitus, *Histories*, tr. Clifford H. Moore, vol. 2, LCL (Cambridge, Mass., and London, 1925), 1.3.3 and 1.86.1. See also Julius Obsequens, *Prodigiorum Liber*, ed. and tr. A. C. Schlesinger, in *Livy*, vol. 14, LCL (Cambridge, Mass., and London, 1959), bk. 14, p. 249. Lucretius and Cicero discuss portents skeptically and at length, offering rationalistic explanations for phenomena generally believed to be divinely inspired. For the former see W. H. D. Rouse, ed. and tr., *Lucretius: De Rerum Natura*, LCL (London and New York, 1924), 4.590-591, 5.878, and 5.923-924. For Cicero's definition as an attack on portents, see *De Divinatione*, ed. and tr. W. A. Falconer, LCL (Cambridge, Mass., and London, 1938), 1.42.93, p. 325, and 2.49.101, pp. 485 f.

16. See G. Goetz, ed., *Glossae Codicvm Vaticani 3321*, in *CGL* vol. 4, p. 538.

17. "Extra naturam nascitur." Papias, *Elementarium Doctrinae Erudimentum* (rpt. Turin, 1966), fol. 100.6. His sources were the *Liber Glossarum*, Isidore, Boethius, Priscian, "Physiologus," and Remigius of Auxerre. See G. Goetz, "Papias und seine Quellen," *Sitzungsberichte der philosophisch-philologischen . . . historischen Klasse der Akademie der Wissenschaften zu München* (1903), pp. 267-286; and more recently Giuseppe Cremascoli, "Ricerche sul lessicografo Papia," *Aevum* 43 (1969): 31-55.

18. See, for example, John Balbus of Genoa, who in his *Catholicon* (1286) cites almost all of Isidore of Seville's discussion in the *Etymologiae* of *monstrum* and its synonyms, as well as a portion of Saint Augustine's treatment of *monstra*. (Venice, 1495), pp. 200, 236, and 242.

19. "Esse ferunt monstra tam diffusa a magnitudine aurium." Papias, *Elementarium*, Fol. 100.xxiii, verso.

20. William D. Sharpe, ed. and tr., *Isidore of Seville: The Medical Writings*, in *Transactions of the American Philosophical Society* 54 (1964), ch. 3.3, p. 51.

21. Isidore of Seville, *Differentiarum Libri Duo*, in PL 83, 56, bk. 1, item 457.

22. See, for example, G. W. Vernon, ed., *Comentum super Dantis Aldigherij Comoediam*, by Benvenuto da Imola (Florence, 1887), 2:461. "Loquendo autem physice credo quod natura semper fecit, facit et feciet aliquos excedentes communem hominum mensuram in omni genere; imo videmus quod natura in una generatione facit homines valde magnos quales sunt frisones in Germania; in alia valde parvos, quales communiter sunt romani in Italia."

23. See A. L. Peck, ed., and tr., *Aristotle: Generation of Animals*, LCL (Cambridge, Mass., and London, 1953), 4.4.770b, p. 425. Aristotle notes that "monstrosities come under the class of offspring which is unlike its parents." In Hugh Tredennick, ed. and tr., *Aristotle: Metaphysics*, LCL (London and Cambridge, Mass., 1968), 7.7.1032a, pp. 337–339, we learn "that by which [creatures] are generated is . . . nature, which has the same form as the thing generated . . . for man begets man." On this subject see generally R. G. Collingwood, *The Idea of Nature* (Oxford, 1964), pp. 80–82, and Robert M. Grant, *Miracle and Natural Law in Graeco-Roman and Early Christian Thought* (Amsterdam, 1952), pp. 4–23. Aristotle was, of course, also aware of the significance of *terata* as divine portents rather than scientifically explicable phenomena, and in the *Histories of Animals* he refers to theological and divine views of what to him was merely a scientific fact. "In Naxos practically all the quadrupeds have so large a [gall bladder] that when foreigners are offering sacrifice they get quite a shock, supposing that this is some sign from heaven meant for themselves, instead of a natural phenomenon." He is referring here to his own explanation of these gall bladders in *Parts of Animals*, ed. and tr., A. L. Peck, LCL (London and Cambridge, Mass., 1937), 4.2.677a, p. 307: "In some individuals [the gall bladder] . . . is so enormous that its excessive size is portentous." He is also questioning here the credulity of those who prefer theological to scientific explanations of phenomena. In *Problems*, Aristotle says of children who speak before the usual age, "Many regard this as abnormal"—that is, *terata*. See W. S. Hett, ed. and tr., *Aristotle: Problems*, LCL (Cambridge, Mass., and London, 1936), 11.27.902a, p. 271.

24. Peck, *Aristotle: Generation of Animals* 4.3.767b, p. 401, and 4.3.769b, p. 419.

25. Hett, *Aristotle: Problems* 10.61.898a, p. 247.

26. Peck, *Aristotle: Generation of Animals* 4.4.772b, p. 441.

27. Francis M. Cornford, ed. and tr., *Aristotle: Physics*, LCL (Cambridge, Mass., and London, 1960), 8.1.252a, p. 281, and Peck, *Aristotle: Generation of Animals* 4.4.770b, p. 425.

28. Peck, *Aristotle: Generation of Animals* 4.3.769b, p. 419.

29. See Rhabanus Maurus, who, amplifying upon Isidore's view of the role of portents in a Christian universe, moralizes: "It is not necessary for us to dispute about the portents spoken of in the books of the Gentiles long ago, but in this way it is appropriate for us to believe that whatever is done in things and described in the changes of nature is not without order and is made by the will of God who in all things acts justly and rightly arranges them, on which account it is said in Psalm 144.17, 'Just are the ways of the Lord and holy His works.' " *De Universo* 7.7, PL 111,199.

30. See Berthe M. Marti, ed., *Arnvlfi Avrelianensis Glosvle Svper Lvcanvm*,

in *Papers and Monographs of the American Academy in Rome* 18 (1958): 1.525, p. 65; 4.243, p. 218; and 6. 635, p. 343.

31. Pierre Bersuire, *Repertorium Morale,* in *Opera Omnia,* vol. 3 (Mainz, 1609), p. 1034. Additional examples of medieval uses of monstrum, monstruositas, and monstruosus can be found in Franz Blatt et al., *Novum Glossarium Mediae Latinitatis* (Copenhagen, 1963), pp. 799–803.

32. "Solinus was not pillaging Pliny in a mechanical fashion. Pliny's phraseology is sometimes reduced and sometimes altered or inverted; nominatives become accusatives or ablatives, active verbs become passive." W. H. Stahl, *Roman Science* (Madison, Wis., 1962), p. 138.

33. T. Mommsen, ed., *Collectanea,* by Solinus (Berlin, 1958), 51, p. 12.

34. John C. Rolfe, ed. and tr., *Ammianus Marcellinus,* LCL (London and Cambridge, Mass., 1935), 19.12, 19–20, pp. 543–545: "In Daphne, [a] suburb of Antioch, a portent [*monstrum*] was born, horrible to see and to report, . . . and this misshapen birth foretold that the state was turning into a deformed condition. Portents of this kind often see the light, as indications of the outcome of various affairs; but as they are not expiated by public rites, as they were in the time of our forefathers, they pass by unheard of and unknown."

35. H. Wuttke, ed., *Cosmographia* (Leipzig, 1853), 2.28, p. 15.

36. Gervase of Tilbury, *Otia Imperialia,* ed. G. W. Liebnitz, in *Scriptores Rerum Brunsvicensium* (Hanover, 1707), 1.3, p. 960. On the dating and sources of this work, see James R. Caldwell, "The Autograph Manuscript of Gervase of Tilbury," *Scriptorium* 11 (1957): 87–98; Raoul Busquet, "Gervais de Tilbury inconnu," *Revue Historique* 191 (1941): 1–20; and H. G. Richardson, "Gervase of Tilbury," *History* 46 (1961): 102–114.

37. G. V. Smithers, ed., *Kyng Alisaunder,* EETS:OS 227 (London, 1952), ll. 13–16.

38. A. O. Lovejoy, *Essays in the History of Ideas* (Baltimore, 1965), p. 324. See also George Boas, *Essays in Primitivism and Related Ideas in the Middle Ages* (New York, 1966), p. 87; and Grant, *Miracle and Natural Law,* p. 23.

39. St. Bonaventure, *In Primum Librum Sententiarum,* in *Opera Omnia,* vol. 1 (Florence, 1882), 45.6, p. 813. See C. C. Swinton Bland, tr., *De Vita Sua,* by Guibert of Nogent, in J. F. Benton, *Self and Society in Medieval France* (New York, 1970), 1.23, p. 107: "God does not idly strike mountains and things inanimate, but He does so to make us reflect that in striking at things that do not sin, He signifies a great judgement on sinners." Raoul Glaber, *Historiarum Libri Quinque,* ed. M. Prou (Paris, 1886), 5.3, p. 130, connects portents with divine justice and natural catastrophe by which God intervenes in the life of man and gives justice. See also Fulcher of Chartres, *A History of the Expedition to Jerusalem 1095–1127,* tr. F. R. Ryan (Knoxville, Tenn., 1969), 2.60, p. 218: "How often and how much our Creator touches us with His reproaches and admonishes us, terrifies us by His portents."

40. On the subject of medieval mirabilia and miracula see Paul Rousset, "Le Sens du merveilleux à l'époque féodale," *Le Moyen Age* 62 (1956): 25–37; Elizabeth Ann Flynn, "The Marvelous Element in the Middle English Alexander Romances" (diss., University of Wisconsin, 1968); and Corrado Bologna, "Natura, Miracolo, Magia, nel pensiero cristiano dell' Alto Medioevo," in P. Xella, ed., *Magia: Studi di storia delle religioni in memoria di Raffaela Garosi* (Rome, 1976), p. 259.

41. William Chase Green, ed. and tr., Saint Augustine, *The City of God,* LCL (Cambridge, Mass., and London, 1959), 21.7, p. 43.

42. Augustine's distinction between man's understanding of nature and

God's is interestingly glossed by Francis of Meyronnes: "Miracula que fecit deus numquam sunt contra naturam sed supra naturam manifestam et secundum naturam occultam" (fol. 124v).

43. Joseph Strange, ed., *Cesarii Heisterbacensis Dialogus Miraculorum* (Cologne, 1851), 2.10.1, pp. 217, 218. Pierre Bersuire in his translation of and commentary on Livy uses *prodigia* as an equivalent to the wonders found in the literature of secular entertainment: "Prodiges estoient appellees aucunes merveilleuses aventures" (BN MS. Fr. 20312 *ter.*, fol. 3). On this work see Robert H. Lucas, "Mediaeval French Translations of the Latin Classics to 1500," *Speculum* 55 (1970): 239.

44. Saint Augustine, *Enchiridion*, in P. Schaff, ed. and tr., *Nicene and Post-Nicene Fathers* (New York, 1905), 3.87, p. 265. Augustine's view here is Aristotelian in his concern for superfluity and defect. In another work he speaks of superfluous growth "quo a caeteris membris integra valetudine augendo aliquid discrepat ... nascantur homines ... monstruosa nominantur" (*De Quantitate Animae* 1.19, PL 32, 1054). Meyronnes uses the passage as a gloss on the *The City of God* 22.19, speaking of "superfluitas monstruosa" (fol. 133).

45. C. C. Mierow, ed. and tr., *Otto of Freising: The Two Cities* (rpt. New York, 1966), 8.12, pp. 470–471.

46. M.R. James, ed., "Ovidius de Mirabilibus Mundi," in *Essays and Studies Presented to William Ridgeway on His Sixtieth Birthday* (Cambridge, 1913), p. 297.

47. The best discussion of this topos is still that of E. R. Curtius, *European Literature and the Latin Middle Ages*, tr. Willard Trask (New York, 1953), pp. 302–347.

48. Alan of Lille, *De Incarnatione Christi*, in PL 210, 579.

49. *Idiotae de Sapientia I*, in Paul Wilpert, ed., *Nikolaus Von Kues: Werke* (Berlin, 1967), 1:217.

50. Saint Bonaventure, *Breviloquium* 2.11, in *Opera Omnia* 5:229.

51. John Block Friedman, ed., "Thomas of Cantimpré, *De Naturis Rerum*: Prologue, Book III, Book XIX," *Cahiers d'Etudes Médiévales II: La Science de la Nature: Théories et Pratiques* (Montreal and Paris, 1974), p. 118.

52. Thomas of Cantimpré, *De Naturis Rerum*, bk. 5, Valenciennes, Bibliothèque Municipale 320, fol. 107v: "Stercus eius calidissimum quando emittitur, sed citissime infrigidatur et significat eos qui in tempore [pacis?] credunt, et in tempore temptationis recedunt."

53. These are Fitzwilliam Museum MS 254, Cambridge; Cambridge University Library MS Kk. 4.25; Westminster Abbey Library MS 22; and Oxford, Bodley Library MS Douce 88, II. Related to this family are the Sion College bestiary, which simply gives pictures and descriptive captions for the races, and some pictures of them in the Old Icelandic *Physiologus* for which no corresponding text survives. See M. R. James, *The Bestiary* (Oxford, 1928), pp. 23–25; and H. Hermannsson, ed., *The Icelandic Physiologus* (Ithaca, N.Y., 1938), pp. 12–15 and plates. Interestingly, on the verso of fol. 1 of the Fitzwilliam bestiary leaf containing the monstrous races is a full-page world map.

54. See Florence McCulloch, *Mediaeval Latin and French Bestiaries*, *University of North Carolina Studies in Romance Languages and Literatures* 33 (rev. ed. 1962).

55. Even the Cynocephalus in the Cambridge bestiary made popular in T. H. White's English translation is transformed into an ape rather than allowed to appear as the dog-headed man common in the material we have studied so far. See T. H. White, ed. and tr., *The Book of Beasts* (London, 1956), p. 35.

56. See, for example, the passage cited from Higden's *Polychronicon* in ch. 3, which discusses violations of nature's order at the extremities of the world.

57. Lindsay, *Etymologiarum* 11.3.14.

58. MS Douce 88 II, fol. 69v: "Gigantes sunt ultra humanam modum grandes quorum figuram superbi tenent qui super volunt videri quam sunt, qui dum laudes affectant uires excedunt." A similar idea occurs in the German commentary on the *Ecloga* of Theodulus, where Mulciber's companions, the giants, are interpreted as presumptuous students or laymen who wish to rise to the level of masters or to higher social station. Arpád P. Orbán, ed., "Anonymi Tuetonici *Commentum in Theodoli Eclogam*," *Vivarium* 11 (1973): 37.

59. MS Douce 88 II, fol. 69v: "De Saulo superbo, dicitur quia ab humero et sursum eminencior erat omni populo." The author probably alludes here to Peter Lombard on Psalms, *PL* 191, 1253–54. The story of Saul is found in I Samuel.

60. MS Douce 88 II, fol. 69v: "Humilitas uero David commendatur, ubi dicitur David minimus inter fratres."

61. MS Douce 88 II, fol 69v: "Cenocephali qui canina capita habent, detractores et discordes designant . . . qui labeo subteriore se contegunt eos figurant de quibus dicitur 'labor labiorum operiet eos.' "

62. MS Douce 88 II, fol. 69v: "Reliquens species potest diligens lector per rit? uolunt uel cet[r?]eis litteris uel aureis luculentius describere."

63. The natural tendency of a medieval homiletic writer would be to see them *in malo*. Note the way Robert Holkot moves from Aristotle and Aquinas to a purely allegorical interpretation: "Quod vitiose se magnificent peccatores monstruosi. Notum est, quod quando in aliquo individuo nimia magnitudo reperitur, & quando in uno individuo diversae species concurrunt, dicitur monstrum naturae: ut si unum individuum esset ex parte porcus & ex parte bos, recte diceretur monstrum, . . . Moraliter loquendo, Peccatores dicuntur multipliciter monstruosi; quia vel ex excessiva magnitudine unius peccati, vel ex aggregatione diversorum peccatorum specie distinctorum. Unde si homo aliquis esset summe superbus & summe luxuriosus, talis posset dici monstrum: quia esset homo per naturam, daemon per superbiam, & taurus per luxuriam." *Postilla Super Librum Sapientiae Salomonis* (Cologne, 1689), 212.1, p. 364.

64. On this subject see Beryl Smalley, *English Friars and Antiquity in the Early Fourteenth Century* (Oxford, 1960), pp. 145–146.

65. H. Oesterley, ed., *Gesta Romanorum* (rpt. Hildesheim, 1963), pp. 574–576.

66. The *moralitates* in the *Bible moralisée* were overseen by Hugh of St. Cher, Peter the Chanter, and other important thirteenth-century theologians. See A. de Laborde, *La Bible moralisée illustrée* (Paris, 1911–1927), vol. 1, pl. 63. In opposition to de Laborde's view (5:143–154) that the glosses are by Hugh of St. Cher, see Reiner Haussherr, "Peter Cantor, Stephan Langton, Hugo von St. Cher, und der Isaias-Prolog der Bible Moralisée," in Hans Fromm et al., eds., *Verbum et Signum* (Munich, 1975), 2:347–364. Haussherr (p. 352) believes Peter Cantor or Stephen Langton to be the author of these glosses.

67. Shirley Marchalonis has noted that the symbolism in the *Gesta Romanorum* is not used with consistency but rather arbitrarily and illogically in the interests of the compiler's didacticism. See her "Medieval Symbols and the *Gesta Romanorum*," *Chaucer Review* 8 (1974): 311–319.

68. The manuscript has been published by Alfons Hilka, "Eine altfranzösische moralisierende Bearbeitung des Liber de Monstruosis Hominibus Orientis aus Thomas von Cantimpré, De Naturis Rerum," in *Abhandlungen*

der Gesellschaft der Wissenschaften zu Göttingen: Philologisch-Historische Klasse 7 (Berlin, 1933): 1–73. Line references are to this edition.

69. Written on excellent parchment, with no corrections or marginalia, the book shows little use. It may have been ordered from a commercial or monastic scriptorium rather than from a single scribe, as the capitals were done after the manuscript was written.

70. For example, almost every monstrous race is introduced with a novel transition designed to weave together verbally the interests of speaker and auditor: "A people quite naked live in this land of whom *you* have heard before" (ll. 107–109, emphasis added). To lift his material emotionally above the level of the usual dry catalog, he frequently employs *exclamatio:* "Sweet God, what a villainous monster this is" (l. 493), and *anominatio,* whose effect is clearer in the French (ll. 920–924, emphasis added):

> *Doners* met le malvais en los;
> *Doners* por Diu est vrais *pardons*
> *Car dons* estaint pecié *par dons*
> *Par dons* est peciés pardounés,
> Et *par pardons* peciés dampnés.

71. One new river in the Orient, "named Gurgis" (l. 1479) he produces by an apparently conscious misreading of the words *fluviorum et gurgites* in the Latin text.

72. Friedman, "Thomas of Cantimpré," p. 126, ll. 120–121.

73. See Robert Guiette, "Symbolisme et 'senefiance' au Moyen Age," *Cahiers de l'Association Internationale des Etudes Françaises* 6 (1954): 107–122.

74. Friedman, "Thomas of Cantimpré," p. 123, ll. 5–6.

7. EXOTIC PEOPLES IN MANUSCRIPT ILLUSTRATION

1. This manuscript has been published and discussed by A. M. Amelli, *Miniature . . . illustrati l'enciclopedia medioevale di Rabano Mauro* (Montecassino, 1896). See on the subject, Fritz Saxl, "Illustrated Mediaeval Encyclopaedias, 1: The Classical Heritage," in *Lectures* (London, 1957), 1:234–239.

2. The Westminster bestiary is described by J. Armitage Robinson and M. R. James, *The Manuscripts of Westminster Abbey* (Cambridge, 1909), item 22, pp. 77–81, and G. C. Druce, "Some Abnormal and Composite Human Forms in English Church Architecture," *Archaeological Journal* 72, 2nd ser. (1915): 135–142.

3. The illustration for the *De Portentis* in the later Vat. Lat. Pal. 291, fol. 75v, in its attempts to show interrelationship among the races, suggests the illustrative technique of the travel books we shall consider at the end of this chapter. A thirteenth-century Solinus cycle in the Ambrosian Library, C. 246 inf., contains a number of the races in laddered registers as well; see fols. 24r-v and 57r. It has been suggested by Rudolf Wittkower in "Marvels of the East," *Journal of the Warburg and Courtauld Institutes* 5 (1942): 171–172, that this manuscript looks back to a ninth-century illustrated Solinus. See also P. Rivelli, "Figurazioni cartografiche . . . ," in *Raccolta di scritti in onore di Felice Ramorino* (Milan, 1927), pp. 615–626, and idem, *I codici ambrosiani di contenuto geografico* (Milan, 1929), pp. 36–38.

4. See Florence McCulloch, *Mediaeval Latin and French Bestiaries, Uni-*

versity of North Carolina Studies in Romance Languages and Literatures 33 (rev. ed., 1962), pp. 78–192.

5. John Block Friedman, ed., "Thomas of Cantimpré, De Naturis Rerum: Prologue, Book III, Book XIX," Cahiers d'Etudes Médiévales II: La Science de la Nature: Théories et Pratiques (Montreal and Paris, 1974), pp. 115–117. The illustrations of the monstrous races in Gautier de Metz, Image du monde, Paris, Bibliothèque Ste. Geneviève 2200, c. 1277, and the moralized Thomas discussed in the last chapter, BN Fr. 15106, with forty-nine miniatures, are very similar in treatment to the standard Thomas of Cantimpré cycle. A page of Gautier's Image containing Apple-Smellers, Monoculus, and Blemmyae is published by J. Baltrušaitis, Réveils et prodiges (Paris, 1960), fig. 23. On the encyclopedia as a medieval genre, see the general but useful studies of L. M. Capelli, Primi Studj sulle enciclopedie medioevali: Le fonti delle enciclopedie latini del XII secolo (Modena, 1897); Eva Matthews Sanford, "Famous Latin Encyclopaedias," Classical Journal 44 (1949): 462–467; and Maurice de Gandillac et al., La Pensée encyclopédique au Moyen Age (Neuchâtel, 1966).

6. Compare Prague University Library MS XIV.A.15, fol. 32v, fourteenth century. The style and organization of the pages containing the monstrous races are extremely similar.

7. See the excellent bibliography in Lilian M. C. Randall, Images in the Margins of Gothic Manuscripts (Berkeley and Los Angeles, 1966). See also Baltrušaitis, Réveils et prodiges, pp. 12, 44.

8. The Plinian races appear in a number of examples of ecclesiastical art, mostly of Burgundian and Cluniac origin. Aside from the Vézelay tympanum discussed in ch. 4, there are Sciopods on the basement walls of Sens Cathedral (Yonne), c. 1190, published by Baltrušaitis, Réveils et prodiges, fig. 7; and on the crypt capital of St. Parize-le-Châtel (Nièvre), c. 1113, published by V.-H. Debidour, Le Bestiaire sculpté en France (Mulhouse, 1961), fig. 340. A pillar at Souvigny (Allier) contains "Podes," "Cidipes," "Soni," and "Ethiops." Nothing is known of the circumstances of its carving. Portions have been published by Debidour, figs. 263, 264, 265, and discussed by Victor Terret, La Sculpture Bourguignonne aux XIIe et XIIIe siècles: Ses origines et ses sources d'inspiration: Cluny (Paris, 1914), pp. 38–40. A carving of a Sciopod exists at Lixy (Yonne) originally the site of an Augustinian Priory of St. Jean de Sens, 1132; the carving may be connected with a baptismal font. It has been published by Debidour, fig. 341. The parish church of Remagen has a portal containing a Sciopod; it has been published and discussed by Richard Hamann, Die Abteikirche von St. Gilles und ihre künstlerische Nachfolge (Berlin, 1955), pp. 413, 415, and pls. 530 and 532.

9. The style of Vienna Nationalbibliothek 1599, fol. 2v is discussed by Gerhard Schmidt, Die Malerschule von St. Florian (Linz, 1962), pp. 177f. The Blemmyae on the beatus page of BL Add. 9810, fol. 7, St. Omer Psalter, c. 1330, occupies much the same position by the shaft of the letter B. Randall, Images, pl. 30, fig. 140, does not identify this figure as a Blemmyae in her description of the page.

10. See Lilian M. C. Randall, "The Fieschi Psalter," Journal of the Walters Art Gallery 23 (1960): 27–47, especially fig. 11.

11. For a bibliography and discussion of the Siren, see John Block Friedman, "L'Iconographie de Vénus," in Bruno Roy, ed., L'Erotisme au Moyen Age (Montreal, 1977), p. 74.

12. Otto Pächt, The Rise of Pictorial Narrative in Twelfth-Century England (Oxford, 1962), p. 22.

13. See E. G. Millar, *The Rutland Psalter* (Oxford, 1937), which discusses the miniatures on pp. 27, 47, and 56; the drawings are found on fols. 57 and 88v (b).

14. See M. R. James, "Pictor in Carmine," *Archaeologia* 94 (1951): 141. For what is perhaps the source of the idea, see St. Bernard's *Apologia*, ch. 12, *PL* 182, 16.

15. Striking instances of naturalistic treatments of birds and plants occur in the *De arte venandi* done for Frederick of Sicily, 1250, ed. C. A. Wood and F. M. Fyfe (Palo Alto, Calif., 1943), and in R. T. Gunther, *The Herbal of Apuleius Barbarus* (Oxford, 1925). The gothic rebirth of naturalism with respect to the rendition of plants and animals in art is well discussed by Derek Pearsall and Elizabeth Salter, *Landscapes and Seasons of the Medieval World* (London, 1973), pp. 161–165, and Otto Pächt, "Early Italian Nature Studies and the Early Calendar Landscape," *Journal of the Warburg and Courtauld Institutes* 13 (1950): 22–32.

16. An especially suggestive study of this subject is by Paul Shepard, *Man in the Landscape* (New York, 1967), pp. 119–120. I am much indebted to his discussion.

17. See the edition by Luisa C. Arano, *The Medieval Health Handbook: Tacuinum Sanitatis* (New York, 1976), pp. 7–11 and 150–152, for discussion and bibliography. A fuller treatment of the mandrake scene occurs in Pächt, "Early Italian Nature Studies," pp. 33, 34–37.

18. See J. Le Sénécal, "Les Occupations des mois dans l'iconographie du Moyen Age," *Bulletin de la Société des Antiquaires de Normandie* 35 (1921-1923): 9–218; Rosemund Tuve, *Seasons and Months* (rpt. Totowa, N.J., and Cambridge, 1974), pp. 42–170; J. C. Webster, *The Labors of the Months* (Evanston and Chicago, Ill., 1938), pp. 5–101; and Pächt, "Early Italian Nature Studies," pp. 37–47, for discussion.

19. See here Millard Meiss, *French Painting in the Time of Jean de Berry: The Late Fourteenth Century and the Patronage of the Duke*, 2 vols. (London, 1967), passim, as well as the edition by J. Longnon et al., *Les Très Riches Heures du Duc de Berry* (London, 1969).

20. See generally F. Bucher, "Medieval Landscape Painting: An Introduction," in *Medieval and Renaissance Studies: Proceedings of the Southeastern Institute of Medieval and Renaissance Studies*, ed. J. M. Headley (Chapel Hill, N.C., 1968), pp. 119–169.

21. See Paul Vignaux, *Nominalisme au XIVe siècle* (Montreal, 1948), and William J. Courtenay, "Nominalism and Late Medieval Religion," in Charles Trinkaus, ed., *The Pursuit of Holiness in Late Medieval and Renaissance Religion* (Leiden, 1974), pp. 56–57.

22. For good discussions of the traveler mentality, see Christian K. Zacher, *Curiosity and Pilgrimage* (Baltimore and London, 1976), passim; Michel Mollat, *Grands Voyages et connaissance du monde du milieu du XIIe siècle à la fin du XVe* (Paris 1966), 1:66–71; and Donald Howard, "The World of Mandeville's Travels," *Yearbook of English Studies* 1 (1971), where he points out that Mandeville combined two preexisting genres, accounts of pilgrimages to Jerusalem and travels to the Far East, developing an altogether new narrative voice. Howard (p. 2) believes that Mandeville was "trying to write a new kind of work, a summa of travel lore which (a) combined the authority of learned books and guidebooks with the eyewitness manner of pilgrims and travel writers; (b) combined the pilgrimage to the Holy Land with the missionary or mercantile voyage into the Orient; and (c) combined the curious and vicarious intentions of some such works with the thoughtful and devotional intentions of

others." See also W. Stanford, *The Ulysses Theme* (Oxford, 1954), pp. 175–210; M. J. Barber, "The Englishman Abroad in the Fifteenth Century," *Medievalia et Humanistica* 11 (1957): 69–77; and A. P. Newton, ed., *Travel and Travellers of the Middle Ages* (New York, 1926).

23. Gerhart Ladner, "*Homo Viator*: Mediaeval Ideas on Alienation and Order," *Speculum* 42 (1967): 233–259.

24. See, for example, Antonia Gransden, "Realistic Observation in Twelfth-Century England," *Speculum* 47 (1972): 29–51.

25. P. Hamelius, ed., *Mandeville's Travels*, EETS:OS 153 (rpt. London, 1960, 1961), ch. 19, p. 108. For a later statement of the idea see John Gower, *Confessio Amantis*, bk. 7, ll. 746–754, in G. C. Macaulay, ed., *The English Works of John Gower*, EETS:ES 81–82 (London, 1957), 2:253.

26. See Rosamond J. Mitchell, *The Spring Voyage: The Jerusalem Pilgrimage in 1458* (London, 1964).

27. Aubrey Stewart, tr., *Burchard of Mount Sion*, Palestine Pilgrims' Text Society 12 (rpt. New York, 1971), pp. 1–4.

28. The best example of a practical pilgrimage narrative is Aubrey Stewart, tr., *The Wanderings of Felix Fabri*, Palestine Pilgrims' Text Society 7–10 (rpt. New York, 1971).

29. Charles Schefer, ed., *Le Voyage de la Sainct Cyté de Hierusalem* (rpt. Amsterdam, 1970), p. 73.

30. Gustav Oppert, ed., *Itinerarius Johannis de Hese*, in *Der Presbyter Johannes in Sage und Geschichte* (Berlin, 1870), p. 182. On Hese, see Francis M. Rogers, *The Quest for Eastern Christians: Travels and Rumor in the Age of Discovery* (Minneapolis, 1962), p. 81. A similar work blending wonders with the itinerary tradition is Paul Walther, *Fratris Pauli Waltheri Guglingensis Itinerarium in Terram Sanctam*, ed. M. Sollweck (Tübingen, 1892).

31. An excellent assortment of these miniatures is in D. J. A. Ross, *Illustrated Medieval Alexander-Books in Germany and the Netherlands* (Cambridge, 1971), and Krystyna Secomska, "The Miniature Cycle in the Sandomierz *Pantheon* and the Medieval Iconography of Alexander's Indian Campaign," *Journal of the Warburg and Courtauld Institutes* 38 (1975): 53–71.

32. Until recently, the standard edition and study of these manuscripts and illustrations has been M. R. James, ed., *The Marvels of the East* (Oxford, 1929). Now the texts have been reedited by J. D. Pickles, "Studies in the Prose Texts of the *Beowulf* Manuscript" (diss., Cambridge University, 1971), and Paul Allen Gibb, "Wonders of the East: A Critical Edition" (diss., Duke University, 1977). Pickles (p. 45) has suggested of the manuscripts that "one, perhaps each of them, has been deliberately altered from an earlier illustrated text ... with illustrations in the main like those of Tiberius-Bodley. When the pictures were redesigned for Vitellius ... another pictorial tradition was used." Pickles rightly noted (p. 35) that both these texts and their pictures belong to the paradoxographic tradition of Hellenistic antiquity. Bodley MS 614 is discussed by Otto Pächt, *Illuminated Manuscripts in the Bodleian Library Oxford* (Oxford, 1966–1973), vol. 3, no. 156.

33. W. W. Boer, ed. *Epistola Alexandri ad Aristotelem* (rpt. Meisenheim am Glan, 1973), pp. 32–33, emphasis added.

34. "Coment Alixandres trouva un home sauvage et le fist ardoir pour ce que il navoit point dentendement mais estoit ainsi comme une beste," BL Harley 4979, fol. 60.

35. H. Omont, "Lettre à l'Empereur Adrien sur les merveilles de l'Asie," *Bibliothèque de l'Ecole des Chartes* 74 (1913): 511.

36. Marjorie Hope Nicolson, *Mountain Gloom and Mountain Glory* (New York, 1963), pp. 39–49.

37. Hayden White, "The Forms of Wildness," in Edward Dudley and Maximillian Novak, eds., *The Wild Man Within: An Image in Western Thought from the Renaissance to Romanticism* (Pittsburgh, 1972), pp. 6–7.

38. See the discussion of this topic in Edward Tompkins McLaughlin, *Studies in Mediaeval Life and Literature* (New York and London, 1894), p. 6, whose translation of John of Salisbury's remarks I use here.

39. Edward Maunde Thompson, ed. and tr., *Chronicon Adae de Usk* (London, 1904), p. 242.

40. Louis Ginzburg, *Legends of the Jews* (Philadelphia, 1909), 1:79–80.

41. Rendel Harris, ed. and tr., *The Voyage of Hanno* (Cambridge, 1928), 7, p. 25; 9, p. 26; 18, p. 27.

42. Leslie Whitbread, "The Liber Monstrorum and Beowulf," *MS* 36 (1974), p. 452. The work has been edited by Corrado Bologna as *Liber Monstrorum de Diversis Generibus* (Milan, 1977). The discovery of a new manuscript of the work, at St. Gallen, is discussed by Ann Knock, "The 'Liber Monstrorum': An Unpublished Manuscript and Some Reconsiderations," *Scriptorium* 32 (1978): 19–28.

43. It is from sources rather later than the work itself that we get our only evidence of authorship. The reference in Thomas of Cantimpré's *De Naturis Rerum*, which draws heavily on the *Liber Monstrorum*, to a certain "adelinus philosophicus" as the author has inspired some writers to connect "adelinus" and Aldhelm of Malmsbury, Bishop of Sherborne, on no real evidence. See Alfons Hilka, ed., "Liber de Monstruosis Hominibus Orientis," by Thomas of Cantimpré, *Festschrift zur Jahrhundertfeier der Universität Breslau* (Breslau, 1911), pp. 153–165; F. Pfister, *Berliner Philologische Wochenschrift* 32 (1912): 1131; Edmond Faral, "La Queue de poisson des Sirènes," *Romania* 74 (1953): 466; and F. Porsia, "Note per una riedizione ed una rilettura del *Liber Monstrorum*," *Università de Bari: Annali della Facoltà di Lettere e Filosofia* 15 (1972): 329–330. Whitbread has argued more cautiously that Aldhelm and his circle were the only people of the time to have the wide range of Latin learning and the highly rhetorical style necessary to have composed the work ("The Liber Monstrorum," pp. 455–461). The European scholars I have mentioned do not give any instances where the name Adelinus or Audelinus was used for Aldhelm. I have, however, found such an identification. Evidence that Aldhelm was at least once called Adelinus exists in a fourteenth-century calendar in the University of Illinois Library, where we find in the table for May 25 (Aldhelm's birthday) "adelinus episcopus" (*Horae*, Sarum use, De Ricci MS 140, fol. 5v). A variant form suggesting minim error "andelmi ep." or "audelmi ep." occurs in the calendar of an English psalter, Gloucester use, c. 1200; it is Munich CLM 835, fol. 3. Although Aldhelm's name appears frequently in Francis Wormald, ed., *English Kalendars before A.D. 1100* (London, 1934) and *English Benedictine Kalendars after A.D. 1100*, vol. 1 (London, 1939) and vol. 2 (London, 1946), it is spelled Aldelmus. Quite possibly the "adelini episcopus" entry resulted from a scribal confusion of "Adelmi" with "Adelini" where the minims of the *m* were understood as an *i* and *n*. Curiously, Raoul de Presles speaking of giants in his translation of *The City of God* quotes directly from the *Liber Monstrorum*, saying, "De telle maniere de gyans raconpte adelinus en son liure de proprietatibus rerum." This suggests that he must have regarded Thomas' entire encyclopedia as the work of "Adelinus." See Raoul de Presles,

Cy commence la table du premier liure de monseigneur saint augustin de la cité de dieu (Abbéville, 1486), 15.4, sig. 1, fol. i verso.

44. Bologna, ed., *Liber Monstrorum,* bk. 1, prologue, p. 34.

45. Whitbread, "The *Liber Monstrorum,*" p. 434.

46. Pächt, *The Rise,* p. 27; and Baltrušaitis, *Réveils et prodiges,* p. 12.

47. H. Omont, ed., *Livre des merveilles: Reproduction des 265 miniatures du manuscrit français 2810 de la Bibliothèque Nationale,* 2 vols. (Paris, 1907), 1:15. The miniatures of this manuscript, a product of the famous Boucicaut workshop, have been discussed by Millard Meiss, *French Painting in the Time of Jean de Berry: The Boucicaut Master* (London, 1968), pp. 38–40, 116–117; some of the miniatures are reproduced, figs. 81–100.

48. This manuscript containing a romance of Alexander and the *Travels of Marco Polo,* Flemish and English, c. 1400, has been edited in part by M. R. James, *The Romance of Alexander* (Oxford, 1933), and discussed by Pächt, *Illuminated Manuscripts in the Bodleian Library,* vol. 1, no. 297. On the mixed nature of such manuscripts see D. J. A. Ross, "Methods of Book Production in a XIVth-Century French Miscellany," *Scriptorium* 6 (1952): 63–75.

49. R. Wittkower, "Marco Polo and the Pictorial Tradition of the Marvels of the East," *Oriente Poliano: Studi e conferenze tenute all'Istituto Italiano per il medio ed estremo oriente* (Rome, 1957), pp. 155–172.

50. Zacher, *Curiosity and Pilgrimage,* pp. 131, 133; and Howard, "The World of Mandeville's Travels," p. 5. It should be noted that *Mandeville's Travels* has undergone considerable reevaluation in recent years. J. W. Bennett's view of Mandeville as a "creator of a romance of travel" (*The Rediscovery of Sir John Mandeville* [New York, 1954], p. 53) has been challenged by Dorothee Metlitzki (*The Matter of Araby in Medieval England* [New Haven and London, 1977], pp. 230f), who sees him as a serious geographer and Arabist, and believes that he actually went to Egypt. A. C. Cawley, "Down Under: A Possible New Source for *Mandeville's Travels,*" in G. Turville-Petre et al., eds., *Iceland and the Mediaeval World* (Victoria, Australia, 1974), pp. 144–150, argues for the originality of Mandeville's geographic views and his bold "imaginary journeying in southern latitudes" (p. 147). D. Butturff, "Satire in *Mandeville's Travels,*" *Annuale Mediaevale* 13 (1973): 155–164, discusses the *persona* of the narrator.

51. A concise discussion of the space in miniatures of the books of this period can be found in John White, *The Birth and Rebirth of Pictorial Space* (Boston, 1967), pp. 219–235. On the court of René d'Anjou, from which Pierpont Morgan 461 comes, see Otto Pächt, "René d'Anjou—Studien I," *Jahrbuch der kunsthistorischen Sammlungen in Wien* 69 (1973): 85–126.

8. MONSTROUS MEN AS NOBLE SAVAGES

1. For a detailed discussion of the concept of primitivism in antiquity and the Middle Ages, see A. O. Lovejoy and G. Boas, *Primitivism and Related Ideas in Antiquity* (New York, 1965), pp. 287–367; and G. Boas, *Essays on Primitivism and Related Ideas in the Middle Ages* (New York, 1966), pp. 129–133.

2. Jacques de Vitry, *Historia Orientalis* (rpt. Meisenheim am Glan, 1971), ch. 92, pp. 215–216.

3. See, for example, Richard Bernheimer, *Wild Men in the Middle Ages* (Cambridge, Mass. 1952), pp. 85–120; and Alan Deyermond, "El hombre salvaje en la novela sentimental," *Filologia* 10 (1964 [1965]): 97–111.

4. *De Mari Erythraeo,* in C. Müller ed., *Geographi Graeci Minores* (rpt. Hil-

desheim, 1965), 1, 140–141. A number of additional texts have been published by Lovejoy and Boas, *Primitivism,* pp. 350–351.

5. R. Henry, ed., *L'Inde,* by Ctesias (Brussels, 1947), 8, p. 66; 11, p. 69; and 20, p. 75.

6. Ibid., 23, p. 78.

7. P. van de Woestijne, ed., *La Périégèse de Priscien* (Bruges, 1953), ll. 570–573, p. 70.

8. R. Jahnke, ed., *Lactantii Placidi Commentarios in Statii Thebaida* (Leipzig, 1898), 427, p. 284. See also R. D. Sweeney, *Prolegomena to an Edition of the Scholia to Statius* (Leiden, 1969), pp. 114–121, for an annotated bibliography of studies on Lactantius Placidus.

9. See L. I. Ringbom, *Paradisus Terrestris,* Acta Societatis Scientiarum Fennicae, Nova Series C., i no. i (Helsinki, 1959).

10. Jean Rougé, ed. and tr., *Expositio Totius Mundi et Gentium,* Sources Chrétiennes 124 (Paris, 1966), ch. 4, pp. 142–144; ch. 12, p. 150.

11. Z. Avalichvili, "Géographie et légende dans un écrit apocryphe de S. Basile," *Revue de l'Orient Chrétien,* 3rd ser., vol. 6, no. 26 (1927–1928): 280–281.

12. Leonardo Olschki, *Marco Polo's Precursors* (Baltimore, 1943), p. 37.

13. John of Plano Carpini, *Ystoria Mongalorum,* ed. A. Van Den Wyngaert, in *Sinica Franciscana* (Florence, 1929), 1.5.10, pp. 57–58.

14. B. Perrin, ed. and tr., *Plutarch's Lives,* vol. 7, LCL, (London and Cambridge, Mass., 1919), ch. 59, p. 393; ch. 64, pp. 405–407, 409.

15. John Watson McCrindle, ed. and tr., *Ancient India as Described by Ktesias the Knidian* (rpt. New Delhi, 1973), pp. 97–107.

16. On this subject see P. R. Coleman-Norton, "The Authorship of the *Epistola de Indicis Gentibus et de Bragmanibus,*" *Classical Philology* 21 (1926): 154–160; A. Wilmart, "Les Textes latins de la lettre de Palladius sur les moeurs des Brahmanes," *Revue Bénédictine* 45 (1933): 29–42; F. Pfister, "Das Nachleben der Überlieferung von Alexander und den Brahmanen," *Hermes* 76 (1941): 143–169; G. A. Cary, "A Note on the Mediaeval History of the Collatio Alexandri cum Dindimo," *Classica et Mediaevalia* 15 (1954): 124–129; J. D. M. Derrett, "The History of 'Palladius on the Races of India and the Brahmans,' " *Classica et Mediaevalia* 21 (1960): 64–135; and Boas, *Essays,* pp. 140–141. W. Berghoff has published an edition of the Greek Brahman text as *De gentibus Indiae et Bragmanibus,* in *Beiträge zur klassischen Philologie* 24 (1967).

17. S. V. Yankowski, tr., *The Brahman Episode,* by Pseudo-Ambrose (Ansbach, 1962), p. 21.

18. See Cary, "A Note," pp. 125–126.

19. On these manuscripts see H. L. D. Ward, *Catalogue of Romances in the Department of Manuscripts in the British Museum* (London, 1883), 1:106–109, 110–111; 114–115; 119–120; 136–137; 138; 140.

20. See Luitpold Wallach, "Alexander the Great and the Indian Gymnosophists in Hebrew Tradition," *Proceedings of the American Academy for Jewish Research* 11 (1941): 51, 54, 58; and, more generally, F. Pfister, *Alexander der Grosse in den Offenbarungen der Griechen, Juden, Mohammedaner und Christen,* in *Deutsche Akademie der Wissenschaften: Sektion für Altertumswissenschaft* 3 (Berlin, 1956); and D. J. A. Ross, *Alexander Historiatus* (London, 1963), p. 165.

21. See B. Graef, "Amazones," in *P-W* 1 (1894): 1754–1789.

22. John C. Rolfe, ed. and tr., *Quintus Curtius: History of Alexander,* vol. 2, LCL (London and Cambridge, Mass., 1962), 6.5, pp. 47–49. A miniature depict-

ing this encounter can be found in BL Harley 4979, fol. 54v, which likewise stresses Thalestris' boldness and large retinue.

23. See Pfister, "Das Nachleben," pp. 165-167, for a discussion of Jacques as a source for Thomas and of Thomas' abridgement.

24. See John Block Friedman, ed., "Thomas of Cantimpré, *De Naturis Rerum: Prologue, Book III, Book XIX,"* Cahiers d'Etudes Médiévales II: La Science de la Nature: Théories et Pratiques (Montreal and Paris, 1974), 88-90, p. 125.

25. H. Boese, ed., *Thomas Cantimpratensis Liber de Natura Rerum* (Berlin and New York, 1973), 1.26, p. 31.

26. Hugh of St. Cher, *Opera Omnia in Universum Vetus et Novum Testamentum* (Venice, 1732), vol. 6, fols. 6v, 7v. On the legend of the three kings see Hugo Kehrer, *Die Heiligen Drei Könige in Literatur und Kunst,* 2 vols. (Leipzig, 1908-1909). More recent studies are G. Vézin, *L'Adoration et le cycle des mages dans l'art chrétien primitif* (Paris, 1950); H. J. Richards, "The Three Kings," *Scripture* 8 (1956): 23-28; and J. C. Marsh-Edwards, "The Magi in Tradition and Art," *Irish Ecclesiastical Record* 85 (1956): 1-9. Pseudo-Jerome had said that "tres magi tres filios Noe ... significant" (*Expositio Quatuor Evangeliorum: Matthaeus,* in PL 30, 537). He was probably an Irishman writing in the seventh or eighth century. See E. Dekkers, *Clavis Patrum Latinorum* (Steenbrugge, 1962), 631.

27. For the first suggestion that Caspar was black, see the homily on Epiphany associated with the name of Sedatus: "In eo, quod ad Christum primum Aethiopes, id est gentiles ingrediuntur." In A. Engelbrecht, ed., *Favsti Reiensis Opera,* in CSEL 21 (Vienna, 1891), p. 253. On Sedatus, see Dekkers, *Clavis Patrum Latinorum,* 1005, and on the possible authorship of this homily, A. Wilmart, "Une homélie de Sedatius," *Revue Bénédictine* 35 (1923): 5-6.

28. C. Horstmann, ed., *The Three Kings of Cologne,* EETS:OS 85 (London, 1886), ch. xv, p. 231. A good recent discussion of John of Hildesheim appears in Ugo Monneret de Villard, *Le leggende orientali sui magi evangelici* (Vatican City, 1952), pp. 182-236; he treats the blackness of Caspar on pp. 217-218. See also Francis M. Rogers, *The Quest for Eastern Christians: Travels and Rumor in the Age of Discovery* (Minneapolis, 1962), passim; and Jean Devisse, *The Image of the Black Man in Western Art,* vol. 2 (New York, 1980).

29. St. Augustine, *Ennarrationes in Psalmos,* ed. B. M. Perez, in *Obras de San Agustin* (Madrid, 1965), vol. 2, pp. 746-747.

30. A. Zingerle, ed., *S. Hilarii Episcopi Pictavensis Tractatvs Svper Psalmos,* in CSEL 22 (Vienna, 1891), 67.32, 33, p. 308.

31. See C. C. Mierow, ed. and tr., *Otto of Freising: The Two Cities* (rpt. New York, 1966), 7.33, p. 444, where the author speaking of how Prester John attempted to come to the aid of Christian Jerusalem observes, "It is said that he is a lineal descendant of the Magi."

32. Merton Jerome Hubert, ed. and tr., *The Romance of Floire and Blanchefleur,* in *University of North Carolina Studies in the Romance Languages and Literatures* 63 (Chapel Hill, N.C, 1966), ll. 61-64.

33. Henri Baudet, *Paradise on Earth: Some Thoughts on European Images of Non-European Man,* tr. Elizabeth Wentholt (New Haven and London, 1965), p. 6.

34. Yankowski, *The Brahman Episode,* pp. 33, 36.

35. This rubric has been published by Lewis Hanke, *Aristotle and the American Indians: A Study in Race Prejudice in the Modern World* (Bloomington, Ill., and London, 1970), pp. 4-5.

9. THE HUMAN STATUS OF THE MONSTROUS RACES

1. J. C. Rolfe, ed. and tr., Suetonius, *The Lives of the Caesars,* LCL (London, and New York, 1914), 1.83, p. 251.

2. F. G. Moore, ed., *Livy,* vol 7, LCL (Cambridge, Mass., and London, 1943), 27.27.5.

3. S. P. Scott, tr., *The Laws of the Twelve Tables,* in *The Civil Law* (rpt. New York, 1973), 1.4.3, p. 65.

4. Scott, *The Civil Law,* 2:229. This passage corresponds to T. Mommsen and P. Krueger, eds., *Corpus Iuris Civilis: Institutiones et Digesta* (rpt. Dublin-Zurich, 1970), 1.5.14, p. 35. See H. F. Jolowicz, *Historical Introduction to the Study of Roman Law* (Cambridge, 1972), 105–108, 110; 401–402; 512–516; Paul Vinogradoff, *Roman Law in Medieval Europe* (New York, 1968); E. Levy, "Vulgarization of Roman Law in the Early Middle Ages . . . ," *Medievalia et Humanistica* 1 (1943): 14–40; and, on the particular interpolation in question, Rodolfo Ambrosino, "In tema di interpolazioni," *Rendiconti Reale Istituto Lombardo di Scienze e Lettere: Classe di Lettere e Scienze Morali e Storiche* 73 (1939–1940): 71–72; and Edoardo Volterra, "Sull'uso delle *Sententiae* de Paolo . . . ," in *Atti del Congresso Internazionale di Diritto Romano: Bologna* (Pavia, 1934), 1:69, 82.

5. *Baldi Vbaldi Pervsini Commentaria in Primam digesti Veteris Partem* (Venice, 1616), 1.14, fol. 31v: "Quod non habet corpus hominis, animam hominis non praesumat habere, quia presumitur, quod natura non ponat animam, vbi non est corpus, . . . Cum forma dat esse rei, qui non habet formam hominis, non est homo . . . additio Baldi: qui caret formam hominis, caret libertatis nomine, sed quod habet aliquid forme hominis, licet forma sit difformis, libertatis tenet effectum."

6. *Lectura Domini Bartoli a Saxoferrato in Primam Digesti Veteris Partem* (Turin, 1577), 1.14, p. 23: "Partus monstruosi id est contra naturam, seu formam hominum dicuntur esse legitimi." On this author see C. N. Wolf, *Bartolus of Sassoferrato* (Cambridge, 1913).

7. A. Friedberg, ed., *Decretalium Collectiones,* in *Corpus Iuris Canonici* (rpt. Graz, 1959), 2.3.42.2, 644.

8. Guido da Baysio, *Rosarivm sev in Decretorvm Volvmen Commentaria* (Venice, 1577), 3.4, fol. 402v: "Sed quid fieret quando baptizandum est monstrum natum cum duobus capitibus, an scilicet baptizari debeat vt vnus homo, vel vt due? Ad hoc Thomas dicit quod quando nascitur monstrum, aut certum est duas esse animas rationales, aut non est certum. Est autem certum si sunt duo capita & duo colla & duo pectora, quia erunt per consequens due corda, in tali casu baptizandi sunt vt duo, & quamuis praesumatur quod plures possunt simil baptizari dicendo, ego baptizo vos: tutius est tamen eos baptizare sigillatim, amplius non est dubium. Verbi gratia, si non sint duo capita bene distincta, vel due cervices bene fundate in eadem nucha. Tunc primo baptizandus est vnus. Deinde illo baptizato potest alter dubie baptizari dicendo: si non es baptizatus, ego baptizo te." Guido comments here on Friedberg, ed., *Decretalium* 1.4.13, 1365. See on this author F. Liotta, "Appunti per un biografia del canonista Guido da Baisio," *Studi Senesi* 76 (1964): 7–52. For a convenient general treatment of canon law, see Stephan Kuttner, *Harmony from Dissonance* (Latrobe, Pa., 1960). It should be noted that the modern *Codex Iuris Canonicis,* canon 748, contains a formula for the baptism of *monstra.*

9. "Et scias quod maxime decernitur in figuracione capitis: si aliquid animal debet dici nostrum genitum: si enim caput habuerit plene vt generans figuratum: etiam si in multis aliis partibus sit monstruosus potuit dici nostrum: quid

et doctores legis nostre considerantes percipiunt baptizari tanquam recipien-
dum sit in specie nostra." *Problemata Aristotelis . . . cum Commento . . . Petri
de Apono* (Paris, 1520), 4.13, fol. 57v. The best study of Peter is that of Nancy G.
Siraisi, "The *Expositio Problematum Aristotelis* of Peter of Abano," *Isis* 61
(1970): 321–339. See also on the subject of the head, Ulrich of Strassburg, "Des
Ulrich Engelberti von Strassburg . . . Abhandlung De Pulchro," ed. M. Grab-
mann, *Sitzungsberichte der Bayerischen Akademie der Wissenschaften: Phi-
losophisch-philologischen und historischen Klasse* (Munich, 1925–1926), p. 78:
"Monstruosi partus non sunt perfecte pulchri, ut si caput in magnitudine vel
parvitate sit inproportionatum reliquis membris et quantitati totius corporis."
See also n. 26 below.

10. John de Marignolli, *Relatio*, in A. Van Den Wyngaert, ed., *Sinica Franci-
scana* (Florence, 1929), 1.7, p. 546, and O. Holder-Egger, ed., *Balduini Nino-
vensis Chronicon*, in MGH: SS 25 (Hanover, 1880), p. 549.

11. Pseudo-Albert the Great, *De Secretis Mulierum* (Paris, 1492), ch. 6, fol.
25v: "Et habent distincta capita . . . et distinctas animas. Et debent baptisari pro
duobus hominibus." On this work see Lynn Thorndike, "Further Considera-
tion of the *Experimentata, Speculum Astronomiae*, and *De Secretis Mulierum*,
Ascribed to Albertus Magnus," *Speculum* 30 (1955): 413–443; and G. Romag-
noli, "Una questione multisecolare: L'opera 'De Secretis Mulierum' attribuita
comunemente ad Alberto Magno . . . ," in *Congresso Nazionale di Storia della
Medicina* 24 (Rome, 1971), pp. 402–416.

12. Sed quid si sit vnum monstrum quod habeat duo corpora coniuncta dum
ne baptizari vt vna persona vel vt due. Dico quod cum baptismus fiat propter
animam et non propter corpus quantumcumque essent duo corpora si solum
esset vna anima dum baptizari vt vna persona. Sed si essent due animae debet
baptizari vt due persone. Sed questio sciatur vtrum sit vna anima vel due. Dico
quod si sint duo corpora sunt due animae. Sed si est vnum corpus est vna
anima. Et ideo si sint duo pectora et duo capita supponendum est esse duas
animas. Si autem esset vnum pectus et vnum caput quantumcumque alia
membra essent duplicata erit vna anima." Guido of Mont Rocher, *Manipulus
Curatorum Officia Sacerdotus* (Strasbourg, 1490), 2.1.5, sig. a, fol. 8v. On Guido
see Pierre Michaud-Quantin, "Guido de Mont Rocher," *Dictionnaire de Spiri-
tualité* 6:1303–1304; and for a survey of editions W. A. Copinger, Supplement
to Hain's *Repertorium Bibliographicum* (Milan, 1950), 2:2824–2850. The popu-
lar English manual of John de Burgo, 1385, gives substantially the same mate-
rial, derived from the *Rosarium*. See *Pupilla oculi* (Strasbourg, 1516/17), fols.
9v–10.

13. "Si monstrum baptizandum est tutius est baptizare singilatun: quando
apparent duo capita, vel duo corpora &c. casu necessitatis amoto: et in secundo
dicere: Si non es baptizatus." Alberto da Castello, *Liber Sacerdotale* (Venice,
1576), 1.1.5, fol. 11b. On Castello see J. Quétif and J. Echard, *Scriptores Ordinis
Praedicatorum* (rpt. New York, 1959), 2.1, p. 48–49. The *Ritvale Romanvm Pavli
V* (Antwerp, 1617), p. 8, reads: "In monstris verò baptizandis, si casus eueniat,
magna cautio adhibenda est . . . Monstrum quod humanam speciem non prae-
seferat [sic], baptizari non debet: de quo si dubium fuerit, baptizetur sub hac
conditione: Si tu es homo, ego baptizo, &c." The work later gives information
on how to determine if the child is one or two persons.

14. Alphonsi à Carranza, *Tractatus Nouus . . . de Partv Natvrali et Legitimo*
(Genoa, 1629), 17.31, p. 633: "An monstrosus partus possit, debeatque bapti-
zari? . . . istas formam humanam habentes, sacro Baptismate ablui posse & de-
bere: monstrosas vero (vt quae anima rationali carent) non sic." Jean Céard, *La*

Nature et les prodiges (Geneva, 1977), p. 9, n. 3. cites several seventeenth-century Protestant authors who were interested in the baptism of monsters.

15. John Block Friedman, ed., "Thomas of Cantimpré, *De Naturis Rerum:* Prologue, Book III, Book XIX," *Cahiers d'Etudes Médiévales II: La Science de la Nature: Théories et Pratiques* (Montreal and Paris, 1974), p. 124, ll. 30-40.

16. A. Derolez, ed., *Liber Floridus* (Ghent, 1968), p. 47, fol. 23r.

17. "Pilosus est homo siluestris . . . Et quamuis esse homines videantur." Pierre Bersuire, *Opera Omnia* (Mainz, 1609), 3.10.79, p. 405.

18. "Sunt homines seu bestiae formam humanam habentes." Ibid., 3.14.19, p. 597.

19. Monstruosorum quoque multa hominum genera post linguarum uarietatem a deo factam, uariis in locis producta fuisse . . . Deus enim ipse cum sciret quarum partium similitudine uel diuersitate contexeret pulchritudinem uniuersi, etiam multos monstruosos homines in mundum producere uoluit." Giacomo Filippo Foresti, *Svpplementvm Chronicorvm* (Paris, 1535), fols. 13-13v. Foresti gets the notion from the *Chronica* of St. Antony of Florence (Lyons, 1587), 1.2, p. 18. On this author, see J. B. Walker, *The 'Chronicles' of Saint Antoninus* (Washington, D.C., 1933). Foresti's work was directly copied by the somewhat better-known chronicler Hartman Schedel in his *Nuremberg Chronicle.* See Adrian Wilson, *The Making of the Nuremberg Chronicle* (Amsterdam, 1976), pp. 15-29, and Céard, *La Nature et les prodiges,* pp. 72-75, for discussion of the Italian author.

20. Indeed, when he speaks of the appearance of the races, Augustine applies the obverse of this aesthetic—which was even more influential during the Middle Ages than the idea of *concordia discors.* In *The City of God* he discusses the resurrection of monstrous men without their deformities. "For all bodily beauty is the harmony of parts . . . But when there is no harmony of parts a thing offends either because it is misshapen, or too small or too large." William Chase Green, ed. and tr., *The City of God,* by Saint Augustine, LCL (Cambridge, Mass., and London, 1959), 22.19, p. 293.

21. P. Knöll, ed., *Sancti Avreli Avgvstini . . . De Ordine Libri Dvo,* in *CSEL* 63 (Vienna and Leipzig, 1922), 1.6.18, p. 133, and 2.4.12, p. 155. For Saint Augustine's ideas on beauty here and later in this chapter, see K. Svoboda, *L'Esthétique de Saint Augustin et ses sources* (Brno, 1933), p. 21.

22. *PL* 176, 819. On the problem of bk. 7, see Roger Baron, "Hugues de Saint-Victor," in *Dictionnaire de Spiritualité,* 2:904-912, and the same author's "Hugues de Saint-Victor: Contribution à un nouvel examen de son oeuvre," *Traditio* 15 (1959): 249-251.

23. "Nota, monstrum dicitur: eo quod monstrat se videntibus: quia oculus diligimus videre monstra propter amirari . . . ad exornationem et decorationem uniuersi. Nam dicunt sicut diuersi colores in pariete existentes decorant ipsum parietem: sic etiam diuersa monstra ipsum uniuersum exornant mundum." Pseudo-Albert the Great, *De Secretis Mulierum,* fols. 23v, 24. On the other side of the coin, it is interesting to see that Saint Bernard uses much the same sort of language we shall find in the next few pages to inveigh *against* monstrous beings in the decoration of churches: "illa ridicula monstruositas, mira quaedam deformis formositas, ac formosa de formositas" (*Apologia,* ch. 12, *PL* 182, 16). For an English version of the relevant passage see Elizabeth G. Holt, *Literary Sources of Art History* (Princeton, 1947), p. 19, and Meyer Schapiro, "On the Aesthetic Attitude in Romanesque Art," in K. B. Iyer, ed., *Art and Thought* (London, 1947), pp. 133-137.

24. *The City of God,* 11.18, and Alexander of Hales, *Summa Theologica,* ed. B. Marrani (Florence, 1928), 2.4.2.2.1.1.3.452, p. 574.

25. On the make-up of this work see M. Gorce, "La Somme Théologique d'Alexandre de Halès est-elle authentique?" *New Scholasticism* 5 (1931): 1–72.

26. These were established as the head, the heart, the liver, and the testicles by Alfred of England or of Sareshal, *De Motu Cordis,* ed. C. Baeumker, in *Beiträge zur geschichte der philosophie des mittelalters* 23 (Münster, 1923), ch. 16.1, pp. 85–86. On this author, see James K. Otte, "The Life and Writings of Alfredus Anglicus," *Viator* 3 (1972): 275–291.

27. Ratramnus of Corbie, *Epistola* 12, in E. Dümmler, ed., *Epistolae Karolini Aevi,* in MGH *Epist.* 6 (Berlin, 1925), p. 155.

28. St. Basil, *Homilies on the Hexameron* 9.2, in P. Schaff, ed., *Post and Ante-Nicene Fathers,* 8:102. For Latin examples, see Lactantius, *Divinae Institutiones* 2.1, 15–18, and Saint Augustine, *De Gen. contra Manichaeos* 1.17.28.

29. Philip Levine, ed. and tr., *Saint Augustine: The City of God,* LCL (London and Cambridge, Mass., 1966), 14.17, p. 361. See the lovely passage on the importance of clothes to mankind in Hugh of St. Victor, *The Didascalicon of Hugh of St. Victor,* tr. Jerome Taylor (New York and London, 1961), 1.9, p. 56.

30. Homer, *Iliad* 3.6. The best study of the Pygmies is that of Martin Gusinde, *Kenntnisse und Urteile über Pygmäen in Antike und Mittelalter,* in *Nova Acta Leopoldina* 162 (Leipzig, 1962).

31. See Charles B. Gulick, ed. and tr., *The Deipnosophists,* by Athenaeus, LCL (London and Cambridge, Mass., 1930), 4.9.393, p. 281.

32. See René Henry, ed. and tr., *Photius: Bibliothèque* (Paris, 1959), 1.3, p. 7. On travelers' accounts of the dwarf peoples of Africa see Peck, ed. and tr., *Historia Animalium,* by Aristotle, 3.8.12.596.

33. "Pigmei scilicet sagitarii et ad bella promptissimi unde figurant gentes iste hereticos," Peter of Cornwall, *Pantheologus* 4.8.14, BL Royal 7.C.xiv, fol. 162v. On Peter see R. W. Hunt, "English Learning in the Late Twelfth Century," *Transactions of the Royal Historical Society* 19 (1936): 33–34, 38–42, and David Knowles et al., eds., *The Heads of Religious Houses: England and Wales* (Cambridge, 1972), p. 174. The best study of the *Distinctiones* collections is R. Rouse, "Biblical Distinctiones in the 13th Century," *AHDLMA* 41 (1974–1975): 27–37.

34. "Sicut modo habentur nani propter ludum." Hugh of St. Cher, *Opera Omnia in Vetus et Novum Testamentum* (Venice, 1732), 5, fol. 96. Hugh shows himself well aware of the problematic meanings of *gammadim,* giving the readings of all the different biblical texts known to him. His allegorization of the passage derives from Jerome's interpretation of Pygmy as a word meaning "disputant": "By Pygmies, therefore," said Hugh, "should be understood evil lawyers and decretists."

35. "In dirisionem hostium." Robert Holkot, *Convertimini,* BL Harley MS 5369, fol. 267v. This work is discussed briefly by Beryl Smalley, *English Friars and Antiquity in the Early Fourteenth Century* (Oxford, 1960), p. 147 and n. 4.

36. This is actually the *Historia Animalium* 8.1.588b, 10–20. It should be noted that the Arabic writers regarded the *Historia Animalium* in ten books, the *De Partibus Animalium* in four books, and the *De Generatione Animalium* in five books as one vast work on animals in nineteen books. Thus Michael Scot simply translated Ibn al-Bitrîq's Arabic version as *De Animalibus,* and Oresme also uses this title. See S. D. Wingate, *The Mediaeval Latin Versions of the Aristotelian Scientific Corpus, with Special Reference to the Biological Works* (rpt. Dubuque, Iowa, 1963), pp. 72–86; G. Lacombe, *Aristoteles Latinus:*

Pars Prior (Rome, 1939), pp. 80–85; and Lynn Thorndike, *Michael Scot* (London, 1965), pp. 22–31. The passage in question is published by Bert Hansen, "Nicole Oresme and the Marvels of Nature" (diss., Princeton University, 1974), ch. 3, p. 248.

37. Hermann Stadler, ed., *Albertus Magnus De Animalibus Libri XXVI,* in *Beiträge zur Geschichte der Philosophie des Mittelalters* 15 (Münster, 1916), 1.1.3.46, p. 18. Gusinde gathers the remarks of Albert on Pygmies in *Kenntnisse,* pp. 13–15.

38. Stadler, *De Animalibus* 4.2.2.96, p. 400.

39. Ibid., 7.1.6.62, pp. 521–522.

40. Hermann Stadler, ed., *Albertus Magnus De Animalibus,* in *Beiträge zur Geschichte der Philosophie des Mittelalters* 16 (Münster, 1920), 21.1.2.11–12, p. 1328. On the subject of *disciplinitas* in the Pygmy, see also H. W. Janson, *Apes and Ape Lore* (London, 1952), pp. 84–85, 89.

41. The information in this paragraph is drawn from E. Hocedez, "La Vie et les oeuvres de Pierre D'Auvergne," *Gregorianum* 14 (1933): 1–15.

42. On the *quaestio* see P. Mandonnet, *Questions disputées de Saint Thomas d'Aquin* (Paris, 1926), 1:1–12. Its development as far as the ninth century was treated by G. Bardy, "La Littérature patristique des *Quaestiones et Responsiones* sur l'Ecriture sainte," *Revue Biblique* 41 (1932): 210–236, 341–369, 515–537; 42 (1933): 14–30, 211–229, 328–352. On the dialectical aspects of the *quaestio,* see G. Paré, A. Brunet, and P. Tremblay, *La Renaissance du XIIe siècle: Les écoles et l'enseignement* (Paris and Ottawa, 1933), pp. 125–131.

43. Peter Cantor, *Verbum Abbreviatum,* ch. 1, PL 205, 25.

44. F. Rabelais, *Oeuvres complètes,* ed. J. Boulanger (Paris, 1955), ch. 7, p. 220.

45. *Utrum* seems to have corresponded to the word *poteron* in Aristotle's *Metaphysics.* See, for example, Thomas Aquinas, *Metaphysics* 10.7.2060.

46. The most authoritative account of *quodlibetal* writing is P. Glorieux, *La Littérature quodlibétique de 1230 à 1320,* 2 vols. (Paris, 1925–1935), and more recently, "Où en est la question du Quodlibet?" *Revue du Moyen Age Latin* 2 (1946): 405–414.

47. In what may be an interesting echo of this argument, Oresme in the treatise on marvels says, "Among things generated some species are proximate like wolf and dog; and even concerning some there is doubt whether they differ in species, like pygmies and men." Hansen, "Nicole Oresme and the Marvels of Nature," ch. 3, p. 239.

48. My summary and quotation come from the Latin text edited by Joseph Koch, "Sind die Pygmäen Menschen?" *Archiv für Geschichte der Philosophie* 40 (1931): 209–213. For discussion, see Gusinde, *Kenntnisse,* pp. 21–26. Like Peter of Auvergne, Peter of Abano in his commentary on the *Problemata* acknowledges the true rather than fabulous existence of Pygmies and speaks, like the earlier Peter, from personal experience: "Notandum quod pygmei sunt animalia precise vt homines sicut vidi et tetigi . . . quos dico non esse homines licet eis similentur." *Problemata Aristotelis* 10.12, fols. 96v–97. The rest of the discussion is very similar to, indeed, dependent upon, Albert the Great, even to the use of the phrase "vmbra rationis."

49. Medieval men found in the *Politics* a doctrine of natural slavery whereby some men with low intelligence and high physical strength were fitted to be directed by those in whom the reverse pertained. Peter had written in his commentary that "in some individual composita of body and soul, of matter and intellect, we find that the matter clogs and hampers the activity of the

intellect; and the servile nature suited to be guided by the intellect of another is the result." On this subject see Conor Martin, "The Medieval Commentaries on Aristotle's *Politics*," *History* n.s. 36 (1951): 29–44; the quotation from Peter's commentary occurs on p. 42. More recent studies are Lester H. Rifkin, "Aristotle on Equality," *JHI* 14 (1953): 276–283, and Charles J. O'Neil, "Aristotle's Natural Slave Reexamined," *New Scholasticism* 27 (1953): 247–279.

EPILOGUE

1. John de Marignolli, *Relatio,* ed. A. Van Den Wyngaert, *Sinica Franciscana* (Florence, 1929), 1.2–3, p. 541; and 2.9, p. 546.

2. F. Rabelais, *Oeuvres complètes,* ed. J. Boulanger (Paris, 1955), 5, ch. 31, p. 866. Shakespeare similarly takes aim at the tales of merchant adventureres when he has Gonzalo say in the *Tempest* 3.3, ll. 43–49:

> When we were boys
> Who would believe that there were mountaineers
> Dewlapped like bulls, whose throats had hanging at 'em
> Wallets of flesh? or that there were such men
> Whose heads stood in their breasts? which now we find
> Each putter-out of five for one will bring us
> Good warrant of.

3. Cornelius Gemma, *De Naturae Divinis Characterismis* (Antwerp, 1575), 1.6, pp. 75–76. See also Jean Céard, *La Nature et les prodiges* (Geneva, 1977), pp. 366–367.

4. Eldred Jones, *Othello's Countrymen: The African in English Renaissance Drama* (Oxford, 1965), p. 11.

5. S. E. Morison, *Journals and Other Documents on the Life and Voyages of Christopher Columbus* (New York, 1963), p. 65.

6. Ibid., p. 185. Columbus' own cartographer, Juan de la Cosa, shows what "many expected" in his world map c. 1500 now in the Naval Museum, Madrid. On it he placed Gog and Magog in their traditional locations and depicted a Blemmyae. See George E. Nunn, *The Mappemonde of Juan de la Cosa* (Jenkintown, Pa., 1934).

7. Francis M. Rogers, "The Songs of the Indies by Giuliano Dati," *Congresso Internacional de Historia dos Descobrimentos* (Lisbon, 1960), p. 280; and idem, *The Quest for Eastern Christians: Travels and Rumor in the Age of Discovery* (Minneapolis, 1962), pp. 94–103.

8. Leonardo Olschki, "I 'Cantari dell' India' de Giuliano Dati," *La Bibliofilia* 40 (1938), pp. 291–295.

9. I use the edition in the New York Public Library: Giuliano Dati, *El secondo Cantare dell' India,* Massachusetts Historical Society (Boston, 1922), pp. 329–331.

10. See David Beers Quinn, "New Geographical Horizons: Literature," in Fredi Chiappelli, ed., *First Images of America* (Berkeley, 1976), 2:642–643; and, more generally, Percy G. Adams, "The Discovery of America and European Renaissance Literature," *Comparative Literature Studies* 13 (1976): 100–115.

11. Luis Nicolau d'Olwer, *Fray Bernardino de Sahagún* (Mexico City, 1952), p. 144.

12. M. F. de Navarrete, ed., *Colección de documentos inéditos para la historia de España* (Madrid, 1842–1895), 1:403. On this theme see Luis Weckmann, "The Middle Ages in the Conquest of America," *Speculum* 26 (1951): 130–141,

and Walter Oakeshott, "Some Classical and Medieval Ideas in Renaissance Cosmography," in D. J. Gordon, ed., *Fritz Saxl . . . Memorial Essays* (London, 1957), pp. 245–260.

13. See M. Toussaint, *Arte Colonial en México* (Mexico City, 1962), fig. 63.

14. Richard Bernheimer, *Wild Men in the Middle Ages* (Cambridge, Mass., 1952), p. 1. See also F. Tinland, *L'Homme sauvage* (Paris, 1968), pp. 41–48.

15. See Bernheimer, *Wild Men,* pp. 179–182; François Gagnon, "Le Thème médiéval de l'homme sauvage dans les premières représentations des Indiens d'Amérique," in Guy-H. Allard, ed., *Aspects de la marginalité au Moyen Age* (Montreal, 1975), pp. 83–103; and Chiappelli, *First Images of America,* vol. 1, especially Hayden White, "The Noble Savage Theme as Fetish," pp. 121–135, and vol. 2, Stephen J. Greenblatt, "Learning to Curse," pp. 566–568, on the languages of the wild men. André Thevet warned against the dangers of identifying Pliny's hairy wild men with aboriginal peoples in terms that suggest it was commonly done. "Many haue this foolish opinion, that those people, whome we call wilde men, as they liue in the woods and fields almost like to brute beasts, so in like maner they are heary all ouer their bodyes, as a Lion, a Bear . . . Also they are so pictured and painted . . . In setting out a wilde man, they set him out al hairy, euen from the head to the foote . . . The which is altogether false and untrue. The wilde men as well of the East *Indies,* as of *America,* come forthe of their mothers wombe as faire and as well pollished as oures of Europe." A. Thevet, *The New Found Worlde or Antarctike* (rpt. Amsterdam and New York, 1971), ch. 31, p. 47v. On Thevet, see J. Adhémar, *Frère André Thevet, grand voyageur et cosmographe des rois de France au XVIe siècle* (Paris, 1947).

16. Charles Schefer, ed., *Le Voyage de la Saincte Cyté de Hierusalem* (rpt. Amsterdam, 1970), ch. 5, p. 22.

17. E. W. Weismann, *Mexico in Sculpture* (Cambridge, Mass., 1950), fig. 19, and pp. 27, 193.

18. The striped tights in the painting may be related to those which the figure of Melancholy wears in the temperament page in BL Egerton 2572, fol. 51 v. See Dorrit Lundbaek, "Fabelvaesener i sengotisk kalkmaleri i Danmark og deres forudsaetninger," *Historie, Jyske Samlinger* 9 (1970): 1–83; on Råby church see especially pp. 10, 13. A handlist of similar representations appears on p. 43. See also R. Broby-Johansen, *Det Danske Billedbibel* (Copenhagen, 1968), pp. 180–181, and G. Franceschi and O. Hjort, *Kalkmalerier fra Danske Landsbykirker* (Copenhagen, 1969), pp. 69–70.

19. On this controversy see Louis Hanke, *Aristotle and the American Indians: A Study in Race Prejudice in the Modern World* (Bloomington, Ill., and London, 1970), pp. 28–96, and his more recent study, *All Mankind Is One* (De-Kalb, Ill., 1974), from which (p. 84) my quotation is drawn.

Index

INDEX

263

races, 2, 84, 88; dispersal of mankind
after, 39, 42, 91, 100–103, 150; re-
called by Vézelay tympanum, 86;
races generated after, 89, 99, 101, 198
Foresti, Giacomo Filippo, *Supplemen-
tum Chronicorum*, 184, 199
France, 7, 53, 77, 81, 127, 141
Fronto, Marcus Cornelius, 111
Fulgentius of Ruspe, 65

Galen, 51
Garamantes, 15
Gauls, 42
Gautier de Metz, *Image du Monde*,
41–42
Gawain and the Green Knight, 149
Gemma, Cornelius, 198
Genealogy of races, 87–107; from Cain,
2, 31, 89, 94–99, 102–103; from Ham,
39, 89, 99–103; from Adam, 59, 88, 89,
91–94, 186–187, 188, 190
Geoffrey of Vinsauf, 55
Gerald of Wales, 53
Germans, 84
Germany, 7, 58
Gervase of Tilbury, *Otia Imperialia*,
118, 160, 185
Gesta Romanorum, 125–126, 171
Giants, 1, 8, 33–34, 58, 113, 116, 121,
151, 156, 157, 158, 159, 160, 161, 163,
164, 199; defined, 15; as Watusi, 24;
origins of, 84, 94, 99, 103, 104, 198; in
excess of Aristotelian mean, 113,
185, 195; moralizing treatment of,
124, 128. See also Churl
Gilla Mo Dutu, *Ban-Shenchus*, 99
Glossa Ordinaria, 190
Gog and Magog, 45, 46, 58, 85, 143
Golden Age, 165–167, 171
Goldsmith, Margaret, 105–106
Goliath, 124
Gorgades, 15, 118
Grendel, 104–107
Guido da Baysio, *Rosarium*, 180–182
Guido of Mont Rocher, *Manipulus
Curatorum*, 182
Guy de Bazoches, *Apologia*, 53
Gymnosophisti, 9, 13, 25, 31, 33, 134,
135, 143, 145, 167; dialogue of, with
Alexander, 167–170; as ur-Christians,
171

Hagar, 64
Hairy Men and Women, 28, 29, 54, 118,
128, 135, 145, 146, 148, 155, 156, 157,
161, 197, 201; defined, 16; Pilosi, 87,
184; in late Middle Ages, 154, 162,

164, 197, 200–201, 204, 216n20. *See
also Wodewose*
Hali, 58
Ham, 39, 89; as father of the races,
99–105, 172; incontinence of, 236n54
Hanno, *Periplus*, 118, 149
Harent of Antioch, 160
Haytoun of Armenia, 198
Hereford map, see Maps, medieval
Herodotus, 6, 18, 55, 160
Higden, Ranulf, *Polychronicon*, 43, 100
Hilary of Poitiers, 174
Himantopodes, 11, 20, 184, 198; de-
fined, 16
Hippocratic *Airs, Waters, Places*,
51–52
Hippocratic *Regimen*, 51
Hippopodes, 20, 60, 94, 103, 133, 183,
184, 198; defined, 16; and lobster-
claw syndrome, 24
Holkot, Robert, 125, 191; *Convertimini*,
191
Holy Land, 42, 45, 76, 77, 80, 86, 143,
159. *See also* Pilgrims; Pilgrimage
Homer, 5, 8, 13, 15, 18, 27, 29, 166, 190;
Iliad, 27, 29; *Odyssey*, 5, 8, 27, 165
Honorius of Regensburg (Autun), 93
Horned Men, 16, 17, 54, 55, 125, 156,
157; Cain, 96, 97; Nimrod, 101
Hugh of St. Cher, 44, 61, 64, 65, 71, 172,
190
Hugh of St. Victor, *Didascalicon*, 185
Huguccio of Pisa, *Magnae Deriva-
tiones*, 32

Ibrihim ben Wasif Sah, *Abrégé des
Merveilles*, 101
Icthiophagi, 27, 147, 159, 160, 165, 198;
described, 17
India, 1, 3, 11, 12, 15, 18, 24, 58, 132,
143, 162, 175; Ctesias' account of, 5,
7, 15, 18, 22; Megasthenes' account
of, 6, 7, 11, 18, 22, 167–168; Alex-
ander the Great in, 6–7, 15, 144, 163,
167, 169, 202 (*see also* Alexander ro-
mances); Pliny on, 7–8, 11, 12; con-
flated with Africa, 8, 15, 213n13;
races of, 8–21 passim, 60, 84, 118,
160, 163, 177, 197 (*see also* Brag-
manni, Gymnosophisti); dominated
by Saturn, 51; Prester John in, 60;
Bartholomew in, 70; races shifted
from, 84, 154; Ham's line in, 103
Indians, 18, 109, 143, 165, 197–198; in
New World, 4, 177, 199, 201, 203,
206–207; conflated with Ethiopians,
8; as sages, 12–13, 134, 164, 167–169,
171, 175

Ireland, 43, 72–73, 99, 109
Isaac, 64, 67
Ishmael, 64–67
Isidore of Seville, 10, 41, 42, 43, 48, 50,
108, 124, 186; *Etymologiae*, 47, 110,
112–116, 124; *Liber Differentiarum*,
112; *Isidorus Versificatus*, 233n16
Islam, 60, 75, 174, 175, 176; embodied in
Pentecost scenes, 63–64, 67; in Chris-
tian apologetic literature, 65; con-
nected with Dog-Heads, 67–69; prej-
udice against, 67, 172; polytheism
associated with, 176

Japheth, 39, 100–101
Jean, Duke of Berry, 154; *Très Riches
Heures*, 141
Jerome, Pseudo-, 172
Jerome, Saint, 53, 87, 97, 101, 143, 190
Jerusalem, 59, 62, 79, 172; races located
far from, 37, 46; as center of world,
43, 45–46, 56, 80, 219n23; as goal of
pilgrims and crusaders, 76, 77
John, Evangelist, 69
John of Hildesheim, *Historia Trium
Regum*, 172
John of Plano Carpini, 75, 167
John of Sacrobosco, *De Sphera*, 41
John of Salisbury, 149
Joinville, Jean de, 76
Jones, Eldred, 198
Jubilees, Book of, 105
Julian the Apostate, 72
Julius Obsequens, 179
Julius Paulus, 179
Julius Valerius, *Deeds of Alexander*,
169

Keverne, Church of Saint, 73
Khan, Genghis, 75, 103
King of Tars, 65, 72, 73

Lactantius Placidus, Commentary on
the *Thebiad*, 166
Lambert of St. Omer, *Liber Floridus*,
41, 183
Lamech, 97–98
Landscape: barren or savage, asso-
ciated with races, 30, 31, 129,
147–153, 159; of Cain's exile, 98; de-
pictions of races without, 131–132,
154; depictions of races in, 131, 141,
147–153, 154, 155–157, 162; late Ro-
manesque interest in, 141. *See also*
Exile; Maps, medieval
Las Casas, Bartolomeo de, 206
Laws of the Twelve Tables, 179
Lebor Gabála, 96, 100–101, 105

Lebor Na Huidre, 99
Lecan, Book of, 99
Leprechauns, 99
Letters and Mirabilia: as a genre, 7,
106, 145; Letter of Alexander to Aris-
totle, 7, 106, 144, 145, 150, 166–167,
169; Letter of Pharasmanes to the
Emperor Hadrian, 7, 23, 146, 151;
Letter of Fermes to Trajan, 7, 21, 23;
antagonism toward races in, 144–145;
Mirabilia, 144–145, 147, 153–154; Let-
ter of Fermes to the Emperor
Adrian, 146, 151; illustrations of
races in, 147–148, 153; correspon-
dence of Alexander and Dindymus,
168–169, 171; typical collections, 169
Libar Breac, 73
Liber Armorum, 102
Liber Glossarum, 110
Liber Monstrorum, 149–153
Libya, 12, 27, 29, 47, 51, 170
Lion-Headed Man, 144, *147*
Livy, 108, 179
Lotus-Eaters, 5, 27
Lovejoy, A. O., 119
Lucian, *True Histories*, 5
Luke, 69

Macrobius, 38, 47; *Commentary on the
Dream of Scipio*, 39, 40, 41; zone the-
ory of, on maps, 38–46 passim, 50,
52, 56
Mahomet, 64, 67
Mandeville's Travels, 1, *28*, 29, 30, 33,
34, 55, 102, 141, 143, 154, *158–159*,
161, 166, 169
Manuscripts: Baltimore, Walters Art
Gallery (MS 45) 137, 138, (MS 539)
66–67; Burgo d'Osma (MS 1) 40, 41;
Cambridge, University Library (MS
Kk. 4.25) 11, *12–13*, 47, 221n35,
242n53; Cambridge, Fitzwilliam Mu-
seum (Add. MS 23) 103, 237n68, (MS
254) 242n53; Coulommiers, Collec-
tion Durrieu, *160–161*; Florence, Bib-
lioteca Laurenziana (MS Plut. 7.32)
63–64, 66, 226n9; Karlsruhe, Bad.
Landesbibliothek (Aug. Perg. 60)
217n24; Leicestershire, Belvoir Castle
(Rutland Psalter) *139–140*; Leningrad,
State Library (MS Gr. 21) 226n9;
London, formerly A. Chester Beatty
Collection (MS 80) *14*, 15; London,
British Library (BL Add. 9810) 245n9,
(BL Add. 17987) 217n24, (BL Add.
28681) 43, *44*, 45, (BL Add. Gr. 19352)
61, *62*, 78, (BL Cotton Cleopatra D. v)
169, (BL Cotton Galba E. xi) 171, (BL